Norman Foster

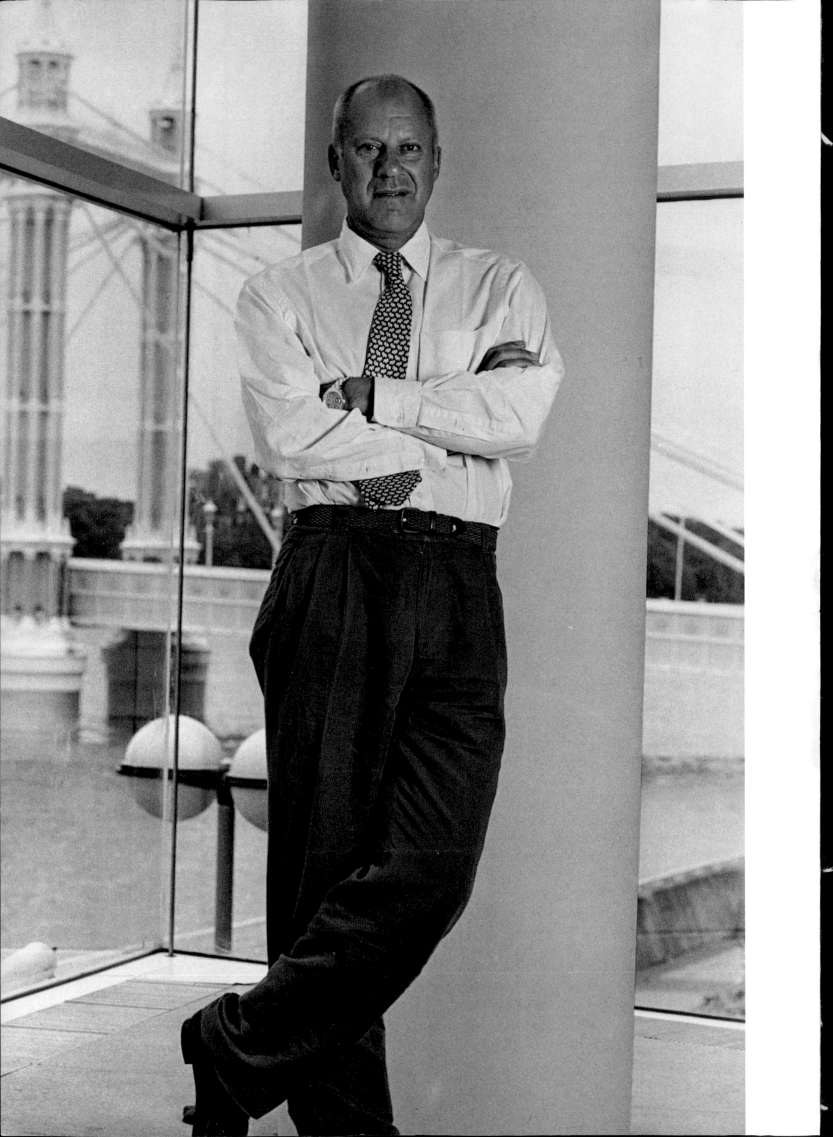

Sir Norman

Foster

Philip Jodidio

TASCHEN

KÖLN LISBOA LONDON NEW YORK PARIS TOKYO

Acknowledgements | Danksagung | Remerciements

The author wishes to thank Katy Harris for her
kind assistance in the preparation of this book.

Der Autor dankt Katy Harris für ihre freundliche
Unterstützung bei der Entstehung des Buches.

L'auteur tient à remercier Katy Harris pour son
soutien sur ce projet de livre.

Page 2 | Seite 2
Portrait of Sir Norman Foster
taken in August 1994 by Luca Zanetti.

Portrait von Sir Norman Foster,
aufgenommen im August 1994 von Luca Zanetti.

Portrait de Sir Norman Foster
pris en août 1994 par Luca Zanetti.
© Photo: 1994 Luca Zanetti/Lookat

© 1997 Benedikt Taschen Verlag GmbH
Hohenzollernring 53, D-50672 Köln
© VG Bild-Kunst, Bonn 1997:
21 b., Alexander Calder, two sculptures

Edited by Christine Fellhauer, Cologne
Design: Sylvie Chesnay, Paris
Cover Design: Mark Thomson, London
French translation: Simone Manceau, Paris
German translation: Franca Fritz, Heinrich Koop, Cologne

Printed in Italy
ISBN 3-8228-8071-x

Contents | Inhalt | Sommaire

The Foster Method
A new relationship between form and function

Die Foster-Methode
Eine neue Beziehung zwischen Form und Funktion

La méthode Foster
Un rapport nouveau entre forme et fonction

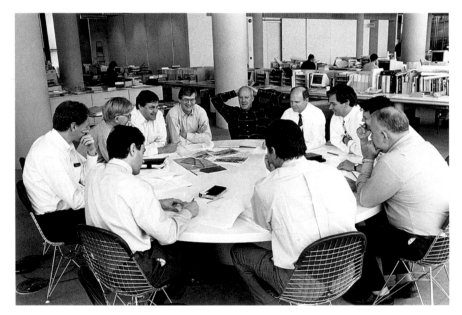

The offices of Sir Norman Foster and Partners near Battersea Bridge, in London, are impressive. A vast, light-filled double-height working space looks out onto the Thames. Every desk is covered with plans and drawings for projects ranging from private houses to massive towers. Here, and in offices in Hong Kong or Berlin, the firm currently employs 400 persons. With commissions such as the largest construction endeavor currently under way in the world, the new airport of Hong Kong, or the Reichstag in Berlin, Sir Norman Foster is one of the truly influential figures of his generation. Size and quality, it is said, are not often synonymous, but he remains sanguine about prospects for the firm. "It is a large office and it is handling a large range of projects and that is the risk. But architecture is a high-risk business. I think that it would be difficult to imagine any profession that has the risks of architecture. It is very volatile. It is feast or famine. It is intensely competitive. It is a challenge."[1]

Some well-known contemporary architects have a signature style, a series of coded responses to the task of design, which are manipulated according to circumstances to provide an immediately identifiable result. This is not the case of Norman Foster, despite attempts to classify him. An attention to detail, or a fascination with new technologies, are evident in almost every Foster project, but it can be asserted that his real style is not so much a matter of external appearances as it is one of method. That method is a question of the requirements of a site, but it is also one that attempts to go beyond the needs expressed by a client, reaching toward more efficient ways of dealing with social, ecological or cost concerns. This is not to say that the visible forms of a Foster building are considered secondary. His energetic remarks on this point are in-

Die Büros von Sir Norman Foster and Partners in der Nähe der Londoner Battersea Bridge sind beeindruckend: Ein riesiger, hoher, lichterfüllter Arbeitsraum bietet einen Blick auf die Themse, und auf allen Tischen liegen Pläne und Zeichnungen für Projekte – von Privathäusern bis hin zu gewaltigen Türmen. Hier und in den Büros in Hongkong oder Berlin beschäftigt die Firma etwa 400 Mitarbeiter. Mit Aufträgen wie dem neuen Flughafen von Hongkong – dem zur Zeit größten Bauvorhaben der Welt – oder dem Berliner Reichstag zählt Norman Foster zu den einflußreichen Persönlichkeiten seiner Generation. Foster zeigt sich optimistisch, was die Zukunftsaussichten seiner Firma angeht: »Ich kann mir kaum einen anderen Berufszweig vorstellen, der mit soviel Risiken verbunden ist. Ein wahres Wechselbad – Sekt oder Selters. Es herrscht ein starker Konkurrenzkampf, aber ich empfinde es als ständige Herausforderung.«[1]

Einige berühmte zeitgenössische Architekten zeichnen sich durch einen persönlichen Stil aus – ein bestimmter Formenkanon, der den Umständen entsprechend abgewandelt wird und für ein Resultat mit hohem Wiedererkennungswert sorgt. Dies trifft auf Norman Foster nicht zu – trotz verschiedener Versuche, ihn einzuordnen. Zwar zeugen fast alle Foster-Projekte von seinem Blick für das Detail und seiner Faszination für neue Technologien, aber sein persönlicher Stil läßt sich weniger am äußeren Erscheinungsbild ablesen als an seiner Methode. Diese berücksichtigt die Anforderungen eines Baugeländes, versucht aber auch, über die Bedürfnisse des Auftraggebers hinauszugehen und bemüht sich im Umgang mit sozialen, ökologischen und Kostenfaktoren um besondere Effizienz. Das heißt nicht, daß die sichtbaren Aspekte eines Foster-Gebäudes eine untergeordnete Rolle spielen. Fosters Anmerkungen zu diesem Punkt sind bezeichnend: »Ich beschäftige mich intensiv mit dem Erscheinungsbild, aber ich bin nicht der Ansicht, daß das Äußere eine Frage der Kosmetik ist oder daß es viel damit zu tun hat, was ich heute morgen zum Frühstück hatte. Das muß nicht heißen, daß etwas automatisch wunderschön ist, weil es in starkem Maße von der Natur inspiriert wurde. Wenn wir in der Haupteinflugschneise des Flughafens Heathrow stehen und nach oben blicken, werden wir einige wirklich häßliche Untiere über unseren Kopf fliegen sehen – von denen manche unglaublich beeindruckend sind. Das hängt davon ab, wie ihre Designer Kräfteverläufe und Drucklasten interpretiert haben. Und damit fängt alles an. Es beginnt nicht damit, daß jemand sagt: ›Welches Flugzeug

Situés près de Battersea Bridge à Londres, les bureaux de Sir Norman Foster et Associés sont impressionnants. Un vaste espace de travail, inondé de lumière, avec double hauteur de plafonds, donne sur la Tamise. Chaque table est couverte de plans et de dessins pour des projets qui vont de la maison privée au gratte-ciel. Ici, et dans ses bureaux à Hong Kong ou Berlin, l'entreprise emploie actuellement 400 personnes. Avec des commandes comprenant le plus grand chantier au monde, le nouvel aéroport de Hong Kong, ou le Reichstag à Berlin, Norman Foster – ou plutôt Sir Norman Foster, puisqu'il a été anobli par la Reine d'Angleterre en 1990 – est une des figures les plus influentes de sa génération. La taille d'une agence et la qualité de son travail, dit-on, ne sont pas souvent synonymes. Mais l'homme demeure confiant quant aux perspectives de son entreprise. «C'est une grande agence où l'on traite d'une grande diversité de projets. C'est là le risque. Mais l'architecture est une affaire à haut risque. Je pense qu'il est difficile d'imaginer une autre profession qui comporte les mêmes risques que l'architecture. C'est un domaine très inconstant. C'est le festin ou la famine. La compétition y est intense. C'est un défi permanent.»[1]

Certains architectes contemporains célèbres possèdent un style identifiable, un ensemble de réponses codées qu'ils utilisent systématiquement dans l'élaboration d'un projet. Ils les manient selon les circonstances et fournissent un résultat immédiatement reconnaissable. Ce n'est pas le cas de Norman Foster, malgré les tentatives cherchant à le classer. Son attention au détail et sa fascination pour les nouvelles technologies apparaissent de manière évidente dans presque tous ses projets. Mais on peut affirmer que son véritable style est moins une affaire d'apparences externes qu'une question de méthode. Il s'agit non seulement de respecter le site, mais aussi d'aller au-delà des besoins exprimés par un client, d'atteindre des moyens plus efficaces de répondre aux problèmes sociaux, écologiques et financiers. Cela ne signifie pas que les formes apparentes d'une construction Foster sont d'un intérêt secondaire. Sur ce point, ses remarques ne laissent aucun doute quant à sa démarche: «Je me soucie profondément de l'apparence physique, mais je ne pense pas qu'elle soit là simplement pour l'esthétique. Je ne pense pas qu'elle dépende de mon humeur, ou de ce que j'ai mangé ce matin au petit-déjeuner. Ce n'est pas parce qu'elle s'inspire de la nature qu'une forme est forcément belle. Sur la grande piste d'atterris-

Page 6: A picture of the Monday morning meeting of the directors, taken at Riverside Three, London, in September 1995.

Seite 6: *Die Konferenz der Direktoren am Montagmorgen. Riverside Three, London, September 1995.*

Page 6: *Réunion des directeurs le lundi matin, à Riverside Three, Londres, en septembre 1995.*

deed significant of his approach: "I care intensely about the appearance, but I don't think that the appearance is a matter of cosmetics. I don't think that it has too much to do with what I did or did not have for breakfast this morning. It doesn't mean to say that because it is massively informed by nature it is automatically going to be beautiful. On the main flight path into Heathrow, we can gaze up and see some of the ugliest brutes flying overheard. Some are absolutely stunning. That has to do with the way the designers have interpreted those forces and those pressures. That is where it starts. It doesn't start with someone saying, what kind of aircraft shall we have today. Shall we have a sort of Sopwith Camel?"[2]

Norman Foster's success in dealing simultaneously with a substantial number of major projects is clearly related to the structure of his firm. As he says, "Communication in this office is quite extraordinary. That has a lot to do with the fact that the partners, the five of us, Spencer de Grey, David Nelson, Graham Phillips and Ken Shuttleworth, who share the running of the practice, have actually been working very closely together for almost twenty-five years. Younger directors have been here twelve or fifteen years. Two key individuals in the organization have been here since 1964. Every Monday morning, we sit around this table and we have our regular meeting. There is a very real continuity." Although he takes pride in being closely involved in the projects, Sir Norman Foster must by the very scale of his work rely on a collective decision-making process symbolized by the Monday morning directors' meetings, symbolized too by the open space of the Riverside Three offices.

Setting the Standards

Born in Manchester in 1935, Norman Foster studied Architecture and City Planning at Manchester University. After graduating in 1961 he was awarded a Henry Fellowship and received a Masters degree from Yale University. He worked on urban renewal and master planning projects on the East and West Coasts of the United States, before founding "Team 4" with his wife Wendy Foster, Richard Rogers, and Georgie Wolton in 1963. This firm worked on one of the first significant projects of Foster's career, the Creek Vean House (Feock, Cornwall, 1964–66), a 350 square meter residence "designed to exploit classic Cornish views of wooded valleys, a creek with bobbing boats, and to the south, the broad sweep of the Fal estuary." A number of features of this house, such as the sliding walls connecting

wollen wir heute bauen? Soll es eine Art Sopwith Camel werden?‹«[2]

Die Tatsache, daß Norman Foster eine beträchtliche Zahl von Großprojekten gleichzeitig erfolgreich bearbeiten kann, ist vor allem der Organisation seiner Firma zu verdanken. Er sagt dazu: »Die Kommunikation in diesem Büro ist wirklich außergewöhnlich. Das hat viel damit zu tun, daß die fünf Partner, also Spencer de Grey, David Nelson, Graham Phillips, Ken Shuttleworth und ich, die die Firma leiten, seit fast 25 Jahren eng zusammenarbeiten. Auch die jüngeren Direktoren sind seit 12 oder 15 Jahren dabei, und zwei der Schlüsselfiguren in der Organisation schon seit 1964. Jeden Montag morgen setzen wir uns an diesem Tisch zusammen und halten unsere Konferenz ab. Kontinuität ist bei uns ein wichtiger Aspekt.« Obwohl er großen Wert darauf legt, eng in alle Projekte einbezogen zu sein, muß sich Norman Foster aufgrund des Umfangs aller Aufträge auf einen kollektiven Entscheidungsfindungsprozeß verlassen, der durch das montagmorgendliche Treffen der Direktoren ebenso symbolisiert wird wie durch die offenen Arbeitsräume der Büros am Riverside Three.

Entwicklung der Maßstäbe

Norman Foster wurde 1935 in Manchester geboren und studierte Architektur und Stadtplanung an der dortigen Universität. Nach seinem Abschluß 1961 erhielt er ein Stipendium – die Henry Fellowship – und machte seinen Master of Architecture an der Yale University. Er arbeitete an Stadtsanierungs- und Bebauungsplänen an der Ost- und Westküste der USA, bevor er 1963 mit seiner Frau Wendy Foster, Richard Rogers und Georgie Wolton »Team 4« gründete. Diese Firma entwarf eines der ersten bedeutenden Projekte in Fosters Karriere, das Creek Vean House (Feock, Cornwall, 1964–66), ein 350 m² großes Wohnhaus, dessen Design »die für Cornwall typischen Ausblicke auf bewaldete Täler, Buchten mit Booten und auf den weiten Bogen der Fal-Mündung bieten sollte«. Verschiedene Merkmale dieses Hauses – wie die Schiebewände, die die Räume untereinander bis hin zur Gemäldegalerie im oberen Geschoß verbinden, und das der Landschaft angepaßte, begrünte Dach – zeugen von einer Flexibilität und einem ökologischen Bewußtsein, die auch in späteren Arbeiten zum Ausdruck kommen. Dieser Entwurf wurde 1969 mit dem RIBA Award des Royal Institute of British Architects gewürdigt.

Nach der Gründung von Foster Associates 1967 erhielt Foster den Auftrag zum Bau eines seiner be-

sage d'Heathrow, vous allez voir aujourd'hui des mastodontes d'une laideur incroyable. Mais vous allez voir aussi des avions superbes. Superbes, parce que les ingénieurs ont su interpréter le jeu des forces et des tensions. Car c'est par là qu'il faut commencer. On ne commence pas en se disant: bon, quel avion allons-nous dessiner aujourd'hui? Un genre de Sopwith Camel?»[2]

Le succès de Norman Foster, qui peut mener de front plusieurs grands projets, est clairement lié à la structure de son entreprise. Il spécifie: «Ici, la communication est tout à fait extraordinaire. Cela tient beaucoup au fait que mes partenaires – Spencer de Grey, David Nelson, Graham Phillips, Ken Shuttleworth – et moi-même partageons la direction de l'agence, nous travaillons étroitement ensemble depuis bientôt 25 ans. Les jeunes directeurs sont ici depuis 12 ou 15 ans, deux individus clefs de l'organisation depuis 1964. Chaque lundi matin, nous nous installons autour de cette table pour notre rencontre hebdomadaire. On peut parler d'une véritable continuité.» Bien qu'il soit fier de son investissement personnel dans chaque projet, Sir Norman Foster doit s'appuyer sur ce processus de décision collective, que symbolisent non seulement les réunions du lundi matin, mais aussi l'espace ouvert des bureaux de la Riverside Three.

Les premiers grands projets

Né à Manchester en 1935, Norman Foster étudie l'architecture et l'urbanisme à l'université de Manchester. Après avoir obtenu son diplôme en 1961, il reçoit une bourse d'études (Henry Fellowship) et sort diplômé de l'université de Yale. Il travaille sur des projets de rénovation urbaine et de planification tant sur la côte Est qu'en Californie, avant de fonder «Team 4» en 1963, avec son épouse Wendy Foster, Richard Rogers et Georgie Wolton. Cette équipe travaille sur l'une des premières œuvres importantes de la carrière de Foster, la Creek Vean House (Feock, Cornouailles, 1964–66), résidence de 350 m² «conçue pour exploiter les panoramas classiques de Cornouailles, ses vallées boisées, une crique avec des bateaux à quai, et au sud, le vaste estuaire de la Fal.» Plusieurs caractéristiques de cette maison, tels les murs coulissants reliant chaque pièce à une galerie d'exposition à éclairage zénithal ou le toit-jardin, annoncent déjà le souci de flexibilité et les préoccupations écologiques qui s'affirmeront dans son travail ultérieur. Le projet est couronné en 1969 par un Prix du Royal Institute of British Architects (RIBA).

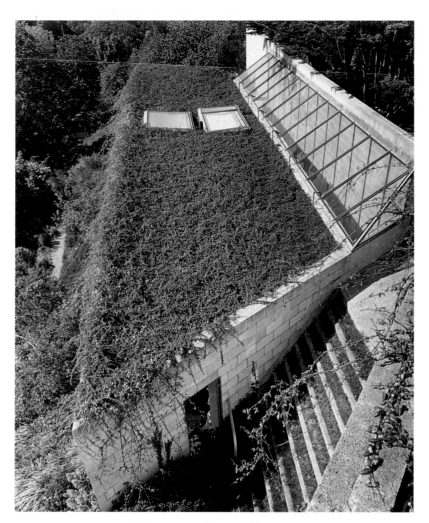

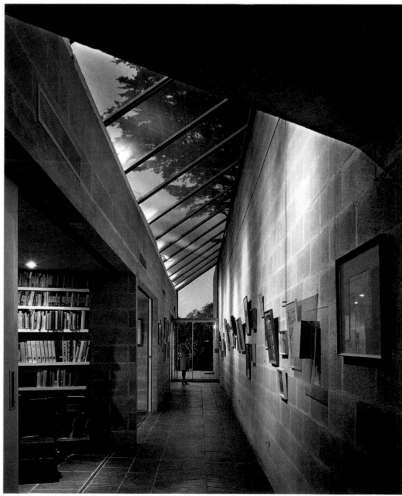

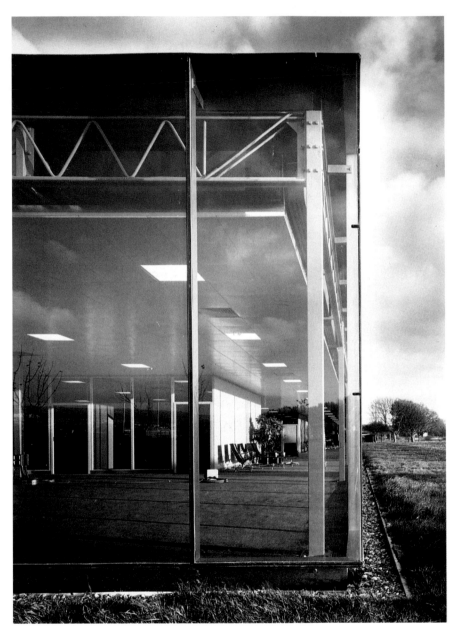

every room to a top-lit picture gallery, or the land-scaped and planted roof, give indications of the flexibility or ecological concerns that were to be affirmed in later work. The significance of this design was recognized in a 1969 Royal Institute of British Architects (RIBA) Award.

Having created Foster Associates in 1967, Norman Foster went on quickly to build one of his more famous buildings, the IBM Pilot Head Office (Cosham, Hampshire, 1970–71). Here, for the first time, a number of the strengths of the architect's method became apparent. A temporary office building erected on reclaimed land for 750 to 1,000 people, the job had to be completed within eighteen months at a cost comparable to the cheapest available temporary structures. Not only did Foster succeed in finishing the work ahead of schedule, but he brought innovations to the design. "The assignment was very simple," says Sir Norman. "IBM had half its space at that time in off the peg, temporary buildings, and half in so-called permanent buildings. Because we have such structures on every construction site, we know what temporary buildings are like. We also know that even though they are temporary and they are awful to work in, and they look so disgusting, they are actually very expensive. Somebody is making a lot of money out of them. IBM said that they had never been able to challenge the economics of that situation. So we said we'd like to try, and they agreed as long as it didn't cost any more and didn't take any longer. We were able to demonstrate that we could build a permanent building for the same budget, not a temporary building, but a permanent one that would be better. It still exists, it serves them well." Beyond the issue of permanence, Foster proposed a change in design to IBM which was to be quite significant. "At the time," he says, "there were separate buildings for their computers. They were a kind of shrine, because a computer building needed access floors and so on. It never occurred to anybody that you could put the access floor anywhere in a regular building, as long as you could service it from overhead and therefore from underneath. You could effectively design out the computer building."[3] As the citation for the 1972 RIBA award put it: "The building demonstrates that architecture can be produced from a tough commercial situation by the exercise of ingenuity and imagination."

The IBM building was followed shortly thereafter by the Willis Faber & Dumas Office (Ipswich, Suffolk, 1973–75). The unusual curving glass facade of the structure, which follows the edge of the irregu-

kanntesten Gebäude, des IBM Pilot Head Office (Cosham, Hampshire, 1970–71). Der Auftrag umfaßte ein provisorisches Bürogebäude für 750 bis 1 000 Mitarbeiter, das in einer Bauzeit von 18 Monaten auf renaturiertem Land entstehen und dabei so preiswert sein sollte wie die billigsten provisorischen Bauten der damaligen Zeit. Foster gelang es nicht nur, die Arbeiten schneller als geplant abzuschließen – er schuf auch einen innovativen Entwurf. »Die Aufgabe war sehr einfach«, sagt er heute, »IBM hatte seine Büros zur Hälfte in provisorischen Bauten von der Stange und zur Hälfte in dauerhaften Gebäuden. Da wir solche Konstruktionen von jeder Baustelle kannten, wußten wir, wie provisorische Bauten im allgemeinen aussehen: Sie bieten keine guten Arbeitsbedingungen und sind nicht nur häßlich, sondern im Normalfall auch sehr teuer. Irgendjemand verdient eine Menge Geld damit. IBM teilte uns mit, daß es ihnen nie gelungen sei, dieses Problem zu wirtschaftlich akzeptablen Konditionen zu lösen. Also antworteten wir ihnen, daß wir es gern versuchen würden, und sie waren einverstanden, sofern unser Vorschlag nicht noch mehr kostete oder noch länger dauerte. Es gelang uns, sie davon zu überzeugen, daß wir für das gleiche Budget nicht nur ein provisorisches, sondern ein wesentlich besseres dauerhaftes Gebäude bauen konnten. Die Büros stehen heute noch, und erfüllen immer noch ihren Zweck.« Außerdem schlug Foster der Firma IBM eine Änderung im Gebäudeinneren vor, die sich ebenfalls als bedeutsam herausstellen sollte. »Damals«, so Foster, »wurden die Computer noch in separaten Gebäuden untergebracht. Sie stellten eine Art Heiligtum dar, da ein Computergebäude eigene Versorgungsebenen usw. benötigte. Bis zu unserem Vorschlag schien noch niemand bemerkt zu haben, daß man die Versorgungsebenen in einem Gebäude überall einplanen kann, solange die Versorgungsleitungen über Kopf zu reparieren sind. Auf diese Weise konnte das Computergebäude auf effektive Weise genutzt werden.«[3] Nicht zuletzt deshalb stand in der Preisrede für den RIBA Award 1972: »Das Gebäude beweist, daß Erfindungsreichtum und Phantasie auch unter schwierigen wirtschaftlichen Bedingungen qualitativ hochwertige Architektur hervorbringen können.«

Auf den IBM-Auftrag folgten kurze Zeit später das Willis Faber & Dumas Office (Ipswich, Suffolk, 1973–75). Die ungewöhnlich geschwungene Gebäudefassade, die laut Foster dem unregelmäßigen Verlauf des Baugeländes folgt »wie ein Pfannkuchen in der Pfanne«, gehört zu den am häufigsten fotografierten Wahrzeichen der zeitgenössischen

Ayant créé Foster and Associates en 1967, Norman Foster parvient à construire rapidement un de ses bâtiments les plus célèbres, l'IBM Pilot Head Office (Cosham, Hampshire, 1970–71). Ici, pour la première fois, certaines forces de sa méthode sont perceptible. Un bâtiment temporaire de bureaux est construit sur un terrain abandonné, pour 750 à un millier de personnes. Le travail doit être achevé en 18 mois, à un coût comparable aux structures temporaires les plus économiques disponibles. Non seulement Foster réussit à terminer le travail en avance, mais il apporte au projet des innovations. «La mission était très simple», dit Sir Norman. «À l'époque, l'espace IBM occupait pour moitié des bâtiments provisoires préfabriqués, et pour l'autre moitié des bâtiments soi-disant permanents. Parce que nous avons de telles structures temporaires sur chaque site de construction, nous savons ce que sont ces bâtiments. Nous savons aussi que, bien qu'ils soient provisoires, il est désagréable d'y travailler et encore plus désagréable de les voir. De plus, ils coûtent très cher. Il y a assurément des gens qui gagnent beaucoup d'argent avec ce genre de bâtiment. IBM n'avait jamais réussi à résoudre l'aspect financier de cette situation. Aussi leur avons-nous fait une proposition, et ils ont donné leur accord à condition que cela ne leur coûte pas plus cher et que les délais de construction ne soient pas plus longs. Nous avons pu faire la preuve que nous pouvions construire un bâtiment permanent pour le même budget, une construction non pas provisoire mais permanente qui serait meilleure. Elle existe encore et leur sert bien.» Dans ce projet pour IBM, au-delà de la question de la permanence, Foster propose un changement qui est parfaitement significatif.

«À l'époque», dit-il, «il y avait des bâtiments séparés pour les ordinateurs. C'était une sorte de sanctuaire parce qu'un bâtiment destiné à l'informatique a besoin, entre autres, de niveaux faciles d'accès. Il n'est jamais venu à l'idée de personne qu'on pouvait placer ce niveau n'importe où, dans la mesure où l'on peut y accéder à partir du dessus, et par conséquent, à partir du dessous. C'est ainsi qu'on a effectivement conçu l'un des premiers bâtiments consacrés à l'informatique.»[3] La déclaration du prix du RIBA (1972) souligne cet aspect, «le bâtiment démontre qu'avec de l'ingéniosité et de l'imagination, on peut faire quelque chose d'intéressant malgré les pires contraintes».

Le bâtiment IBM fut bientôt suivi des bureaux Willis Faber & Dumas (Ipswich, Suffolk, 1973–75). La façade surprenante en verre incurvé, qui suit le

Page 10: IBM Pilot Head Office, Cosham, Hampshire, 1970–71. A permanent structure for the price of temporary offices.

Seite 10: IBM Pilot Head Office, Cosham, Hampshire, 1970–71. Ein dauerhaftes Bauwerk für den Preis provisorischer Büros.

Page 10: Siège social pilote d'IBM, Cosham, Hampshire, 1970–71. Une structure permanente au coût de bureaux temporaires.

lar site "like a pancake in a pan," in the words of Norman Foster, is one of the most frequently photographed icons of contemporary architecture. Despite its relatively complex form, inspired by the medieval street pattern of Ipswich, the exterior is intended to be almost maintenance free. With two fully open office floors for 600 persons on each level, a central atrium and raised floors, the structure presages that of the Hongkong and Shanghai Bank building (1981–86), while the roof garden looks back to the Creek Vean House. Norman Foster seems particularly proud of the achievements of this project. As he says, "If you examine a building like Willis Faber, it is very easy to focus on the way that glass as a suspended curtain had not been used before. It is interesting, however, to look back and see that it has won as many energy awards as architecture awards. It is a Grade One Listed Building. I think that that is a bit of an anomaly, but it is the only modern building that has the same listing as a cathedral. The most significant thing about Willis Faber is its social dimension. In that sense, it really was and is revolutionary. It represents the vision of the office as a place which is filled with sun, has fantastic views, where everybody wants to work because you know that you can sunbathe on the lawn at lunch time... At the time it was created, when there were absolutely no social facilities in this little market town, this building was a place where you could swim with your family on weekends. This was a social revolution and the technology was a means to that end. I am focusing on this aspect very deliberately because in a way, in microcosm, what I am threading is related to history, to a social dimension, to energy usage, and to the appropriate use of technology. I believe that all of these actually come together. That is the story of any of these buildings."[4]

Built at the University of East Anglia in Norwich, the Sainsbury Centre for Visual Arts (1976–77) was intended to house the collection of primitive and twentieth century art of Sir Robert and Lady Sainsbury, together with temporary exhibition space, a conservatory, restaurant, senior common room and Faculty of Fine Art. Measuring 6,186 square meters, the structure is basically an inspired development of the 19th century glass and iron train shed, including numerous energy-saving features such as the use of a foam-filled aluminum sandwich panel or a highly reflective exterior finish. A column-free space 35 meters wide and 7.5 meters high is the most spectacular interior feature of the building, but less obvious elements contribute to the overall

Architektur. Trotz ihrer relativ komplexen Formen, die vom mittelalterlichen Straßenplan Ipswichs inspiriert wurden, sind die Außenseiten so wartungsfrei wie möglich konzipiert. Mit zwei völlig offenen Großraumbüros für 600 Mitarbeiter auf jeder Etage, einem zentralen Atrium und erhöhten Geschossen wirkt die Konstruktion wie ein Vorläufer der Hongkong and Shanghai Bank (1981–86), während der Dachgarten bereits beim Creek Vean House zu finden ist. Norman Foster äußert sich folgendermaßen: »Wer heute das Bürogebäude für Willis Faber betrachtet, konzentriert sich sehr leicht auf die Tatsache, daß hier Glas auf eine vollkommen neuartige Weise als Vorhang die Fassade umhüllt. Dabei hat dieses Projekt ebenso viele Energie-Preise wie Architekturpreise gewonnen. Es wurde als besonders erhaltenswertes Gebäude eingestuft und ist damit das einzige moderne Bauwerk, das ebenso eingestuft wurde wie eine Kathedrale. Das Bemerkenswerteste am Willis-Faber-Gebäude ist jedoch seine soziale Komponente; in dieser Hinsicht war und ist es revolutionär. Ein lichtdurchfluteter Ort mit einer phantastischen Aussicht, wo jeder arbeiten möchte, weil man hier in der Mittagspause auf dem Rasen sonnenbaden kann... Die Angestellten können am Wochenende sogar mit ihren Familien den Swimmingpool im Erdgeschoß nutzen – eine soziale Revolution... was ich entwerfe, ist bezogen auf Geschichte, eine soziale Dimension, auf Energieverbrauch und die angemessene Nutzung der Technologie. Meiner Ansicht nach sind all diese Dinge in jedem meiner Gebäude vorhanden.«[4]

Das auf dem Gelände der University of East Anglia in Norwich erbaute Sainsbury Centre for Visual Arts (1976–77) sollte Sir Robert und Lady Sainsburys Sammlung primitiver und moderner Kunst des 20. Jahrhunderts beherbergen, Platz für eine Wechselausstellung, einen Wintergarten und ein Restaurant bieten sowie einen Raum für die Dozenten und die Fakultät für Bildende Kunst. Der Entwurf für das 6 186 m² große Gebäude, das an die Bahnhöfe des 19. Jahrhunderts aus Glas und Eisen erinnert, hat viele energiesparende Konstruktionsmerkmale wie etwa Sandwichplatten aus Aluminium mit ausgeschäumten Zwischenräumen oder die stark reflektierenden Außenfassaden. Interessant ist der völlig stützenlose Raum von 35 m Breite und 7,5 m Höhe; aber auch weniger auffällige Elemente tragen zur Effizienz des Bauwerkes bei. So wurden z.B. die Platten der Außenverkleidung »mit Dichtungsmanschetten aus Neopren versiegelt, die als Regenwasserkanäle dienen und Regenrinnen

bord du site irrégulier «comme une crêpe dans une poêle», selon les termes de Norman Foster, est une des icônes les plus photographiées de l'architecture contemporaine. En dépit de sa forme relativement complexe, inspirée du tracé des rues médiévales d'Ipswich, l'extérieur est prévu pour ne nécessiter presque aucun entretien. Avec deux étages de bureaux entièrement ouverts, destinés à 1 200 personnes en tout, un atrium central sur lequel s'ouvrent les différents niveaux, la structure annonce le bâtiment de la Hongkong and Shanghai Bank (1981–86), alors que le jardin sur le toit rappelle la Creek Vean House. Norman Foster semble particulièrement fier de cette réalisation: «Si vous examinez un immeuble comme le Willis Faber, vous voyez immédiatement que le verre, en tant que rideau suspendu, n'avait jamais été utilisé auparavant. Mais rétrospectivement, il est intéressant de noter que le bâtiment a reçu autant de prix pour l'énergie que pour l'architecture. Ce bâtiment est classé monument historique. C'est peut-être étrange, mais il s'agit du seul immeuble moderne au Royaume-Uni qui soit classé comme une cathédrale. La chose la plus significative à propos du Willis Faber, c'est sa dimension sociale. En ce sens, il a été et demeure révolutionnaire. Il représente la vision du bureau en tant que lieu inondé de soleil, avec des vues fantastiques, où tout le monde veut venir travailler parce que l'on sait que l'on peut prendre un bain de soleil sur la pelouse à l'heure du déjeuner ... À l'époque où il a été créé, quand il n'existait absolument aucun équipement social dans cette petite bourgade, c'était un lieu où on pouvait venir nager avec sa famille, les fins de semaine. Cela a constitué une révolution sociale et la technologie a été un moyen d'arriver à cette fin. J'insiste délibérément sur cet aspect, parce qu'en un sens, dans ce microcosme, ce que j'essaie de dire a trait à l'histoire, à une dimension sociale, à l'emploi de l'énergie, et à la bonne utilisation des progrès techniques. Je suis persuadé que tous ces aspects sont intimement liés. C'est le cas de beaucoup de mes réalisations.»[4]

Construit à l'université d'East Anglia à Norwich, le Sainsbury Centre pour les Arts Visuels (1976–77) était destiné à abriter la collection d'art primitif, ainsi que celle du XXe siècle de Sir Robert et Lady Sainsbury, de surcroît un espace destiné à des expositions temporaires, une serre, un restaurant, une salle de réunion pour les étudiants en dernière année et finalement la faculté des Beaux-Arts. Avec ses 6 186 m², la structure s'inspire fondamentalement des hangars ferroviaires du XIXe siècle, en

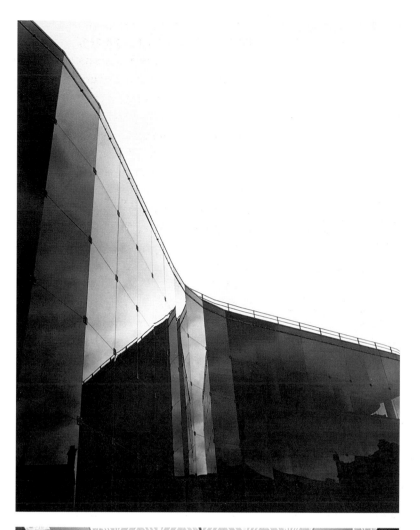

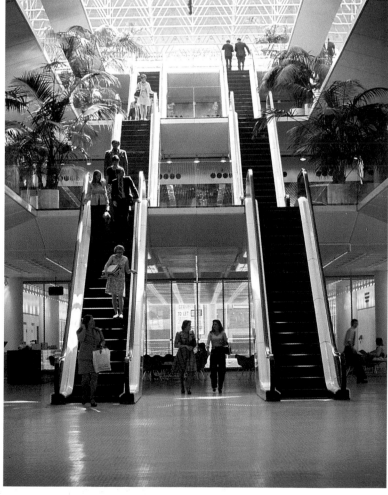

appearance and efficiency of the architecture. Thus, the individual exterior panels are "sealed with neoprene gaskets which also double up as rainwater channels, thus obviating the use of traditional gutters and downpipes."

Despite the fact that its design permitted linear expansion, Norman Foster, when called on by the Sainsburys to extend the Centre did so by means of an underground expansion baptized the Crescent Wing (1989–91). With an area of 3,000 square meters the Crescent Wing takes advantage of the sloping site to emerge as a curved glass "eyebrow" with a view onto a lake. It is interesting to note that despite the care taken by the architect to devise the original structure so that it could be expanded, the clients' satisfaction with the building led them to consider it as a "perfect" entity, which should not be modified. A winner of numerous prizes, the Sainsbury Centre brought international attention to Norman Foster, and made it clear that, at the age of 42, he had joined the small rank of world-class architects.[5]

In the Architectural Elite
By the time he won the commission to build the Hongkong and Shanghai Banking Corporation Headquarters (Hong Kong, 1981–86) in 1979, Norman Foster was prepared for one of the most substantial challenges of his career. Both because of the soaring land values in Hong Kong, and because of the nature of the tower itself, the Headquarters quickly earned the title of "most expensive building in the world." Though this description may not have been entirely flattering, it does give some indication of the outstanding nature of the project. Located in the very heart of Hong Kong's Central District, the completed building measures 178.8 meters in height, with 47 stories above ground, one groundlevel plaza, and four levels below grade. Accommodating 3,500 people in a usable area of 70,398 square meters, it has such unusual features as an air-conditioning system which uses sea water as a primary coolant pumped from the bay via a tunnel running 75 meters below ground level. A "sun scoop" consisting of 20 arrays of 24 mirrors, each powered by a computer programmed with solar timetables, brings daylight into the heart of the building. A 52 meter high atrium develops further concepts first evoked in Foster's Willis Faber & Dumas building several steps, giving a sense of space and light to an office environment more often characterized, particularly in Hong Kong, by faceless anonymity.

und Fallrohre überflüssig machen.« Als die Sainsburys ihn mit der Erweiterung des Centre beauftragten, schuf Norman Foster mit dem Crescent Wing (1989–91) einen unterirdischen Anbau. Mit einer Gesamtfläche von 3 000 m² nutzt der Crescent Wing die Hanglage des Baugeländes und erscheint nur in Form einer gläsernen »Augenbraue« über der Erde, die einen Ausblick über den nahen See bietet. Obwohl Foster darauf geachtet hatte, daß das Gebäude erweitert werden konnte, waren seine Auftraggeber so zufrieden, daß sie sich dazu entschlossen, diese »perfekte« Einheit nicht zu verändern. Das Sainsbury Centre wurde mit zahlreichen Preisen ausgezeichnet und brachte Foster internationale Anerkennung, so daß er mit 42 Jahren zu der kleinen Gruppe der weltbesten Architekten zählte.⁵

In der Architekturelite

Als Norman Foster 1979 den Auftrag zum Bau des Hongkong and Shanghai Banking Corporation Headquarters (HSBC, Hongkong, 1981–86) erhielt, stand er vor einer der größten Herausforderungen seiner Karriere. Sowohl aufgrund der in die Höhe schnellenden Grundstückspreise Hongkongs als auch aufgrund der Eigenschaften des Turms selbst erhielt sein Entwurf schnell den Beinamen »Teuerstes Bauwerk der Welt«. Das Gebäude mißt 178,8 m und besitzt 47 Stockwerke über der Erde, eine zentrale Plaza auf Bodenniveau und vier unterirdische Geschosse. Mit seiner Nutzfläche von 70 398 m² bietet der Turm Raum für 3 500 Menschen; darüber hinaus besitzt die Konstruktion so ungewöhnliche Merkmale wie eine mit Meerwasser gekühlte Klimaanlage (das Wasser wird durch einen Tunnel 75 m unter der Erdoberfläche aus der Bucht in die Anlage gepumpt) und eine nach dem aktuellen Sonnenstand computergesteuerte »Sonnenschaufel« aus 20 Reihen mit je 24 Spiegeln, die Tageslicht ins Gebäudeinnere lenkt. Das 52 m hohe Atrium ist eine Weiterentwicklung von Fosters Konzept für Willis Faber & Dumas und bringt ein Gefühl von Raum und Licht in eine Büroumgebung, die – gerade in Hongkong – sehr häufig von gesichtsloser Anonymität gekennzeichnet ist.

Auf den ersten Blick scheint es, als ob das HSBC ohne große Veränderungen in jeder modernen Stadt der Welt hätte erbaut werden können, aber Norman Fosters Erläuterungen zu seinem persönlichen Standpunkt geben einen genaueren Einblick in die Foster-Methode. »Ich bin der Ansicht, daß dieses Gebäude damals nur in Hongkong entstehen konnte«, betont Foster. »Als ich letztes Wo-

verre et en fer, et comprend de nombreux éléments destinés à économiser l'énergie, comme ces panneaux en aluminium remplis de mousse, ou le fini extérieur hautement réverbérant. L'espace sans colonnes, de 35 m de large et 7,5 m de haut, constitue la caractéristique la plus spectaculaire de l'intérieur du bâtiment. Toutefois, des éléments moins évidents apportent leur contribution à l'apparence et à l'efficacité de l'ensemble. Ainsi, les panneaux extérieurs sont scellés avec des joints en néoprène qui servent également de rigoles d'eau de pluie, évitant ainsi l'utilisation des gouttières traditionnelles et des tuyaux de descente.

Bien que ce plan permette un prolongement linéaire, quand la famille Sainsbury demanda à Norman Foster un agrandissement du Centre, il opta pour une extension souterraine, qu'il baptisa le Crescent Wing (1989–91). Avec une surface de 3 000 m², cette aile en forme de croissant s'appuie sur le site pentu et émerge comme un «sourcil» de verre incurvé, avec vue sur un lac. Il est intéressant de noter, que malgré le soin apporté par les architectes à concevoir une structure originale qui puisse être agrandie, les clients sont si satisfaits du bâtiment, qu'ils le qualifient d'entité «parfaite» et qu'il n'est pas question de le modifier. Remportant de nombreux prix, le Sainsbury Centre attira l'attention internationale sur Norman Foster, et souligne de manière évidente qu'à 42 ans, il fait désormais partie du petit cercle des architectes de calibre international.⁵

Un grand de l'architecture

En 1979, quand il remporte la commande du siège social de la Hongkong and Shanghai Banking Corporation (Hong Kong, 1981–86), Norman Foster doit affronter l'un des défis les plus importants de sa carrière. À la fois à cause de la flambée du prix des terrains à Hong Kong et de la nature même de la tour, le siège social est très vite étiqueté comme «l'immeuble le plus coûteux du monde». Bien que cette description ne soit pas très flatteuse, elle donne quelque indication sur la nature exceptionnelle du projet. Installé au cœur même du quartier Central de Hong Kong, l'immeuble terminé mesure 178,8 m de haut, avec 47 étages au-dessus du sol, une place au rez-de-chaussée et quatre niveaux en dessous. Avec 3 500 personnes travaillant sur une surface de 70 398 m², il présente des caractéristiques originales, par exemple un système d'air conditionné alimenté à l'eau de mer, pompée depuis la baie par un tunnel long de 75 m, creusé en sous-sol. Un capteur solaire composé de 20 ran-

Page 14: Sainsbury Centre for Visual Arts and Crescent Wing, University of East Anglia, Norwich, 1976–77; 1989–91. The original building is visible on the right.

Seite 14: Sainsbury Centre for Visual Arts and Crescent Wing, University of East Anglia, Norwich, 1976–77; 1989–91. Das ursprüngliche Gebäude ist rechts zu erkennen.

Page 14: Centre Sainsbury pour les Arts Visuels et la Crescent Wing, Université d'East Anglia, Norwich, 1976–77; 1989–91. Le bâtiment d'origine est visible sur la droite.

Indeed, the architecture of modern Hong Kong has little to do with its local roots, and the very evocation of an appropriate reaction to its culture might bring a look of amusement from most architects. It does seem at first glance that the Hongkong and Shanghai Banking Corporation Headquarters could have been built anywhere, in any modern city without many changes, and yet as Norman Foster explains his own point of view on this important question of context and style, a fuller idea of the Foster method emerges. "I don't think that it could have happened anywhere at that time, except in Hong Kong," says Foster emphatically. "I was there last weekend, and the space under the building was the scene of the most extraordinary series of picnics I have ever seen. The idea of lifting the building up in a crowded city would not have the same meaning anywhere else. The building has a very particular relationship to Statue Square, where the force of pedestrian traffic is so strong, ebbing and flowing, where space is at such a premium that it would actually produce the kind of encampment I saw there. It is the only building in the world where you can put a dealers floor in a high-rise tower, and that could have only happened in that bank in that location. The building is unbelievably flexible. Its whole population has changed locations twice so far without great difficulty. The bank wanted that sort of flexibility, and I don't think that anybody else would have paid the premium that they paid for that degree of performance. If you look at the rise of the Hongkong and Shanghai Bank from the time that it took occupancy of that building it is astonishing... I'm not saying that the building was the only factor... it most certainly wasn't. It is a chicken and egg situation. Nobody would have put that kind of investment in future growth – no other bank. That was very much to do with the symbolic relationship of the bank to the economy of Hong Kong."

When pressed further about the relationship of the building to the culture of Hong Kong, Norman Foster makes reference to feng shui. Feng shui, literally meaning "wind (and) water," is the ancient practice that dictates the placement and design of buildings in China to maximize good fortune. Feng shui experts associate straight lines with bad influences; they abhor structures with sharp angles, which are said to be like daggers pointed at neighbors. Today, an estimated 80% of the British colony's 6 million Chinese use feng shui to choose an apartment, site a factory or get an extra edge in business. Foster recalls that "When the bank

chenende die Stadt besuchte, bot der Platz unter der HSBC die außergewöhnlichste Picknick-Szene, die ich je gesehen habe. Die Idee, ein Gebäude in einer dicht besiedelten Stadt vom Boden abzuheben, hätte nirgendwo anders eine solche Bedeutung erhalten. Das Bauwerk steht in einer ganz besonderen Beziehung zum Statue Square, wo die Kraft des Fußgängerstroms an Ebbe und Flut erinnert. Freier Raum stellt dort etwas so Seltenes dar, daß sich sofort wie von selbst eine 'Picknickwiese' bildet. Das Gebäude ist außerdem unglaublich flexibel: Die Mitarbeiter sind bisher schon zweimal problemlos darin umgezogen. Die Bank wünschte diese Flexibilität, und ich glaube nicht, daß irgendjemand anders für diese Art von Leistung den Preis bezahlt hätte, den sie bezahlt hat.

Auf die Frage nach der Beziehung des Gebäudes zur Kultur Hongkongs erwähnt Norman Foster das Phänomen des Feng Shui. Der Ausdruck bedeutet wörtlich übersetzt »Wind (und) Wasser« und bezeichnet einen jahrhundertealten chinesischen Brauch, der die Anordnung und den Entwurf von Gebäuden vorschreibt, um so den Bewohnern möglichst viel Glück zu bringen. Für Feng Shui-Experten besitzen gerade Linien einen schlechten Einfluß, und sie lehnen Bauten mit spitzen Winkeln ab, da sie wie Dolche auf die Nachbarn gerichtet seien. Auch heute noch ziehen etwa 80% der sechs Millionen Hongkong-Chinesen Feng Shui zu Rate, um sich bei der Wahl einer Wohnung, beim Kauf eines Fabrikgeländes oder im Geschäftsleben besondere Vorteile zu verschaffen. Foster erinnert sich: »Als die Bank allen in Frage kommenden Architekten ihre Vorstellungen erläuterte, erklärte sie uns, daß sie Wert auf Feng Shui legen würde. Nach diesem Treffen winkten alle anderen Architekten ab, aber wir entschieden uns dafür, zu bleiben und suchten uns unseren eigenen Feng Shui-Mann. Er fertigte die erste Zeichnung an und zeigte uns die Ecke, an der man das Gebäude betreten sollte. Seiner Ansicht nach sollte der Eingang ein mindestens zwei Stockwerke hohes Tor sein. Ich kann ehrlich sagen, daß wir uns anfänglich nicht von dem Feng Shui-Mann beeinflussen ließen. Aber als wir an einem bestimmten Punkt des Projekts angekommen waren und zurückblickten, stellten wir fest, daß alles so gelöst worden war, wie es der Feng Shui-Mann vorgeschlagen hatte. Man könnte behaupten, daß dies Zufall sei. Man könnte es auch dem Unterbewußtsein zuschreiben. Wer weiß? Tatsache ist, daß die Geschäfte der Bank florieren. Ich glaube nicht, daß dieses Gebäude irgendwo anders hätte entstehen können.«[6]

gées de 24 miroirs, chacun actionné par un ordinateur programmé sur le cycle solaire, conduit la lumière du jour au cœur du bâtiment. Un atrium haut de 52 m reprend des principes d'abord élaborés dans le bâtiment Willis Faber & Dumas de Foster, les améliore et donne une sensation d'espace et de lumière à un environnement de bureaux, qui se caractérise d'ordinaire, et surtout à Hong Kong, par un anonymat monotone.

Certes, l'architecture du Hong Kong moderne a peu de rapport avec la tradition locale, et la seule évocation d'une solution plus proche de la culture ne manquerait pas de susciter un regard amusé chez la plupart des architectes. À première vue, il semble que le siège social de la Hongkong and Shanghai Banking Corporation aurait pu être construit n'importe où, dans une ville moderne, sans trop de modifications. Toutefois, lorsque Norman Foster explique son point de vue sur la question importante du contexte et du style, on voit apparaître une idée plus complète de sa méthode: «Je ne pense pas que cela pouvait se réaliser où que ce soit, à cette époque, sauf à Hong Kong», déclare Foster de façon catégorique. «J'étais là-bas le week-end dernier et l'espace au-dessous du bâtiment était le théâtre des plus extraordinaires piqueniques que j'aie jamais vus. L'idée de surélever ce bâtiment dans une cité surpeuplée n'aurait pas la même signification n'importe où ailleurs. L'immeuble a une relation très particulière avec Statue Square, où la force de la circulation piétonne de la ville est si puissante et où le moindre espace a une telle valeur que cela finit par produire cette sorte de campement que j'ai découvert. Songez qu'on a réservé tout un étage aux courtiers. Cela ne pouvait arriver qu'à cette banque et en ce lieu. Le bâtiment est incroyablement polyvalent. Tout le personnel a déjà déménagé deux fois dans l'immeuble et sans grande difficulté. La banque a exigé cette sorte de flexibilité, et je ne pense pas que quelqu'un d'autre aurait payé ce qu'ils ont payé pour obtenir ce niveau de performance. Quand on voit la croissance de la Hong Kong and Shanghai Bank depuis qu'elle occupe ce bâtiment, c'est étonnant. Je ne dis pas que l'immeuble a été le seul facteur..., certainement pas. On est dans la situation de la poule et de l'œuf. Personne n'aurait fait un investissement de cette envergure sur la seule base d'un espoir de croissance future – aucune autre banque. Tout cela a beaucoup à voir avec le rapport symbolique que la banque entretient avec l'économie de Hong Kong.»

Quand on insiste davantage sur les rapports

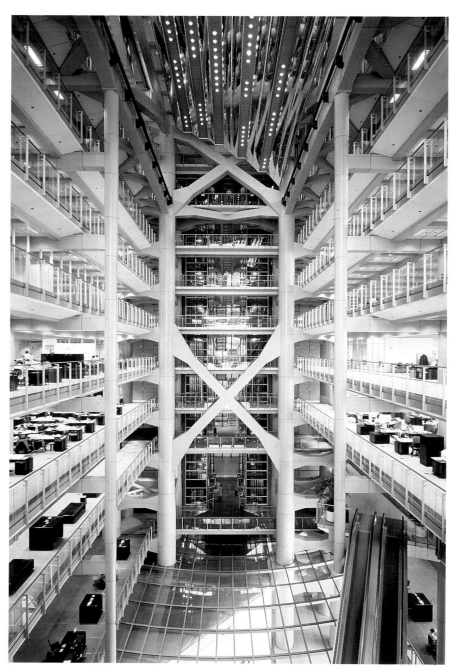

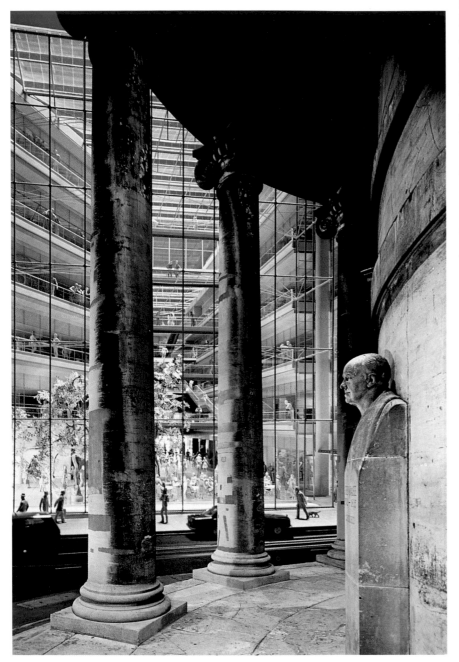

briefed us, along with the other architects, they said that they would take care of the issue of feng shui. When they finished the briefing, all of the other architects left; we decided to stay on. We decided to get our own feng shui man. He did the first drawing. He talked about the corner where you should enter the building. He said that it should be a gateway, which should be at least two stories high. I can tell you honestly that we did not allow ourselves to be immediately influenced by the feng shui man. I can equally honestly tell you that when we got to a certain point and looked back, it was actually just how the feng shui man had suggested it should be. You could say that that is coincidence. You could say it's subconscious. Who knows ? The reality is that the bank has prospered. I don't think the Hong Kong building could have been built anywhere else."[6]

Though it seems that Norman Foster has a longer list of built works than most architects his age, he does express regrets about some of his unbuilt projects. One of the most outstanding of these is the BBC Radio Headquarters (London, 1982). Located at the southern end of Portland Place, near All Souls Church (John Nash, c. 1825), Foster's design represented an effort not only to respond to a prestigious historic location, but also to open the BBC itself to a more direct contact with the public through a large glazed atrium. The winner of an international competition, Foster's scheme was abandoned in 1985, when Lord Howard stepped down as chairman of the BBC. The symbolic charge implied in the conjunction of a site formed by John Nash and the headquarters of the national broadcasting company makes clear the stature accorded to Sir Norman Foster in his own country, even if this particular design was not carried out.

An even more impressive commission, which was not carried out, was the King's Cross Masterplan (London, 1987). On a 52 hectare tract situated between the City and the West End, Foster proposed to clear out and open up a decaying industrial zone, building a new international rail terminal between the King's Cross and St Pancras stations. Located very close to the new British Library, this urban renewal scheme created for the London Regeneration Consortium showed just how Sir Norman Foster could apply some of the ideas evident in his architecture, such as clarity and respect for the site, to a large surface. One of the key elements of the plan was to make use of the Regent's canal to bring "boats and varied recreational activities" into the area.

Obwohl Norman Foster wahrscheinlich mehr Entwürfe realisierte als die meisten anderen Kollegen seines Alters, äußert er Bedauern über die Tatsache, daß bestimmte Projekte nicht fertiggestellt werden konnten. Dies gilt vor allem für das BBC Radio Headquarters (London, 1982), das am südlichen Ende des Portland Place, in der Nähe von John Nashs All Souls Church (ca. 1825) entstehen sollte. Foster versuchte mit seinem Entwurf einerseits, auf die berühmte historische Umgebung zu reagieren und andererseits, mit Hilfe eines großen verglasten Atriums, die BBC in direkteren Kontakt mit der Öffentlichkeit zu bringen. Sein Entwurf, mit dem er sich in einem internationalen Wettbewerb durchgesetzt hatte, wurde 1985 aufgegeben, als Lord Howard als Intendant der BBC zurücktrat. Die symbolische Last, die in einer berühmten historischen Bebauung einerseits und in dem Hauptgebäude der nationalen Rundfunkgesellschaft andererseits liegt, verdeutlicht, welches Vertrauen man Norman Foster in seinem Heimatland entgegenbringt – selbst wenn sein Entwurf nicht zur Ausführung kam.

Ein ähnlich eindrucksvolles, leider ebenfalls nicht realisiertes Projekt war der Bebauungsplan für King's Cross (London, 1987). Foster wollte ein 52 ha großes, verfallenes Industriegebiet zwischen der City und dem Londoner Westend räumen, so daß hier – zwischen den Bahnhöfen King's Cross und St. Pancras – ein internationaler Bahnhof entstehen konnte. Dieses im Auftrag des »London Regeneration Consortium« entwickelte Sanierungsprojekt war in der Nähe der neuen British Library geplant und zeigte, daß Foster einige Grundsätze seiner Architekturmethode, Klarheit und Respekt für die Umgebung, auch auf große urbane Flächen übertragen kann. Eines der zentralen Elemente seines Entwurfs bestand darin, den Regent's Canal zu nutzen, um »Boote und ein vielfältiges Erholungsangebot« in das Gebiet zu holen.

Auch das letzte Beispiel bestätigt den Status Sir Norman Fosters und zeigt eine der besonderen Qualitäten seiner Verfahrensweise. Die Sackler Galleries in der Royal Academy of Arts (London, 1989–91) besitzen eine Gesamtfläche von nur 312 m² und wurden mit einem Budget von 5,2 Millionen Pfund fertiggestellt. Foster und sein Büro legen nach wie vor großen Wert auf die Arbeit an Projekten in kleinem Maßstab – in diesem Fall in der Umgebung der weltberühmten Royal Academy. Die früheren Diploma Galleries, die man in viktorianischer Zeit auf das Burlington House (Hugh May, 1666, von Lord Burlington im 18. Jahrhundert um-

entre ce bâtiment et la culture de Hong Kong, Norman Foster évoque le feng shui. Cette expression, qui signifie littéralement «vent (et) eau», désigne une pratique de la Chine ancienne qui consiste à choisir le site et le plan de manière à placer le bâtiment sous les meilleurs auspices. Les experts en feng shui attribuent aux lignes droites une influence néfaste. Ils détestent les structures à angles aigus qu'ils considèrent comme des poignards pointés sur les voisins. Aujourd'hui, on estime que 80% des 6 millions de Chinois de l'ancienne colonie britannique utilisent le feng shui pour choisir un appartement, implanter une usine ou mieux réussir en affaires. Foster se souvient: «Quand la banque nous a présenté le dossier, ainsi qu'à d'autres architectes, ils nous ont dit qu'ils s'occupaient de la question du feng shui. À la fin de la présentation, tous les autres architectes sont partis, et nous sommes restés un peu plus longtemps. Nous avons décidé de nous trouver notre propre expert en feng shui. C'est lui qui a fait le premier dessin. Il a parlé de l'angle par lequel on pourrait pénétrer dans le bâtiment. Il a dit que l'entrée devait être monumentale et avoir au moins la hauteur de deux étages. Honnêtement, je peux vous dire que nous ne nous sommes pas laissés influencer immédiatement par cet avis. Tout comme je peux également vous dire en toute honnêteté qu'arrivés à un certain point, nous avons analysé notre travail et nous nous sommes aperçu qu'en fait, c'était exactement ce que notre expert en feng shui avait suggéré. Vous pouvez penser que c'est une coïncidence, que c'est une affaire de subconscient. Qui sait? Toujours est-il que la banque a prospéré. Je ne pense pas que cet immeuble de Hong Kong aurait pu être construit à n'importe quel autre endroit.»[6]

Norman Foster semble avoir un palmarès plus impressionnant que la plupart des architectes de son âge. Mais il regrette que certains de ses projets n'aient pas été réalisés. Parmi les plus impressionnants, le siège social de la BBC Radio (Londres, 1982). Situé à l'extrémité sud de Portland Place, près de All Souls Church (John Nash, 1825), le projet de Foster témoignait d'un effort non seulement pour s'intégrer à cet emplacement historique et prestigieux, mais également pour ouvrir la BBC elle-même à un contact plus direct avec le public grâce à un vaste atrium vitré. Bien qu'ayant remporté un concours international, le projet de Foster est abandonné en 1985, quand Lord Howard quitte son poste à la tête de la BBC. La valeur symbolique liée à l'association de l'édifice signé par John

Page 18: BBC Radio Headquarters, London, 1982. A photomontage shows the view that would have existed into the atrium from All Souls Church across the street.

Seite 18: BBC Radio Headquarters, London, 1982. Diese Fotomontage zeigt den fiktiven Blick in das Atrium, von der All Souls Church auf der gegenüberliegenden Straßenseite aus gesehen.

Page 18: Siège social de la BBC, Londres, 1982. Photomontage montrant la vue qu'on aurait pu avoir sur l'atrium depuis All Souls Church, de l'autre côté de la rue.

A final, more recent example testifies to the status of Sir Norman Foster and illustrates one of the particular qualities of his practice. The Sackler Galleries at the Royal Academy of Arts (London, 1989–91) cover a surface of only 312 square meters, and were completed for a budget of £5.2 million. Foster's office has made a point of continuing to work on small-scale projects, in this instance in the very prestigious circumstances of the Royal Academy. The former Diploma Galleries, a Victorian addition to the top of Burlington House (Hugh May, 1666, converted by Lord Burlington in the 18th century), were not in appropriate use, and Foster determined that it was possible to use lightwells separating the existing structures to provide access through a new elevator and stairway. This renewed, elegant, light-filled space attracted some 135,000 visitors in 1993, and provides a more intimate counterpoint to the large Victorian galleries of the floor below. Foster's own rationalization for accepting this job again does much to cast light on his method. "It was a challenge to actually take a very small sum of money and a building that was a kind of nightmare maze of spaces behind the scenes and try and turn that into something positive," he says.[7]

Telecommunications and Transport

An adept pilot of competition soaring or helicopter flight, Norman Foster has indeed always been interested in the technological aspects of his projects, searching out new materials or methods in areas such as aircraft design. His interest in design as applied to telecommunications or transport facilities may not be typical of many other contemporary architects, but it has become one of the defining features of his practice. One of the most outstanding Foster-designed projects in recent years is his Telecommunications Tower in Barcelona (Torre de Collserola, Barcelona, Spain, 1990–92), a 288 meter tall structure with a public viewing platform situated 135 meters above the ground. Foster is proud of the fact that a more conventional design for a tower of this height would have required a main support more than six times broader than the 4.5 meter diameter hollow slip-formed reinforced concrete shaft, which reduces to just 300 millimeters to hold a radio mast. It was in May 1988 that he won the competition for a "monumental technological element," which was part of the city's renovation for the 1992 Summer Olympic Games. Norman Foster admits that some in his office were against accepting their role as subcontractors to the engineers in this instance, but clearly the elegance of the completed

gebaut) gesetzt hatte, dienten schon lange nicht mehr ihrem eigentlichen Zweck. Foster nutzte die Lichtschächte zwischen den bestehenden Bauten und schuf durch den Einbau eines Fahrstuhls und einer Treppe einen neuen Zugang zur Galerie. 1993 zogen die sanierten, eleganten, lichtdurchfluteten Räume 135 000 Besucher an und bildeten das intime Gegenstück zu den großen viktorianischen Ausstellungsräumen in den darunterliegenden Etagen. Fosters Begründung für die Annahme dieses Auftrags zeigt den für ihn typischen Ansatz wieder in einem anderen Licht: »Es war eine Herausforderung, diese sehr kleine Geldsumme und ein versтecktes Gebäude mit einem alptraumartigen Labyrinth aus Räumen zu nehmen und etwas Positives zu schaffen.«[7]

Transport und Telekommunikation

Als begeisterter Kunstflieger und Hubschrauberpilot hat Sir Norman Foster großes Interesse an den technologischen Aspekten seiner Projekte bewiesen und sich mit der Auswahl neuer Baumaterialien oder Konstruktionsmethoden aus dem Flugzeugbau beschäftigt. Seine Vorliebe für Entwürfe von Telekommunikations- oder Transporteinrichtungen wird nur von wenigen anderen zeitgenössischen Architekten geteilt, zählt aber zu den typischen Merkmalen seiner Arbeit. Zu den herausragenden neueren Projekten Fosters gehört sein Telekommunikationsturm in Barcelona (Torre de Collserola, Barcelona, Spanien, 1990–92), eine 288 m hohe Konstruktion mit einer öffentlichen Aussichtsplattform in 135 m Höhe. Foster ist stolz darauf, daß ein konventionellerer Entwurf eines Turms dieser Größe einen sechsmal breiteren Säulenschaft erfordert hätte als sein hohler, in Gleitbauweise errichteter Stahlbetonschaft von 4,5 m Durchmesser, der sich am Fuß des Antennenmasts bis auf 30 cm verjüngt. Mit seinem Konzept gewann er im Mai 1988 die Ausschreibung für ein »monumentales technologisches Element«, das zu den Sanierungsplänen der Stadt für die Olympischen Sommerspiele 1992 gehörte. Einige Mitarbeiter von Fosters Büro sprachen sich bei diesem Projekt gegen ihre Rolle als Subunternehmer von Ingenieuren aus, aber die Eleganz des fertigen Turms rechtfertigt das Risiko, sich auf ein Gebiet zu begeben, auf dem Architekten nur selten erfolgreich sind.

Barcelona führte zu einem weiteren Telekommunikationsprojekt, dessen deutlicher Unterschied zum Torre de Collserola ein weiteres bezeichnendes Licht auf die Foster-Methode wirft. Auf die Frage, ob seine Arbeiten einen Einfluß auf die zeitgenössi-

Nash et du siège de la radiodiffusion nationale témoigne clairement de la notoriété dont Sir Norman Foster, lauréat du concours, jouit dans son pays, même si ce projet précis n'a jamais été exécuté.

Autre commande encore plus impressionnante, qui n'a pas vu le jour: le plan directeur de King's Cross (Londres, 1987). Sur une étendue de 52 ha, entre la City et le West End, Foster proposait de dégager et d'ouvrir une zone industrielle vétuste pour y construire un nouveau terminal ferroviaire international, entre les gares de King's Cross et de St. Pancras. Situé tout près de la nouvelle British Library, ce projet de rénovation urbaine créé pour le London Regeneration Consortium, montrait comment Sir Norman Foster savait adapter certaines des idées évidentes dans son architecture, telles que la clarté et le respect du site, à un gigantesque projet. Un des éléments clefs du plan était d'utiliser le Regent's Canal pour faire venir «des bateaux et d'autres activités de loisirs» jusqu'à cette zone.

Un dernier exemple, plus récent, témoigne de la place de Sir Norman Foster et illustre l'une des qualités particulières de sa technique. Les Sackler Galleries de la Royal Academy of Arts (Londres, 1989–91) couvrent une surface de 312 m² seulement, et n'ont coûté que 5,2 millions de livres. L'agence de Foster s'est fait un point d'honneur de continuer à travailler sur des projets de petite échelle et, dans le cas présent, pour la très prestigieuse Royal Academy. Les anciennes Diploma Galleries – adjonction victorienne au sommet de la Burlington House (Hugh May, 1666, modifiée par Lord Burlington au XVIIIᵉ siècle) – n'étaient pas utilisées de manière satisfaisante. Foster constate qu'il est possible de se servir des cours intérieures séparant les structures existantes pour créer l'accès grâce à un nouvel ascenseur et un escalier. Cet espace rénové, élégant et lumineux attira, en 1993, quelque 135 000 visiteurs. De plus, il fournit un contrepoint plus intime aux vastes galeries victoriennes de l'étage en dessous. Là encore, la manière dont Foster explique pourquoi il a accepté ce travail met davantage en lumière ce qui caractérise sa méthode. «De fait, c'était un défi de prendre une très petite somme d'argent et un bâtiment qui est une sorte de cauchemar, un labyrinthe d'espaces et de coulisses, pour essayer de le transformer en quelque chose de valable», explique-t-il.[7]

Télécommunications et transport

Adepte de compétition de vol à voile et d'hélicoptère, Norman Foster a toujours été intéressé par les aspects technologiques de ses projets, cherchant à

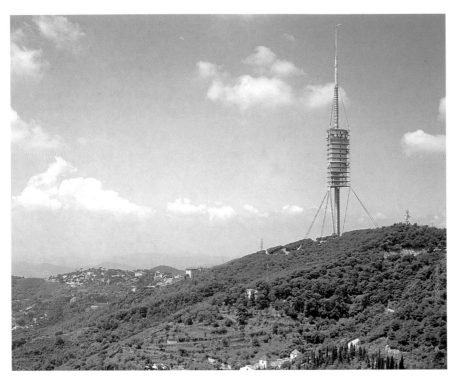

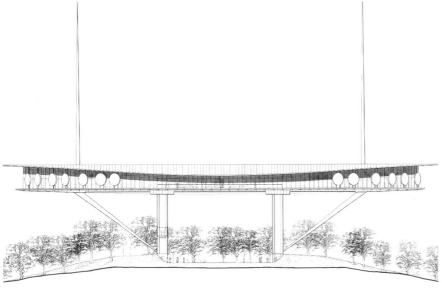

tower fully vindicates his decision to take the risks implied in delving into an area not often mastered by architects.

Barcelona led to another telecommunications project, whose very differences from the Torre de Collserola do much to cast further light on the Foster method. When asked if he feels his work is having an impact on the direction of contemporary architecture, Norman Foster makes reference to this new job in Santiago de Compostela. "You end up giving an answer which is a post-rationalization," he says. "You can only really do what you do by focusing on that project and challenging preconceptions, researching, absorbing the place where it is, debating and using that opportunity as if you were coming to it for the first time. That has always been an important part of the way that we've worked. We treat every project as if it was the first project we'd ever done. The test of that approach occurs when someone like the mayor of Santiago de Compostela comes and says, 'I've got a similar problem to Barcelona and I like the tower there. Will you do a tower for me ?' The easy thing would have been to do a second-generation Barcelona tower, but when we looked at Santiago, culturally, the first thing that came to mind is that it is a pilgrimage city. The dominant building on the skyline is the cathedral. You have this mountain opposite where they want to put a tall mast, albeit an elegant one. It is in a prime location vis-à-vis the city. When you question it at a technical level as well, you establish that you really don't need a tower, but the mayor has come to you because he wants just that. The only reason that you can make a more sensitive response, which becomes in effect a public viewing platform, is because of the way you've tackled some of the technical issues. But that is only a means to an end. We did not start this project by asking 'Are we going to be able to pioneer a new form of communications structure?' But undoubtedly, if I think about it now, it is an interesting precedent and I'm sure that you will start to see a number of look-alikes."[8] The Foster project for Santiago is thus not a high tower, but a 25 meter platform. This idea seemed to be such a radical departure from the traditional telecommunications tower that the technicians assigned to the job at first thought it unworkable, but since Foster's office had indeed done its own technical analysis accurately, they were obliged to admit that on this site there was no need for a tall structure.

One of the most influential of Sir Norman's projects has been his design for London's third air-

sche Architektur ausüben, verweist Foster auf diesen neuen Auftrag in Santiago de Compostela: »Eine Antwort auf solche Fragen wirkt immer wie eine nachträgliche Begründung. Alles was man tun kann, ist, sich auf das Projekt zu konzentrieren, seine vorgefaßten Meinungen in Frage zu stellen, zu recherchieren, das Baugelände in sich aufzunehmen, zu diskutieren und diese Möglichkeiten so abzuwägen, als ob man sich ihnen zum ersten Mal nähert... Wir behandeln jedes Projekt, als wäre es unser erstes. Dieser Ansatz wird immer dann auf die Probe gestellt, wenn jemand wie der Bürgermeister von Santiago de Compostela sagt: ›Ich habe ein ähnliches Problem wie in Barcelona, und ich bin vom neuen Fernsehturm begeistert. Können Sie mir auch einen Turm bauen?‹ Es wäre sehr einfach gewesen, einen zweiten Torre de Collserola zu bauen, aber als wir uns Santiago und seine Kultur ansahen, drängte sich uns sofort der Eindruck einer Pilgerstadt auf. Das beherrschende Gebäude der Stadtansicht ist die Kathedrale. Ihr gegenüber liegt ein Berg, auf dem wir einen hohen Mast errichten sollten – immerhin mit einer eleganten Form –, in einer erstklassigen Lage mit direktem Blick auf die Stadt. Als wir uns auf technischer Ebene mit dem Problem auseinandersetzten, stellten wir fest, daß wir eigentlich gar keinen Turm brauchten, aber der Bürgermeister war zu uns gekommen, weil er genau so etwas wollte. Der einzige Grund, warum wir zu einer sensibleren Lösung fanden, nämlich letztendlich einer öffentlichen Aussichtsplattform, lag darin, daß wir uns zuvor mit einigen technischen Fragen befaßt hatten. Wir gingen an dieses Projekt nicht mit der Frage heran: ›Sind wir in der Lage, auf dem Gebiet der Telekommunikationseinrichtungen eine Pionierleistung zu vollbringen?‹ Aber wenn ich jetzt darüber nachdenke, handelt es sich zweifellos um einen interessanten Präzedenzfall, und ich bin sicher, daß man in Zukunft eine Reihe ähnlicher Bauten zu sehen bekommen wird.«[8] Fosters Entwurf für Santiago bestand also nicht aus einem Turm, sondern einer 25 m hohen Plattform. Diese Idee schien so radikal vom traditionellen Konzept des Fernsehturms abzuweichen, daß die für dieses Projekt verpflichteten Ingenieure die Aufgabe zunächst für undurchführbar hielten. Aber da Fosters Büro eine eigene technische Analyse erstellt hatte, waren sie gezwungen zuzugeben, daß auf diesem Gelände nicht unbedingt ein Turm errichtet werden mußte.

Zu den einflußreichsten Projekten Norman Fosters zählt sein Entwurf für Londons dritten Flughafen, der 1987–91 in Stansted bei Cambridge erbaut

découvrir des matériaux et des procédés nouveaux dans des secteurs comme le design aéronautique. Cet intérêt pour les télécommunications ou les moyens de transport est sans doute rare chez les architectes contemporains. C'est en tout cas l'une des caractéristiques du travail de Foster. L'un de ses projets les plus significatifs des dernières années demeure sa Tour de Télécommunications à Barcelone (Torre de Collserola, 1990–92). Elle s'élève à 288 m du sol et comporte une plate-forme d'observation ouverte au public et située à 135 m. Foster fait remarquer avec fierté que, pour une tour de cette hauteur, une conception plus conventionnelle aurait exigé un support principal six fois plus large que le mât creux de 4,5 m de diamètre en béton armé et de forme lisse, qui se réduit à 300 mm seulement pour accueillir un pylône radio. C'est en mai 1988 que Foster remporte le concours pour cet «élément technologique monumental» qui fait partie de la rénovation de la ville à l'occasion des Jeux Olympiques d'été de 1992. Norman Foster admet que, dans son agence, certains se sont opposés à l'idée de faire de la sous-traitance pour des ingénieurs. Il n'empêche que l'élégance de la tour justifie pleinement sa décision de prendre des risques et d'explorer un domaine rarement maîtrisé par les architectes.

Barcelone entraîne dans son sillage un autre projet de télécommunications dont les différences mêmes avec la Torre de Collserola permettent d'éclairer encore davantage la méthode Foster. Quand on lui demande s'il a le sentiment que son travail a un impact sur les orientations de l'architecture contemporaine, Norman Foster évoque sa nouvelle commande à Saint-Jacques-de-Compostelle. «On finit par donner une réponse qui est une rationalisation a posteriori», dit-il. «On arrive seulement à faire ce que l'on fait à force de se concentrer sur tel projet, de remettre en question les idées préconçues, de chercher, d'absorber l'espace où il doit être bâti, de discuter et d'utiliser telle opportunité comme si elle se présentait à vous pour la première fois. Cette méthode a toujours joué un rôle important dans notre façon de travailler. Nous traitons chaque projet comme si c'était le premier. L'épreuve de vérité, c'est quand quelqu'un comme le maire de Saint-Jacques-de-Compostelle vient nous voir et nous dit: «J'ai un problème semblable à celui de Barcelone et j'aimerais qu'on érige une tour semblable chez moi. En feriez-vous une pour moi?» La solution facile aurait consisté à construire une deuxième tour de Barcelone. Mais quand on étudie Saint-Jacques-de-Compostelle, culturelle-

port, located at Stansted not far from Cambridge (1987–91). Approaching the airport, the visitor is immediately surprised by the lush green countryside, which seems to continue right up to the edges of the terminal building. Indeed, some 4 hectares of grasslands and ponds along with 1,000 year old hedgerows were conserved during the construction process, and some 250,000 trees planted, adding to the impression of a particularly "green" airport, one of the first to take such considerations into account. The main facility is an 85,700 square meter building with a 198 meter square roof. Designed to handle eight million passengers per year, it was built for 15% less cost than previous BAA terminals. All passenger facilities are located on one level, with a British Rail station below the main concourse. The external height of the building is only 15 meters, and this undoubtedly participates in the general impression of a space where the human scale is respected, as opposed to most airports where such factors seem secondary. Inside the terminal, the lattice-shelled roof structure is supported by 12 meter high structural "trees," the bases of which also contain lighting and other service requirements. Indeed, the lighting, which seems to pervade the space, is largely natural, from triangular lights in the roof occupying a mere 5% of the roof area. Sir Norman confirms that despite all of the technical considerations that went into the Stansted design, his own concern was very much one of making the space a luminous one. "If you take a typical terminal with ducts and fluorescent light tubes, I think that the space at Stansted is calmer, more ordered. I believe that the structure orders the space, has a geometry, a sense of order, and a sense of calmness. That is because a lot of hard work has gone into avoiding things like the intrusion of rainwater pipes. If they came inside that building, they would be more dominant than the structure which holds up the building itself. Lighting, whether natural or artificial, is a very powerful influence on the way that space is modeled and perceived. It may look as though some things are happy accidents or chance but there is nothing that is left to chance. The way that a shaft of sunlight goes through the perforated metal shapes in space is absolutely deliberate and it brings the floor to life. It actually does let some excess heat in, so it says that a series of value judgments have been made, that it is more important to have that sparkle and that dimension, than to have the most economic energy equation. There are subjective value judgments. Uplighting that space so that the ceil-

wurde. Wer als Fluggast hier ankommt, ist sofort beeindruckt von der üppig grünen englischen Landschaft, die bis unmittelbar an das Flughafengebäude heranzureichen scheint. Tatsächlich wurden während der Bauphase 4 ha Grünland mit Teichen und tausend Jahre alten Hecken erhalten und etwa 250 000 Bäume gepflanzt, um dem Flughafen ein besonders »grünes« Äußeres zu verleihen – eines der ersten Flughafenprojekte, bei dem man solche Erwägungen mit einbezog. Das Hauptgebäude besitzt eine Fläche von 85 700 m² und ein 198 m langes, viereckiges Dach. Der für acht Millionen Passagiere pro Jahr konzipierte Terminal wurde um 15% preisgünstiger erbaut als frühere britische Flughafengebäude. Sämtliche Passagiereinrichtungen befinden sich auf einer Ebene; nur der Bahnhof der British Rail liegt unter der Haupthalle. Dabei beträgt die lichte Höhe des Gebäudes nur 15 m, was den Eindruck eines Raumes erzeugt, in dem der menschliche Maßstab noch respektiert wird – ganz im Gegensatz zu den meisten anderen Terminals, wo solche Aspekte zweitrangig erscheinen. Im Inneren des Gebäudes wird die Gitterschalen-Dachkonstruktion von 12 m hohen Konstruktions-»Bäumen« getragen, in deren »Stämmen« auch das Beleuchtungssystem und andere Versorgungsleitungen untergebracht sind. Dabei fällt ein Großteil des Lichts als Naturlicht durch dreieckige Oberlichter im Dach ein, die nur 5% der Dachfläche ausmachen. Trotz aller technischen Erwägungen, die in den Stansted-Entwurf einflossen, wollte Foster einen hell erleuchteten Raum schaffen. »Im Vergleich zu einem typischen Flughafenterminal mit langen Gängen und Neonlicht wirkt die Halle in Stansted wesentlich ruhiger und geordneter. Die Konstruktion teilt den Raum ein und gibt ihm eine Geometrie, ein Gefühl der Ordnung und der Ruhe. Das liegt nicht zuletzt daran, daß störende Elemente wie etwa Regenabflußrohre vermieden wurden. Licht – sowohl künstliches wie natürliches – beeinflußt sehr, wie Räume geformt und wahrgenommen werden. Die Art und Weise, in der ein Sonnenstrahl durch die perforierten Metallformen in den Raum einfällt, ist bewußt durchdacht – denn sie erweckt die Halle zum Leben. ... Nach oben gerichtetes Licht, durch das die Decke zu schweben scheint, wirkt poetischer und besitzt eine Magie, eine Qualität, die sich nicht messen läßt. Diese Qualität hat nichts mit dem Maß der Lichtstärke zu tun, sondern ist eine rein subjektive Empfindung, eine Geschmacksfrage. Es gibt einfach Dinge, die man nicht messen kann, die aber in bezug auf ihre Funktion oder ihre Auswirkung ebenso wichtig sind wie

ment, la première chose que l'on remarque, c'est qu'il s'agit d'une ville de pèlerinage. Le bâtiment qui domine la ligne d'horizon, c'est la cathédrale. En face, vous avez cette montagne où ils veulent installer un mât très haut, quoiqu'élégant. C'est un emplacement de première importance par rapport à la ville. Mais quand on s'interroge sur l'aspect technique, on s'aperçoit qu'une tour n'est pas réellement nécessaire, même si le maire est venu vers nous parce c'est précisément ce qu'il veut. La seule manière de donner une réponse raisonnable, sous l'aspect d'une plate-forme d'observation, vient de la façon dont nous avons abordé les problèmes techniques. Mais ce n'est qu'un moyen d'arriver au but. Nous n'avons pas commencé ce projet en nous disant ‹allons-nous être capable d'inventer un nouveau type de structure de communications?› Mais indubitablement, quand j'y pense maintenant, cela constitue un précédent intéressant et je suis sûr que vous allez commencer à en voir un certain nombre de sosies.»[8] Ainsi, pour Saint-Jacques-de-Compostelle, le projet Foster n'est donc plus une tour, mais une plate-forme haute de 25 m. Cette idée semble tellement à l'opposé de la tour de télécommunications traditionnelle que les techniciens affectés à ce projet ont d'abord estimé qu'il était irréalisable. Mais comme l'agence de Foster avait réalisé des études techniques concluantes, ils ont dû admettre que, pour ce site, une structure élevée n'était pas nécessaire.

Un projet très important de Sir Norman a été celui du troisième aéroport de Londres, situé à Stansted non loin de Cambridge (1987–91). En s'approchant de l'aéroport, le visiteur est aussitôt surpris par la campagne verdoyante qui semble se prolonger jusqu'aux abords du terminal. En effet, 4 ha environ de prairies et d'étangs, ainsi que des haies d'arbres millénaires, ont été conservés, malgré la construction. Quelque 250 000 arbres y ont été plantés, ajoutant à l'impression d'aéroport particulièrement «vert», l'un des premiers à prendre en compte de telles considérations. L'installation principale est constituée du bâtiment de 85 700 m² avec un toit carré de 198 m. Prévu pour faire transiter huit millions de passagers par an, il a coûté 15% de moins que les anciens terminaux. Toutes les installations destinées aux passagers sont situées sur un seul niveau, avec une gare du British Rail au-dessous du hall principal. La hauteur extérieure du bâtiment est seulement de 15 m, et ceci contribue indubitablement à l'impression générale d'espace, car la dimension humaine est respectée, contrairement à la plupart des aéroports où

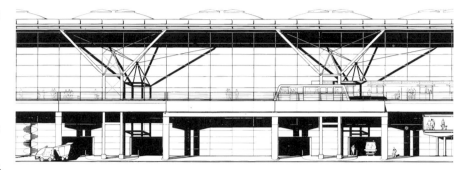

ing appears to float is more poetic, has a magic, has a quality that you can't measure. The quality of the light is not about measuring lumens, it is about subjective judgments. Decisions of taste if you like. They are things that you can't necessarily measure, but in terms of the function of the spirit, they are as important as ensuring that the building is watertight and that you can actually be able to read and show your passport and your ticket. Those humanistic considerations are the driving forces. If you've been through an airport where somebody is having to change the light bulbs in the ceiling, that is not a great experience. If you can change all of the light bulbs from the floor below without interfering with the action of the airport, then that is good news to a maintenance man. It makes a lot of obvious common sense."9

If imitation is indeed a sincere form of flattery, then Stansted Airport has been frequently flattered. Sir Norman sees the new Stuttgart airport, Richard Rogers' Terminal 5 for Heathrow or Renzo Piano's Kansai airport as all having a great deal in common with his design, but he takes this as a compliment, or perhaps as a measure of his own success.

Linking Past and Present
Certain types of modern architecture have been based on a rejection of historical precedent and, more often, on an insensitivity to existing environments. Sir Norman Foster, through a number of recent projects, has redefined the response of contemporary architecture to the historically rich environment of European cities. Moreover, he has shown that beyond addressing the question of context, modern buildings can also break ground in such critical domains as respect for the environment. Foster is by no means alone in his ecological concerns, but he is one of very few architects on the current scene who is able to orchestrate energy efficiency, cost, contextual and aesthetic demands within a given project.

Foster's Carré d'Art in Nîmes (1987–93) in southern France was by no means an easy project. The site, opposite the Maison Carrée (built between 10 and 5 B.C.), an elegant, well-preserved Roman temple, and at the end of one of the city's busiest arteries, the Boulevard Victor Hugo, could hardly have been more challenging. Foster responded with a building of almost classical appearance, measuring no less than 18,000 square meters, half of which is situated below grade in order to permit the structure to align itself on the height of nearby buildings. Indeed, it is the main facade of the Carré

die Tatsache, daß ein Flughafengebäude wasserdicht sein sollte und daß man hier Schilder lesen, den Weg finden und seinen Paß und sein Flugticket vorzeigen können muß. Diese humanistischen Erwägungen sind die wahren Triebfedern. Wer einmal in einem Flughafengebäude erlebt hat, daß urplötzlich alle Lichtquellen ausfallen, wird dies als höchst unangenehm empfunden haben. Wenn dagegen sämtliche Leuchtkörper ohne Beeinträchtigung des Flughafenbetriebes ausgetauscht werden können, ist das für die Techniker eine Erleichterung. Solche praktischen Konstruktionen sind einfach eine Frage des gesunden Menschenverstandes.«[9]

Wenn man Imitation als eine Form der Bewunderung bezeichnen will, wurde Stansted Airport schon oft Bewunderung entgegengebracht. Norman Foster sieht im neuen Stuttgarter Flughafen, in Richard Rogers' Terminal 5 für den Flughafen Heathrow und in Renzo Pianos Kansai Airport große Ähnlichkeiten zu seinem Entwurf, aber er betrachtet dies als Kompliment – oder als Gradmesser für seinen eigenen Erfolg.

Verbindung von Vergangenheit und Gegenwart

Bestimmte Bauformen moderner Architektur entstanden aus der bewußten Ablehnung der historischen Vorbilder, wesentlich häufiger aber aus mangelnder Sensibilität gegenüber einer bereits existierenden baulichen Umgebung. Mit einer Reihe aktueller Projekte gelang es Norman Foster, die Reaktion der zeitgenössischen Architektur auf das reichhaltige historische Umfeld europäischer Städte neu zu definieren. Außerdem hat er bewiesen, daß moderne Gebäude – über die Frage des historischen Kontextes hinaus – in so sensiblen Bereichen wie dem Respekt vor der Natur Neuland erschließen können. Mit seiner Sorge um die Umwelt steht Norman Foster natürlich nicht allein da, aber er gehört zu den wenigen Architekten, die in der Lage sind, im Rahmen eines Auftrags Faktoren des geringen Energieverbrauchs, der Kosten, des Kontexts und der Ästhetik gleichermaßen zu berücksichtigen.

Fosters Carré d'Art im südfranzösischen Nîmes (1987–93) war in keiner Hinsicht ein einfaches Projekt. Das Baugelände konnte kaum größere Herausforderungen bieten: Es liegt direkt gegenüber dem Maison Carrée, einem eleganten, guterhaltenen römischen Tempel (erbaut ca. 10 bis 5 v.Chr.) und am Ende einer der belebtesten Straßen der Stadt, dem Boulevard Victor Hugo. Foster reagierte mit einem fast klassisch anmutenden Entwurf von 18 000 m² Gesamtfläche, der zur Hälfte unter Pla-

de tels facteurs semblent secondaires. À l'intérieur du terminal, la structure en treillis du toit est soutenue par des «arbres» hauts de 12 m, dont la base contient aussi l'éclairage et d'autres installations thermiques. La lumière naturelle, qui semble inonder l'espace, provient en fait d'ouvertures triangulaires qui n'occupent que 5% de la superficie du toit. Sir Norman insiste sur le fait que, malgré les nombreuses considérations techniques qui entraient en jeu dans le projet de Stansted, sa préoccupation personnelle avait été essentiellement de rendre l'espace lumineux. «Par rapport à un terminal classique, avec tubes fluorescents, je trouve qu'à Stansted l'espace est plus tranquille, plus ordonné. Je pense que la structure ordonne l'espace, qu'elle possède une géométrie, un sens de l'ordre et un sens du calme. Une partie importante du travail a consisté à éviter l'intrusion d'éléments comme les descentes d'eau pluviale. S'ils pénétraient à l'intérieur du bâtiment, ils seraient plus dominants que la structure qui soutient la construction. L'éclairage, qu'il soit naturel ou artificiel, constitue une influence toute puissante sur la façon dont l'espace est modelé et perçu. Certains éléments peuvent apparaître comme d'heureux accidents ou coup de chance, or ici, rien n'a été laissé au hasard. La façon dont un rayon de lumière solaire traverse, dans l'espace, les formes métalliques perforées est absolument délibérée: il vient donner vie au sol. Certes, la chaleur pénètre un peu trop. Mais des choix ont été faits sciemment: nous avons préféré cette luminosité et cette sensation d'espace à la recherche de la solution énergétique la plus économique. Ce sont des jugements de valeur subjectifs que je revendique. L'éclairage zénithal de cet espace, où le plafond semble flotter, est plus poétique, il dispense une magie, une qualité qui n'est pas quantifiable. La qualité de la lumière ne se mesure pas en lumens, mais en jugements subjectifs. C'est une question de goût, si vous voulez. Il est des choses qu'on ne peut pas nécessairement mesurer, mais, en termes spirituels, elles sont aussi importantes que de s'assurer que le bâtiment est étanche, et qu'on y voit assez clair pour lire ou présenter son passeport et son billet. Ces considérations humanistes constituent pour moi les forces motrices de l'architecture. Si vous vous êtes trouvé dans un aéroport où l'on était en train de changer les ampoules du plafond, vous savez qu'il faut toute une installation. Si l'on peut procéder au remplacement des ampoules depuis le niveau inférieur, sans gêner le fonctionnement de l'aérogare, alors c'est une

d'Art, whose high light canopy respectfully echoes its venerable neighbor, that most clearly makes the point that modernity and tradition are no longer to be considered as incompatible. Within, a five-story atrium brings light into the lower levels and ties together the upper spaces intended as a museum of contemporary art, and the library below. It was precisely this spectacular atrium that led the English magazine *Blueprint* to launch a scathing attack on Foster in 1994. Arguing that the domination of the internal courtyard pushes usable spaces to the periphery or underground in the Carré d'Art, this design magazine noted the spectacular success of Foster's office with some forty projects under way around the world at that time, and blasted him in the following terms: "Style has hardened into mannerism. Inspiration has been replaced by formulae. And Foster's greatest weakness, his over-diagrammatic conception of space and form, remains... But when a Foster building offers nothing more than some crisp glazing and a curve, you are more inclined to notice that, spatially, it gives no particular pleasure, or, worse, is chillingly ungainly."[10] Applied in particular to the Nîmes Carré d'Art, this criticism would appear to be excessive to a point that it makes the reader suspect some ulterior motive. That said, it would be surprising if an architect as successful as Foster did not have some detractors. As to the idea that the very number of projects being handled by his office might lead to a loss of quality, Foster replies by describing his personal situation. "I feel very comfortable here," he says of his practice. "I have never enjoyed in my life the prospect of coming into the office as much as I do now. I have never felt closer to the process of architecture and working on projects than I do at the moment. That does not mean to say that there are not times when I feel stretched. Probably if I think about it, I have always been stretched. When the office was smaller, I was doing competition soaring, which was quite time consuming. I have sacrificed that. But in turn I fly now as part of the work of the office. I couldn't be in Berlin this morning, in Birmingham tomorrow morning and in Glasgow tomorrow afternoon to chair a jury and back in time for dinner tomorrow evening otherwise. That would be inconceivable. It is also part of the substitute for the competition soaring that I used to do. I'm stretched, but there is a degree of tolerance."

A second Foster project that directly confronts the issue of architectural context is his recent University of Cambridge Faculty of Law building (1993–95).

num angelegt wurde, um das Bauwerk in seiner Höhe den umliegenden Gebäuden anzupassen. Vor allem die Hauptfassade des Carré d'Art, dessen hohes, helles Vordach respektvoll die Form des altehrwürdigen Nachbarn widerspiegelt, ist ein deutlicher Beweis dafür, daß Modernität und Tradition nicht als unvereinbar gelten müssen. Ein zentrales, fünf Stockwerke hohes Atrium bringt das Tageslicht auch in die unterirdischen Geschosse der Bibliothek und verbindet sie mit den oberen Etagen, die ein Museum für zeitgenössische Kunst beherbergen. Genau dieses aufsehenerregende Atrium war der Anlaß für das englische Magazin »Blueprint«, Foster in einem Artikel 1994 scharf anzugreifen. Das Design-Magazin erwähnte den spektakulären Erfolg von Fosters Architekturbüro, das zu dieser Zeit an etwa 40 Projekten gleichzeitig arbeitete. Dann stellte es die These auf, daß die Dominanz des Innenhofes die nutzbaren Räume an den Rand des Gebäudes oder unter die Erde verdrängen würde und attackierte Foster mit den folgenden Sätzen: »Stil hat sich zu Manierismus verhärtet, Inspiration wurde durch Formelhaftigkeit ersetzt. Und Fosters größte Schwäche, seine über-schematische Konzeption von Raum und Form, bleibt bestehen... Aber wenn ein Foster-Gebäude nicht mehr als flotte Glasflächen und eine Rundung zu bieten hat, ist man noch stärker geneigt, zu bemerken, daß es räumlich nicht besonders attraktiv, oder schlimmer noch, abschreckend plump erscheint.«[10] Diese Kritik wirkte so überzogen, daß man als Leser ein verstecktes Motiv dahinter vermuten mußte. Andererseits wäre es natürlich ungewöhnlich, wenn ein so erfolgreicher Architekt keine Kritiker hätte. Auf die Frage, ob die große Zahl von Projekten, die in seinen Büros bearbeitet werden, zu einem Qualitätsverlust führen könnte, reagiert Foster mit einer Beschreibung seiner persönlichen Situation. »Ich fühle mich hier sehr wohl«, sagt er über seine Firma. »Ich habe mich noch nie so darauf gefreut, ins Büro zu gehen, wie heute. Ich habe mich dem Prozeß der Architektur und der Arbeit an Projekten nie näher gefühlt als heute. Das soll nicht heißen, daß es keine Augenblicke gäbe, in denen ich die Anspannung fühle. Wenn ich genauer darüber nachdenke, habe ich die Anspannung eigentlich immer gefühlt. Als das Büro noch kleiner war, nahm ich an Kunstflugwettbewerben teil, was sehr zeitaufwendig sein konnte. Dieses Hobby habe ich der Arbeit geopfert. Aber heute gehört Fliegen zu meiner Arbeit für das Büro. Andernfalls könnte ich nicht heute morgen in Berlin, morgen früh in Birmingham, morgen nachmittag als Vorsitzender ei-

bonne chose pour le responsable de la maintenance. C'est le bon sens même.»[9]

Si l'imitation est bien une forme sincère de flatterie, alors l'aéroport de Stansted a souvent été flatté. Sir Norman trouve que le nouvel aéroport de Stuttgart, le Terminal 5 de Richard Rogers pour Heathrow, ou l'aéroport de Kansai de Renzo Piano, ont beaucoup en commun avec Stansted. Toutefois, il prend cela comme un compliment, ou peut-être comme une façon de mesurer sa propre réussite.

Lier le passé et le présent

Certains types d'architecture moderne se basent sur un rejet des précédents historiques et plus souvent encore, sur une absence de sensibilité envers l'environnement. À travers plusieurs projets récents, Sir Norman Foster a redéfini les réactions de l'architecture contemporaine face à la richesse de l'environnement historique des villes européennes. Qui plus est, il a démontré qu'en abordant la question du contexte, l'architecture contemporaine peut aussi innover dans des domaines aussi critiques que le respect de l'environnement. Foster n'est certes pas isolé dans ses préoccupations écologiques, mais il est l'un des rares architectes sur la scène contemporaine capable d'associer dans un même projet rationalité énergétique, souci des coûts, sensibilité à l'environnement et exigence esthétique.

Son Carré d'Art à Nîmes (1987–93) n'a été, en aucune manière, un projet facile. Situé face à la Maison Carrée (construite entre 10 et 5 av. J.-C.), temple romain, élégant et bien préservé, à l'extrémité du boulevard Victor Hugo, l'une des artères les plus actives de la ville, l'emplacement était pour le moins un défi. Foster y a répondu avec une construction d'apparence presque classique, mesurant pas moins de 18 000 m², dont la moitié est construite au-dessous du sol pour permettre à la structure de s'aligner sur la hauteur des immeubles voisins. De fait, c'est la façade principale du Carré d'Art dont l'auvent fait respectueusement écho à sa vénérable voisine, qui montre clairement que modernité et tradition ne doivent plus être considérées comme incompatibles. À l'intérieur, un atrium sur cinq étages apporte la lumière aux espaces inférieurs et relie entre eux les espaces supérieurs. Ceux-ci abritent un musée d'art contemporain, et en dessous, une bibliothèque. C'est précisément cet atrium spectaculaire qui, en 1994, a amené la revue anglaise «Blueprint» à lancer une attaque cinglante contre Foster. Après avoir noté que la do-

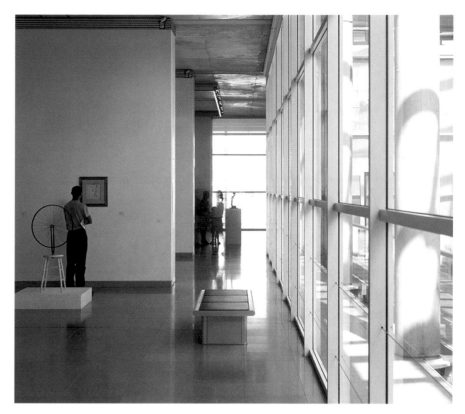

Here, in the midst of the Sidgwick Avenue campus, the neighboring structures are modern, but by no means any easier to adapt to. To the west is the History Faculty Library (1967) by James Stirling, a veritable icon of modern British architecture, and to the south is Hugh Casson's Medieval Languages Faculty and Library. Aside from this prestigious company, a first difficulty of the site concerned the uneven ground levels around the buildings. By repaving the area, lowering the ground level near the Stirling building in a manner said to have been that originally intended by the architect, and creating steps up to Casson's rather heavy structure, Foster managed to create a unity that may also serve for a future "Gateway Building" intended for the Institute of Criminology and the Faculty of English nearby. Formerly the location of a small garden and cricket pavilion, the Cambridge site had other constraints, such as trees that could not be cut. The curve in the design on the side facing the park solved the issue of the trees, while the main entrance, a rather modest revolving door angled toward the History Faculty Library, appears to be an act of discreet homage to Stirling. The most spectacular external feature of the new Law Faculty is its curved glass facade, resolved by applying a triangular grid to a cylindrical form. In a glazing system used for the first time in England, the glass is almost literally glued onto the building, obviating the need for frames, which would have impeded water runoff. A solar shade at the top is intended to cut the sun at its peak summer angle, while a frit matrix has been applied to the glass near the entrance to cut penetrating sunlight. The four-story building, with two further levels below grade, contains the Squire Law Library and five auditoria together with offices and seminar rooms. Natural ventilation, relying in part on the very mass of the concrete to cool the structure, is used throughout, except for the lecture areas below ground. The library and reading areas, looking out onto the garden side, are a particularly successful design. The bookstacks, made of metal and maple veneer, were designed by the practice for the Squire Library, and have already been chosen for use in other libraries, such as that of the Japanese Cultural Institute in Paris.

Two of Foster's most prestigious and indeed ambitious commissions are for the redevelopment of the British Museum (1997–2000), and for the new German Parliament, the Reichstag in Berlin (1995–99). In the case of the British Museum, the challenge is to reclaim the Great Court, which was originally intended to be part of the Museum itself, only to become the property of the British Library. The

ner Jury in Glasgow und abends rechtzeitig zum Essen zurück sein; so etwas wäre undenkbar. Es ist eine Art Ersatz für das Kunstfliegen. Ich fühle die Anspannung, aber es gibt einen gewissen Spielraum.«

Fosters zweites Projekt, das sich mit dem Thema des architektonischen Kontexts konfrontiert sieht, ist der kürzlich fertiggestellte Neubau der Faculty of Law der University of Cambridge (1993–95). Zwar sind die Nachbargebäude auf dem Campus der Sidgwick Avenue modern, aber sie erforderten eine ähnlich hohe Anpassungsfähigkeit wie im Falle des Carré d'Art. Westlich liegt die von James Stirling erbaute History Faculty Library (1967), ein echtes Wahrzeichen moderner britischer Architektur, und im Süden Hugh Cassons Medieval Languages Faculty and Library. Abgesehen von diesen berühmten Nachbarn, bereiteten die unterschiedlichen Bodenniveaus rund um die Gebäude zusätzliche Schwierigkeiten. Foster ließ das Gelände neu pflastern, senkte den Boden nahe des Stirling-Gebäudes so weit ab, wie es der Architekt angeblich ursprünglich selbst beabsichtigt hatte und legte eine Treppe zu Cassons massivem Bauwerk an. Auf diese Weise schuf er eine Einheit, in die auch die geplante Gateway des Institute of Criminology und die nahegelegene Faculty of English integriert werden könnte. Darüber hinaus bot das Baugelände – ein ehemaliger kleiner Garten mit einem Kricketpavillon – weitere Beschränkungen in Form von Bäumen, die nicht gefällt werden durften. Dieses Problem löste Foster durch die Rundung des Entwurfs zur Parkseite hin, während der Haupteingang – eine bescheidene Drehtür, die zur History Faculty Library hin ausgerichtet wurde – wie eine dezente Hommage an Stirling erscheint. Das herausragende Merkmal der neuen Law Faculty ist ihre gewölbte Glasfassade, bei der ein dreieckiges Raster auf eine zylindrische Form übertragen wurde. Für die Verglasung des Gebäudes fand ein in England bis dahin unbekanntes System Verwendung, bei dem die Glasflächen auf das Gebäude aufgeklebt werden, so daß man keine Fensterrahmen mit hinderlichen Wasserabflüssen benötigt. Sonnenblenden auf dem Gebäude sollen die Sonneneinstrahlung im Hochsommer verhindern, während auf die Glasflächen in der Nähe des Eingangs Glasmasse aufgetragen wurde, um das einfallende Sonnenlicht abzuschwächen. Das vierstöckige Gebäude, das zwei weitere Geschosse unter Planum besitzt, beherbergt die Squire Law Library sowie fünf Hörsäle, Seminarräume und Verwaltungsbüros. Bis auf die unterirdischen Seminarräume wird das gesamte Bau-

mination de la cour intérieure pousse les espaces utilisables vers la périphérie ou le sous-sol, l'auteur de l'article rappelle la réussite spectaculaire de Foster – et de ses quelques 40 projets en chantier à travers le monde – et le foudroie en ces termes: «Le style s'est figé en maniérisme. L'inspiration a été remplacée par des recettes. Toutefois, la faiblesse la plus marquante de Foster, sa conception hyper-schématique de l'espace et de la forme, demeure... Mais quand une construction de Foster n'offre rien de plus que l'élégance d'un vitrage et d'une courbe, on ne peut s'empêcher de remarquer que, du point de vue de l'espace, elle ne produit aucun plaisir particulier, ou pire encore, elle est glaciale et disgracieuse.»[10] Appliquée au Carré d'Art de Nîmes en particulier, cette critique semble si excessive qu'elle amène le lecteur à soupçonner quelque motif inavoué. Cela dit, il serait surprenant qu'un architecte aussi demandé que Foster n'ait pas quelques détracteurs. Quant à l'idée selon laquelle le très grand nombre de projets traités par son agence entraînerait une baisse de qualité, Foster y répond en décrivant sa situation personnelle. «Je me sens très à l'aise ici», dit-il de son agence. «Jamais, dans ma vie, je n'ai eu autant de plaisir à venir travailler que maintenant. Jamais je ne me suis senti plus proche du travail architectural ni de mon engagement dans des projets que maintenant. Cela ne signifie pas qu'il n'y a pas des moments où je me sens débordé. Probablement si j'y pense, je l'ai toujours été. Quand l'agence était plus petite, je faisais de la compétition de vol à voile, ce qui prenait beaucoup de mon temps. J'y ai renoncée. Par contre, je prends beaucoup mon avion personnel pour le travail. Sinon, je ne pourrais pas être à Berlin ce matin, à Birmingham demain matin et à Glasgow demain après-midi, pour présider un jury et revenir à temps pour dîner à Londres demain soir. Ce serait inconcevable. C'est aussi une façon de remplacer ces vols de compétition, que je pratiquais. Je suis très occupé, mais pas surmené.»

Second projet de Foster qui se mesure directement à la question du contexte architectural: son récent bâtiment pour la faculté de droit (1993–95) à l'université de Cambridge. Ici, au milieu du campus de la Sidgwick Avenue, les structures voisines sont modernes, ce qui pourtant ne rend pas leur voisinage plus facile. À l'ouest, la bibliothèque de la faculté d'histoire (1967) due à James Stirling, est une véritable icône de l'architecture britannique moderne. Au sud, se trouvent la faculté et la bibliothèque des langues médiévales d'Hugh Casson. Pour ajouter à cette prestigieuse compagnie, une

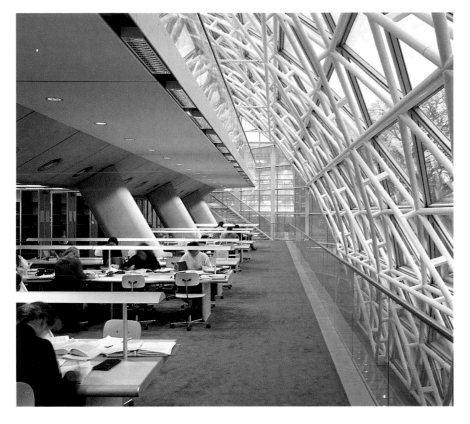

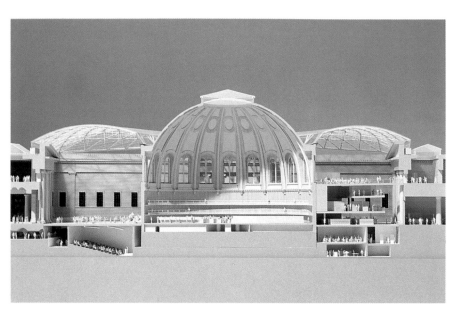

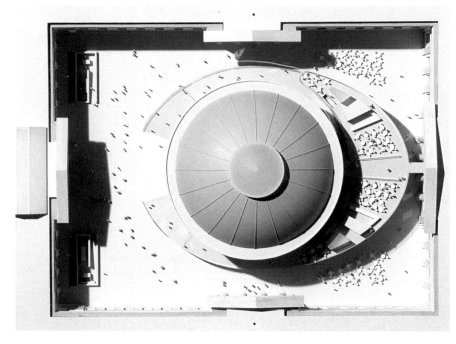

famous Round Reading Room is located in this Court, but other spaces occupied by the Library are being freed thanks to the construction of the new facilities at St Pancras. Enclosing the court with a "lightweight glazed roof", Foster's design returns the entrance of the Museum to its original function, leading visitors through the court, and to upper levels, or to new ethnographic galleries below ground. Just as he did in Nîmes, where he redesigned the paving around the Maison Carrée, Foster intends to clear the forecourt of the Museum, now a jumble of parked cars, giving the entrance facade the breathing room that it most certainly needs.

The Reichstag is an even more significant project in that it is the very symbol of a nation. After a first failed competition in 1871, Paul Wallot was chosen ten years later to design the seat of government in Berlin. Wallot was to leave the project in 1884, some twenty two years before the motto that he proposed, and which was initially rejected by the Emperor, "Dem Deutschen Volke" was finally engraved. The history of the Reichstag is of course closely involved with some of Germany's most difficult moments, from its burning in 1933 to the famous images of Soviet soldiers waving their flag from its charred hulk in 1945. The decision to again make the Reichstag the seat of parliament was bound to be fraught with political controversy and internal disagreements. Indeed the competition, which Norman Foster originally entered with a design for an enormous 33,000 square meter canopy covering the structure, finally led to another solution, a new structure that is both symbolic and ecological. When asked about the Reichstag, it is not its history that seems to first retain the attention of Norman Foster. Rather he speaks with obvious conviction of the unusual schemes that he has developed to make the building self-sufficient in energy. "We are burning rapeseed oil to make electricity," he explains. "It is totally renewable. The waste product of the cogeneration which makes the electricity is then fed through a heat absorption machine to produce free cooling, using water as a medium. Water as a medium means that you can shrink all of the duct sizes down by a factor of more than one to three thousand. So instead of moving huge volumes in great floor voids, you can move it in less than the diameter of a drinking straw. We add to that a degree of solar power. You generate more heat than you actually need, so where does that heat go? You have a choice. You can release it into the atmosphere or you can do what we have done,

werk natürlich belüftet, wobei die Baumasse des Betons zur Kühlung der Konstruktion beiträgt. Besonders gelungen sind vor allem die Bücherei und ihre Lesebereiche mit Blick auf den Garten. Die speziell für die Squire Library entworfenen Bücherregale aus Metall und Ahornfurnier wurden bereits von anderen Bibliotheken wie dem Japanischen Kulturinstitut in Paris übernommen.

Zu Fosters prestigeträchtigsten und mit Sicherheit ehrgeizigsten Bauaufträgen gehören die Umgestaltung des British Museum (1997–2000) und der Umbau des Berliner Reichstags für den Deutschen Bundestag (1995–99). Beim British Museum besteht die Herausforderung darin, den Great Court – der ursprünglich als Teil des Museums gedacht war, aber in den Besitz der British Library überging – einer neuen Nutzung zuzuführen. Der berühmte Round Reading Room liegt mitten in diesem zentralen Innenhof, aber durch die Fertigstellung neuer Räumlichkeiten in St. Pancras wurden die anderen, von der Bibliothek besetzten Flächen frei. Foster versieht den Court mit einem »Leichtbau-Glasdach« und gibt dem Museumseingang seine ursprüngliche Funktion zurück – die Besucher durch den Innenhof in die oberen Stockwerke oder in die unterirdischen Räume der neuen Ethnographischen Sammlung zu leiten. Wie schon in Nîmes, wo er den Platz vor dem Maison Carrée neu pflastern ließ, plant Foster auch hier eine Neugestaltung des zur Zeit noch als Parkplatz genutzten Museumsvorplatzes, um der Eingangsfassade den dringend benötigten Raum zum Atmen zu geben.

Als Symbol einer Nation ist der Reichstag ein noch renommierteres Projekt. Nach einem erfolglosen ersten Wettbewerb 1871 wurde Paul Wallot zehn Jahre später mit dem Entwurf für den Regierungssitz in Berlin beauftragt. Aber bereits 1884 schied er aus diesem Projekt aus, und erst zwanzig Jahre später gravierte man das von ihm vorgeschlagene Motto »Dem Deutschen Volke«, das der Kaiser ursprünglich abgelehnt hatte, über dem Portal ein. Die Geschichte des Reichstags ist natürlich eng mit dem dunkelsten Kapitel der deutschen Geschichte verbunden – vom Reichstagsbrand 1933 bis hin zu dem berühmten Bild der sowjetischen Soldaten, die 1945 ihre Flagge auf seiner verkohlten Hülle hissen –, und die Entscheidung, den Reichstag erneut zum Sitz des Parlaments zu machen, wurde von heftigen politischen Debatten und internen Streitigkeiten überschattet. Auch der Wettbewerb, an dem sich Foster ursprünglich mit dem Entwurf für einen 33 000 m² großen Baldachin beteiligte, führte letztendlich zu einer ganz anderen Lösung – einer Kon-

autre difficulté s'est imposée à cause du niveau inégal du sol autour des bâtiments. En repavant la surface, en abaissant le niveau autour de l'immeuble Stirling tout en restant dans les intentions de son architecte, et en ajoutant des marches pour accéder à la structure plutôt lourde de Casson, Foster a réussi à créer une unité qui pourra être également utilisée pour le «Gateway Building», prévu à l'intention de l'institut de criminologie et de la faculté d'anglais. Jadis l'emplacement d'un petit jardin et d'un pavillon de cricket, le site de Cambridge devait obéir à d'autres contraintes, comme l'obligation de conserver les arbres, par exemple. La courbe côté parc résout ce problème, tandis que l'entrée principale, une porte-tambour plutôt modeste sise dans l'angle face à la bibliothèque de la faculté d'histoire, apparaît comme un hommage discret à l'œuvre de Stirling. La caractéristique extérieure la plus spectaculaire de la nouvelle faculté de droit, c'est en effet sa façade courbe en verre, réalisée en plaquant une grille triangulaire sur une forme cylindrique. Grâce à un système utilisé pour la première fois en Angleterre, le verre est littéralement collé sur le bâtiment, évitant le recours à des châssis qui auraient entravé l'écoulement des eaux. Au sommet, un écran protège du soleil à son zénith en été, tandis que près de l'entrée le verre a été traité pour atténuer les rayons solaires. L'immeuble de quatre étages, avec ses deux niveaux en sous-sol, abrite la Squire Law Library ainsi que cinq auditoriums, des bureaux et des salles pour séminaires. Une ventilation naturelle, s'appuyant en partie sur la masse du béton pour refroidir la structure, est utilisée partout, excepté pour les salles de conférences en sous-sol qui sont, quant à elles, climatisées. La bibliothèque et les salles de lecture qui donnent côté jardin sont des espaces particulièrement réussies. Les rayonnages en métal et le placage en érable ont été spécialement conçus pour la Squire Library. Ils ont d'ailleurs été repris pour d'autres bibliothèques, de même que pour l'Institut culturel japonais à Paris.

Deux des commandes les plus prestigieuses, voire ambitieuses, de Foster concernent le réaménagement du British Museum (1997–2000), et le nouveau parlement allemand, le Reichstag de Berlin (1995–99). Pour ce qui est du British Museum, la gageure consiste à récupérer la grande cour qui, originellement, était destinée à faire partie du Museum lui-même, mais qui a été attribuée au XIXᵉ siècle à la British Library. La célèbre salle de lecture ronde fait partie de cette cour, mais d'autres espaces auparavant occupés par la bibliothèque sont

Page 32: British Museum Redevelopment, London, 1997–2000. By covering the space in the central courtyard around the Round Reading Room, the architect permits a more natural orientation and flow of visitors through the Museum.

Seite 32: Umgestaltung des British Museum, London, 1997–2000. Durch die Überdachung eines Bereichs im zentralen Innenhof rund um den Round Reading Room ermöglicht der Architekt eine natürliche Orientierung und einen gleichmäßigen Besucherstrom durch das Museum.

Page 32: Extension du British Museum, Londres, 1997–2000. En couvrant la cour centrale autour de la salle de lecture ronde, l'architecte permet une orientation plus naturelle et la circulation des visiteurs dans le musée.

which is to feed it into the ground, to a depth which is slightly greater than the Eiffel Tower. We recover it in the winter as a free heat source, because it is stable below ground. This is so efficient that the Reichstag is no longer just its own power plant, it is the power station for the large complex of new buildings that surround it, providing power to a development three times the size of the Reichstag itself. It is totally independent of the city utility grid. Except in one case. If the power supply goes down through a technical malfunction, then the emergency backup kicks in, and that is the city grid. There is no standby generator. The system is so efficient that even when it has satisfied its own demands and the demands of the buildings around it, it produces excess power, which it sells back into the national grid. The technology of using vegetable oil in fact arises out of the circumstances of East Germany. At a very critical political phase, it was worried about its dependence on the Soviet bloc for power, and wanted to have independence if necessary. East Germany pioneered engines that would run very efficiently with vegetable oil as a fuel. Everything that I have described has only been approved by the accountants because it makes economic sense."[11] As passionately as he speaks about energy efficiency, Sir Norman also makes a case for his analysis of the needs of the parliament in terms of space. He points out that the original brief called for separate buildings to be used for the parliamentary factions despite the fact that there was excess space within the Reichstag. By proposing to move the faction rooms into the Reichstag itself, Foster achieved a cost reduction and a gain in time for members of the governing body, who move frequently between the chamber and the spaces assigned to their groups. He also pleaded successfully for the public to be admitted into the building as freely as possible. Beyond the issues of energy and space, Norman Foster emphasizes his interest in the history of the Reichstag. As he says, "I have been at pains to retain and incorporate memories from the past in the fabric of the building – such as graffiti from the Russian occupation, the torching in the 1930s, the scars of war, original mouldings and 1960s interventions. By contrast the new is inserted into this shell, which has been partly reconstructed and partially peeled away in layers to reveal its past. Like the Royal Academy, the totality is like the city in microcosm. The sense of history is heightened by the presence of the new – and the architecture of today is made more intense in the context of the old."[12] Foster's comments on the

struktion, die symbolisch und ökologisch zugleich ist. Aber nicht die historische Entwicklung des Reichstags zog Norman Fosters unmittelbare Aufmerksamkeit auf sich, sondern ein anderer Aspekt: Mit offensichtlicher Begeisterung spricht er von den ungewöhnlichen Plänen, die eine autarke Energieversorgung des Bauwerks garantieren sollen. »Wir verbrennen Rapsöl, um Elektrizität zu erzeugen«, erklärt Foster. »Es handelt sich um eine erneuerbare Energie. Danach werden die Abfallprodukte in eine Wärmeabsorptionsanlage geleitet, um natürliche Kühlung zu erzeugen, wobei Wasser als Medium dient. Wasser als Medium bedeutet auch, daß man die Zuleitungsrohre um den Faktor Eins zu Dreitausend verkleinern kann; auf diese Weise müssen wir keine riesigen Röhren durch große, leere Bodenkammern führen, sondern können uns auf Zuleitungen von der Dicke eines Strohhalms beschränken. Dazu speisen wir Solarenergie in die Anlage ein. So entsteht mehr Wärme, als wir eigentlich benötigen – also wohin damit? Entweder entläßt man die Wärme in die Atmosphäre, oder man leitet sie – so wie wir es getan haben – in den Erdboden bis in eine Tiefe, die etwa der Höhe des Eiffelturms entspricht. Da der Erdboden unter dem Gebäude sehr fest ist, erhalten wir so im Winter eine natürliche Wärmequelle. Auf diese Weise erzeugt der Reichstag nicht nur seine eigene Energie, sondern dient auch als Kraftwerk für die umgebenden Neubauten, und zwar auf einer Fläche, die dreimal seiner eigenen Größe entspricht. Das Gebäude ist völlig unabhängig vom Versorgungsnetz der Stadt – es sei denn, es tritt ein Notfall ein: Wenn die Energieversorgung aufgrund eines technischen Defekts zusammenbricht, setzt die Notstromversorgung ein, die aus dem städtischen Netz bezogen wird. Es gibt keinen Reserve-Generator. Das System ist so effizient, daß es über seine eigenen und die Bedürfnisse der umliegenden Gebäude hinaus noch überschüssigen Strom produziert, der an den regionalen Stromerzeuger weiterverkauft wird. Die Technologie zur Nutzung von pflanzlichen Ölen entstand in der ehemaligen DDR. In einer politisch besonders kritischen Phase machte sich die Regierung Sorgen über ihre Abhängigkeit von der sowjetischen Stromversorgung und suchte nach einer Möglichkeit der Selbstversorgung. Dadurch war die DDR führend in der Entwicklung von Maschinen, die mit Pflanzenöl betrieben werden können. Übrigens wurde alles, was ich gerade beschrieben habe, von der Rechnungsabteilung nur deshalb genehmigt, weil es wirtschaftlich ist.«[11]

libérés grâce à la construction de nouvelles salles à
St. Pancras. Enfermant la cour sous une «voûte vi-
trée légère», le projet de Foster ramène l'entrée du
Museum à sa fonction originelle: conduire les visi-
teurs à travers la cour, jusqu'aux étages ou aux
nouvelles galeries ethnographiques, en sous-sol.
Exactement comme à Nîmes, où il a redessiné le
pavage autour de la Maison Carrée, Foster veut dé-
gager l'esplanade du musée, actuellement un en-
chevêtrement de voitures en stationnement, pour
donner à la façade d'entrée l'espace libre dont elle
a certainement besoin.

Le Reichstag est un projet encore plus significatif
dans la mesure où il est le symbole même d'une
nation. Après un premier concours raté en 1871,
Paul Wallot fut choisi dix ans plus tard pour conce-
voir le siège du gouvernement à Berlin. Wallot de-
vait quitter le chantier en 1884, environ vingt-deux
ans avant que l'épigraphe, qu'il avait proposée et
qui avait été initialement rejetée par l'empereur,
«Dem Deutschen Volke», soit enfin gravée au-des-
sus de la porte principale. Bien sûr, l'histoire du
Reichstag est intimement liée à certains des mo-
ments les plus difficiles de l'Allemagne, depuis son
incendie en 1933, jusqu'aux célèbres images des
soldats soviétiques qui, en 1945, agitent leurs dra-
peaux sur cette carcasse calcinée. La décision de
réintégrer le parlement au Reichstag ne pouvait
qu'entraîner controverse politique et désaccords in-
ternes. De fait, le concours auquel Norman Foster
participa avec son projet d'une énorme couverture
de 33 000 m² pour abriter la structure, finit par dé-
boucher sur une autre solution, un nouveau dôme,
à la fois symbolique et écologique. Quand on l'in-
terroge sur le Reichstag, ce n'est pas son histoire
qui semble d'abord retenir l'attention de Norman
Foster. Il parle plutôt, et avec une intime convic-
tion, des procédés inhabituels qu'il a développés
afin que ce bâtiment soit autosuffisant en matière
d'énergie. «Nous brûlons de l'huile de colza pour
fabriquer de l'électricité», explique-t-il. «C'est tota-
lement renouvelable. Le résidu de la cogénération
qui fabrique cette électricité est alors dirigé dans un
dispositif d'absorption de chaleur pour produire
une climatisation par circulation d'eau. Utiliser
l'eau signifie que l'on peut réduire considérable-
ment le diamètre des conduits. Donc, au lieu de
faire circuler d'énormes volumes dans d'énormes
espaces, on peut se contenter d'avoir des tuyaux
pas plus larges qu'une paille. En plus, nous faisons
aussi appel à l'énergie solaire. En fait, on génère
toujours plus de chaleur que nécessaire, alors, que
peut-on en faire? On a le choix. Soit on la libère

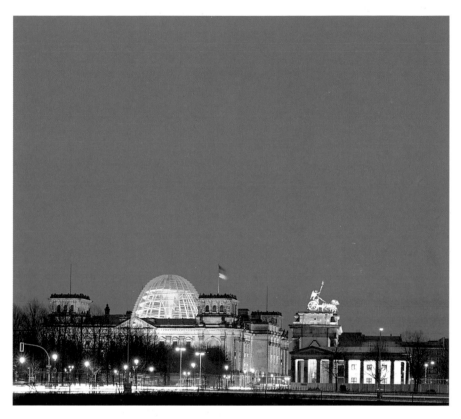

Reichstag certainly provide a significant insight into his method as applied in this instance to an historic building, and also give clues as to why his office has been successful in obtaining so many large, prestigious commissions. When asked if he isn't putting undue stress on the technological aspects of this project he replies emphatically, "No, they are intensely social. They are not technological. You can't look at any structure from Stonehenge to a barn without accepting its technological content. What I have been talking about here is 90% social. Accessibility in terms of the public, reducing the pollution. I've also talked about the history."[13]

Bigger, Longer, Better

With his evident success in building increasingly demanding projects, it seems natural that Sir Norman Foster has been called on to design what will be the largest airport in the world in terms of international passenger movements, the new facility of Hong Kong at Chek Lap Kok. Those who have flown into the current airport of Hong Kong, Kai Tak, have some idea of just how urgent it is to replace the terminal that handled 27.4 million passengers in 1995, an increase of 8.7% over 1994. Sandwiched into the city, Kai Tak obliges enormous 747s to perform acrobatic manœuvers before touching down between rows of densely populated apartment buildings. Although Kai Tak ranked second in terms of international air cargo and fourth in international passenger traffic amongst the world's airports in 1994, the infrastructure project being undertaken to prepare Chek Lap Kok for its opening is on an almost unimaginably large scale. Aside from the terminal itself, nine other interlinked projects are being carried out simultaneously, including a new 34 kilometer airport railway, the development of five highway networks, two major land reclamation projects in West Kowloon and the Central District, and a new town development. The highway work includes the world's longest suspension bridge carrying both road and rail traffic, the Tsing Ma Bridge with its 1.4 kilometer main span. The whole of the program involves creating no less than 1,669 hectares of land, of which 1,248 are reserved for the airport itself. The total cost of the construction is estimated at $20 billion, with every indication that the work will be completed on time and on budget. Initially designed to handle 35 million passengers and three million tons of cargo a year, Chek Lap Kok can be expanded in stages to a capacity of 87 million passengers per annum and nine million tons of cargo.

Ebenso leidenschaftlich wie sein Exkurs über Energieeinsparung fällt auch Fosters Analyse der räumlichen Bedürfnisse des Parlaments aus: Er erläutert, daß die ursprüngliche Ausschreibung separate Gebäude für die verschiedenen Fraktionen vorsah, obwohl der Reichstag genügend Raum bot. Durch den Vorschlag, die Fraktionsräume in den Reichstag selbst zu verlegen, konnte Foster die Kosten reduzieren und Zeit für die Abgeordneten sparen, da der Weg vom Plenarsaal zu den einzelnen Fraktionsräumen wesentlich verkürzt wurde. Darüber hinaus setzte er sich mit seiner Bitte durch, der Öffentlichkeit möglichst freien Zugang zum Gebäude zu gewähren. Daneben betont Foster sein Interesse an der Geschichte des Reichstags: »Ich habe mir große Mühe gegeben, Erinnerungen an die Vergangenheit zu bewahren oder sie in das Skelett des Gebäudes zu integrieren – Graffiti aus der Zeit der russischen Besatzung, Brandspuren aus den 30er Jahren, Narben des Krieges, Originalformen und Eingriffe aus den 60er Jahren ...«[12]

Fosters Anmerkungen zum Reichstag gewähren einen tiefen Einblick in seine Methode, die in diesem Fall auf ein historisches Bauwerk angewandt wurde; darüber hinaus erhält man einen Hinweis darauf, warum sein Büro bei Bewerbungen für große, renommierte Bauprojekte so erfolgreich ist. Auf die Frage, ob er die technologischen Aspekte dieses Projekts nicht zu sehr in den Vordergrund stelle, antwortet Foster entschieden: »Nein, denn eigentlich handelt es sich um soziale, nicht um technologische Aspekte. Man kann kein Bauwerk – ob Stonehenge oder eine Scheune – betrachten, ohne seinen technischen Anteil zur Kenntnis zu nehmen. Worüber ich hier gesprochen habe, ist zu 90% sozial – Zugänglichkeit für die Öffentlichkeit, Reduzierung der Umweltverschmutzung, und nicht zuletzt die Geschichte.«[13]

Größer, länger, besser

Aufgrund seines offensichtlichen Erfolgs beim Bau zunehmend anspruchsvollerer Projekte erschien es nur natürlich, daß man Sir Norman Foster bat, den neuen Chek Lap Kok Airport in Hongkong zu entwerfen, den in bezug auf das Passagieraufkommen größten Flughafen der Welt. Jeder, der schon einmal auf dem heutigen Hongkonger Flughafen Kai Tak angekommen ist, besitzt eine ungefähre Vorstellung davon, wie dringend ein Ersatz benötigt wird – denn hier landeten 1995 27,4 Millionen Passagiere. Der mitten in der City gelegene Flughafen zwingt riesige Boeing 747-Jets zu akrobatischen Manövern, bevor sie mitten zwischen dicht bevöl-

dans l'atmosphère, soit on l'utilise comme nous
l'avons fait, c'est-à-dire on la stocke en sous-sol,
jusqu'à une profondeur légèrement supérieure à la
hauteur de la Tour Eiffel. En hiver, nous la récupé-
rons comme source de chaleur gratuite, parce que,
sous terre, elle reste stable. Ce système est si effi-
cace que le Reichstag possède non seulement son
propre générateur, mais il sert encore de centrale
électrique pour le grand complexe de constructions
nouvelles qui l'entourent. Il produit assez d'énergie
pour un bâtiment trois fois plus grand que lui. Il est
totalement indépendant du réseau de la ville. Sauf
dans un cas: Si l'énergie diminue à cause d'un dys-
fonctionnement technique, à ce moment-là une
source d'énergie d'urgence se déclenche, laquelle
n'est autre que le réseau urbain. Nous avons ainsi
évité l'obligation d'inclure dans le projet un généra-
teur de secours. Le système est si efficace que,
même quand il a satisfait toutes ses demandes et
celles des immeubles qui l'entourent, il produit un
excédent qui est revendu au réseau national. En
fait, cette technologie du combustible végétal a été
développée en Allemagne de l'Est. Lors d'une
phase politique particulièrement critique, le pays
s'est inquiété de sa dépendance énergétique à
l'égard du bloc soviétique et a souhaité pouvoir
être autosuffisant en cas de besoin. Il a expéri-
menté des machines capables de fonctionner très
efficacement avec de l'huile végétale. Tout ce que je
décris a seulement été approuvé par les comp-
tables du gouvernement allemand parce que cela à
un sens du point de vue économique.»[11] Passionné
par le dossier de l'efficacité énergétique, Sir Norman
l'est tout autant quand il analyse les besoins du
parlement en termes d'espace. Il souligne que le
cahier des charges initial préconisait des bâtiments
séparés pour les groupes parlementaires, alors
qu'il y avait énormément d'espace à l'intérieur du
Reichstag. En proposant de placer les salles réser-
vées aux groupes à l'intérieur même du Reichstag,
Foster a permis une réduction du coût et un gain
de temps pour les membres du bureau qui se dé-
placent fréquemment entre l'hémicycle et les salles
assignées à leur groupe. Parallèlement il a réussi
à faire admettre le public dans le bâtiment aussi
librement que possible. Au-delà des questions
d'énergie et d'espace, Norman Foster met en avant
l'intérêt qu'il porte à l'histoire du Reichstag. Il ex-
plique: «Je me suis donné un certain mal afin de
conserver et d'incorporer des souvenirs du passé
dans le tissu du bâtiment – des graffitis datant de
l'occupation russe, des traces de l'incendie des an-
nées 30, les cicatrices de la guerre, les moulures

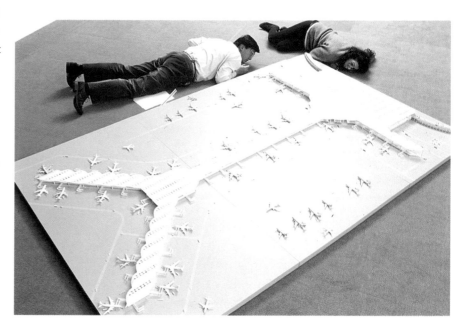

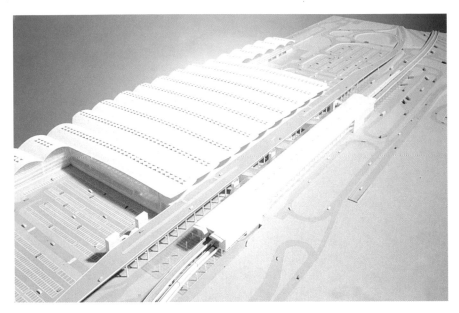

Norman Foster is playing a substantial role in this enormous project, because he has been commissioned to build not only the main terminal, but also the HCTL Superterminal and Express Center, the largest single automated air cargo terminal in the world, with an area of some 260,000 square meters, and the Ground Transportation Center intended for the Mass Transit Railway Corporation (MTRC) as well as taxis, buses or car arrivals. Covered by a "single unified gull wing roof," this complex intended to be used by 45 million people a year, will include 28,000 square meters of station area and 66,000 square meters of office space.

These impressive statistics underscore the expansion of Asia, leading Sir Norman to state that such projects cannot really be examined without taking into account the historic shifts occurring in the world economy. "You can't really measure them by all of the normal criteria used to evaluate a project in Europe for example. That has to do with the explosive growth of cities and the shift of that growth from the west to the east. In 1939 London was the most populated city in the world. In the late 40s, early 50s, New York and Moscow, Paris and Milan were still the big cities. By the end of this century, those cities are no longer even present in lists of the world's largest urban areas. Apart from Mexico City or São Paulo, they are all centered in the east. If you look at the way in which infrastructure is growing to cope with that shift, then it is different from the European pattern, which is one of incremental growth. In three years, on an island that was man-made and is bigger than Heathrow, Hong Kong is creating from nothing, from sea water, something which is bigger than the world's biggest airport, which for the moment is Heathrow in terms of international passenger movement. And then it throws away the existing facility and it has a six hour period in which you can close one airport and open another."[14] As Foster's office description of the new terminal has it, "The airport is being constructed at Chek Lap Kok, a largely man-made purpose-built island 6 kilometers long and 3.5 kilometers wide. The terminal will be 1.5 kilometers long and the baggage hall alone will be the size of Wembley Stadium. Within the terminal, arriving and departing passengers are separated by level, and clarity of movement is established by keeping all land-side connections to the east and air-side to the west. All passengers enter and leave the building through a vast entrance hall atrium, the base of which is used as the meeting and greeting area for arrivals, while departing passengers pass overhead

kerten Wohnhäusern zur Landung ansetzen. Obwohl schon Kai Tak 1994 beim internationalen Frachtumschlag an zweiter und im Passagieraufkommen an vierter Stelle aller Flughäfen weltweit lag, zeichnet sich bereits der Bau der Infrastruktur für Chek Lap Kok durch einen beinahe unvorstellbar großen Maßstab aus. Neben dem eigentlichen Terminal entstehen gleichzeitig neun weitere Projekte, darunter die neue, 34 km lange Bahnlinie zum Flughafen, fünf Autobahnen, zwei große Landgewinnungsprojekte in West Kowloon und im Central District sowie eine Stadterweiterung. Die Autobahnarbeiten umfassen auch den Bau der Tsing Ma-Brücke, die mit einer Spannweite von 1,4 km die längste Hängebrücke der Welt für Bahn- und Straßenverkehr sein wird. Im Rahmen dieses Programms entstehen nicht weniger als 1 669 ha Neuland, von denen 1 248 für den neuen Flughafen reserviert sind. Die Gesamtkosten belaufen sich auf geschätzte 20 Milliarden Dollar, wobei alles dafür spricht, daß weder der Zeitplan noch das Budget überschritten werden. Der Flughafen Chek Lap Kok, der für 35 Millionen Passagiere und 3 Millionen Tonnen Fracht pro Jahr geplant ist, läßt sich in mehreren Schritten auf eine Kapazität von jährlich 87 Millionen Passagieren und 9 Millionen Tonnen Fracht erweitern.

Norman Foster spielt bei diesem riesigen Projekt eine zentrale Rolle, da er nicht nur den Auftrag zum Bau des Hauptterminals, sondern auch des HCTL Superterminal and Express Center erhielt, das mit einer Gesamtfläche von 260 000 m² das weltweit größte automatische Luftfrachtterminal werden soll. Darüber hinaus errichtet sein Büro das Ground Transportation Center, das sowohl für die Mass Transit Railway Corporation (die Eisenbahn-Frachtgesellschaft MTRC) als auch als Ankunftsort für Taxis, Busse oder Autos dienen soll. Dieser von einem »einzigen durchgehenden Tragflügel-Dach« bedeckte Komplex kann von 45 Millionen Menschen pro Jahr genutzt werden und umfaßt einen Bahnhofsbereich von 28 000 m² sowie 66 000 m² Büroflächen.

Diese Zahlen unterstreichen den Aufschwung Asiens und bringen Foster zu der Bemerkung, daß solche Projekte nicht bewertet werden können, ohne die historische Verschiebung in der Weltwirtschaft zu berücksichtigen. »Ein solches Projekt läßt sich nicht mit den üblichen Maßstäben messen, die zur Bewertung eines Bauwerks in Europa herangezogen werden. Das hängt mit dem explosiven Wachstum der Städte und der Verschiebung dieses Wachstums von West nach Ost zusammen.

originales ou les interventions structurales des années 60. Une architecture nouvelle a été ainsi insérée dans cette carcasse qui a été partiellement reconstruite et partiellement grattée pour mettre à jour son passé. Comme pour la Royal Academy, le Reichstag ressemble quelque part à la ville, en un microcosme. Le sens historique est rehaussé par la présence du neuf, tandis que l'architecture nouvelle est intensifiée par le contexte de l'ancien». [12]

À n'en pas douter, ces commentaires de Foster fournissent un éclairage significatif sur sa méthode, appliquée dans le cas présent à un bâtiment historique. De plus, ils aident à comprendre pourquoi son agence réussit à obtenir tant de commandes si prestigieuses. Quand on lui demande s'il n'exagère pas l'importance des aspects technologiques de ce projet, il réplique: «Pas du tout. Ils sont essentiellement sociaux. Ils n'ont rien de technologique. On ne peut pas regarder une structure, qu'il s'agisse de Stonehenge ou d'une simple grange, sans en accepter le contenu technologique. Ce dont je parle ici, est à 90% social. Prenez par exemple l'accessibilité du public ou la réduction de la pollution. J'ai aussi parlé de l'histoire.»[13]

Plus haut, plus fort, plus grand
Compte tenu de son succès dans la réalisation de projets de plus en plus complexes, il n'est pas étonnant que Sir Norman Foster ait été sollicité pour concevoir ce qui sera le plus grand aéroport au monde: l'aménagement de Chek Lap Kok, à Hong Kong. Ceux qui sont passés par l'actuel aéroport de Kai Tak connaissent l'urgence qu'il y a à remplacer ce terminal qui a accueilli 27,4 millions de passagers en 1995, soit un accroissement de 8,7% sur 1994. Incrusté au milieu de la ville, Kai Tak oblige les pilotes d'énormes 747 à réaliser des manœuvres acrobatiques avant d'atterrir entre des rangées d'immeubles très peuplés. En 1994, Kai Tak occupait la deuxième place mondiale pour le fret et la quatrième pour le nombre de passagers. Reste que le projet de Chek Lap Kok se situe à une échelle d'une importance presque inimaginable. Outre le terminal lui-même, 9 autres projets d'infrastructure seront réalisés simultanément, dont une nouvelle voie de chemin de fer longue de 34 km, le développement d'un réseau de cinq autoroutes, deux projets de mise en valeur d'importants terrains à Kowloon Ouest et dans le quartier Central, ainsi que la création d'une ville nouvelle. Les travaux d'autoroute incluent le pont suspendu le plus long du monde (1,4 km), véhiculant à la fois un trafic par route et par voie ferrée, le pont Tsing Ma.

Page 38: Airport at Chek Lap Kok, Hong Kong, 1995–98, model view of the Ground Transportation Center.

Seite 38: Flughafen Chek Lap Kok, Hongkong, 1995–98, Modell des Ground Transportation Center.

Page 38: Aéroport de Chek Lap Kok, Hong Kong, 1995–98, maquette du centre de transports.

Page 41: KCRC Kowloon Railway
Station, Hong Kong, 1995–97.
A lightweight canopy erected
to the east of the old station
doubles the size of the building.

Seite 41: KCRC Kowloon
Bahnhof Hongkong, 1995–97.
Das leichte Vordach über dem
Ostteil des alten Bahnhofs
verdoppelt die Ausmaße des
Gebäudes.

Page 41: Gare de chemins de
fer KCRC Kowloon, Hong Kong,
1995–97. Une voûte légère
érigée à l'est de la vieille gare
double la taille du bâtiment.

on glass bridges. From check-in, departing passengers pass through immigration and security control to a long 'Y' shaped concourse, from which all gates can be accessed either by foot, moving walkway or internal train. The concrete structure supports a series of 36 meter lightweight steel shells, connected to form continuous barrel vaults running east-west, giving direction to passenger flows. The roof covers the building like a blanket, hugging its contours, unifying its various functions, while providing the symbolic identity of the building."[15]

Nor will Sir Norman Foster's presence in Hong Kong be limited to the Hongkong and Shanghai Bank Headquarters and the new airport. He is also completing an extension and reorganization of the KCRC Kowloon Railway Station (1995–97). Enlarging the existing mid 1970s station, which serves the link to the mainland to the east with a new lightweight pavilion structure, Foster is doubling the size of the original facility and improving traffic flow. Once again, the statistics concerning this project are impressive. The 45,000 square meter building will serve no less than 80 million passengers a year, or 160,000 per day with a peak rate of 23,000 per hour.

It would appear that Sir Norman's own interest in technology, in particular that of flight, offers him a capacity to master projects that are on the new, gargantuan scale of the rising Eastern economies. His reputation for completing jobs on time and on budget is also a factor, which may have significantly swayed the jury in a recent competition won by the office, this time in France. Surprisingly though, the scale of the planned new Grand Viaduc de Millau is such that it is in a league with Foster's Asian commissions. His multi-span cable-stayed structure in seven sections is intended to bridge a gap of 2,460 meters on the A75 highway, linking Clermont-Ferrand and Beziers. With columns varying between 75 and 235 meters in height, the road deck will pass 275 meters above the modest Tarn River in the valley below. The office description of the project proudly points out that the tallest building in Europe, Foster's own Commerzbank in Frankfurt, is about the same height as that span of the Viaduct.

Not everyone, however, seems to agree that Foster's design will result in "a dramatic silhouette against the sky, an elegant and taut structure spanning effortlessly across the valley," as his description would have it. Valéry Giscard d'Estaing, the former President of France went so far as to write to his successor Jacques Chirac that "This project

1939 war London die größte Stadt der Welt; Ende der 40er und Anfang der 50er Jahre galten New York, Moskau, Paris und Mailand als wirkliche Großstädte. Aber am Ende dieses Jahrhunderts wird man diese Städte nicht einmal mehr auf der Liste der größten Stadtgebiete der Welt finden – außer Mexiko City und São Paulo wird es sich nur um Städte in Asien handeln. Das Wachstum ihrer Infrastruktur, die versucht, diese Verschiebung zu bewältigen, entspricht nicht dem europäischen Muster der langsamen Zunahme. Innerhalb von drei Jahren erbaut Hongkong auf einer zum größten Teil künstlich angelegten Insel ein Gebilde, das größer ist als der größte Flughafen der Welt – als den man Heathrow zumindest in bezug auf die Passagierzahlen bezeichnen kann – einfach aus dem Nichts, aus dem Meer heraus. Und dann wirft die Stadt die bestehenden Einrichtungen weg und hat sechs Stunden Zeit, um einen Flughafen zu eröffnen und den anderen zu schließen.«[14] Fosters Büro beschreibt den neuen Terminal mit folgenden Worten: »Der Flughafen entsteht auf Chek Lap Kok, einer größtenteils künstlich angelegten Insel von 6 km Länge und 3,5 km Breite. Der Terminal wird eine Länge von 1,5 km besitzen, wobei allein die Gepäckhalle die Größe des Wembley-Stadions erreicht. Innerhalb des Terminals werden die ankommenden und abreisenden Passagiere durch verschiedene Ebenen voneinander getrennt sein, wobei aus Gründen der Übersichtlichkeit alle Wege zum Land nach Osten und alle Wege zum Flugzeug nach Westen führen. Die Passagiere betreten und verlassen den Flughafen durch ein riesiges Atrium, dessen Bodenniveau als Treffpunkt für ankommende Passagiere dient, während die Abreisenden den Eingangsbereich auf Glasbrücken durchqueren. Nach dem Einchecken und den Paß- und Sicherheitskontrollen betreten die abreisenden Passagiere eine lange, Y-förmige Halle, von der sich alle Flugsteige zu Fuß, auf Rollbändern oder mit einer Zubringerbahn erreichen lassen. Die Betonkonstruktion trägt eine Reihe von 36 m langen stählernen Leichtbau-Skelettrahmen, die miteinander zu Tunnelgewölben verbunden wurden. Diese verlaufen in Ost-West-Richtung und leiten so den Strom der Passagiere. Die Dachkonstruktion bedeckt das Gebäude wie ein Tuch, kaschiert seine Konturen, vereinigt die verschiedenen Funktionen und verleiht dem Bauwerk eine symbolische Identität.«[15]

Aber Fosters Präsenz in Hongkong beschränkt sich nicht nur auf die Hongkong and Shanghai Bank und den neuen Flughafen: Noch ist er mit der Erweiterung und Umgestaltung der KCRC Kowloon

L'ensemble du programme dispose de 1 669 ha de terres, dont 1 248 sont réservés à l'aéroport lui-même. Le coût total de la construction est estimé à 20 milliards de dollars, avec l'assurance que le chantier sera réalisé dans les temps et dans les limites de ce budget. Initialement prévu pour desservir 35 millions de passagers et 3 millions de tonnes de cargaison par an, Chek Lap Kok pourra être étendu, par étapes, jusqu'à une capacité de 87 millions de passagers et de 9 millions de tonnes de fret.

Au centre de cet énorme projet, Norman Foster joue un rôle considérable, dans la mesure où il a reçu non seulement la commande pour le terminal principal, mais aussi pour le superterminal HCTL et l'Express Center, le plus grand terminal de fret aérien automatisé au monde, avec une surface de quelques 260 000 m², et le centre de transport terrestre destiné au Mass Transit Railway Corporation (MTRC) visant à accueillir aussi bien les taxis que les autocars et les voitures. Le complexe devra accueillir sous un immense toit en «aile de goéland» 45 millions de personnes par an, et il comprendra 28 000 m² de gare routière et 66 000 m² d'espaces de bureaux.

Ces statistiques impressionnantes mettent en évidence l'expansion économique de l'Asie. Elles amènent Sir Norman à déclarer que de tels projets ne peuvent sérieusement être examinés sans prendre en compte les changements historiques de l'économie mondiale. «Il est véritablement impossible de les mesurer selon les critères normalement utilisés pour évaluer un projet en Europe, par exemple à cause de la croissance phénoménale des villes et du déplacement de cette croissance de l'Ouest vers l'Est. En 1939, Londres était la ville la plus peuplée du monde. À la fin des années 40, au tournant des années 50, New York et Moscou, Paris et Milan étaient encore de grandes villes. À la fin de notre siècle, ces villes n'apparaissent même plus sur la liste des plus vastes centres urbains du monde. Excepté Mexico et São Paulo, toutes les mégalopoles sont en Orient. Si on étudie la façon dont leur infrastructure s'accroît pour s'adapter à ce changement, on trouve un modèle différent du modèle européen qui est une sorte d'accroissement par addition. En trois ans, sur une île créée des mains de l'homme et qui est plus grande que l'aéroport de Heathrow, Hong Kong va bâtir à partir de rien, si ce n'est de l'eau de mer, quelque chose qui sera plus grand que le plus grand aéroport du monde, en ce qui concerne le trafic international de passagers. Et il ne s'écoulera pas plus de six heures

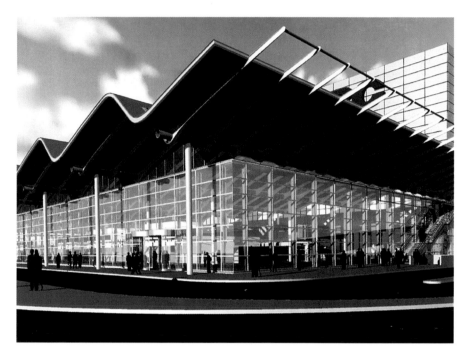

must elicit the most serious reservations, which is why I ask you to reexamine this question at your earliest convenience... The project envisaged for Millau belongs to the family of cable-stayed bridges often built near the entries to ports or in the mouths of rivers... In designing a bridge which spans a valley at such a great height, it is necessary to obtain a less opaque profile, which is less oppressive for the surrounding countryside."[16] Though nothing is impossible when prestigious political figures take sides in such an issue, it would seem that the decision to grant the Millau project to Foster will stand. It may be suspected that hostility to Sir Norman Foster in this instance has more to do with the fact that he is English, than with any reasoned consideration of his project, which is the result of the solution favored by the French Roads Department (AIOA) and the engineers associated with the project, Sogelerg, FFG and SERF. The public works magazine *Le Moniteur* went so far as to openly take position in a revealing way. "Far be it from us to deny the talent usually displayed by the winner of this competition, the Englishman Sir Norman Foster," writes *Le Moniteur*. "Far be it from us, in the midst of the construction of the European Community to argue that preference should be given to French candidates, even if the architectural profession in this country is in a state of severe depression. Couldn't it be imagined though, that French architects might one day receive such commissions in Italy, England or Spain?"[17]

Foster's own commentary on this project, made before the controversy reached the French press, has to do with just why it is important for him, as an architect, to design a bridge, usually a domain left to engineers. "It is why some things which appear to be very simple, look better than others, whether it be aircraft, or bridges. You don't have to be an architect to have an eye, and I know lots of architects who don't have an eye. When you see a bridge that really sings, then you can be sure that that engineer had an eye. When you see one aircraft which is more remarkable than another, the same is true. They are all obeying the laws of nature. There are a whole series of visual options which permit one to achieve an optimal engineering solution, whether it is in designing a building, a bridge or an aircraft. You are making a choice. You are using an eye."[18]

In Pursuit of the Ultimate
Sir Norman Foster's interest in very large projects should not be given disproportionate attention; in-

Railway Station (1995–97) beschäftigt. Indem er den in den 70er Jahren entstandenen Bahnhof, Bindeglied zum Festland, auf der Ostseite durch eine Überdachung in Leichtbauweise vergrößert, verdoppelt Foster die Ausmaße des Gebäudes und verbessert den Verkehrsfluß. Die statistischen Zahlen des Projekts: Das 45 000 m² große Gebäude ist für 80 Millionen Fahrgäste pro Jahr konzipiert, was 160 000 Reisenden pro Tag oder – in Stoßzeiten – 23 000 Menschen pro Stunde entspricht.

Allem Anschein nach versetzt Sir Norman Fosters persönliches Interesse an Technologie und besonders am Flugzeugbau, ihn in die Lage, die gigantischen Projekte zu meistern, die den Maßstäben der aufstrebenden asiatischen Wirtschaftsnationen entsprechen. Sein Ruf, Aufträge pünktlich und im Rahmen des vorgegebenen Budgets fertigzustellen, spielt ebenfalls eine wichtige Rolle und dürfte auch die Jury eines vor kurzem ausgeschriebenen Wettbewerbs in Frankreich bewogen haben, seinem Büro den Zuschlag zu erteilen. Dabei entspricht der geplante Grand Viaduc de Millau in seinen Ausmaßen durchaus Fosters asiatischen Bauprojekten. Die in sieben Abschnitte eingeteilte Mehrfeld-Schrägseilbrücke soll für den Bau der A75 zwischen Clermont-Ferrand und Béziers eine Lücke von 2 460 m Länge überspannen. Auf Pfeilern von 75 bis 235 m Höhe wird die Autobahn in einer Höhe von 275 m den kleinen Fluß Tarn im darunterliegenden Tal überqueren. Fosters Büro weist in seiner Projektbeschreibung stolz darauf hin, daß das höchste Gebäude Europas, die ebenfalls von Foster erbaute Commerzbank in Frankfurt, unter der Spannweite des Viadukts Platz finden würde.

Dennoch scheint nicht jeder davon überzeugt zu sein, daß Fosters Entwurf »eine aufsehenerregende Silhouette gegen den Himmel und eine elegante, straffe Konstruktion« darstellt, die »mühelos das Tal überspannt«, wie die Beschreibung seines Büros lautet. Der ehemalige französische Staatspräsident Valéry Giscard d'Estaing ging soweit, seinem Nachfolger Jacques Chirac zu schreiben: »Dieses Projekt erweckt die ernsthaftesten Bedenken, weshalb ich Sie bitten muß, die ganze Angelegenheit so bald wie möglich noch einmal zu überdenken... Der für Millau vorgesehene Entwurf gehört zur Familie der Schrägseil-Brückenkonstruktionen, die häufig an Hafeneinfahrten oder Flußmündungen errichtet werden... Eine Brücke, die in derart großer Höhe ein Tal überspannt, sollte ein weniger undurchsichtiges Profil besitzen, da sie sich sonst bedrückend auf die umliegende Landschaft auswirkt.«[16] Obwohl nichts unmöglich ist, wenn ange-

entre la fermeture de l'aéroport actuel et l'ouverture du nouveau.»[14] Selon la description du nouveau terminal publiée par l'agence de Foster: «l'aéroport est construit à Chek Lap Kok, une île, en grande partie artificielle, longue de 6 km et large de 3,5 km. Le terminal aura 1,5 km de long et le hall à bagages, à lui seul, aura la taille du stade de Wembley, à Londres. À l'intérieur du terminal, tous les passagers qui arrivent ou partent, se trouvent séparés selon les niveaux. Les mouvements s'organisent du fait que toutes les connections terrestres s'effectuent à l'est et les aériennes à l'ouest. Tous les passagers entrent ou sortent de l'aérogare par un atrium, vaste hall d'entrée dont la base sert de lieu de rencontre et d'accueil pour les arrivées, tandis que les passagers en partance passent au-dessus, sur des ponts en verre. Après l'enregistrement, les voyageurs traversent le contrôle d'immigration et de sécurité le long d'un grand hall en forme d''Y', à partir duquel toutes les portes d'embarquement sont accessibles à pied ou par le train intérieur. La structure en béton supporte une série de 36 coquilles en acier léger, reliées pour former une voûte continue en berceau qui court d'est en ouest, et oriente le flux des passagers. Le toit couvre le bâtiment comme un manteau qui enserre ses contours et unifie ses diverses fonctions, tout en préservant l'identité symbolique de la construction.»[15]'

La présence de Sir Norman Foster à Hong Kong ne se limite pas au siège social de la Hongkong and Shanghai Bank ou au nouvel aéroport. Elle se retrouve dans l'extension et la réorganisation de la gare de chemins de fer de KCRC Kowloon (1995–97). En élargissant la gare qui existait depuis le milieu des années 70 et qui sert de liaison entre la terre ferme à l'est et une nouvelle structure de pavillons légers, Foster double la taille de l'installation originale et améliore l'écoulement du trafic. Une fois encore, les chiffres du projet, sont impressionnants. Le bâtiment de 45 000 m² accueillera, par an, 80 millions de passagers, soit 160 000 par jour, avec des pointes de 23 000 passagers à l'heure.

Il semblerait que l'intérêt personnel de Sir Norman pour la technologie, en particulier celle du vol à voile, lui permette de maîtriser des projets conçus à l'échelle nouvelle, gargantuesque, des économies en pleine expansion de l'Extrême Orient. Sa réputation – terminer ses travaux dans les temps et selon le budget – est aussi un facteur qui peut avoir fait pencher le jury en faveur de son agence, au cours d'une récente compétition, cette fois en France. Néanmoins, ce nouveau grand via-

Page 42: Commerzbank Headquarters, Frankfurt am Main, Germany, 1994–97. Designed for one of Germany's "Big Three" private sector banks, this new tower is the tallest office building in Europe (298.74 meters with its aerial) and will house 2,400 staff.

Seite 42: Zentrale der Commerzbank, Frankfurt am Main, Deutschland, 1994–97. Der für eine der drei größten deutschen Privatbanken entworfene Turm ist mit einer Höhe von 298,74 m (inklusive Antenne) das höchste Bürogebäude Europas und bietet Platz für 2 400 Mitarbeiter.

Page 42: Siège social de la Commerzbank, Francfort sur-le-Main, Allemagne, 1994–97. Conçue pour l'une des trois grandes banques allemandes du secteur privé, cette nouvelle tour est l'immeuble de bureaux le plus haut d'Europe (298,74 m avec son antenne). Elle accueillera 2 400 employés.

deed, he insists on the fact that his office continues to undertake modest commissions. And yet, quite naturally, the press, both professional and sometimes economic or political, have focused on his large commissions because they challenge some of the underlying assumptions about the city or about the presence of the large corporation in an urban environment. Norman Foster, unlike some other contemporary architects, clearly does not feel that the very tall building is a thing of the past. His most spectacular venture to date into the domain of the skyscraper is his proposed Millennium Tower for Tokyo (1989). No less than 840 meters high, which is to say almost twice the size of the Sears Tower in Chicago, the Millennium Tower would have been 170 stories high. Again, the office description of the project reveals some of its underlying assumptions. "Rising out of Tokyo Bay, 2 kilometers offshore, the tower will be a miniature vertical township, similar in size to Tokyo's Ginza, or New York's Fifth Avenue, embracing not only office space but hotels, shops and residential apartments. The building is conceived as a huge needle, bound in a helical steel cage, rising out of a marina. It will be linked to the mainland by road and rail. The primary circulation route, up the tower, will be by means of a vertical 'metro' of giant lift cars, capable of carrying 160 people at a time. These will stop at sky centers every 30 floors, and visitors will complete their journey by high-speed lifts. The tower is conceived as a place of work, manufacture, leisure and habitation. It offers a technological solution to human and social challenges, which are liable to become more and more pressing in the world's most densely crowded conurbations."[19] As this description makes clear, Norman Foster's idea in designing the Millennium Tower goes beyond the issue of office space and corporate symbolism. When asked if such a tower does not inevitably create traffic problems in an already crowded city, he responds, "That is absolutely untrue. If you take a city like Copenhagen, which has about the same population as Detroit, it is a much more compact city. Its energy consumption is one-tenth that of Detroit, but it is still a flat city with people commuting to and fro. The tower doesn't generate traffic. It takes away traffic and roads because the people who live and work there travel by elevator. They don't take the road..." This naturally assumes that people would actually live and work in the same tower. "Yes, but it's a vertical city," responds Foster. "They live there, and they work there. That is the essence of it. Not having commuting is designing out a road system. You are creating a new

sehene Politiker in solchen Fragen deutlich Stellung beziehen, scheint sich an der Vergabe des Millau-Auftrags an Foster nichts zu ändern. Dabei könnte man annehmen, daß die ablehnende Haltung gegenüber Norman Foster mehr mit der Tatsache zusammenhängt, daß er Engländer ist, als mit begründeten Zweifeln an seinem Entwurf, der das Ergebnis einer vom französischen Straßenbauamt (AIOA) und den beteiligten Ingenieurbüros Sogelerg, FFG und SERF bevorzugten Lösung darstellt. »Le Moniteur«, ein Magazin für öffentliche Bauten, bezog auf bezeichnende Weise öffentlich Stellung: »Es sei fern von uns, das Talent anzuzweifeln, das der Gewinner dieser Ausschreibung, der Engländer Sir Norman Foster, im allgemeinen an den Tag legt«, schrieb »Le Moniteur«. »Ebenso sei es fern von uns, in Zeiten der Europäischen Gemeinschaft zu verlangen, daß einem französischen Kandidaten der Vorzug gegeben wird, selbst wenn sich der Berufsstand des Architekten in diesem Land in einem Zustand schwerer Depression befindet. Aber ist es wirklich vorstellbar, daß französische Architekten eines Tages derartige Aufträge in Italien, England oder Spanien erhalten werden?«[17]

Fosters eigener Kommentar zu diesem Projekt – der abgegeben wurde, bevor die Kontroverse durch die französische Presse ging – zeigt, wie wichtig es für ihn als Architekten ist, eine Brücke zu entwerfen, die im allgemeinen in den Bereich der Ingenieurtechnik fällt: »Manche Dinge, die auf den ersten Blick sehr schlicht erscheinen, sehen besser aus als andere – dies gilt für Flugzeuge ebenso wie für Brücken. Man muß kein Architekt sein, um dafür ein gutes Auge zu haben, und ich kenne eine Menge Architekten, die kein gutes Auge besitzen. Wenn man eine wirklich schwungvolle Brücke sieht, kann man sicher sein, daß der Ingenieur dieses Auge hatte; das gleiche gilt für ein besonders attraktiv geformtes Flugzeug. Und sie alle folgen den Gesetzen der Natur. Es gibt eine ganze Reihe visueller Möglichkeiten, die eine optimale technische Lösung erlauben – unabhängig davon, ob es sich um ein Gebäude, eine Brücke oder ein Flugzeug handelt. Man trifft seine Wahl. Man benutzt das Auge.«[18]

Streben nach Höherem

Ungeachtet der bisher vorgestellten Entwürfe sollte man Fosters Interesse an Großprojekten nicht überproportional viel Aufmerksamkeit schenken – und auch er selbst weist immer wieder darauf hin, daß sein Büro nie aufgehört hat, sich mit relativ bescheidenen Aufträgen zu beschäftigen. Dabei ist es

duc de Millau est d'une échelle comparable à celle des commandes» asiatiques de l'architecte. Sa structure multi-haubanée, suspendue par des câbles, en sept sections, est destinée à enjamber une vallée de 2 460 m sur l'autoroute A75, qui relie Clermont-Ferrand à Béziers. Avec des pylônes mesurant entre 75 et 235 m de haut, le tablier routier passera à 275 m au-dessus du modeste Tarn qui coule dans la vallée. La description du projet par l'agence insiste fièrement sur le fait que le plus haut immeuble d'Europe, à savoir la Commerzbank de Francfort due à Foster lui-même, pourrait être logée sous le viaduc.

Toutefois, l'unanimité ne semble pas se faire autour de l'idée que ce projet s'inscrira telle «une silhouette spectaculaire contre le ciel, structure élégante et tendue, franchissant la vallée sans le moindre effort», selon les termes de sa propre description. Valéry Giscard d'Estaing, l'ancien Président français, est même allé jusqu'à écrire à son successeur Jacques Chirac pour lui demander de réexaminer sa décision. Il estime en effet que le projet appartient à la famille des ponts haubanés, construits pour les entrées de ports ou les estuaires de fleuves ... Selon lui, pour un ouvrage situé à grande hauteur, on doit rechercher un profil moins opaque et moins oppressant pour le paysage.[16] Quoique rien ne soit impossible quand des personnalités politiques prestigieuses prennent parti sur de telles questions, il semble que la décision de concéder le projet de Millau à Foster ne sera pas remise en cause. On peut aussi penser que, dans ce cas précis, l'hostilité à l'égard de Sir Norman Foster soit davantage liée au fait qu'il est anglais qu'à une réflexion raisonnable sur son projet. En effet, celui-ci était le résultat de la solution approuvée par le Ministère français de l'Équipement, ainsi que des ingénieurs associés au projet, Sogelerg, FFG et SERF. La revue «Le Moniteur» est allée jusqu'à prendre ouvertement position, de manière pour le moins révélatrice: «Loin de nous l'idée de nier le talent dont fait généralement preuve le lauréat, le Britannique Sir Norman Foster. Loin de nous, à l'heure de l'Europe, d'avancer le moindre argument de préférence nationale, même si la profession d'architecte est, en France, sinistrée. Ne pourrait-on, en revanche, imaginer, au nom de cette même Europe, qu'un cabinet français se voit ouvrir aussi généreusement les frontières de l'architecture anglaise, italienne ou espagnole, un jour prochain?»[17]

Sur ce projet, le commentaire personnel de Foster – établi avant la controverse provoquée par

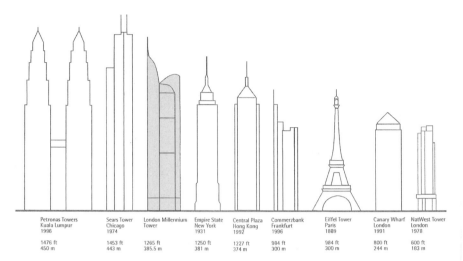

Petronas Towers Kuala Lumpur 1996	Sears Tower Chicago 1974	London Millennium Tower	Empire State New York 1931	Central Plaza Hong Kong 1992	Commerzbank Frankfurt 1996	Eiffel Tower Paris 1889	Canary Wharf London 1991	NatWest Tower London 1978
1476 ft 450 m	1453 ft 443 m	1265 ft 385.5 m	1250 ft 381 m	1227 ft 374 m	984 ft 300 m	984 ft 300 m	800 ft 244 m	600 ft 183 m

settlement... and in the growth of cities that is not an unreasonable assumption to make." Foster admits that others, such as the Japanese architect Hiroshi Hara, have advanced such ideas in recent years, but as he says, " I am not suggesting that the idea is original at all. I think that this idea has its roots in the medieval village or in Renaissance times, where you didn't separate the process of working from living. You could argue that that separation and the zoning of residential areas has in part come about because industry was traditionally a blighting influence, which pushed the two apart."

Norman Foster insists on the cultural differences that currently separate the Asian and Western points of view, but as usual he has a very personal take on this issue. When asked if an enormous tower like the Millennium project could be built anywhere, he responds, "In a way I could not imagine a European society embracing with such extraordinary appetite some of the ideas we've talked about. In Europe, for example, virtually everybody agrees that we must bring in more bicycles, and fewer cars. A city like Shanghai has very different priorities. They have millions of bicycles, and they want very badly to trade them for cars. What is the culture of a city like Shanghai? If you said that they should preserve or build on some of their local traditions, I think that you would be laughed out of court. Cultural differences are on the contrary an extraordinary force for absorbing some of the things that have happened in the West. To suggest that Asia should be denied what was long seen as progress in the West, would be almost impossible to achieve. Is the culture of Hong Kong to dare to do some of the things we may have talked about here, but have never had the courage to do, like creating buildings and engineering structures on a scale which is mind-boggling to a Western mind? They are developing larger versions of models which have originated here."[20]

While emphasizing the differences that underlie current attitudes in Asia or Europe, Norman Foster has gone forward with two projects, in different stages of development, which call into question the viability of the very tall building in the West. His Commerzbank Headquarters (Frankfurt am Main, Germany, 1994–97) is a triangular plan structure, reaching up 298.74 meters with its aerial, currently the highest office building in Europe. "How do you reconcile work and nature within the compass of one office building?" asks Foster. "The design of Willis Faber with its turfed roof-top garden, for example, was an early attempt at bringing the park

nur natürlich, daß sich die Presse – sowohl die Fachpresse als auch Wirtschaftszeitungen und politische Magazine – mehr auf seine Großaufträge konzentriert, da diese einige grundlegende Vorstellungen über die Stadt und über die Präsenz einer Großfirma innerhalb einer urbanen Umgebung in Frage stellen. Im Gegensatz zu vielen anderen zeitgenössischen Architekten vertritt Foster nicht die Meinung, daß sehr hohe Gebäude der Vergangenheit angehören. Sein bisher aufsehenerregendstes Vorhaben im Bereich der Wolkenkratzer ist sein Entwurf für den Millennium Tower in Tokio (1989). Mit einer Höhe von 840 m – was der doppelten Höhe des Sears Tower in Chicago entsprechen würde – sollte der Millennium Tower 170 Geschossen Platz bieten. Auch in diesem Fall offenbart die Projektbeschreibung des Büros einige von Fosters grundlegenden Vorstellungen: »Der Turm, der sich zwei Kilometer vor der Küste aus der Bucht von Tokio erheben soll, ist wie ein vertikales Stadtviertel konzipiert, das in seiner Größe etwa der Tokioter Ginza oder der New Yorker Fifth Avenue entspricht und nicht nur Büroräume, sondern auch Hotels, Geschäfte und Apartmentwohnungen umfaßt. Das Gebäude wurde wie eine riesige, von einem spiralförmigen Stahlkäfig umgebene Nadel entworfen, an deren Fuß ein ringförmiger Yachthafen entstehen soll. Der Millennium Tower wird über Land- und Wasserwege mit dem Festland verbunden sein. Die wichtigste Zugangsroute – in den Tower hinauf – soll durch eine vertikale ›Metro‹ aus großen Liftwagen mit einem Fassungsvermögen von 160 Personen erreichbar sein. Diese Wagen werden alle 30 Stockwerke an sogenannten ›Sky Centers‹ halten, von denen aus die Besucher mit Hochgeschwindigkeitsaufzügen in die dazwischen liegenden Etagen fahren. Der Millennium Tower wurde als Arbeits-, Herstellungs-, Freizeit- und Wohnzentrum konzipiert; er bietet eine technische Lösung für viele menschliche und soziale Probleme, die in einer Zeit der ständig dichter bevölkerten Ballungsräume immer größer werden.«[19] Fosters Ideen gingen beim Entwurf des Millennium Tower weit über die Fragen nach Büroraum und Firmensymbolik hinaus. Auf die Frage, ob ein solcher Turm in einer übervölkerten Stadt nicht unweigerlich für zusätzliche Verkehrsprobleme sorge, antwortet er: »Das ist absolut falsch. Wer eine Stadt wie Kopenhagen betrachtet, deren Einwohnerzahl in etwa der von Detroit entspricht, stellt fest, daß sie sehr kompakt wirkt. Kopenhagens Energieverbrauch ist etwa zehnmal geringer als der von Detroit, aber es handelt sich immer noch um eine flache Stadt mit star-

la presse française – met en évidence surtout la raison pour laquelle il est important pour lui, en tant qu'architecte, de dessiner un pont, domaine habituellement réservé aux ingénieurs. «Certaines choses apparaissent très simples et ont l'air plus belles que d'autres, comme un avion, ou un pont. Il n'est pas nécessaire d'être architecte pour avoir l'œil, et je connais beaucoup d'architectes qui ne l'ont pas. Quand on voit un pont d'une certaine élégance, alors on peut être sûr que cet ingénieur a un œil d'architecte. Quand on voit un avion qui est plus remarquable qu'un autre, il en est de même. Ils obéissent tous deux aux lois de la nature. Il existe toutefois une série d'options visuelles qui permettent de parvenir à une solution technique optimale, que ce soit dans la conception d'un immeuble, d'un pont ou d'un avion. Il y a un choix à faire. Mai il faut avoir ce fameux œil.»[18]

En quête d'absolu

Il ne faudrait pas accorder une importance démesurée à l'intérêt de Sir Norman Foster pour de très grands projets. En effet, il insiste sur le fait que son agence continue à se charger de commandes modestes. Pourtant, et tout à fait naturellement, la presse, aussi bien professionnelle que, parfois, économique ou politique, focalise sur ses grandes commandes parce qu'elles remettent en question certaines hypothèses de base sur la ville ou sur la présence de grandes entreprises dans l'environnement urbain. Contrairement à d'autres architectes contemporains, Norman Foster ne pense pas vraiment que la tour appartient au passé. Dans le domaine du gratte-ciel, son dessin le plus spectaculaire à ce jour demeure sa Millennium Tower, projetée pour Tokyo (1989). Avec pas moins de 840 m de haut, c'est-à-dire presque le double de la Sears Tower de Chicago, la Millennium Tower comporterait 170 étages. L'agence propose une description du projet qui révèle quelques-unes de ses idées de base: «S'élevant de la Baie de Tokyo, à 2 km au large, la tour sera une ville verticale miniaturisée. Semblable par sa taille au Ginza de Tokyo ou à la Fifth Avenue à New York, elle ne contiendra pas seulement des bureaux, mais aussi des hôtels, des boutiques et des appartements résidentiels. Le bâtiment est conçu comme une gigantesque aiguille, insérée dans une cage d'acier hélicoïdale, s'élevant de la marina. Il sera relié à la terre ferme par la route et par le rail. L'accès principal à la tour sera constitué par un ‹métro› vertical avec des ascenseurs géants capables de transporter 160 personnes à la fois. Il s'arrêtera à des plates-formes

Page 46: Profiles of the world's tallest buildings place the London Millennium Tower between the Sears Tower in Chicago and the Empire State Building in New York.

Seite 46: Ein Vergleich der höchsten Gebäude der Welt plaziert den Londoner Millennium Tower zwischen den Sears Tower in Chicago und das Empire State Building in New York.

Page 46: Les tours les plus hautes du monde. La Millennium Tower de Londres se situe entre la Sears Tower de Chicago et l'Empire State Building de New York.

into the office, and one of the office's regrets is that the 'gardens in the sky' planned for the Hong Kong Bank failed to materialize. The competition-winning scheme for the Commerzbank, Frankfurt... is the world's first ecological high-rise tower resulting from close cooperation with the Bank and the City Planners... Four-story high gardens spiral around the triangular plan form, giving each desk a view of greenery and eliminating large expanses of unbroken office space. Every office is designed to have natural ventilation with opening windows. Lifts, staircases and services are placed in the three corners in groups designed to reinforce the village-like clusters of offices and gardens. The fifty-three story tower, just over 300 meters high, rises from the center of the city block alongside the existing Commerzbank building. By rebuilding and restoring the perimeter edge buildings, the scale of the neighborhood is preserved."[21] Though it might be argued that Foster's description caters to a clientele and a critique likely to look first at the environmental impact of a tall building, it is also clear that a real interest in ecology and in making the typology of the skyscraper evolve are expressed here.

Although Norman Foster considers that the Tokyo Millennium Tower may still be built in some form, his London Millennium Tower, which is unrelated except in name and insofar as it too is a tall building, seems closer to realization. This ninety-two-story office tower on the site of the Baltic Exchange, which was severely damaged by an IRA bomb in 1992, would offer a public viewing platform at 1,000 feet, symbolizing the expected year of completion, 2000. About 20% of the half-hectare site would be given over to a new public plaza, and the tower itself would be mixed use, with shops, restaurants, cafés, offices, trading floors and residential units. At 385 meters without its mast, the Millennium Tower would be higher than the Empire State Building (381 meters), but not quite as massive as the new Petronas Twin Towers in Kuala Lumpur (452 meters). Designed for Trafalgar House Property Limited, which is owned by the Norwegian construction and engineering firm Kvaerner ASA, the London Millennium Tower would, according to Foster, be "a statement of confidence in the City for the next century." As Norman Foster declared, "Tall buildings are expressions of the energy and aspirations of world class modern cities."[22] As might be expected, the press and other commentators were not universally favorable to the Foster scheme. In an editorial published on September 10, 1996 under the title "The height of

kem Pendlerverkehr. Der Tower erzeugt keinen zusätzlichen Verkehr; er entlastet den Verkehr und die Straßen, weil die Menschen, die in ihm leben und arbeiten, mit dem Fahrstuhl reisen. Sie benutzen keine Straßen...« Das setzt natürlich voraus, daß die Menschen wirklich im selben Turm leben und arbeiten. »Ja, aber es handelt sich auch um eine vertikale Stadt«, antwortet Foster. »Sie leben dort, und sie arbeiten dort. Das ist das Wesentliche daran. Wenn man nicht pendeln muß, benötigt man auch kein Straßennetz. Man kann so neue Ansiedlungen schaffen... und bei dem Wachstum der heutigen Städte ist das keine unvernünftige Vorstellung.« Foster gibt zu, daß andere, wie der japanische Architekt Hiroshi Hara, in den letzten Jahren ähnliche Konzepte entwickelt haben, aber er sagt auch: »Ich behaupte nicht, daß meine Idee besonders originell ist. Meiner Ansicht nach stammen die Ursprünge dieser Idee von den mittelalterlichen Dörfern oder aus der Renaissance, wo man Wohnen und Arbeiten auch nicht voneinander trennte. Man könnte sagen, daß diese Trennung und die Einteilung von Wohnbezirken zum Teil deshalb entstand, weil der schädliche Einfluß der Industrialisierung die beiden Bereiche auseinander drängte.«

Norman Foster hebt die kulturellen Unterschiede hervor, die zur Zeit die asiatischen und westlichen Auffassungen voneinander trennen, aber wie üblich nimmt er auch zu diesem Thema einen sehr persönlichen Standpunkt ein. Auf die Frage, ob ein enormes Projekt wie der Millennium Tower auch an anderen Orten entstehen könnte, antwortet er: »Ich kann mir keine europäische Gesellschaft vorstellen, die die von uns angesprochenen Ideen mit derart großer Begierde aufnehmen würde. In Europa stimmt fast jeder darin überein, daß in unseren Städten weniger Autos und mehr Fahrräder fahren müßten. Eine Stadt wie Shanghai setzt dagegen ganz andere Prioritäten: Dort hat man Millionen Fahrräder, die man lieber heute als morgen gegen Autos eintauschen würde. Worin besteht die Kultur einer Stadt wie Shanghai? Wenn man dort vorschlägt, Gebäude zu restaurieren oder im Rahmen der lokalen Traditionen zu bauen, wird man aus dem Saal gelacht. Kulturelle Unterschiede stellen im Gegenteil eine außergewöhnliche Kraft dar, mit der sich einige westliche Errungenschaften absorbieren lassen. Es ist unmöglich, Asien all die Dinge zu verweigern, die im Westen lange als Fortschritt betrachtet wurden. Vielleicht besteht die Kultur einer Stadt wie Hongkong darin, Dinge zu tun, über die wir hier zwar gesprochen haben, für die wir aber nie genügend Mut aufbrachten – wie den

tous les 30 étages d'où l'on pourra monter encore plus haut grâce à d'autres ascenseurs à grande vitesse. La tour est conçue comme un lieu de travail, de production, de loisirs et d'habitation. Elle offre une solution technologique aux défis humains et sociaux qui risquent de devenir de plus en plus stressants dans les villes les plus peuplées du monde.»[19] Comme le montre clairement cette description, dans sa conception de la Millennium Tower, Norman Foster dépasse la question de l'espace de bureau ou du symbolisme de l'entreprise. Quand on lui demande si ce genre de tour n'engendre pas inévitablement des encombrements de circulation dans une ville déjà engorgée, il rétorque: «C'est absolument faux. Si vous prenez une ville comme Copenhague qui a environ la même population, la tour est beaucoup plus compacte. Sa consommation en énergie est dix fois moins élevée que celle de Detroit, mais c'est une ville basse, étendue, avec des banlieusards qui se déplacent. Ce n'est pas la tour qui génère la circulation. Elle la réduit, ainsi que le nombre de routes parce que les gens qui vivent et travaillent ici se déplacent en ascenseur. Ils ne prennent pas la route…» En fait, cela suppose que les gens vivent et travaillent dans la tour? «Oui, mais c'est une cité verticale», répond Foster. «Ils vivent là, donc ils travaillent là. Cela constitue l'essence même du projet. Ne pas devoir faire venir les gens de la banlieue, c'est ne plus avoir à concevoir un système routier. Il s'agit de créer un nouveau lieu de vie… et compte tenu de la croissance urbaine, ce n'est pas une hypothèse déraisonnable.» Foster admet que d'autres, comme l'architecte japonais Hiroshi Hara, ont dans les années récentes avancé de telles idées, mais il précise: «Je ne prétends en rien que l'idée soit originale. Je pense qu'elle prend ses racines dans le village médiéval ou à la Renaissance, époques où l'on ne séparait pas le lieu de travail et celui d'habitation. On peut dire aussi que cette séparation et le zonage en quartiers résidentiels se sont produits en partie parce que les premières industries détruisaient beaucoup les paysages.»

Norman Foster insiste sur les différences culturelles qui séparent les points de vue asiatiques et occidentaux. Mais, comme d'habitude, il a un point de vue très personnel sur cette question. Quand on lui demande si une tour énorme, comme le projet du Millennium, pourrait être construite n'importe où, il répond: «Dans un sens je ne peux pas imaginer une société européenne qui fasse sienne, avec un tel appétit, certaines des idées dont nous avons parlé. En Europe, par exemple, on peut dire que

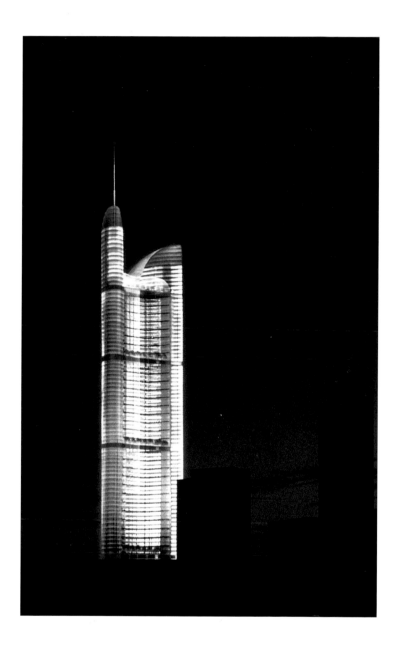

folly," *The Daily Telegraph* wrote, "Follies may be out of fashion, architecturally speaking; folly, as a vice, is clearly not. That is the only conclusion that can be drawn from yesterday's unveiling of Sir Norman Foster's design for the ninety-two-story Millennium Tower in the City of London... it exemplifies the most traditional of human frailties – hubris."[23]

As Sir Norman Foster reaches upward and outward with his numerous projects, it is apparent that his success is the result not of a media-inspired fashion, but rather of a solid analysis of the opportunities offered by each new site. Rather than settling for a repetitive style-driven design, he has consistently sought with his large office to challenge assumptions about such questions as office design, and environmental impact, while seeking out materials that offer the fullest possibilities of contemporary construction technology. As he says himself, he is far from considering appearance a secondary matter, but he feels that the visible aspects of a building should be informed by its inner workings, by the facts of its existence, which naturally include any existing architectural environment. His theories relating to the development of a kind of vertical city, where large numbers of people live and work within the same massive structure, may strike some as utopian or, conversely, fraught with negative implications. And yet, as much as any architect currently working, Sir Norman Foster has done a great deal to broaden the appeal of an architecture of indisputable quality. A Foster building quite obviously offers more than a pretty facade, or a "crisp curve" as one critic has it, and this fact places him in the forefront of an effort to redefine the fundamental goals of contemporary architecture. A modernity capable of integrating itself into the historically rich environment of a city like Nîmes, or of facing the challenges of the largest airport in the world, rising from an artificial island in the South China Sea, is certainly one that deserves attention. Beyond the style wars fought out in the pages of architectural magazines, Norman Foster brings hope that by focusing on the real issues of cost, ecology or urban organization, and by combining these factors with what he calls the architect's "eye," it is possible to make buildings that are better than those of the past. This may be the most important legacy of the Foster method.

1 Interview with Sir Norman Foster, London, June 13, 1996.
2 Ibid.
3 Ibid.
4 Interview with Sir Norman Foster, London, June 13, 1996.
5 1980 "Museum of the Year" Award
 1980 Ambrose Congreve Award
 1980 6th International Prize for Architecture, Brussels
 1979 British Tourist Board Award
 1979 R.S. Reynolds Memorial Award
 1978 Structural Steel Finniston Award
 1978 Royal Institute of British Architects Award
6 Interview with Sir Norman Foster, Southern France, July 21, 1996.
7 Ibid.
8 Ibid.
9 Interview with Sir Norman Foster, London, June 13, 1996.
10 "Foster, Inc.", *Blueprint*, October 1994 ,
11 Interview with Sir Norman Foster, London, June 13, 1996.
12 Fax from Sir Norman Foster, November 1, 1996.
13 Ibid.
14 Interview with Sir Norman Foster, Southern France, July 21, 1996.
15 Text copied on the Foster and Partners Internet site:
 http://www.archinet.co.uk/fosterandpartners/main.html
16 "Viaduc de Millau: Giscard écrit à Chirac." *Le Figaro*, August 18, 1996.
 "Ce projet me paraît appeler les plus graves réserves, c'est pourquoi je
 me permets de vous saisir de cette question en vous demandant de
 réexaminer cette décision... Or le projet envisagé pour Millau appar-
 tient à la famille des ponts haubanés, construits pour les entrées de
 ports ou les estuaires des fleuves ... Lorsqu'il s'agit, par contre, d'un
 ouvrage situé à grande hauteur, on doit rechercher un profil moins
 opaque et moins oppressant pour le paysage."
17 "Réciprocité", *Le Moniteur*, August 2, 1996. "Loin de nous l'idée de nier
 le talent dont fait généralement preuve le vainqueur, le Britannique Sir
 Norman Foster. Loin de nous, à l'heure de l'Europe, d'avancer le moin-
 dre argument de préférence nationale, même si la profession d'archi-
 tecte est, en France, sinistrée. Ne pourrait-on, en revanche, imaginer,
 au nom de cette même Europe, qu'un cabinet français se voit ouvrir
 aussi généreusement les frontières de l'architecture anglaise, italienne
 ou espagnole, un jour prochain?"
18 Interview with Sir Norman Foster, Southern France, July 21, 1996.
19 Text copied on the Foster and Partners Internet site:
 http://www.archinet.co.uk/fosterandpartners/main.html
20 Interview with Sir Norman Foster, Southern France, July 21, 1996.
21 Text copied on the Foster and Partners Internet site:
 http://www.archinet.co.uk/fosterandpartners/main.html
22 Louise Jury: "Sir Norman Foster's £400m dream – to build Europe's
 tallest building on a City bomb site," *The Independent*, September 10,
 1996.
23 Editorial, "The height of folly," *The Daily Telegraph*, September 10, 1996.

Bau von Gebäuden und technischen Konstruktionen in einer Größenordnung, bei der einem westlichen Gehirn schwindlig wird. Dort entwickelt man nur größere Versionen der Modelle, die wir hier geschaffen haben.»[20]

Während er die Unterschiede zwischen Asien und Europa hervorhebt, beschäftigt sich Sir Norman Foster gleichzeitig mit zwei Projekten, die sich mit der Lebensfähigkeit sehr hoher Gebäude im Westen neu auseinandersetzen. Seine Zentrale der Commerzbank (Frankfurt am Main, 1994–97), ein Entwurf mit einem dreieckigen Grundriß, ist mit einer Höhe von 298,74 m (inklusive Antenne) zur Zeit das höchste Bürogebäude Europas. »Wie kann man Arbeit und Natur in den Grenzen eines Bürogebäudes miteinander in Einklang bringen?« fragt Foster. »Das Design von Willis Faber mit seinem Dachgarten war beispielsweise ein früher Versuch, einen Park ins Büro zu bringen, und unsere Firma bedauert, daß das Konzept der für die Hong Kong Bank geplanten ›Gärten im Himmel‹ letztlich nicht umgesetzt werden konnte. Der Entwurf für die Commerzbank in Frankfurt, mit dem wir den Wettbewerb gewannen... stellt den ersten ökologischen Büroturm der Welt dar, der in enger Zusammenarbeit mit der Bank und den Stadtplanern entstand... über vier Geschosse winden sich in dem dreieckigen Grundriß Gärten, so daß man von jedem Schreibtisch aus auf Grünanlagen blickt und ununterbrochene, riesige Büroflächen vermieden werden. Jedes Büro wurde so entworfen, daß man die Fenster öffnen und es natürlich belüften kann. Aufzüge, Treppenhäuser und Versorgungsleitungen wurden in Gruppen in die drei Winkel des Gebäudes verlegt und verstärken den Eindruck dorfähnlicher Zusammenballungen von Büros und Gärten. Der 53 Stockwerke umfassende Turm von knapp 300 m Höhe erhebt sich im Stadtzentrum, unmittelbar neben dem bereits bestehenden Commerzbank-Gebäude. Durch den Neubau und die Sanierung der Gebäude rund um diesen Block wird der bauliche Zusammenhang der Umgebung bewahrt.»[21]

Obgleich Sir Norman Foster es für möglich hält, daß der Millennium Tower in Tokio in der einen oder anderen Form noch erbaut werden kann, scheint sein Londoner Millennium Tower – der bis auf den Namen und die Tatsache, daß es sich ebenfalls um ein hohes Gebäude handelt, keine Gemeinsamkeiten mit dem Tokioter Turm aufweist – näher vor der Realisierung zu stehen. Dieser 92 Stockwerke hohe Turm soll auf dem Gelände der Baltic Exchange errichtet werden, die 1992 von einer

tout le monde s'accorde à penser que nous devrions introduire plus de bicyclettes et moins d'automobiles. Une ville comme Shanghai a des priorités fort différentes. Ils ont des millions de bicyclettes, et ils désirent profondément les remplacer par des voitures. Quelle est la culture d'une ville comme Shanghai? Si vous leur dites qu'ils devraient préserver certaines de leurs traditions locales ou construire sur leurs modèles, je pense qu'on rira de vos prétentions. Là-bas, les différences culturelles sont au contraire une force extraordinaire capable d'absorber certaines choses qui se sont produites à l'Ouest. Suggérer que l'Asie devrait refuser ce qui fut longtemps considéré comme un progrès à l'Ouest, serait presque impossible. La culture de Hong Kong ne consiste-t-elle pas à oser réaliser certaines des choses dont nous avons parlé, mais que nous n'avons jamais eu le courage de faire, comme par exemple de créer des bâtiments et des structures industrielles à une échelle qui confond notre imagination d'Occidentaux? Aujourd'hui, ils développent des versions plus importantes de modèles qui sont nés ici.» [20]

Tout en mettant l'accent sur la différence entre les attitudes en Asie ou en Europe, Norman Foster travaille sur deux projets, à différents niveaux de développement, qui remettent à l'ordre du jour la question de la viabilité même de la tour en Occident. Son siège social pour la Commerzbank (Francfort-sur-le-Main, Allemagne, 1994–97) est un bâtiment à plan triangulaire, qui s'élève jusqu'à 298,74 m avec son antenne, et est actuellement l'immeuble de bureaux le plus haut d'Europe. «Comment réconcilier travail et nature à l'intérieur d'un immeuble de bureaux?» demande Foster. «Le Willis Faber, par exemple, avec son jardin gazonné sur le toit, était une première tentative pour faire entrer la nature à l'intérieur du bureau. D'ailleurs, l'un des regrets de l'agence, c'est que les ‹jardins célestes› prévus pour la Banque de Hong Kong n'aient pas pu être concrétisés. Le projet lauréat pour la Commerzbank est la première tour écologique du monde. Elle résulte d'une étroite coopération entre la banque et les urbanistes... Des jardins hauts de quatre étages montent en spirale autour du plan de base triangulaire. Ainsi, à chaque niveau le regard tombe sur de la verdure, et les successions ininterrompues de bureaux sont éliminées. Chaque bureau a une ventilation naturelle et des fenêtres qui s'ouvrent. Les ascenseurs, les cages d'escaliers et les locaux techniques sont regroupés aux trois angles pour renforcer les ensembles – type village – de bureaux et de jardins. Avec ses 53

Page 50: Carré d'Art, Nîmes, France, 1987–93. The upper level café, looking out onto the Maison Carrée.

Seite 50: Carré d'Art, Nîmes, Frankreich, 1987–93. Blick aus dem Café im oberen Stockwerk auf das Maison Carrée.

Page 50: Carré d'Art, Nîmes, France, 1987–93. Le café, au niveau le plus élevé, donne sur la Maison Carrée.

Pages 54–55: A view of the open work space in the office, taken at Riverside Three, London, in September 1995.

Seite 54–55: Ein Blick in den offenen Arbeitsraum der Firma. Haus Riverside Three, London, September 1995.

Pages 54–55: L'espace de travail ouvert à l'agence de Riverside Three, Londres, en septembre 1995.

IRA-Bombe schwer beschädigt wurde; in einer Höhe von genau 1 000 Fuß ist eine öffentliche Aussichtsplattform geplant, die das voraussichtliche Jahr der Fertigstellung (2000) symbolisiert. Etwa 20% des einen halben Hektar großen Baugeländes sind für eine neue öffentliche Plaza reserviert; der Turm selbst soll Geschäfte, Restaurants, Cafés, Büros, einen Börsensaal und Wohneinheiten enthalten. Mit einer Höhe von 385 m ohne Mast wäre der Millennium Tower höher als das Empire State Building (381 m), aber nicht ganz so gewaltig wie die Petronas Twin Towers in Kuala Lumpur (452 m). Der London Millennium Tower wurde im Auftrag der Trafalgar House Property Limited entworfen, die zum norwegischen Bau- und Ingenieurkonzern Kvaerner ASA gehört, und stellt laut Foster »einen Beweis des Vertrauens in die City für das nächste Jahrhundert« dar. Sir Norman Foster erklärt: »Hohe Gebäude sind Ausdruck der Energie und der Ambition der modernsten Städte der Welt.«[22] Wie zu erwarten war, zeigten sich die Presse und andere Kritiker von Fosters Plänen nicht ganz so begeistert. Der »Daily Telegraph« schrieb in einem Leitartikel unter dem Titel »The height of folly« (Der Gipfel der Torheit) am 10. September 1996: »Architektonische Torheiten mögen zwar aus der Mode sein, Torheit als Untugend aber ist es offensichtlich nicht. Das ist der einzige Schluß, den man aus der gestrigen Vorstellung von Sir Norman Fosters Entwurf für den 92stöckigen Millennium Tower in der Londoner City ziehen kann ... er dient als Beispiel für die typischste aller menschlichen Schwächen – Hochmut.«[23]

Während Sir Norman Foster mit seinen zahlreichen Projekten immer höher und weiter strebt, wird klar, daß sein Erfolg nicht einer von den Medien hochgespielten Modeströmung zu verdanken ist, sondern das Ergebnis einer gründlichen Analyse jedes neuen Baugeländes darstellt. Anstatt sich mit Entwürfen in einem sich wiederholenden Stil zufriedenzugeben, versuchen er und sein Büro beständig, sich kritisch mit den festgefügten Vorstellungen über Bürodesign und Umwelteinflüsse auseinanderzusetzen, während sie gleichzeitig nach Materialien suchen, die alle Möglichkeiten einer zeitgenössischen Konstruktionstechnik bieten. Wie er selbst sagt, ist Foster weit davon entfernt, das äußere Erscheinungsbild zweitrangig zu behandeln; aber er vertritt auch die Ansicht, daß die sichtbaren Aspekte eines Bauwerks auf dessen innerer Wirkungsweise und auf dessen Existenz begründet sein müssen, zu der natürlich auch jede bereits bestehende architektonische Umgebung zählt. Zwar mögen seine Theorien

étages et sa hauteur dépassant les 300 m, la tour surgit du centre urbain, près de l'ancienne Commerzbank. En reconstruisant et en rénovant les immeubles du périmètre, l'échelle du voisinage est respectée.«[21] Même si l'on peut rétorquer que la description de Foster prend en compte son client, ainsi qu'une éventuelle critique qui, vraisemblablement, s'intéresserait d'abord à l'impact d'un bâtiment si élevé sur l'environnement, on ne peut nier le réel intérêt de l'architecte pour l'écologie et sa volonté de faire évoluer la typologie du gratte-ciel.

Bien que Norman Foster pense que la Millennium Tower de Tokyo pourrait encore être construite sous une forme ou une autre, sa Millennium Tower de Londres, qui n'a avec la première d'autre rapport que le nom et sa hauteur, semble avoir plus de chances d'être réalisée. Avec ses 92 étages, cette tour de bureaux, qui remplacerait la Baltic Exchange sérieusement endommagée en 1992 par une bombe de l'IRA, offrirait une plate-forme d'observation à 1 000 pieds de haut. Elle symboliserait l'année espérée de sa construction, l'an 2000. Environ un cinquième de ce site large d'un demi-hectare serait réservé à une nouvelle esplanade, tandis que la tour serait consacrée à des activités diverses, avec boutiques, restaurants, cafés, bureaux, étages commerciaux et unités d'habitation. Avec ses 385 m sans compter son mât, la Millennium Tower serait plus haute que l'Empire State Building (381 m), sans être aussi massive que les nouvelles tours jumelles Petronas de Kuala Lumpur (452 m). Conçue pour la Trafalgar House Property Limited, propriété de la Kvaerner ASA, société norvégienne de construction et d'engineering, la Millennium Tower de Londres serait, selon Foster, un acte de foi de la City envers le XXIᵉ siècle. «Les tours de grande hauteur sont l'expression de l'énergie et des aspirations des villes modernes d'envergure internationale.»[22] Comme on pouvait s'y attendre, la presse et d'autres commentateurs n'ont pas été unanimes. Dans un éditorial publié le 10 septembre 1996 sous le titre «Les sommets de la folie», «The Daily Telegraph» écrit: «Les folies sont peut-être démodées, architecturalement parlant. La folie, en tant que vice, à l'évidence ne l'est pas. C'est la seule conclusion que l'on peut tirer du projet de Norman Foster dévoilé hier: la Millennium Tower de 92 étages dans la City de Londres. C'est l'exemple même de la plus commune des faiblesses humaines – l'arrogance.»[23]

À mesure que Sir Norman Foster progresse et confirme sa réputation, il paraît évident que sa réussite provient non pas d'une mode inspirée par

über die Entwicklung einer vertikalen Stadt, in der große Menschenmengen innerhalb eines riesigen Gebäudes leben und arbeiten, manchen als utopisch oder mit negativen Implikationen beladen erscheinen; dennoch hat Norman Foster mehr als jeder andere zur Zeit tätige Architekt dazu beigetragen, die Anziehungskraft einer Architektur von unzweifelhafter Qualität zu verbreiten. Ein Foster-Gebäude bietet mehr als nur eine hübsche Fassade – oder »flotte Flächen«, wie es ein Kritiker nannte –, und diese Tatsache plaziert ihn in die vorderste Linie einer Bewegung, die die grundlegenden Ziele der zeitgenössischen Architektur neu definieren will. Eine Modernität, die in der Lage ist, sich in einer Stadt wie Nîmes einer historisch vielfältigen Umgebung anzupassen, und die sich den Herausforderungen des größten Flughafens der Welt stellt, der im Südchinesischen Meer auf einer künstlichen Insel heranwächst, verdient unsere volle Aufmerksamkeit. Jenseits aller Stilkämpfe, die auf den Seiten der Architekturmagazine ausgefochten werden, läßt uns Sir Norman Foster darauf hoffen, daß ein Architekt durch die Konzentration seines »Auges« – wie er es nennt – auf die wahren Herausforderungen wie Kosten, Umwelt oder urbane Organisation in der Lage ist, Bauwerke zu schaffen, die besser sind als die der Vergangenheit. Dies könnte das wichtigste Vermächtnis der Foster-Methode sein.

les médias, mais plutôt d'une analyse solide des opportunités offertes par chaque nouveau site. Plutôt que de s'installer dans un style répétitif, il a constamment cherché, avec sa grande agence, à remettre en question les idées reçues en matière d'immobilier commercial et d'impact sur l'environnement. Il est constamment à la recherche des matériaux les plus performants de la technologie contemporaine. Comme il le dit lui-même, il est loin de considérer l'apparence comme secondaire. Néanmoins, il a le sentiment que l'aspect visible d'un bâtiment doit se nourrir de son énergie intrinsèque, de la substance même de son existence, qui inclut naturellement l'environnement architectural déjà existant. Ses théories sur la ville verticale réunissant lieux de travail et habitations peuvent sembler utopiques, ou inversement, inquiétantes. Cependant, Sir Norman Foster a beaucoup fait pour imposer une architecture de qualité. Une construction signée Foster offre très évidemment davantage qu'une jolie façade ou une «courbe élégante» selon l'expression d'un critique, et cela le place au premier rang de ceux qui font un effort pour redéfinir les objectifs fondamentaux de l'architecture contemporaine. Une modernité capable de s'intégrer dans le riche environnement historique d'une ville comme Nîmes ou d'affronter les défis du plus grand aéroport du monde ne peut que retenir l'attention. Dépassant les guerres de styles qui s'affrontent dans les pages des revues d'architecture, Norman Foster démontre que, en s'attachant aux véritables questions du coût, de l'environnement ou de l'organisation urbaine, et en combinant ces facteurs avec ce qu'il appelle l'«œil» de l'architecte, il est possible de réaliser des bâtiments qui sont mieux que ceux du passé. Ce pourrait être le legs le plus important de la méthode Foster.

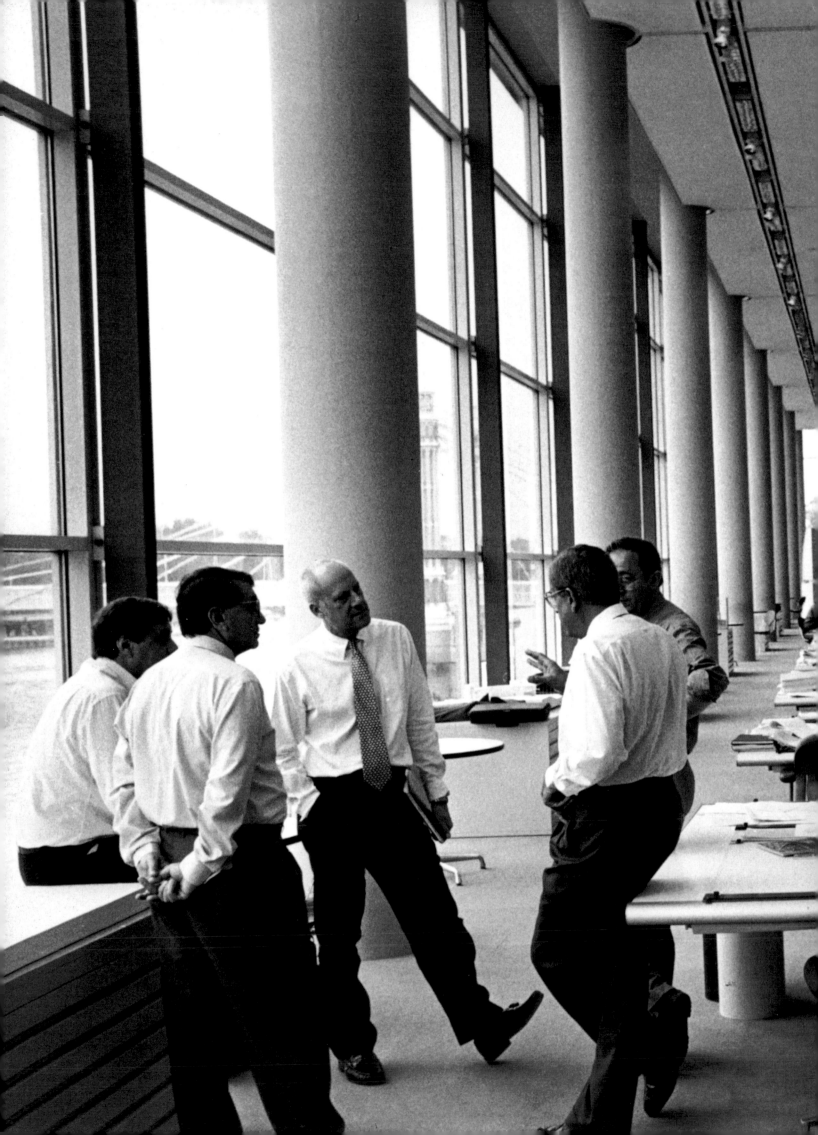

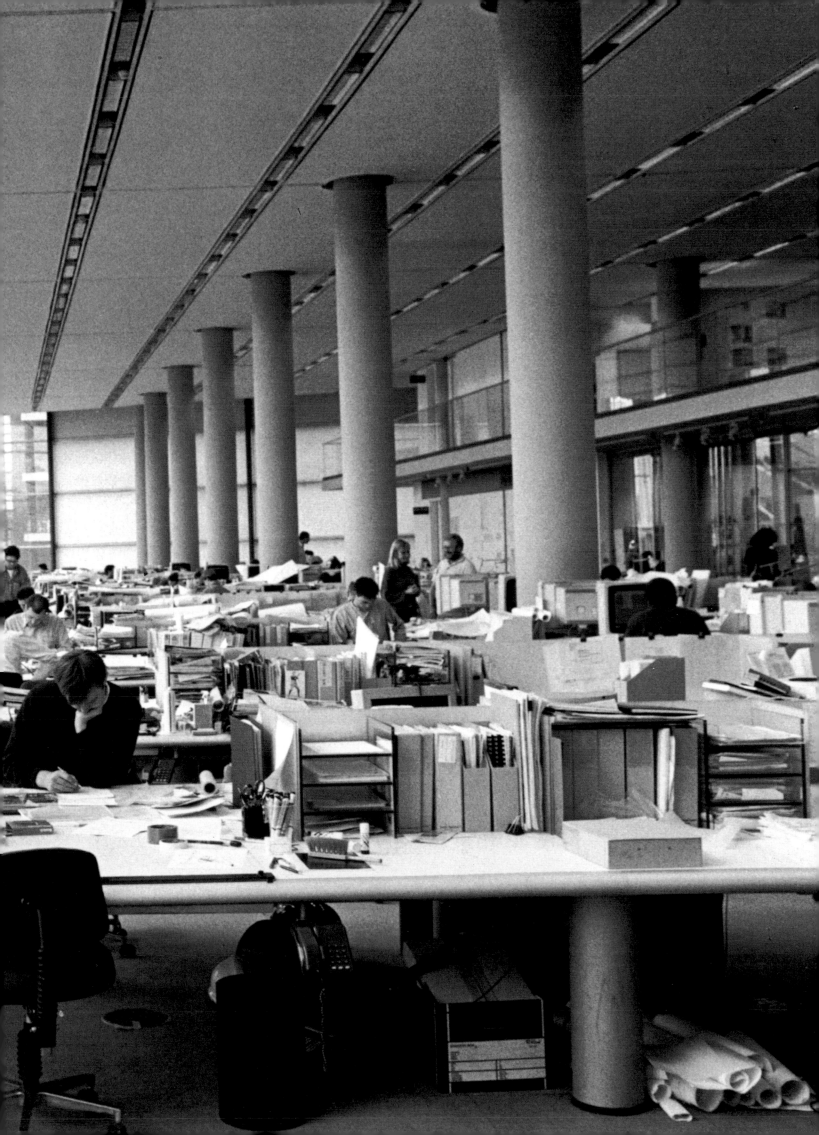

Creek Vean House

Feock, Cornwall, UK, 1964–1966

Page 56: The steps leading up to the house. The skylight above the gallery is just visible at the top of the steps to the left.
Page 57: An elevation drawing of an early scheme (above) and a cross section (right).

Seite 56: Die zum Haus führenden Stufen. Am höchsten Punkt der Treppe erkennt man auf der linken Seite einen Teil der Oberlichter der Galerie.
Seite 57: Eine Ansicht des Hauses auf einer frühen Skizze (oben) und ein Querschnitt (rechts).

Page 56: Les marches conduisant à la maison. On aperçoit en haut à gauche des marches la verrière qui éclaire la galerie.
Page 57: Élévation (en haut), projet antérieur, et coupe transversale (à droite).

One of Norman Foster's first commissions, designed with Wendy Foster and Richard Rogers, the Creek Vean House is a 350 square meter residence located on a steeply sloped site. Living spaces and the toplit picture gallery are integrated into a single continuous space through the use of sliding walls. The house, built with honey-colored concrete blocks and floors of blue Welsh slate, has a landscaped and planted roof, a feature of the later Willis Faber & Dumas offices in Ipswich. With a blank wall pierced by an entrance bridge facing the road, the Creek Vean House offers its occupants views westward to a creek, and north toward a valley. The double-height living and dining area with frameless sliding sashes, facing the Fal estuary to the south, again foreshadows many later buildings. 44 meters long, the house is in fact designed to take advantage of the views and to be in close harmony with its site.

Das zusammen mit Wendy Foster und Richard Rogers entworfene Creek Vean House zählt zu Fosters ersten Aufträgen. Das 350 m² große Wohnhaus liegt auf einem steilen Gelände, wobei die Wohnräume und die von oben belichtete Gemäldegalerie mittels Schiebewänden zu einem einzigen durchgehenden Raum geöffnet werden können. Das Haus aus honigfarbenen Betonblocksteinen besitzt Böden aus blauem walisischem Schiefer und ein der Landschaft angepaßtes, begrüntes Dach. Mit einer geschlossenen Front, die nur von der Eingangsbrücke zur Straße hin durchbrochen wird, öffnet das Creek Vean House seinen Bewohnern den Blick nach Westen auf eine Bucht und nach Norden in ein Tal. Der zweigeschossige Wohn- und Eßbereich mit den rahmenlosen Schiebefenstern – ein Kennzeichen vieler späterer Bauten – bietet die Aussicht auf die Mündung des Fal im Süden. Mit seiner Länge von 44 m ist das Haus so konzipiert, daß verschiedene Ausblicke möglich sind und es sich harmonisch in die Umgebung einpaßt.

La Creek Vean House, l'une des premières commandes de Norman Foster, conçue avec Richard Rogers, est une résidence de 350 m² située sur une pente escarpée. Les aires de séjour et la galerie de tableaux à éclairage zénithal s'intègrent dans un seul espace ininterrompu grâce à l'utilisation de cloisons coulissantes. Bâtie avec des blocs de béton d'un beige doré et des sols en ardoise bleue du Pays de Galles, la maison est surmontée d'un toit-jardin, caractéristique que l'on retrouvera dans les bureaux Willis Faber & Dumas à Ipswich. Avec un mur aveugle percé par un pont d'accès face à la route, la Creek Vean House offre à ses occupants une vue sur une crique vers l'ouest et sur une vallée au nord. L'aire de séjour et de repas avec sa double hauteur et ses ouvertures coulissantes sans châssis donne sur l'estuaire de la Fal au sud. Elle annonce déjà nombre de constructions à venir. Avec ses 44 m de long, cette résidence est, de fait, conçue pour jouir du paysage et s'inscrire en parfaite harmonie à l'intérieur de son cadre.

IBM Pilot Head Office

Cosham, Hampshire, UK, 1970–1971

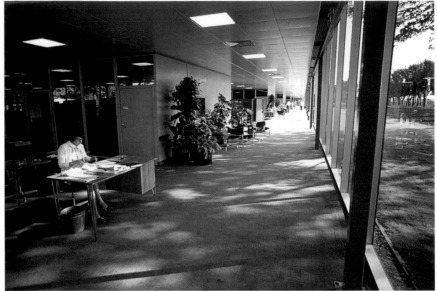

Interior and exterior views emphasize the transparency and the low-lying design of the IBM office.

Die Innen- und Außenansichten zeigen die Transparenz und die flache Gestaltung des IBM Office.

Vues intérieure et extérieure qui soulignent la transparence et la conception de faible hauteur du bureau IBM.

The challenge of this project was to show that a high-quality building could be produced at the same cost as off-the-peg temporary site huts. Winner of a 1972 RIBA Award, the IBM Pilot Head Office confirmed the reputation of Norman Foster in a low-cost project designed to accommodate 750 to 1,000 people. Measuring 10,869 square meters, or 146 meters by 73, this single-story lightweight steel frame building has a corrugated steel roof deck. By using a modular component assembly system, and locating the services in the roof, bringing the wiring down through hollow steel columns to rectangular "dice" boxes, Foster dealt not only with issues of cost, but also with those of greater flexibility within the building. Another unexpected feature of the building is that it was the first of its type to include spaces for computers, which until that time had been located in separate structures. Intended to be built in a period of 18 months, the IBM Office was completed ahead of schedule. Originally intended as a temporary building, to be used for only two years, it is still in service some 25 years later.

Die Herausforderung bei diesem Projekt bestand darin, ein Gebäude von hoher Qualität zu den gleichen Kosten zu erstellen wie eine vorgefertigte, provisorische Halle. Das IBM Pilot Head Office – Gewinner des RIBA Awards 1972 – bietet Platz für etwa 750 bis 1 000 Mitarbeiter und bestätigte den Ruf Norman Fosters als Architekt kostengünstiger Bauten. Der eingeschossige Stahlrahmenleichtbau von 146 x 73 m und einer Grundfläche von 10 869 m² besitzt ein Wellblechdach. Foster verwendete ein aus Modulen bestehendes Montagesystem und verlegte die Versorgungsleitungen in das Dach, wobei die Kabel durch stählerne Hohlsäulen in rechteckige »Würfelkästen« geführt werden. Damit hielt er nicht nur die Kosten niedrig, sondern erreichte auch größere Flexibilität im Inneren. Ein völlig neuartiges Kennzeichen des Gebäudes sind Stellplätze für Computer, die bis dahin in separaten Räumen untergebracht waren. Trotz der geplanten Bauzeit von 18 Monaten wurde das IBM Office noch früher fertiggestellt, und obwohl es ursprünglich als Provisorium konzipiert wurde, ist es heute immer noch in Gebrauch.

Le défi de ce projet consistait à démontrer qu'une construction de qualité pouvait être réalisée au même coût qu'un préfabriqué temporaire. Premier prix au RIBA de 1972, le IBM Pilot Head Office confirme la réputation de Norman Foster grâce à un projet à coût modique, susceptible d'accueillir 750 à 1 000 personnes. Avec ses 10 869 m², soit 146 x 73 m, ce bâtiment d'un seul niveau, à structure légère en acier, est recouvert d'un toit en tôle d'acier ondulé. En utilisant un système d'assemblage à composants modulaires, en plaçant les dispositifs techniques dans le plafond et en faisant passer les câbles dans des colonnes creuses en acier, Foster résout la question du coût tout en augmentant la fléxibilité d'utilisation du bâtiment. Autre caractéristique inattendue: ce bâtiment est le premier de ce type à intégrer des espaces pour les ordinateurs qui, jusqu'alors, étaient installés dans des structures séparées. Devant être réalisé en 18 mois, l'IBM Office est livré avant échéance. Prévu au départ comme un bâtiment temporaire qui serait utilisé deux ans seulement, il est toujours en service, 25 ans plus tard.

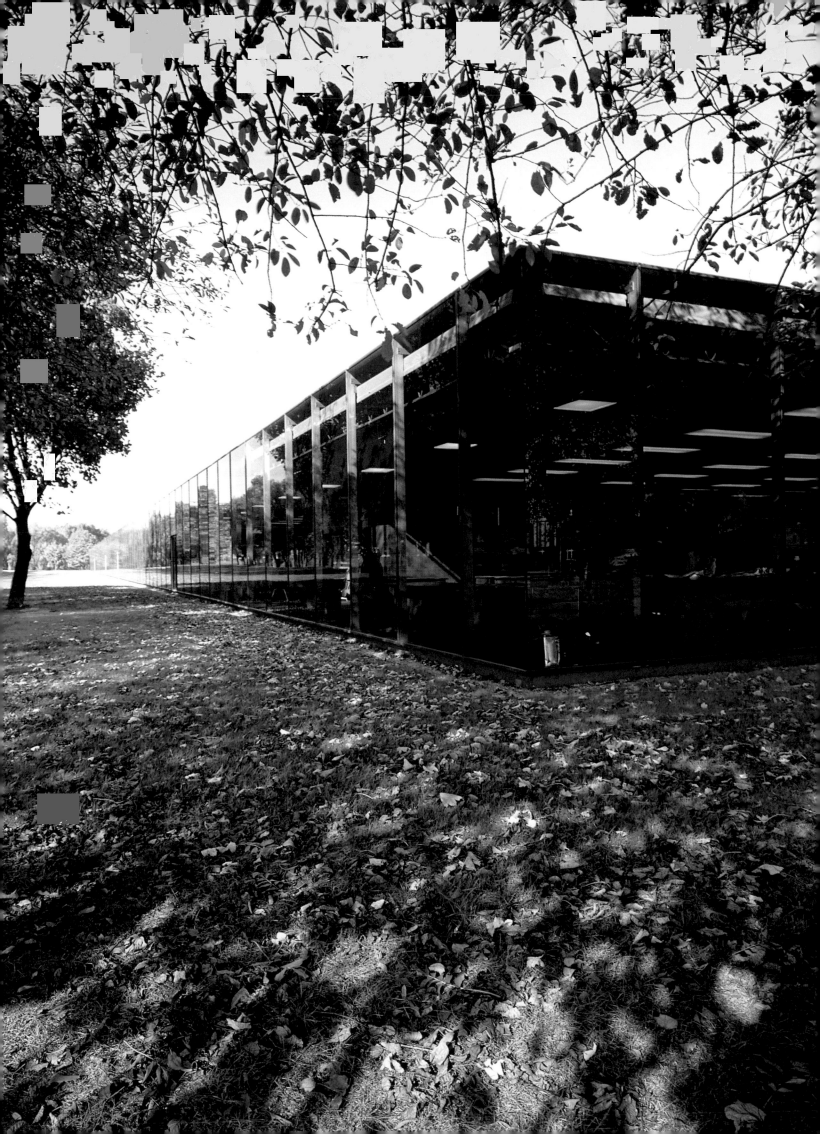

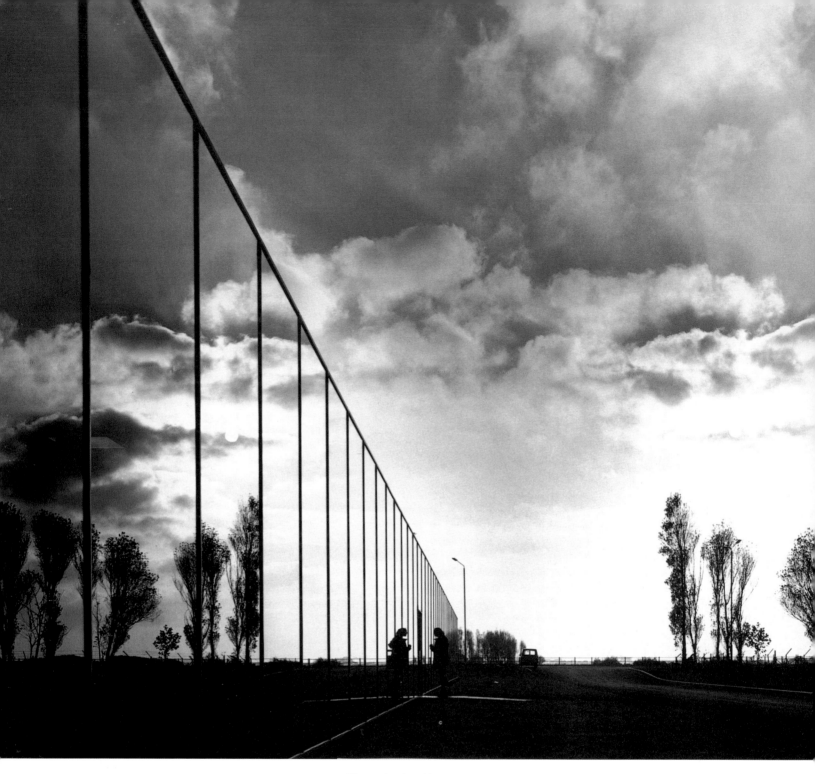

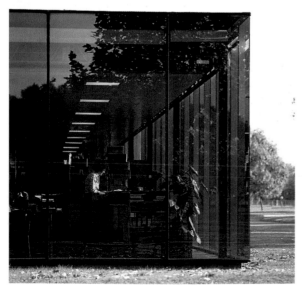

The exterior glass skin
reflects the neighboring
countryside as it permits users
within to look out.

Die Glasfassade reflektiert die
umgebende Landschaft und
ermöglicht den Nutzern den
Blick ins Freie.

Le revêtement extérieur en
verre reflète la campagne
environnante, tout en
permettant aux utilisateurs
d'admirer le paysage.

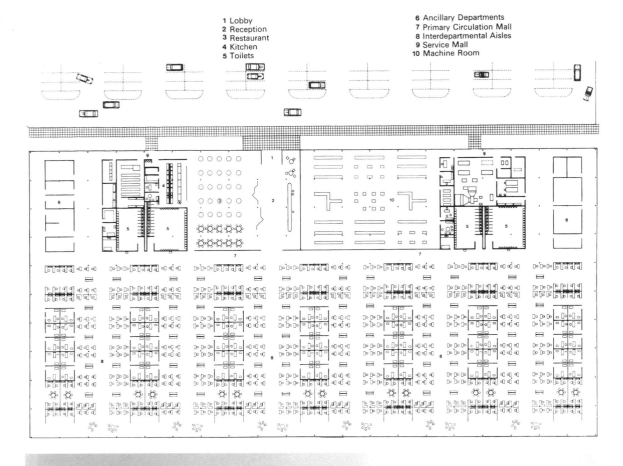

1 Lobby
2 Reception
3 Restaurant
4 Kitchen
5 Toilets

6 Ancillary Departments
7 Primary Circulation Mall
8 Interdepartmental Aisles
9 Service Mall
10 Machine Room

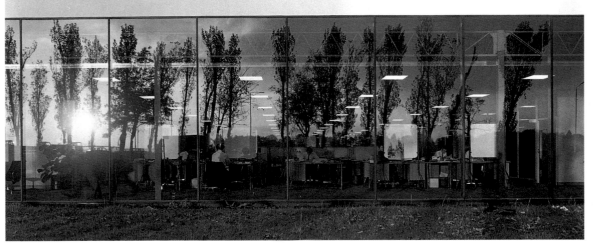

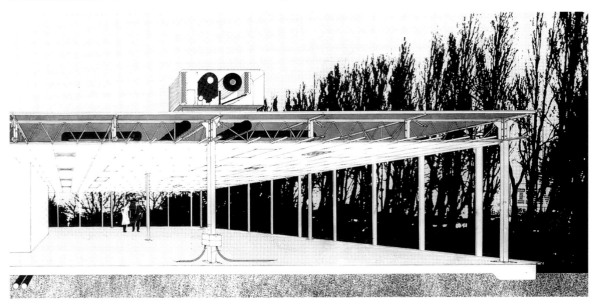

Left a floor plan, and another exterior view seen again below left, in the form of perspective section.
***Above:** A drawing of the junction of the glass wall with the outside podium.*

Ein Grundriß und eine weitere Außenansicht, darunter eine Außenansicht in Form einer Perspektivzeichnung.
***Kleine Zeichnung:** Verbindungsstelle zwischen vorgehängter Fassade und äußerem Sockel.*

Un plan du sol et une autre vue de l'extérieur, ci-dessous une vue de l'extérieur (une coupe en perspective).
***Ci-dessus:** Dessin de la jonction du mur en verre avec le soubassement extérieur.*

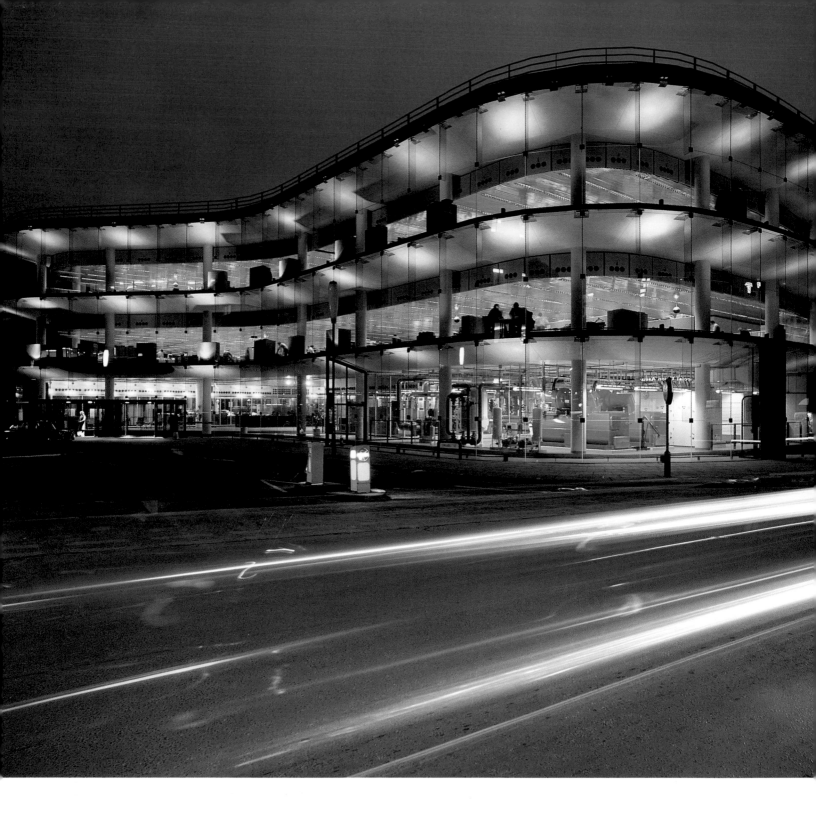

Reintroduction in new guise and more appropriate form of escalator route.

would develop so that roof is predominantly glazed. shouts for one overall glazed envelope

Willis Faber & Dumas Office

Ipswich, Suffolk, UK, 1973–1975

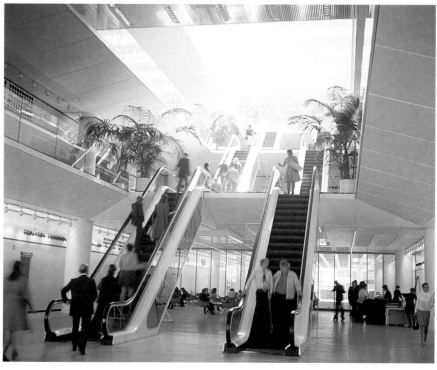

Page 62: At night the building becomes transparent (top). Below, sketches by Norman Foster show the interior escalators, visible in finished form on page 63 top.
Page 63 right: Axonometric diagram of floor plans.

Seite 62: In der Nacht wird das Gebäude transparent (oben). Darunter Skizzen der inneren Rolltreppen, die in ihrer fertigen Form auf Seite 63 oben abgebildet sind.
Seite 63 rechts: Eine Axonometrie der Grundrisse.

Page 62: La nuit, le bâtiment devient transparent (en haut). Croquis de Norman Foster montrant les escaliers roulants, que l'on peut voir sous leur forme définitive à la page 63 en haut.
Page 63 à droite: Axonométrie des plans d'étages.

This innovative office building was designed to provide the client with considerable flexibility, and also to make a sensitive contribution to the historic center of Ipswich. On a 7,000 square meter site, the three-story building includes two open-plan office floors for about 600 persons on each level, centered on an atrium containing escalators that link all the floors to the restaurant pavilion on the roof, surrounded by its garden landscape. The area of the building is 21,000 square meters, with an exterior envelope defined by an innovative glass cladding system, suspended from columns that follow the irregular street contours. Reflective during the day, the glass becomes transparent at night, offering views into the building. With their Olympic-size swimming pool, coffee bar and gym on the ground level, the Willis Faber offices are considered a model of social responsiveness in contemporary architecture. Employing a team approach to design and construction of the building, Foster again managed to create a unique solution to a complex problem.

Das innovative Design dieses Bürokomplexes bot nicht nur dem Auftraggeber optimale Flexibilität, sondern leistete auch einen einfühlsamen Beitrag zum historischen Zentrum von Ipswich. Das dreigeschossige Gebäude auf einem 7 000 m² großen Gelände enthält auf zwei Etagen Großraumbüros für jeweils 600 Mitarbeiter; es gruppiert sich um ein Atrium mit Rolltreppen, die bis zum Restaurant-Pavillon auf dem Dach führen, das in eine Art Gartenlandschaft eingebettet wurde. Die 21 000 m² große Gesamtfläche der Anlage umgibt ein Glasverkleidungssystem, das tagsüber das Licht reflektiert und nachts transparent wirkt. Mit seinem Schwimmbad von olympischen Ausmaßen, dem Café und der Sporthalle im Erdgeschoß gilt der Bau als beispielhaftes Modell für soziale Verantwortlichkeit in der Architektur. Indem Foster gemeinschaftliche Überlegungen in den Entwurf einfließen ließ, gelang ihm einmal mehr eine einzigartige Lösung für ein komplexes Problem.

Cet immeuble de bureaux novateur a été conçu pour offrir au client une souplesse considérable, ainsi qu'un ajout intéressant au centre historique d'Ipswich. Sur une surface de 7 000 m², l'immeuble à trois niveaux comprend deux étages de bureaux pour environ 1 200 personnes au total. Les bureaux sont centrés sur un atrium où sont placés les escaliers mécaniques qui les relient au pavillon-restaurant sur le toit, entouré de son jardin. Le bâtiment occupe 21 000 m². Il est revêtu de panneaux en verre suspendus à des colonnes qui suivent les contours irréguliers de la rue. Réfléchissant durant la journée, le verre devient transparent la nuit. Il permet alors de voir l'intérieur du bâtiment. Avec sa piscine de taille olympique, un café et un gymnase au rez-de-chaussée, le bâtiment Willis Faber est considéré comme un modèle de sensibilité sociale dans l'architecture contemporaine. Grâce à un travail d'équipe, Foster réussit à nouveau à trouver une solution originale à un problème complexe.

Sainsbury Centre for Visual Arts and Crescent Wing

University of East Anglia, Norwich, Norfolk, UK, 1976–1977; 1989–1991

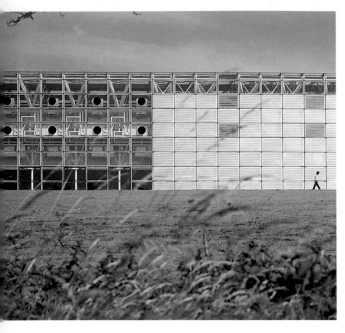

Page 64: *The original building of the Sainsbury Centre seen in profile.*
Page 65: *The building seen from the site. The high, open-plan exhibition spaces and the restaurant are visible in the images below.*

Seite 64: *Das ursprüngliche Sainsbury Centre.*
Seite 65: *Ansicht des Gebäudes vom Baugelände aus und Blick in die hohen, offenen Ausstellungsräume und das Restaurant (unten).*

Page 64: *Le Sainsbury Centre: le bâtiment original, vu de profil.*
Page 65: *Le bâtiment vu depuis le site. Les espaces d'exposition et le restaurant (en bas).*

Sir Robert and Lady Sainsbury commissioned Foster to design this center to house their private art collection, which they had donated to the University of East Anglia. The brief was subsequently enlarged to include a conservatory, restaurant, senior common room and Faculty of Fine Art. A single clear span structure, glazed at each end, enclosed all activities within one flexible space. Employing superplastic aluminum for the first time In the building industry, the original Sainsbury Centre is derived in its conception from 19th century train stations, but takes the form to new heights through its energy-efficient design and ease in maintenance. The 35 meter span of the interior space offers an unencumbered height of 7.5 meters for the display of works of art, lit by an innovative combination of natural and artificial light sources. In 1988 Foster was asked to extend the Centre. Despite its obviously flexible design, Sir Robert and Lady Sainsbury saw the Centre as a finite object, perfect in itself. Sir Norman Foster respected this opinion because the solution that he proposed was, in his view, the most functional way to extend the existing basement, and also, some areas required separate access. This led to the creation of a 3,000 square meter underground addition, visible above ground only as a curved "eyebrow" or "crescent" of glass looking out onto a lake.

Sir Robert und Lady Sainsbury beauftragten Foster mit dem Entwurf dieses Komplexes für ihre private Kunstsammlung, die sie der University of East Anglia geschenkt hatten. Der Auftrag wurde anschließend um einen Wintergarten, ein Restaurant, einen Universitätsclubraum und eine Fakultät für Bildende Kunst erweitert. Eine stützenfreie Tragekonstruktion mit verglasten Giebeln vereinigt alle Funktionen in einem flexiblen Raum; dabei fand zum ersten Mal hochelastisches Aluminium Verwendung. Die Konzeption des eigentlichen Sainsbury Centre ist von den Bahnhöfen des 19. Jahrhunderts hergeleitet, führt aber diese Bauform durch den energiesparenden Entwurf und seine Funktionalität zu einem neuen Höhepunkt. Der Innenraum mit einer Spannweite von 35 m bietet eine lichte Höhe von 7,5 m für die Ausstellung der Kunstwerke. 1988 bat man Foster, das Zentrum zu erweitern. Obgleich es veränderbar konzipiert worden war, betrachteten Sir Robert und Lady Sainsbury das Gebäude als abgeschlossenes Bauwerk. Foster respektierte ihre Entscheidung, da sein neues Konzept die funktionalste Lösung zur Erweiterung des bestehenden Erdgeschosses darstellte und einige Bereiche einen separaten Zugang benötigten. So wurde der Crescent Wing als 3 000 m² großer, unterirdischer Bau geplant, von dem überirdisch nur eine geschwungene »Mondsichel« aus Glas zu sehen ist, die zum See weist.

Sir Robert et Lady Sainsbury ont demandé à Foster de concevoir ce Centre pour abriter la collection qu'ils ont léguée à l'université d'East Anglia. Ultérieurement, on ajoute au cahier des charges une serre, un restaurant, une salle pour les élèves de dernière année et une école des Beaux-Arts. Une structure à travée unique, vitrée à chaque extrémité, accueille toutes les activités à l'intérieur d'un espace polyvalent. Utilisant pour la première fois dans l'industrie du bâtiment un aluminium de haute plasticité, le Centre Sainsbury s'inspire dans sa conception des gares de chemins de fer du XIXᵉ siècle, mais avec un souci d'efficacité énergétique et de facilité de maintenance. Le volume intérieur (35 m et 7,5 m sous plafond) met en valeur les œuvres d'art. Il est éclairé par une combinaison novatrice de lumière naturelle et artificielle. En 1988, on demande à Foster d'agrandir le Centre. Mais malgré l'évidence de sa flexibilité, Sir Robert et Lady Sainsbury estiment que le bâtiment est un objet achevé et parfait. Norman Foster respecte ce point de vue en créant une nouvelle aile, Crescent Wing: une adjonction souterraine de 3 000 m², uniquement visible au-dessus du sol sous la forme d'un «sourcil» incurvé ou d'un «croissant» en verre, qui s'ouvre sur le lac.

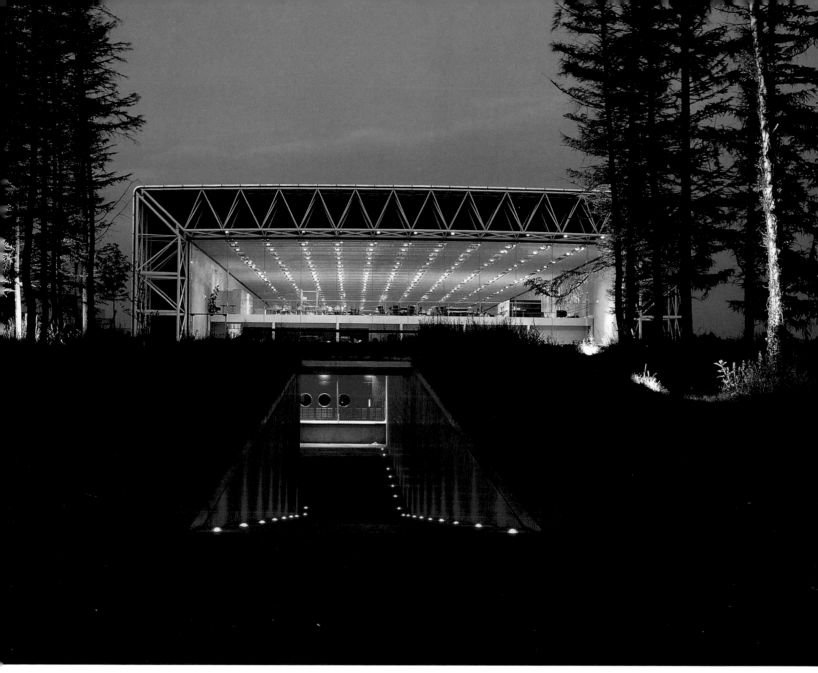

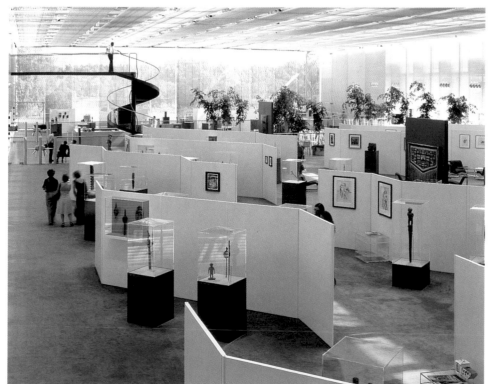

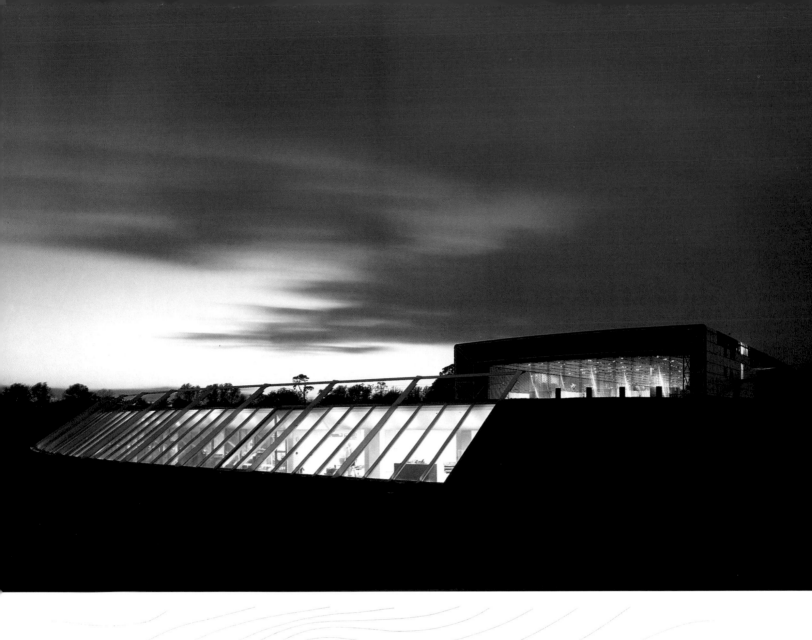

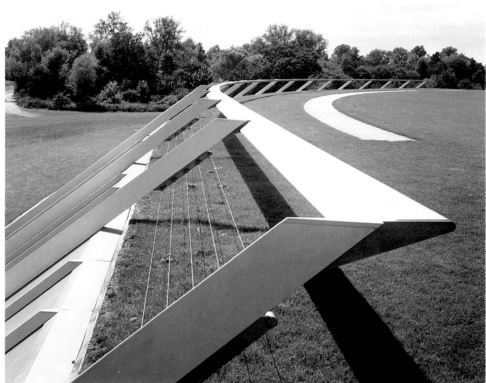

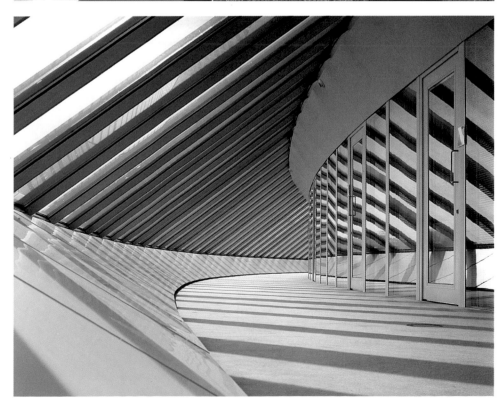

Several views of the Crescent Wing; guard rail and roof light (right), curved corridor (bottom), an interior view of the study reserve (above), and a drawing showing a section of the partially buried structure (top).

Verschiedene Ansichten des Crescent Wing: Oberlichter (rechts oben), geschwungener Korridor (unten), eine Innenansicht des Arbeitsbereiches (Mitte) und eine Zeichnung, die einen Abschnitt des teilweise unter Planum angelegten Gebäudes zeigt (ganz oben).

Différentes vues de la Crescent Wing: balustrade de protection et éclairage du toit (à droite), couloir en courbe (en bas), la salle d'étude et de recherche (ci-dessus) et schéma en coupe de la structure en partie enterrée (en haut).

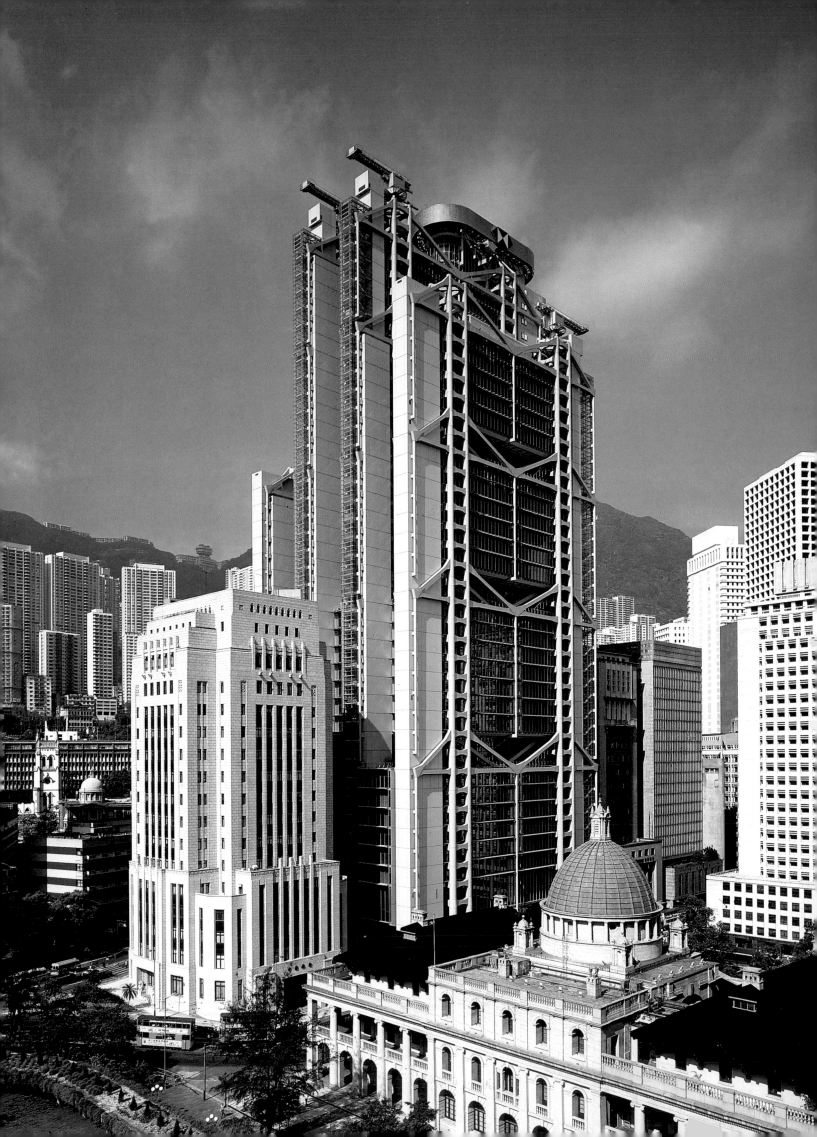

Hongkong and Shanghai Banking Corporation Headquarters

Hong Kong, 1981–1986

RECURRING THEMES - RICH MIX OF SPACES & ACTIVITIES WITHIN A GRID OF STRUCTURE & TOWERS FOR VERTICAL MOVEMENT & SERVICES

Page 68: The Bank in its setting in the Central District, with the Victoria Peak behind.
Page 69: A series of sketches by Norman Foster show the evolution of the design.

Seite 68: Blick auf die Bank im Central District mit dem Victoria Peak im Hintergrund.
Seite 69: Verschiedene Skizzen von Norman Foster, die die Entwicklung des Entwurfs zeigen.

Page 68: La banque dans son environnement du quartier Central District, avec le Victoria Peak en arrière-plan.
Page 69: Série d'esquisses de Norman Foster montrant l'évolution du projet.

On a site of nearly 5,000 square meters strategically located at the head of Statue Square in the Central District, this tower rises to a total height of 178.8 meters, with forty-seven stories above the ground plaza and four levels below ground. The expressed steel structure is clad with specially designed modular aluminum gray and metallic silver panels with fixed aluminum louvers shading the glazing. The building features a 52 meter high atrium, and is designed to accommodate 3,500 people. Reputed to have been the most expensive building ever built, partially due to the exorbitant cost of land in Hong Kong, the tower seems to have proven its high degree of flexibility when the bank installed a new dealer room in 1995 in a period of less than six weeks. The 12 meter high pedestrian concourse beneath the building seems to be particularly appreciated in a city where available ground space is always at a premium. Connecting the public space to the bank offices themselves, a pair of escalators mark a transition much as they do in the Willis Faber building, while permitting interior space to remain clearly comprehensible.

Der Turm mit einer Gesamthöhe von 178,8 m besitzt 47 Etagen oberhalb eines öffentlichen Platzes sowie vier unterirdische Geschosse und steht auf einem fast 5 000 m² großen Gelände unmittelbar an der Kopfseite des Statue Square im Central District. Die Stahlkonstruktion wurde mit speziellen aluminiumgrauen und silbermetallicfarbenen Paneelen verkleidet, wobei feststehende Aluminiumlamellen die Verglasung beschatten. Den Mittelpunkt des Gebäudes, das für etwa 3 500 Personen entworfen wurde, bildet ein 52 m hohes Atrium. Nicht zuletzt aufgrund der extrem hohen Grundstückspreise in Hongkong gilt dieser Turm als das teuerste jemals realisierte Gebäude; als die Bank 1995 in weniger als sechs Wochen einen neuen Geschäftsbereich einrichten mußte, konnte er seine große Flexibilität unter Beweis stellen. Der 12 m hohe Fußgängerbereich unterhalb des Gebäudes findet besonderen Anklang in einer Stadt, in der Freiflächen rar sind. Wie bei für Willis Faber & Dumas markieren zwei Rolltreppen den Übergang vom Publikumsbereich zu den Büros der Bank und machen den Innenraum für jedermann zugänglich.

Sur un site d'environ 5 000 m² situé stratégiquement à l'entrée de Statue Square, dans le quartier Central District, cette tour s'élève à 178,8 m, avec ses 47 étages au-dessus d'une place publique, plus quatre niveaux en sous-sol. La structure en acier est revêtue de panneaux modulaires en aluminium gris spéciaux. Des lames en aluminium fixées servent de pare-soleils. Avec son atrium haut de 52 m, la structure est conçue pour accueillir 3 500 personnes. Réputée pour être le bâtiment le plus cher jamais construit, en partie à cause du coût exorbitant du terrain à Hong Kong, la tour semble avoir démontré sa flexibilité d'utilisation quand, en 1995, la banque a installé en moins de six semaines tout un étage pour les opérations boursières. Le hall piétonnier, haut de 12 m situé au-dessous du bâtiment, semble particulièrement apprécié dans une ville où l'espace au sol disponible est toujours hors de prix. Reliant l'espace public aux bureaux mêmes de la banque, deux escaliers mécaniques marquent une transition, comme dans le Willis Faber, tout en préservant la lisibilité des volumes intérieurs.

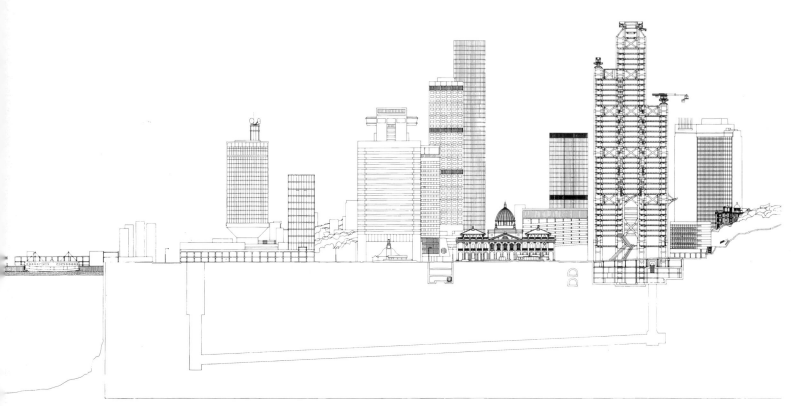

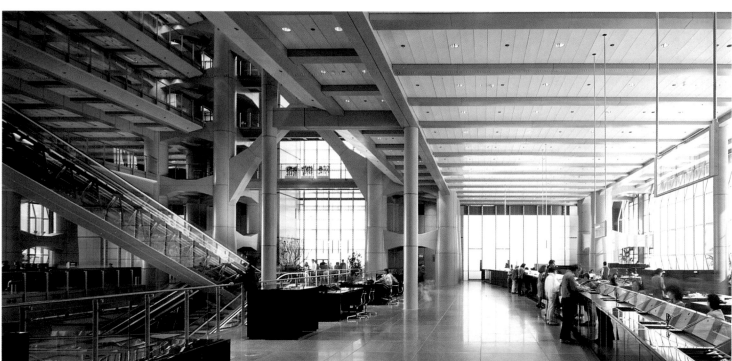

Page 70: A long section through
Bank and Statue Square
showing the pipe bringing in
water for cooling from the bay
(top) and the Banking Hall on
Level 3.
Page 71: The spectacular central
atrium.

Seite 70: Längsschnitt durch die
Bank und den Statue Square,
der die Kühlwasserzuleitung aus
der Bucht zeigt (oben) und die
Schalterhalle auf Ebene 3.
Seite 71: Das aufsehenerregende,
zentrale Atrium.

Page 70: Coupe longitudinale de
la banque et de Statue Square,
montrant le conduit qui amène
l'eau de refroidissement depuis la
baie (en haut) et le hall de la
banque au niveau 3.
Page 71: L'impressionnant
atrium central.

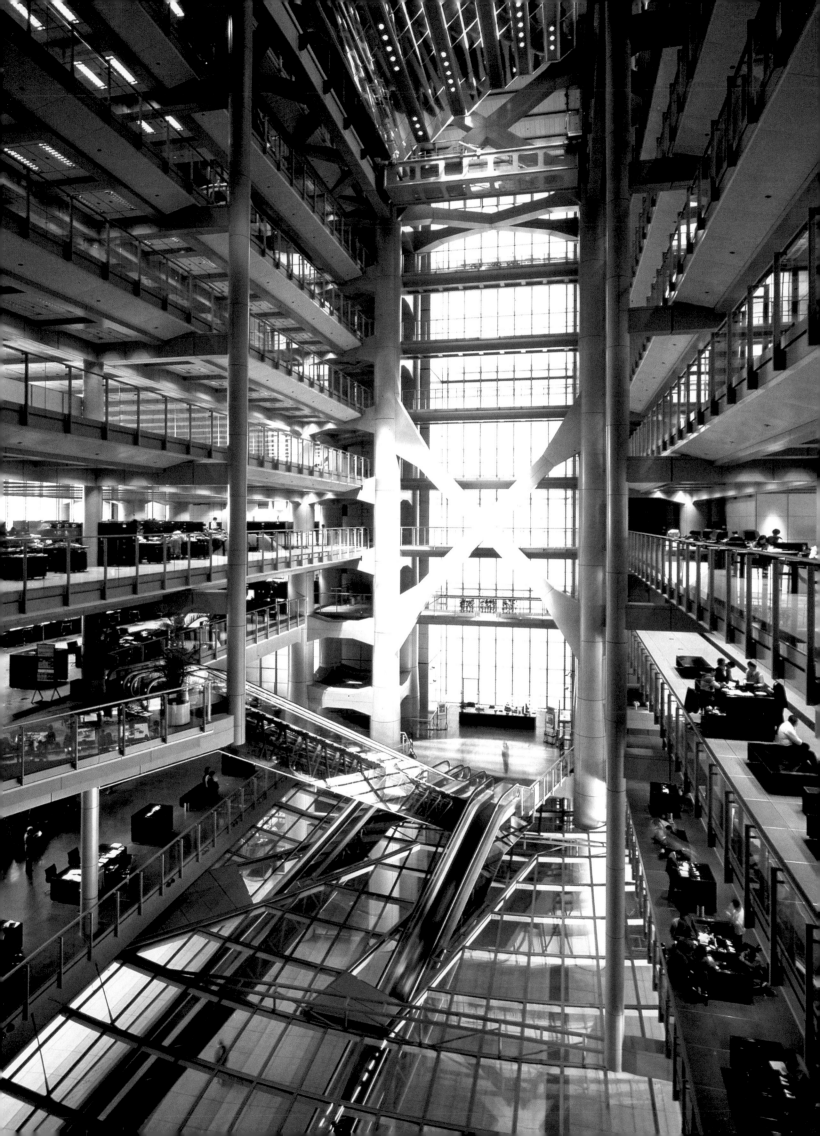

BBC Radio Headquarters

London, UK, 1982

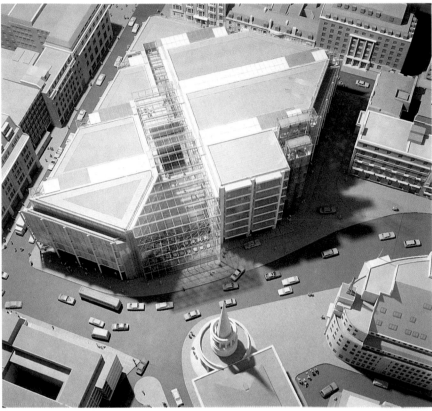

This 52,000 square meter complex, intended by the then BBC Chairman Lord Howard as the symbol of a new openness in the organization, was to have been located in an historically sensitive site at the double bend in Nash's great processional route down Regent Street, responding to All Souls Church (John Nash, c. 1825). An outstanding feature was to have been a large glazed atrium, open to the public, inscribed on the diagonal axis of the Church and neighboring Cavendish Square, which in turn dictated the diagonal geometry of the structural grid. Foster planned to link the new building to the existing Broadcasting House to share services and to respond not only to the older neighboring architecture, but also to the complex S-shaped pattern of the street front. When Lord Howard retired, the new BBC Chairman canceled the project to follow his own policy of dispersing the BBC to the suburbs.

Nach dem Willen des damaligen Intendanten der BBC, Lord Howard, sollte der 52 000 m² große Komplex als Symbol für die neue Offenheit des Senders dienen und auf einem historisch sensiblen Gelände an der zweifachen Biegung der Regent Street entstehen – auf Nashs großer Prachtstraße, gegenüber der berühmten All Souls Church (John Nash, um 1825). Als herausragendes Merkmal war das große, verglaste Atrium geplant, das auf der diagonalen Achse zwischen der Kirche und dem benachbarten Cavendish Square lag. Foster wollte das neue Gebäude mit dem existierenden Funkhaus verbinden, um die vorhandenen Einrichtungen zu nutzen und Bezug auf die angrenzende ältere Bausubstanz und die S-Form der Straße zu nehmen. Als Lord Howard zurücktrat, stoppte der neue Intendant der BBC das Projekt, da er die Abteilungen des Senders auf die Vorstädte verteilen wollte.

Souhaité par Lord Howard, alors président de la BBC, comme le symbole d'une nouvelle ouverture de l'organisation envers le public, ce complexe de 52 000 m² devait être situé sur un site historique, au double virage de la route prestigieuse de Nash, le long de Regent Street, face à All Souls Church (John Nash, vers 1825). Sa caractéristique marquante aurait été son grand atrium vitré, ouvert au public, inscrit dans l'axe diagonal de l'église et du Square Cavendish tout proche, qui aurait engendré la géométrie oblique de la structure. Foster avait prévu de relier le nouveau bâtiment à la Broadcasting House déjà existante, pour mettre en commun les installations techniques et faire écho non seulement à l'architecture voisine, plus ancienne, mais aussi au schéma des façades sur la rue en forme de S. Quand Lord Howard prit sa retraite, le nouveau président de la BBC annula le projet et poursuivit sa propre politique, à savoir délocaliser la BBC en banlieues.

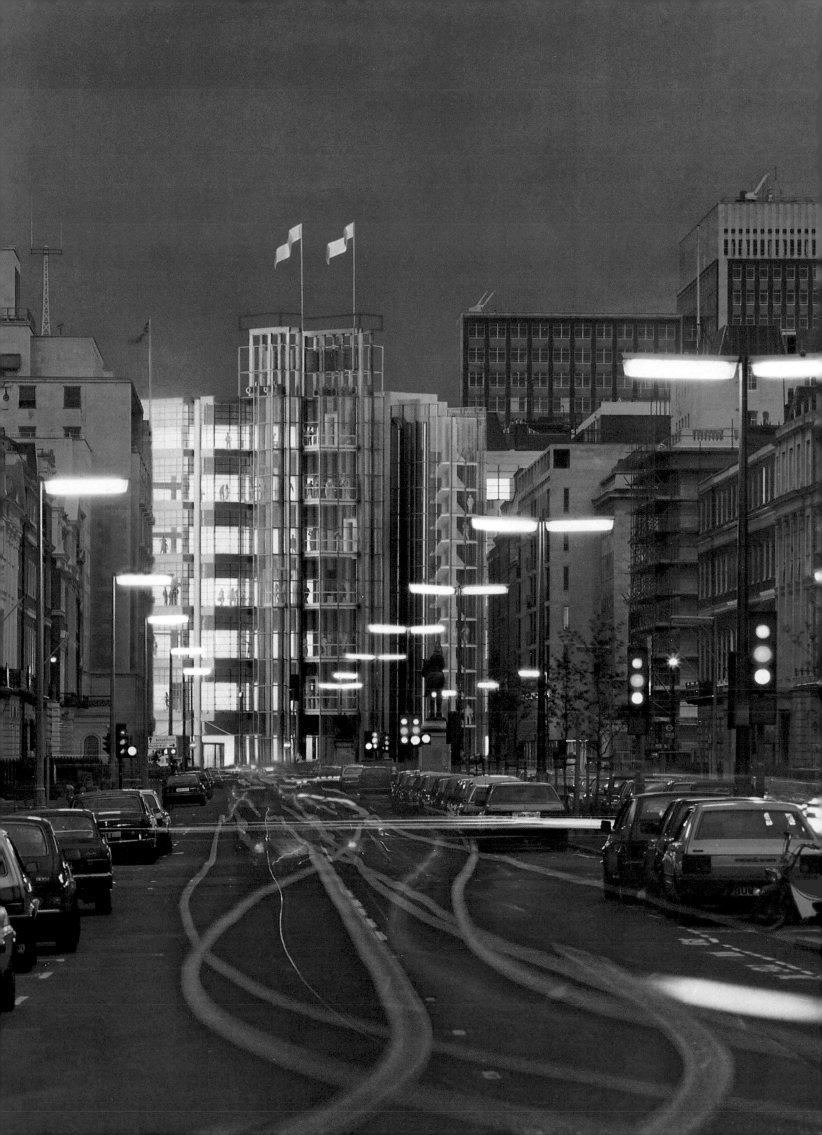

King's Cross Masterplan
London, UK, 1987

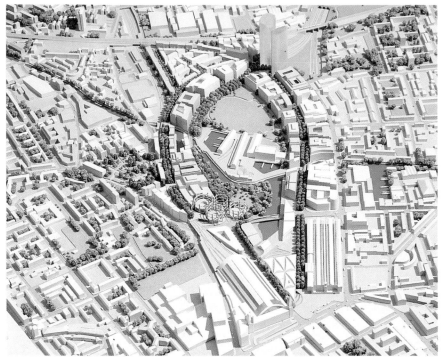

Pages 74, 75 top: With its forms determined largely by the proximity of King's Cross and St Pancras Stations, Norman Foster developed a stunning, light, wedge-shaped design for the planned Eurostar terminal (model views).
Page 75 bottom: An aerial view of the site shows current state of the stations.

Seite 74, 75 oben: Für den geplanten Eurostar-Terminal entwarf Norman Foster eine aufsehenerregende, leichte Konstruktion, deren keilförmige Grundform zu einem Großteil durch die unmittelbare Nähe der Bahnhöfe King's Cross und St. Pancras vorgegeben wurde (Modelle).
Seite 75 unten: Eine Luftaufnahme zeigt den momentanen Zustand der Bahnhöfe.

Pages 74, 75 en haut: Le plan triangulaire du terminal est largement dicté par la proximité des gares de King's Cross et de St. Pancras. Les maquettes montrent bien la légèreté et l'admirable grâce qu'aurait eu le bâtiment une fois terminé.
Page 75 en bas: Vue aérienne du site montrant la situation des deux gares.

The masterplan for the regeneration of the railway lands to the north of King's Cross and St Pancras stations was generated by the need for a new international railway terminal to be situated between the two stations. Triangular in shape, the new terminal was to be the main arrival point in London, operating in conjunction with Waterloo Station. The masterplan was centered on a new 52 hectare landscaped park bisected by the Regent's Canal, which threads through the middle of the area. As the office description had it, "by capitalizing on its random and aquatic nature we are able to introduce a rich element into the plan bringing in boats and varied recreational activities." Although this masterplan, like the Sagrera Station Masterplan (Barcelona, 1991), was not carried out, both demonstrate the mastery of Foster's practice in dealing with very large urban areas.

Der Bebauungsplan für die Umgestaltung des Bahngeländes im Norden der Bahnhöfe King's Cross und St. Pancras entstand aus dem Bedarf an einem neuen internationalen Terminal, der zwischen diesen beiden Bahnhöfen liegen und zusammen mit Waterloo Station als wichtigster Ankunftspunkt Londons gedacht war. Im Zentrum dieser Bebauung sollte ein neuer, 52 ha großer Landschaftspark entstehen, der durch den mitten durch das Gelände verlaufenden Regent's Canal zweigeteilt wurde. In der Projektbeschreibung heißt es: »Durch die Nutzung seiner willkürlichen Form und der vom Wasser bestimmten Eigenschaften können wir vielfältige Erholungsangebote und sogar Boote in den Plan einbringen.« Auch wenn dieser Bebauungsplan – ebenso wie der geplante Sagrera-Bahnhof (Barcelona, 1991) – nicht ausgeführt wurde, zeigt sich hier Fosters Meisterschaft im Umgang mit extrem großen urbanen Flächen.

Le plan directeur détaillé pour l'exploitation d'anciens terrains des chemins de fer au nord des gares de King's Cross et de St. Pancras a été dicté par le besoin de créer un nouveau terminal international pour les rames Eurostar, entre les deux gares. De forme triangulaire, celui-ci devait être le principal point d'arrivée dans Londres, en liaison avec la gare de Waterloo. Le plan directeur est centré sur un nouveau parc de 52 ha, traversé par le Regent's Canal qui coule en plein milieu. Selon la description de l'agence: «En tablant sur son aspect bucolique et aquatique, nous avons introduit un élément riche et fait entrer dans le projet, des bateaux et d'autres activités de loisirs». Quoique ce projet, comme celui de la gare Sagrera (Barcelone, 1991), n'ait jamais été réalisé, il montre le professionnalisme de Foster en ce qui concerne l'utilisation des grands espaces urbains.

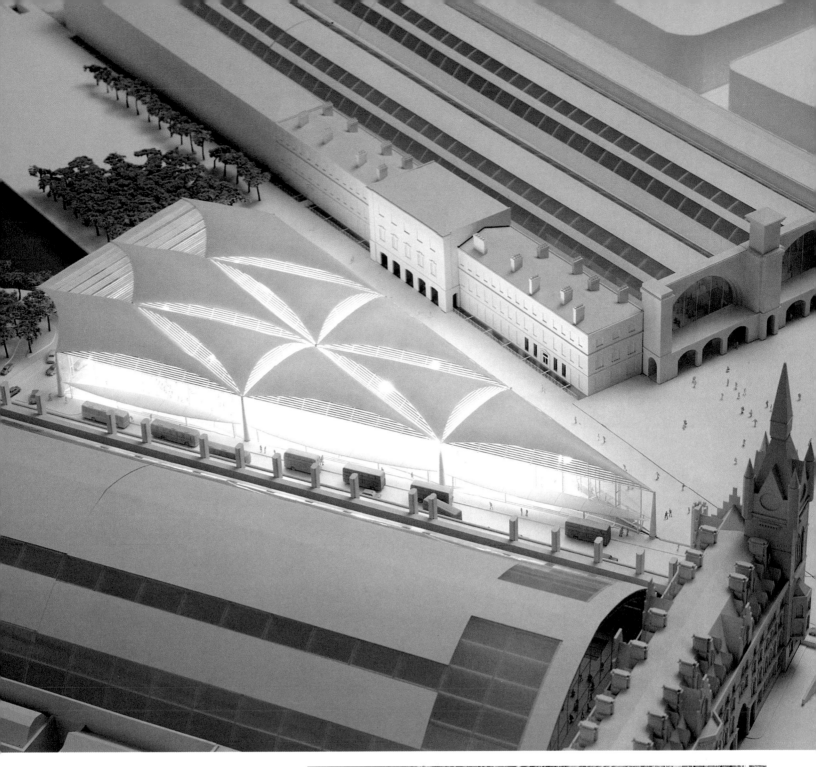

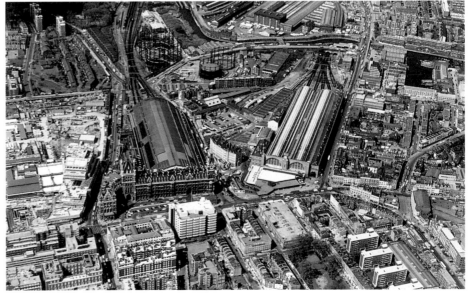

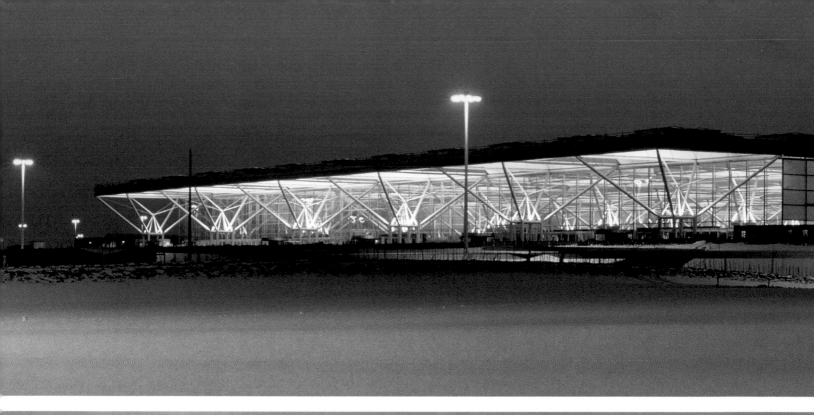

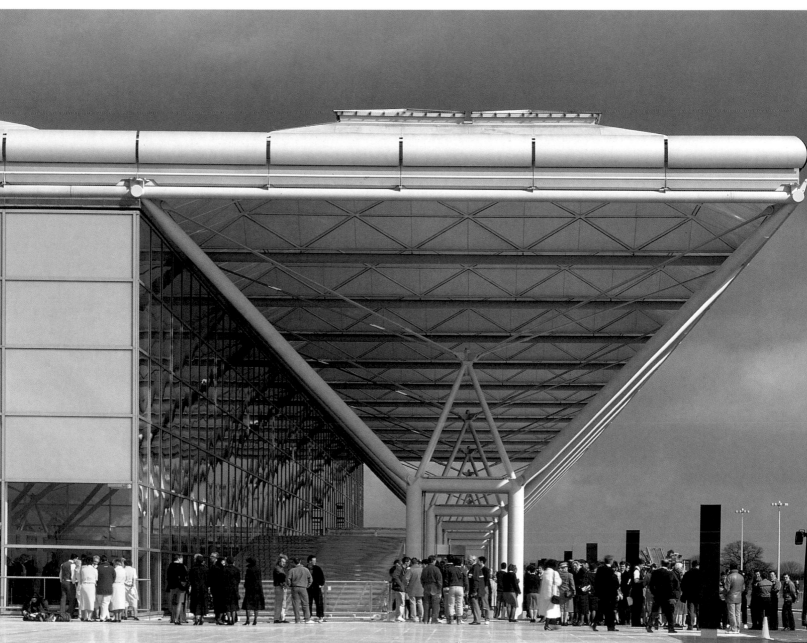

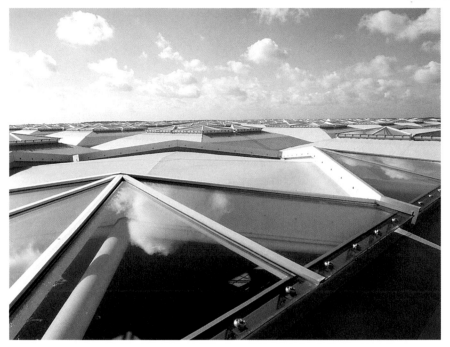

The Stansted Terminal, which was built at a cost some 15% less than previous UK terminal buildings, consists of a single level for passengers, serviced from an undercroft below. Although there is a British Rail station below providing a direct, forty minute link to London, all other land arrivals are concentrated at the same level as the departure gates. With an area of 85,700 square meters and an external height of 15 meters, the terminal is set in a lush green setting, assured by four hectares of preserved grasslands and ponds, as well as 250,000 newly planted trees. A lattice-shelled roof structure, the outstanding architectural achievement of the complex, is supported by 12 meter high structural "trees," which include supply and return air for the ventilation system, TV monitors, display boards, safety equipment, and the upwardly directed artificial lighting fixtures. Natural light is omnipresent in the building, entering from glazed side walls and perforated overhead apertures in the form of a square rotated within another square.

Der Flughafen in Stansted, der um etwa 15% preiswerter gebaut wurde als vorherige englische Flughafengebäude, besteht aus einer einzigen Passagierebene, die von einem unterirdischen Bereich aus versorgt wird. Obwohl sich in diesem Versorgungsbereich auch ein Bahnhof befindet, der eine direkte Verbindung nach London in 40 Minuten bietet, sind alle anderen Landverbindungen auf der gleichen Ebene konzentriert wie die Abflugsteige. Mit einer Fläche von 85 700 m² und einer lichten Höhe von 15 m liegt der Terminal in einer üppigen grünen, 4 ha großen Umgebung aus geschütztem Grünland, Teichen und 250 000 neu gepflanzten Bäumen. Eine Gitterschalen-Dachkonstruktion wird von 12 m hohen »Säulen-Bäumen« getragen, die das Lüftungssystem sowie Bildschirme, Anzeigetafeln, Sicherheitsanlagen und nach oben gerichtete künstliche Lichtquellen beinhalten. Tageslicht durchflutet das Gebäude durch die gläsernen Seitenwände und Dachöffnungen, deren Form an ein Quadrat in einem zweiten, gedrehten Quadrat erinnert.

Le Terminal de Stansted, construit à un coût inférieur de 15% par rapport aux autres terminaux situés au Royaume-Uni, est un bâtiment de plain-pied dont la maintenance se fait par le sous-sol. Hormis la gare de chemin de fer située en sous-sol qui permet de rejoindre Londres en 40 minutes, toutes les autres arrivées terrestres sont concentrées au même niveau que les portes d'embarquement. Avec une surface de 85 700 m² et une hauteur extérieure de 15 m, le terminal est placé dans un environnement verdoyant, grâce à quatre hectares de prairies et d'étangs qui ont été préservés, ainsi qu'à 250 000 arbres nouvellement plantés. Le toit – une série de «coquilles» – est soutenu par des «arbres» hauts de 12 m, qui constituent le système de ventilation et contiennent les moniteurs de télés, les écrans d'affichage, les équipements de sécurité et l'éclairage artificiel dirigé vers le haut. Ici, la lumière naturelle est omniprésente. Elle pénètre par les façades vitrées ainsi que par le toit, grâce à des lanterneaux qui ressemblent des losanges inscrits dans des carrés.

Page 76: A night view and an image of the entrance canopy of the airport.
Page 77: An outside view of the skylights which admit a large amount of natural light into the terminal area.

Seite 76: Eine Nachtansicht und ein Blick auf die Eingangsüberdachung des Flughafens.
Seite 77: Außenansicht der Oberlichter, die viel natürliches Licht in den Terminal lassen.

Page 76: Vue nocturne et vue de l'auvent à l'entrée de l'aérogare.
Page 77: Vue extérieure des lanterneaux qui font largement pénétrer la lumière du jour dans le terminal.

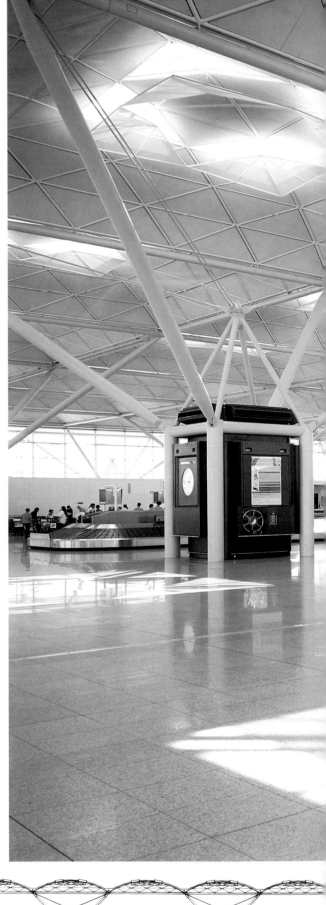

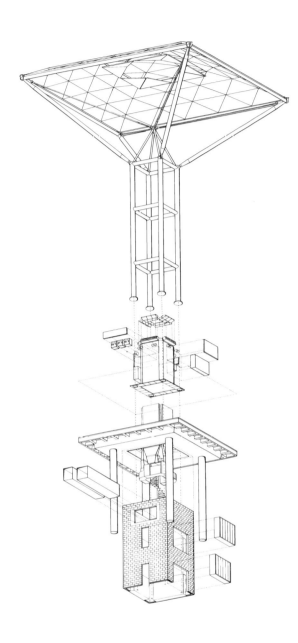

Right: A drawing of a structural
tree and services pod, and a
broader view showing the bright,
open interior space.
Bottom: A cross section of the
entire terminal.

Rechts: Zeichnung eines
»Säulen-Baumes« mit den darin
geführten Serviceleitungen. Das
größere Bild zeigt den lichten,
offenen Innenraum.
Unten: Ein Querschnitt durch
den gesamten Terminal.

À droite: Croquis d'un arbre
structural et d'une gaine
technique, avec une vue plus
générale des espaces intérieurs
mettant en évidence la
luminosité et l'accessibilité du
bâtiment.
En bas: Coupe transversale du
Terminal.

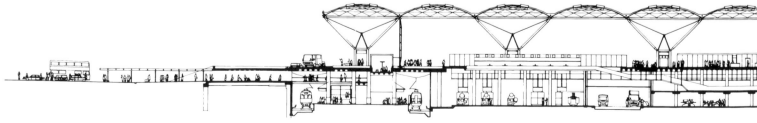

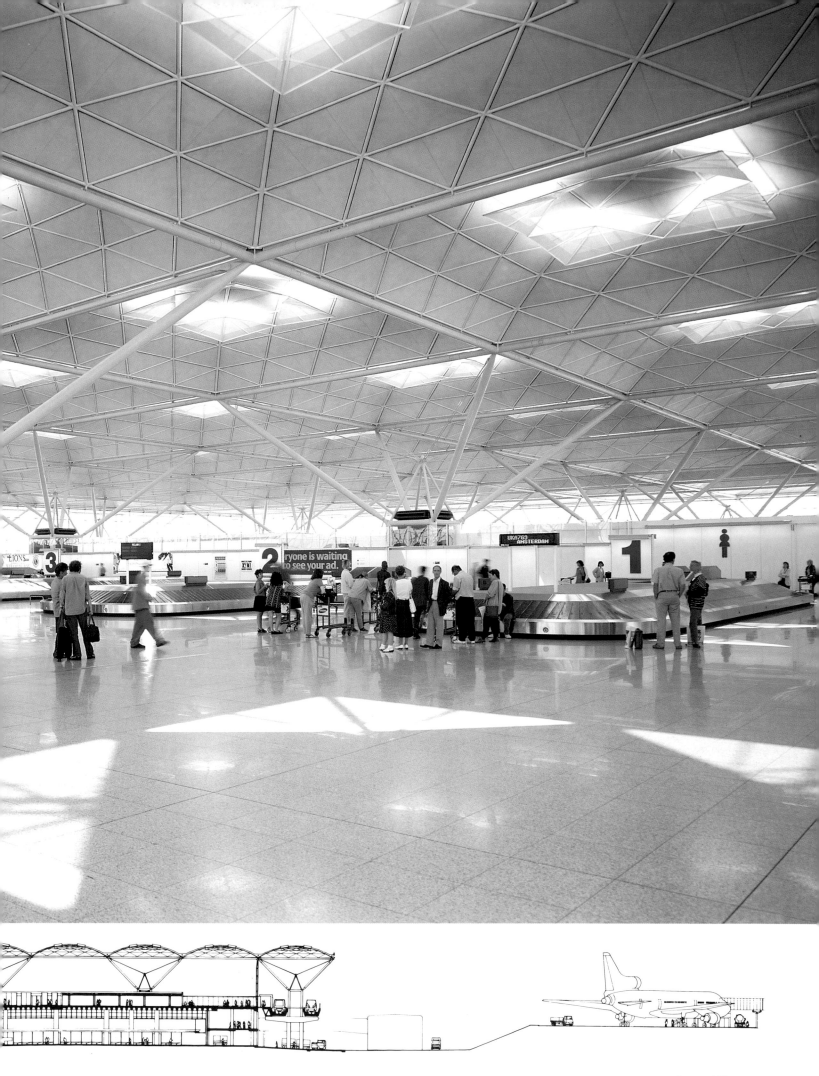

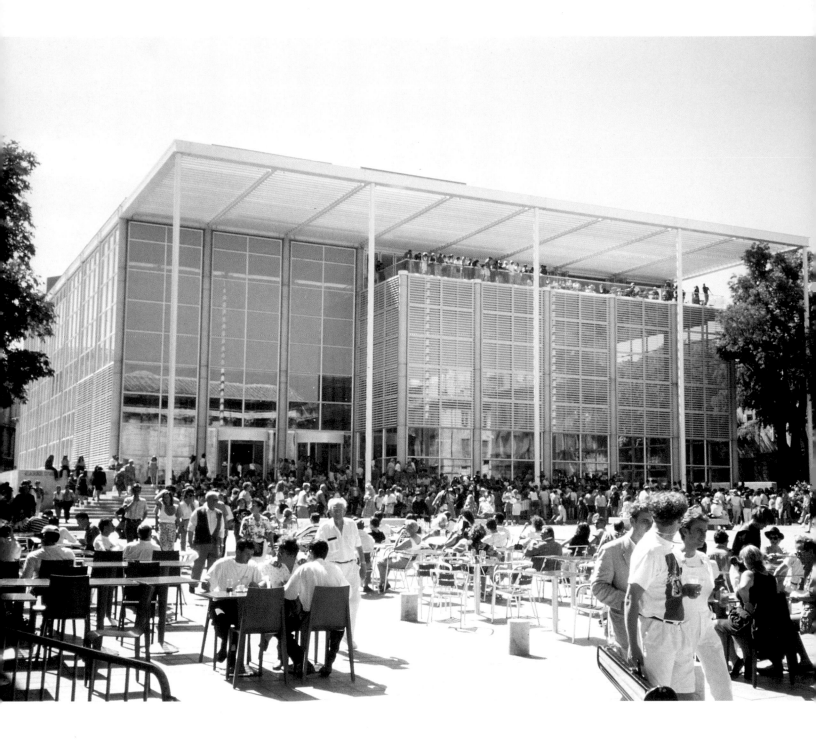

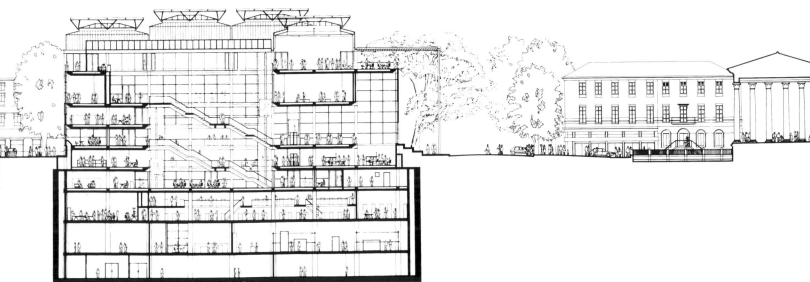

Carré d'Art

Nîmes, France, 1987–1993

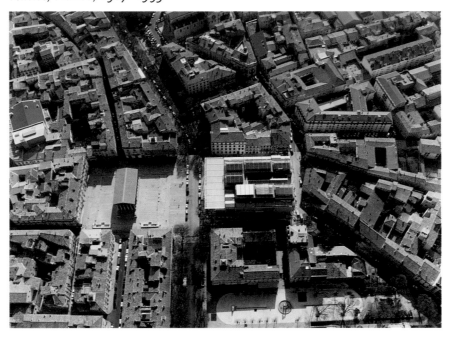

Two of the outstanding features of this southern French city are its Roman arena (c. 90–120 A.D.) and the so-called Maison Carrée, also built by the Romans between 10 and 5 B.C. The site of the Carré d'Art is just opposite this well-preserved temple, the portico of which was an influence in the design of the louvered canopy of the newer building. Other contextually related design decisions include the limitation of the overall height to correspond to other nearby structures. Most of the nine-story volume below grade is storage and places that do not require natural light. A central five-story atrium brings light to the lower-level library. Finally, Foster placed the main entrance on the corner of the building to correspond to the Boulevard Victor Hugo, which approaches the Carré d'Art diagonally. He also repaved 7,069 square meters between the Maison Carrée and his own building with granite and local limestone. With an area of 18,000 square meters the Carrée d'Art includes library Museum of Contemporary Art, Médiathèque, auditorium and café.

Zu den Wahrzeichen dieser südfranzösischen Stadt zählen das römische Amphitheater (ca.90–120 n.Chr.) und das ebenfalls römische Maison Carrée (ca. 10–5 v.Chr.). Das Carré d'Art liegt genau gegenüber diesem gut erhaltenen Tempel. Eine weitere Entwurfsentscheidung war die Begrenzung der Bauhöhe durch die benachbarten Gebäude. Ein Großteil des neungeschossigen Gebäudes unter Planum wird als Magazin oder Lager genutzt und benötigt daher kein Tageslicht. Ein zentrales, fünf Stockwerke hohes Atrium bringt Licht in die unterirdisch gelegene Bibliothek. Foster verlegte den Haupteingang auf eine Gebäudeecke, um einen Zusammenhang zum Straßenverlauf des Boulevard Victor Hugo herzustellen, die sich dem Carré d'Art diagonal nähert. Darüber hinaus ließ er den 7 069 m² großen Platz zwischen dem Maison Carrée und seinem Gebäude mit Granit und Kalkstein aus der Region pflastern. Auf einer Fläche von 18 000 m² beherbergt das Carré d'Art eine Bibliothek, ein Museum für zeitgenössische Kunst, eine Mediathek, ein Auditorium und ein Café.

Cette ville du Midi se caractérise essentiellement par deux monuments: ses arènes romaines (construites entre 90 et 120 ap. J.-C.) et sa Maison Carrée, construite aussi par les Romains, entre 10 et 5 av. J.-C. Le Carré d'Art se trouve juste en face de ce temple si bien conservé, et dont le portique a influencé le dessin de l'auvent. Parmi les autres décisions relatives au contexte, il faut noter la limitation de la hauteur totale afin de s'aligner sur les structures voisines. Une grande partie des niveaux situés en sous-sol ne nécessitent pas de lumière naturelle. Un atrium central de cinq étages apporte cependant la lumière jusqu'à la bibliothèque située au niveau inférieur. Enfin, Foster a placé l'entrée principale à l'angle du bâtiment pour l'ouvrir sur l'avenue Victor Hugo qui se dirige vers le Carré en diagonale. Il a aussi repavé les 7 069 m² entre la Maison Carrée et sa propre réalisation, avec du granit et du calcaire local. Avec une surface de 18 000 m², le Carré d'Art comprend une bibliothèque, un musée d'art contemporain, une médiathèque, un auditorium et un café.

Page 80: The crowded square formed in front of the Carré d'Art, and a long section showing how much of the structure is below grade.
Page 81: An aerial view, with the Avenue Victor Hugo arriving on a diagonal from the left upper part of the image.

Seite 80: Der gut besuchte Platz vor dem Carré d'Art und ein Längsschnitt, der zeigt, wie weit das Gebäude unter Planum liegt.
Seite 81: Eine Luftaufnahme mit der diagonal vom linken oberen Bildrand verlaufenden Avenue Victor Hugo.

Page 80: La foule sur la place devant le Carré d'Art, et coupe longitudinale montrant l'importance de la structure au-dessous du niveau du sol.
Page 81: Vue aérienne, avec l'avenue Victor Hugo qui arrive en diagonale (en haut à gauche).

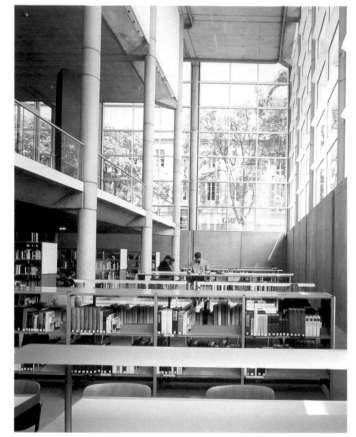

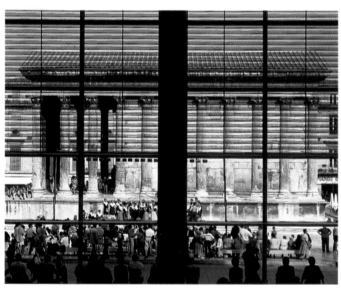

Page 82: An interior view showing how light penetrates into the lower areas (top). The Maison Carrée seen from inside the Carré d'Art (center) and a 1985 sketch by Norman Foster (bottom).
Page 83: The Maison Carrée with the Carré d'Art behind, and a 1985 sectional sketch by Norman Foster.

Seite 82: Die Innenansicht zeigt, wie Licht in die unteren Bereiche eindringt (oben). Das Maison Carrée, vom Inneren des Carré d'Art aus gesehen (Mitte), darunter eine Zeichnung von Norman Foster (1985).
Seite 83: Das Maison Carrée mit dem dahinterliegenden Carré d'Art, und eine Skizze aus dem Jahr 1985 von Norman Foster.

Page 82: Vue intérieure montrant comment la lumière pénètre jusqu'aux espaces inférieurs (en haut). La Maison Carrée vue depuis l'intérieur du Carré d'Art (centre). Esquisse de 1985, signée Foster (en bas).
Page 83: La Maison Carrée avec le Carré d'Art en arrière-plan et une coupe tracée par Norman Foster en 1985.

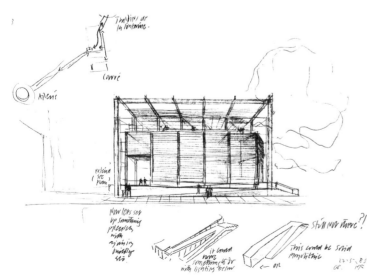

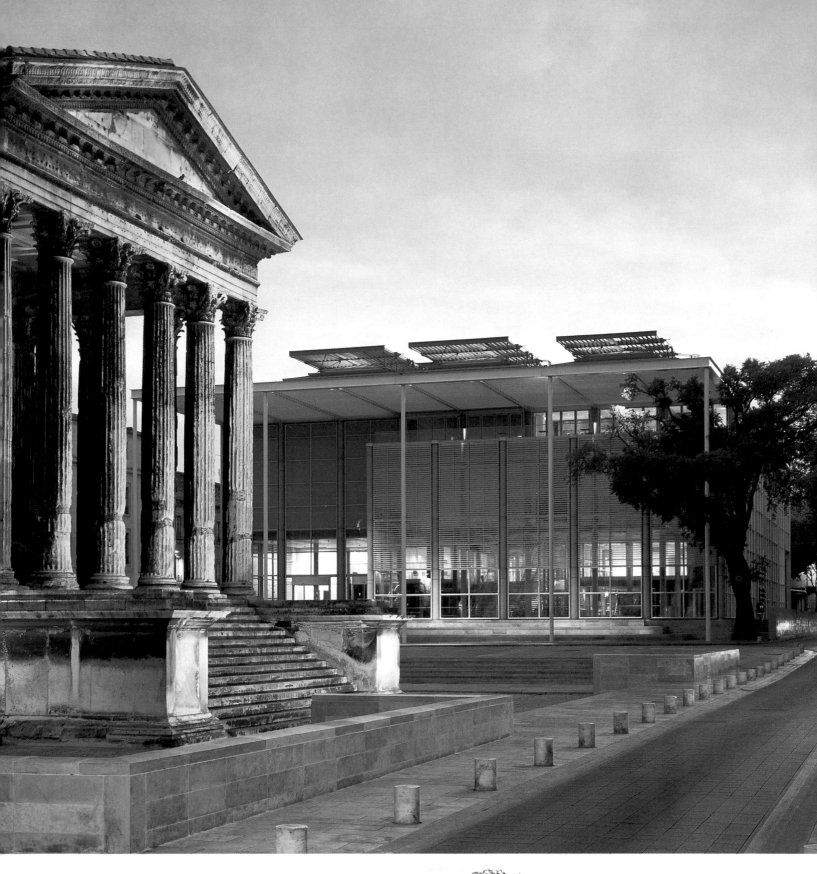

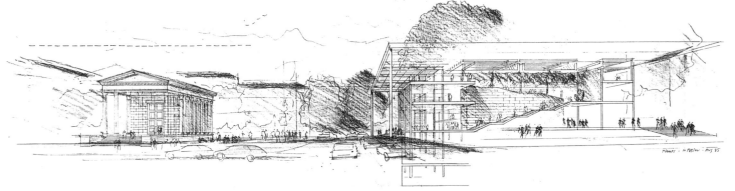

ITN Headquarters

London, UK, 1988–1990

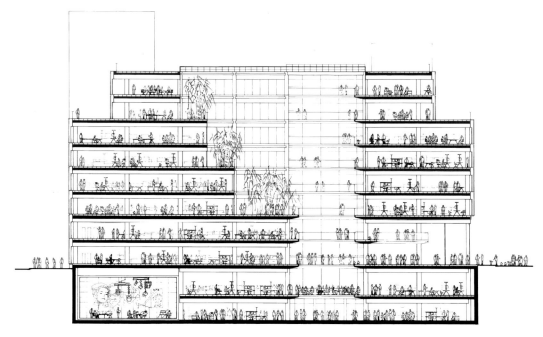

The site of the former *Times* printing plant on Gray's Inn Road, the ITN building inherited a very large underground space formerly used for the presses. These basements were ideal for use as TV studios. Large glass panes with silver venetian blinds define the facade. The double layer glazed walls have an unusually deep cavity of 350 millimeters giving very high insulation levels and contributing to energy savings. Within, a full-height atrium reaching two levels below grade brings light into the structure. Sir Norman points out the difficulties involved not only in using the deep basements, but also "the commercial realities of having to create a building in a year, which is usually the excuse to do something that is less of a talking point." Given these constraints, the ITN Headquarters, which also houses other firms, is undoubtedly successful. It commands some of the highest rents in London.

Das ITN-Gebäude liegt auf dem Gelände der ehemaligen »Times« Druckerei an der Gray's Inn Road und übernahm deren sehr große unterirdische Räume, die früher für die Druckpressen genutzt wurden und sich hervorragend als Fernsehstudios eigneten. Große Glasflächen mit silberfarbenen Zugjalousien charakterisieren die Fassade. Die doppelten Glaswände weisen eine extrem tiefe Aussparung von 350 mm auf und tragen damit zum Energiesparen bei. Im Inneren läßt ein Atrium, das sich über die gesamte Gebäudehöhe bis in die zwei unterirdischen Etagen erstreckt, Licht in das Bauwerk. Foster weist auf die Probleme hin, die sich nicht nur aus der Nutzung der Kellergeschosse ergeben, sondern auch aus den »wirtschaftlichen Zwängen, die die Realisierung eines Projektes innerhalb eines Jahres hervorrufen – was meist als Entschuldigung für ein Bauwerk gilt, das nicht unbedingt zum Gesprächsthema wird«. Im Rahmen dieser Vorgaben kann man das Gebäude der ITN-Hauptverwaltung zweifellos als gelungen einstufen.

À l'emplacement de l'ancienne imprimerie du «Times», sur Gray's Inn Road, le bâtiment ITN a hérité d'un très grand espace souterrain, autrefois occupé par les presses. Ces sous-sols convenaient parfaitement à des studios de télévision. De grands panneaux de verre protégés par des stores vénitiens argentés définissent la façade. Les murs sont constitués d'un double vitrage séparé par un vide de 350 mm d'épaisseur, d'où une excellente isolation et une économie d'énergie. À l'intérieur, sur toute la hauteur et jusqu'à deux niveaux au-dessous du sol, un atrium fait pénétrer la lumière. Foster insiste sur les difficultés non seulement à utiliser les sous-sols dans toute leur profondeur, mais aussi sur «les réalités commerciales, à savoir créer un immeuble en un an, ce qui constitue d'ordinaire une bonne excuse pour faire des choses d'une banalité infligeante». Compte tenu de ces contraintes, le ITN Headquarters, qui abrite aussi d'autres entreprises, est un succès indiscutable. Les loyers y sont du reste très élevés.

Page 84: A cross section of the building.
Page 85: The facade on Gray's Inn Road.

Seite 84: Ein Schnitt des Gebäudes.
Seite 85: Die Fassade zur Gray's Inn Road.

Page 84: Coupe transversale du bâtiment.
Page 85: La façade sur Gray's Inn Road.

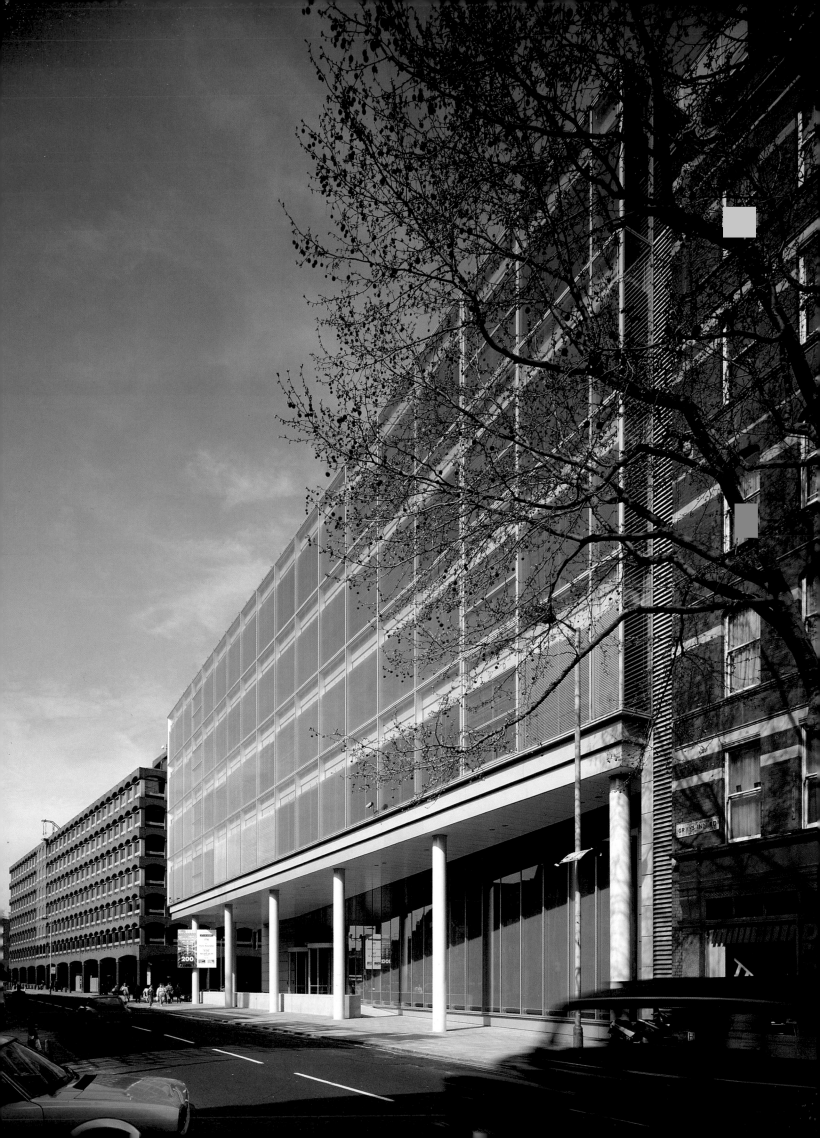

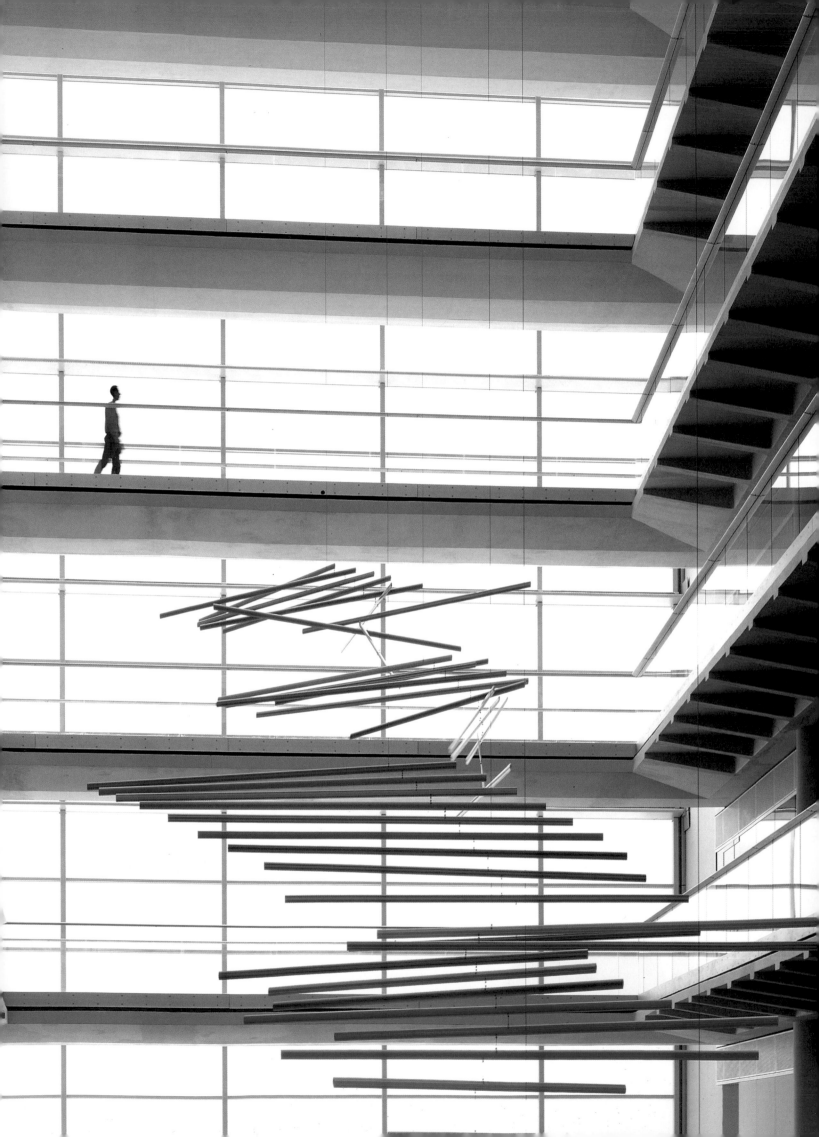

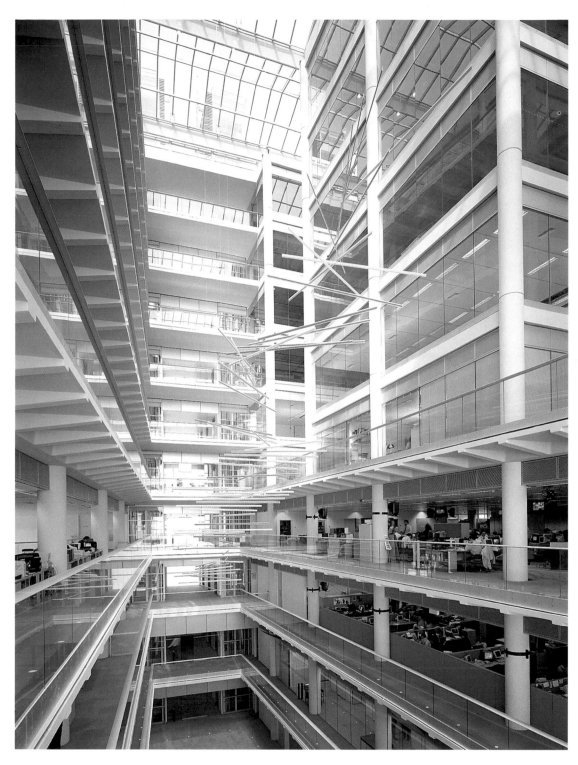

Pages 86, 87 top: *Views of the central atrium, with a sculpture by Ben Johnson.*
Page 87 bottom: *The seventh-floor plan shows the skewed form of the atrium.*

Seite 86, 87 oben: *Ansichten des zentralen Atriums mit einer Skulptur von Ben Johnson.*
Seite 87 unten: *Der Grundriß der siebten Etage zeigt die asymmetrische Form des Atriums.*

Pages 86, 87 en haut: *Vues de l'atrium central, avec une sculpture de Ben Johnson.*
Page 87 en bas: *Le plan du 7ᵉ étage montre la forme en biais de l'atrium.*

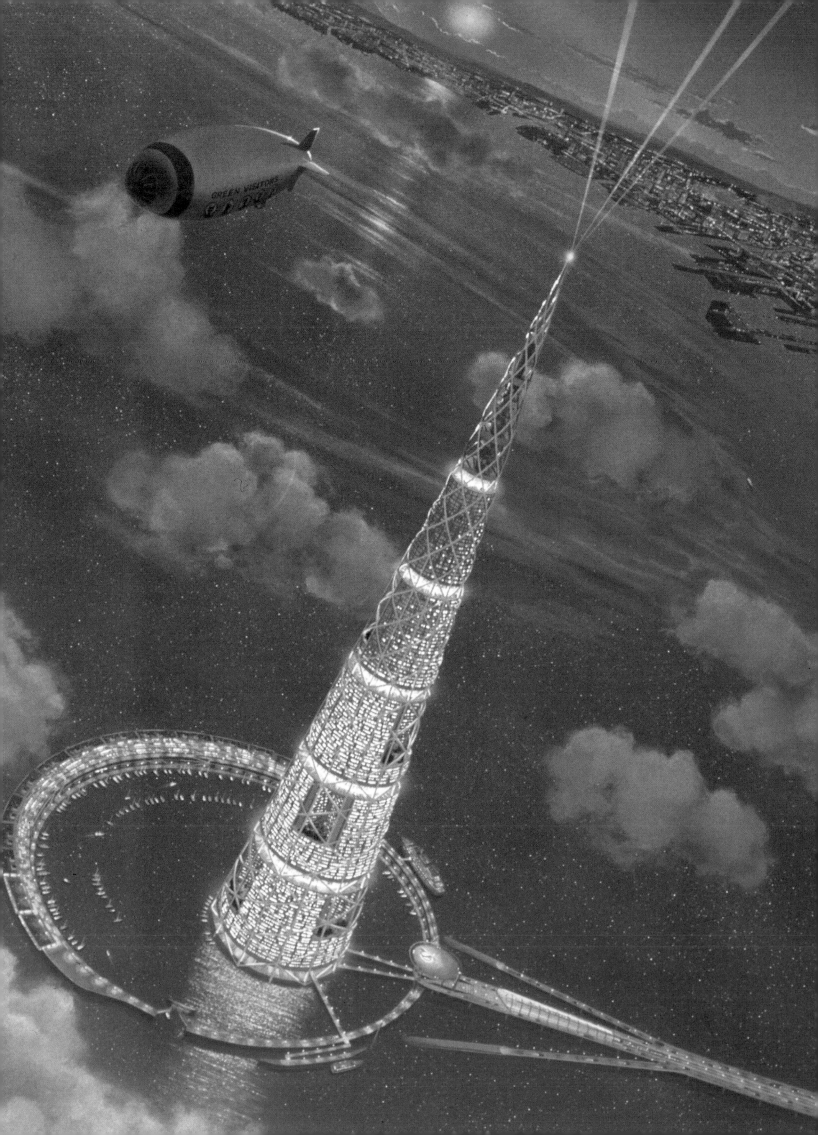

Tokyo Millennium Tower
Tokyo, Japan, 1989

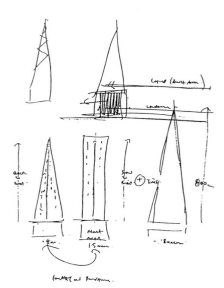

Frank Lloyd Wright imagined a tower one mile high, but Norman Foster took the concept of the ultra tall building a step further by actually delving into the formidable design problems posed by a 170-story, 840 meter high tower to be built in the Bay of Tokyo. Almost twice the height of the Sears Tower in Chicago, it would have a "resident population of 50,000," fleshing out Foster's concept of a work place which would also include living space, a vertical town. With an estimated cost of £10 billion and an impressive area of 1,039,206 m², the Millennium Tower was a victim of the bursting of the real estate "bubble" in Japan, but Foster maintains that he still hopes to construct some version of the building. An unpublished variant of the project, conceived for a Shanghai site with Donald Trump, was called the M Tower. Unlike the Millennium Tower with its central core, the M Tower would have a hollow center, allowing sunlight to penetrate from one side to the other. Working with the Obayashi Corporation of Japan, the clients for the project, they were able to demonstrate that the development would be self-sufficient and could even process its own waste.

Während Frank Lloyd Wright nur von einem Turm von einer Meile Höhe träumen konnte, stellte sich Sir Norman Foster den gewaltigen Problemen bei der Konzeption eines extrem hohen Bauwerks und entwarf einen 840 m hohen Turm mit 170 Geschossen für die Bucht von Tokio. Nahezu doppelt so hoch wie der Sears Tower in Chicago, sollte dieser Turm etwa »50 000 Bewohner« beherbergen und damit Fosters Vorstellung eines Arbeitsplatzes verwirklichen, der gleichzeitig Wohnraum bietet – eine vertikale Stadt. Mit geschätzten Baukosten in Höhe von etwa 25 Milliarden DM und einer beeindruckenden Gesamtfläche von 1 039 206 m² wurde der Millennium Tower jedoch ein Opfer der Immobilien-»Seifenblase« in Japan. Eine unveröffentlichte Variante des Projektes, die er zusammen mit Donald Trump für ein Grundstück in Shanghai konzipierte, wurde »M Tower« genannt. Im Gegensatz zum Millennium Tower mit seinem zentralen Kern sollte der M Tower von innen hohl sein, damit das Sonnenlicht das Gebäude durchdringen und der Turm für seinen eigenen Energiebedarf sorgen konnte.

Frank Lloyd Wright avait imaginé une tour d'un kilomètre et demi de hauteur (Mile High Tower). Norman Foster a repris le concept pour explorer les formidables problèmes de conception posés par la construction d'une tour de 170 étages et de 840 m de haut dans la baie de Tokyo. Presque deux fois plus haute que la Sears Tower de Chicago, elle aurait une population résidente de 50 000 habitants et concrétiserait une idée chère à Foster, celle de la ville verticale. D'un coût estimé de dix milliards de livres, et d'une superficie totale de 1 039 206 m², la Millennium Tower a été victime de la «bulle» immobilière au Japon. Toutefois, Foster affirme qu'il espère toujours construire ce type de bâtiment. Une variante inédite du projet, conçue avec Donald Trump pour Shanghai, a reçu le nom de M Tower. Contrairement à la première, avec son noyau central, celle-ci aurait un centre creux et laisserait la lumière la pénétrer de part en part. Une étude réalisée en collaboration avec la Obayashi Corporation of Japan, commanditaire du projet, indique que le bâtiment serait autosuffisant et pourrait même traiter ses propres déchets.

Page 88: A perspective drawing showing the tower rising from Tokyo Bay.
Page 89: Design sketches by David Nelson.

Seite 88: Eine Perspektivzeichnung des aus der Bucht von Tokio aufragenden Turmes.
Seite 89: Entwurfsskizzen von David Nelson.

Page 88: Perspective montrant la tour s'élevant dans la baie de Tokyo.
Page 89: Esquisses de David Nelson.

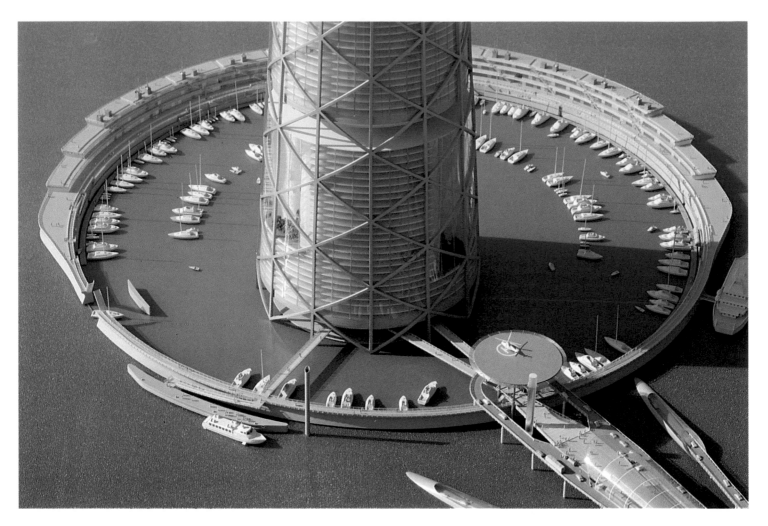

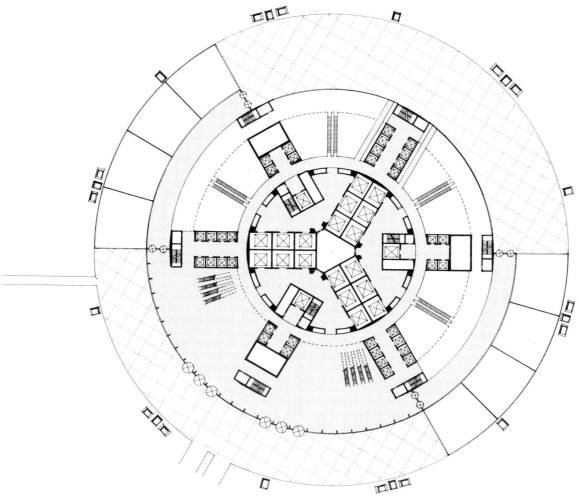

Page 90: With a circular marina around its base, the tower would have a diameter of 126 meters. Left a plan for Level 1.
Page 91: An image of the model, emphasizing the great height of the building.

Seite 90: Mit einem runden Jachthafen um den Sockel besäße der Turm einen Durchmesser von 126 m, links ein Grundriß der ersten Etage.
Seite 91: Die Modellansicht verdeutlicht die Höhe des Gebäudes.

Page 90: Avec une marina circulaire autour de sa base, la tour mesurerait 126 m de diamètre. A gauche un plan du premier niveau.
Page 91: Image de la maquette soulignant la hauteur du bâtiment.

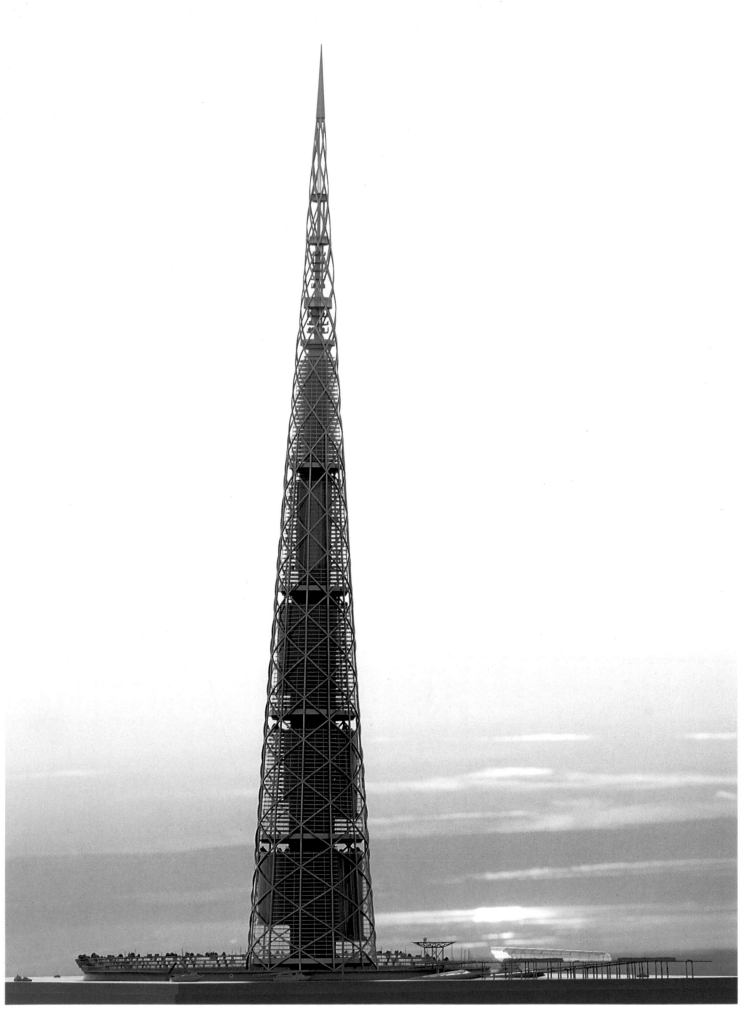

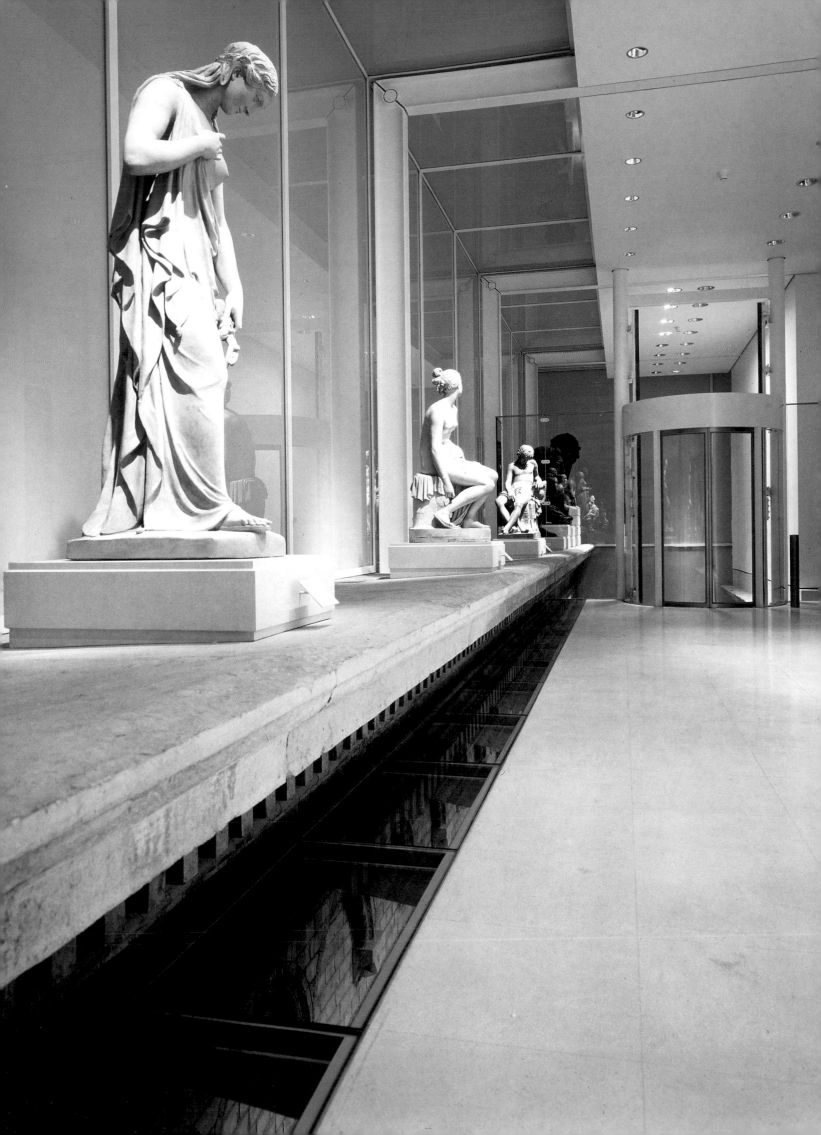

Sackler Galleries, Royal Academy of Arts

London, UK, 1989–1991

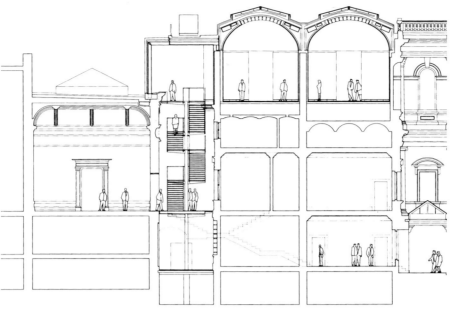

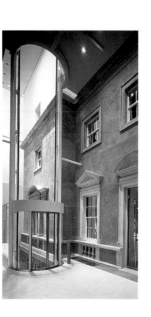

Foster created a new sequence of spaces for movement between the existing galleries and a new complex – the Sackler Galleries, which he designed at the roof level of Burlington House (Hugh May, 1666). A glass staircase and elevator has been inserted into a new space between the original 17th century house and the 19th century additions. The original historic facades, now restored, are visible again for the first time in over a hundred years. The new galleries are used for temporary exhibitions. Sculptures from the Academy's permanent collection including Michelangelo's Tondo of the Virgin and Child with the Infant Saint John have been installed on a parapet created within the lightwell. Confirming the continued interest of Norman Foster's office in smaller-scale work, the Sackler Galleries (312 square meters), and all the new circulation spaces were achieved within a budget of just over £4 million. This demonstrates how much a talented architect can do with restricted space and means. In 1993, 135,000 people visited the new galleries.

Foster schuf eine neue Folge von Räumen, die die Bewegung zwischen den bereits existierenden Galerien und einem neuen Komplex ermöglichen – den Sackler Galleries, die er im Dachgeschoß des Burlington House (Hugh May, 1666) entwarf. Man baute ein verglastes Treppenhaus und einen modernen Fahrstuhl in einen ehemaligen Lichtschacht ein, der zwischen dem ursprünglichen Bauwerk aus dem 17. Jahrhundert und den Ergänzungen aus dem 19. Jahrhundert frei geblieben war. Die historischen Fassaden wurden restauriert und sind zum ersten Mal seit über 100 Jahren wieder zu sehen. Die Sackler Galleries dienen als Raum für Wechselausstellungen. Skulpturen aus der Sammlung der Royal Academy, wie etwa Michelangelos Tondo der »Madonna mit Kind und dem Johannesknaben« wurden auf einer Brüstung montiert, die innerhalb des Lichtschachtes entstanden war. Mit einer Gesamtfläche von 312 m² und Baukosten von kaum 10 Millionen DM zeigen die Sackler Galleries, was ein Architekt wie Foster auch auf kleinem Raum und mit geringem Budget zu schaffen vermag.

Foster a créé une nouvelle série d'espaces permettant de se déplacer entre les galeries existantes et un nouveau bâtiment: les Sackler Galleries. Il les installe au niveau du toit de la Burlington House (Hugh May, 1666). Une cage d'escalier et un ascenseur en verre sont insérés dans une cour intérieure, entre le bâtiment original du XVIIᵉ siècle et ses adjonctions du XIXᵉ. Les façades historiques d'origine ont été restaurées et redeviennent visibles, pour la première fois depuis plus d'un siècle. Les Diploma Galleries, rebaptisées Sackler, accueillent des expositions temporaires. Des sculptures de la collection permanente de l'Academy, et des tableaux dont un tondo de Michel Ange (Vierge à l'Enfant avec Saint Jean enfant) sont exposés dans les nouveaux espaces. Confirmant l'intérêt continu du bureau de Norman Foster pour les travaux à petite échelle, les Sackler Galleries, avec leurs 312 m² seulement, ont été réalisées avec un budget dépassant à peine les quatre millions de livres. Ceci montre bien ce que peut faire un architecte talentueux dans un espace et avec des moyens limités. En 1993, 135 000 personnes ont visité les nouvelles salles.

Page 92: The "Sculpture shelf."
Page 93: A North-south cross-section showing the access area between the two buildings, and the former Diploma Galleries above (top) and the first floor lift lobby (left).

Seite 92: Die Skulpturenbrüstung.
Seite 93: Der Nord-Süd-Querschnitt zeigt den Bereich zwischen den beiden Gebäuden und die ehemaligen Diploma Galleries im oberen Stockwerk, links das Fahrstuhlfoyer auf der ersten Etage.

Page 92: Un alignement de sculptures.
Page 93: Coupe nord-sud montrant le hall d'entrée entre les deux bâtiments et les anciennes Diploma Galleries au-dessus (en haut) et l'entrée avec l'ascenseur au premier étage (à gauche).

Century Tower

Tokyo, Japan, 1989–1991

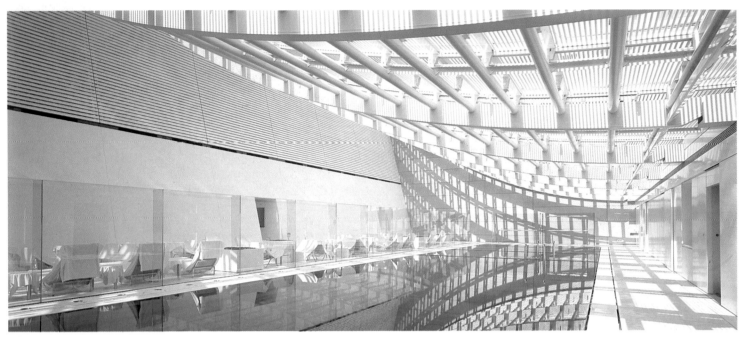

Designed for the Obunsha Publishing Group, these two linked towers of nineteen and twenty-one stories provide an office area of 10,877 square meters. Next to a heavily traveled road and a rail line in the Bunkyo-ku district, the tower is some 136 meters high (top of mast), a relatively unusual sight in earthquake-prone Tokyo, especially outside of the Shinju-ku area, which does now have a number of skyscrapers. Service cores are located on the outside of each of the two towers, allowing the inner office space to be free of columns. An atrium between the two towers rises up the full nineteen stories (71.3 meters), bringing light into the heart of the structure, and lightening the scale of the structure, which responds to the seismic conditions of Japan. These constraints are exploited to create an image that in the context of Tokyo is both distinctive and, according to Foster, "Japanese" in spirit.

Dieser Doppelturm mit 19 und 21 Geschossen wurde für die Obunsha Publishing Group entworfen und bietet 10 877 m² für Büroräume. Mit seiner Höhe von 136 m (bis zur Mastspitze) bietet das im Distrikt Bunkyo-ku an einer stark befahrenen Straße und einer Eisenbahn-linie gelegene Gebäude einen ungewöhnlichen Anblick im erdbebengeplagten Tokio – insbesondere deshalb, weil sich der Doppelturm außerhalb des Shinju-ku-Viertels befindet, wo inzwischen eine ganze Reihe von Wolkenkratzern stehen. Die Versorgungseinheiten liegen an den Außenseiten der beiden Türme, so daß die Büroflächen völlig ohne Säulen auskommen. Ein Atrium, das sich zwischen den beiden Türmen über die gesamte Höhe von 19 Geschossen (71,3 m) erstreckt, bringt Licht in das Innere der Konstruktion, die den seismologischen Bedingungen Japans entsprechend angepaßt werden mußte. Aber Foster gelang es, ein Gebäude zu schaffen, das aus dem architektonischen Kontext Tokios hervorsticht und dennoch »typisch japanisch« wirkt.

Conçues pour le groupe d'édition Obunsha, ces deux tours de 19 et 21 étages, reliées entre elles, offrent une superficie de bureaux de 10 877 m². Au voisinage d'une route à circulation intense et d'une voie ferrée, dans le quartier de Bunkyo-ku, la tour mesure 136 m de haut (au sommet du mât). C'est un spectacle relativement inhabituel pour Tokyo, ville particulièrement sensible aux tremblements de terre, surtout en dehors du quartier Shinju-ku qui compte aujourd'hui plusieurs gratte-ciel. Les espaces techniques sont situés à l'extérieur de chacune des deux tours, ce qui permet de ne pas avoir de colonnes à l'intérieur des bâtiments. Entre les deux tours, un atrium occupe entièrement les 19 étages (71,3 m). Il apporte la lumière au cœur de la structure et allège la silhouette du bâtiment, qui doit tenir compte de la réglementation antisismique. Ces contraintes sont utilisées pour créer en plein Tokyo un bâtiment à la fois original et, selon Foster, «d'esprit typiquement japonnais».

Page 94: A CAD drawing (left) and an image of the indoor swimming pool (above).
Page 95: The building is designed to respect the strict seismic regulations now required in Japan.

Seite 94: Eine CAD Zeichnung (links) und ein Blick in die Schwimmhalle (oben).
Seite 95: Das Gebäude wurde so entworfen, daß es den strengen japanischen Erdbebenbestimmungen entspricht.

Page 94: Croquis du CAD (à gauche) et une image de la piscine intérieure (ci-dessus).
Page 95: L'immeuble est conçu en respect de la stricte réglementation antisismique en vigueur aujourd'hui au Japon.

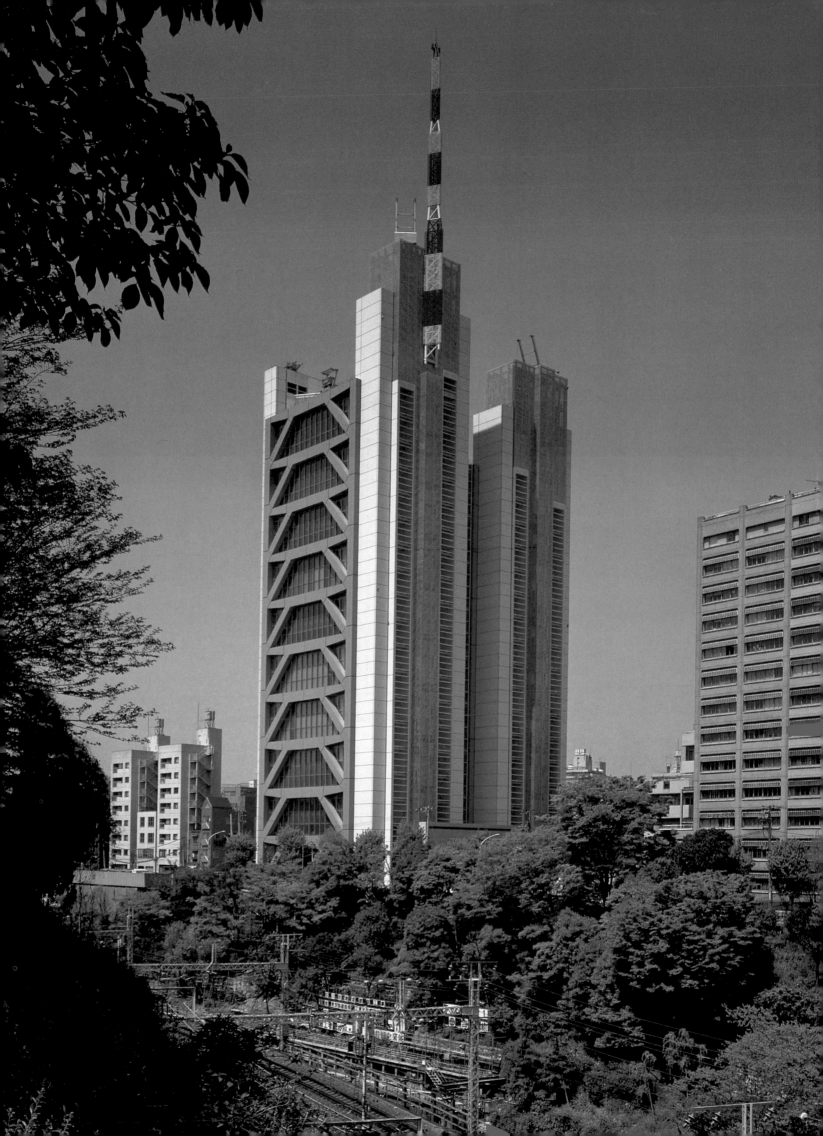

Torre de Collserola

Barcelona, Spain, 1990–1992

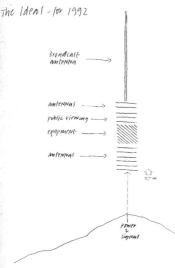

The Ideal - for 1992

Broadcast antenna →

antennas →
public viewing →
equipment →

antennas →

57 m

power & signal

The Mayor of Barcelona, Pasquall Maragal, was concerned that the hill behind the city should not be cluttered with the usual array of telecom masts that have blighted many other cities. His idea was to have a single, elegant structure for all to share. Inaugurated on June 27, 1992, the Torre de Collserola is 288 meters tall, with a public viewing platform situated 135 meters above the ground. Held to the mountainside 440 meters above sea-level by three pairs of guy wires made of pre-tensioned high strength steel, the tower is very stable, despite its extremely thin (4,5 meter diameter) shaft. As always, Norman Foster is fascinated by the technological aspects of his buildings, calling on the most sophisticated techniques and materials available. The project description made by Foster's office proudly points out for example that "the upper guys are made from Aramid fiber cable which does not conduct electricity and so makes unrestricted transmission and reception of signals possible." Foster is also proud of the fact that a

Der Bürgermeister von Barcelona, Pasquall Maragal, vertrat die Ansicht, daß der Berg im Hinterland der Stadt nicht mit der üblichen Phalanx von Sendemasten übersät werden sollte, die die Ansicht vieler anderer Städte ruinierte. Ihm schwebte eine einzelne, elegante Konstruktion vor. Der am 27. Juni 1992 eingeweihte, 288 m hohe Torre de Collserola besitzt in 135 m Höhe eine dem Publikumsverkehr zugängliche Aussichtsplattform. Der Turm wird auf der dem Gebirge zugewandten Seite in 440 m Höhe über dem Meeresspiegel von drei doppelten Stahlseilen gehalten und ist – trotz des extrem geringen Durchmessers (4,5 m) des Säulenschaftes – außerordentlich standfest. Auch hier begeisterte sich Foster für die technischen Aspekte seines Bauwerks, die den Einsatz hochentwickelter Techniken und Materialien erforderten. Sein Architekturbüro vermeldet in der Projektbeschreibung nicht ohne Stolz: »...die oberen Abspannseile wurden aus nicht leitender Aramidfaser gefertigt, so daß ein ungestörtes Senden und Empfangen von Funk-

Le maire de Barcelone, Pasquall Maragal, voulait éviter que la colline derrière la ville se voit encombrée par l'habituel déploiement d'antennes de télécommunications qui ont abîmé tant d'autres cités. Son idée était d'avoir une structure unique et élégante. Inaugurée le 27 juin 1992, la Torre de Collserola s'élève à 288 m et offre au public une plate-forme d'observation à 135 m au-dessus du sol. Retenue au flanc de la colline, à 440 m au-dessus du niveau de la mer, par trois paires de haubans en acier pré-tendu, extrêmement résistant, la tour est parfaitement stable, malgré sa hampe extraordinairement fine (4,5 m de diamètre). Comme toujours, Norman Foster – fasciné par l'aspect technologique de ses constructions – a fait appel aux techniques et aux matériaux les plus sophistiqués. La description du projet, publiée par son agence, signale fièrement par exemple que «les haubans supérieurs sont fabriqués avec du câble de fibre Aramid qui n'est pas conducteur d'électricité, ce qui permet la transmission et la réception des signaux sans au-

Page 96: A sketch by Norman Foster (left). A site plan (top) shows the contours of the hill.
Page 97: Image of the tower seen from below.

Seite 96: Eine Skizze von Norman Foster (links). Der Lageplan (oben) zeigt die Höhenlinien des Berges.
Seite 97: Blick auf den Turm von unten.

Page 96: Esquisse de Norman Foster (à gauche). Plan du site (en haut) montrant les contours de la colline.
Page 97: La tour vue d'en bas.

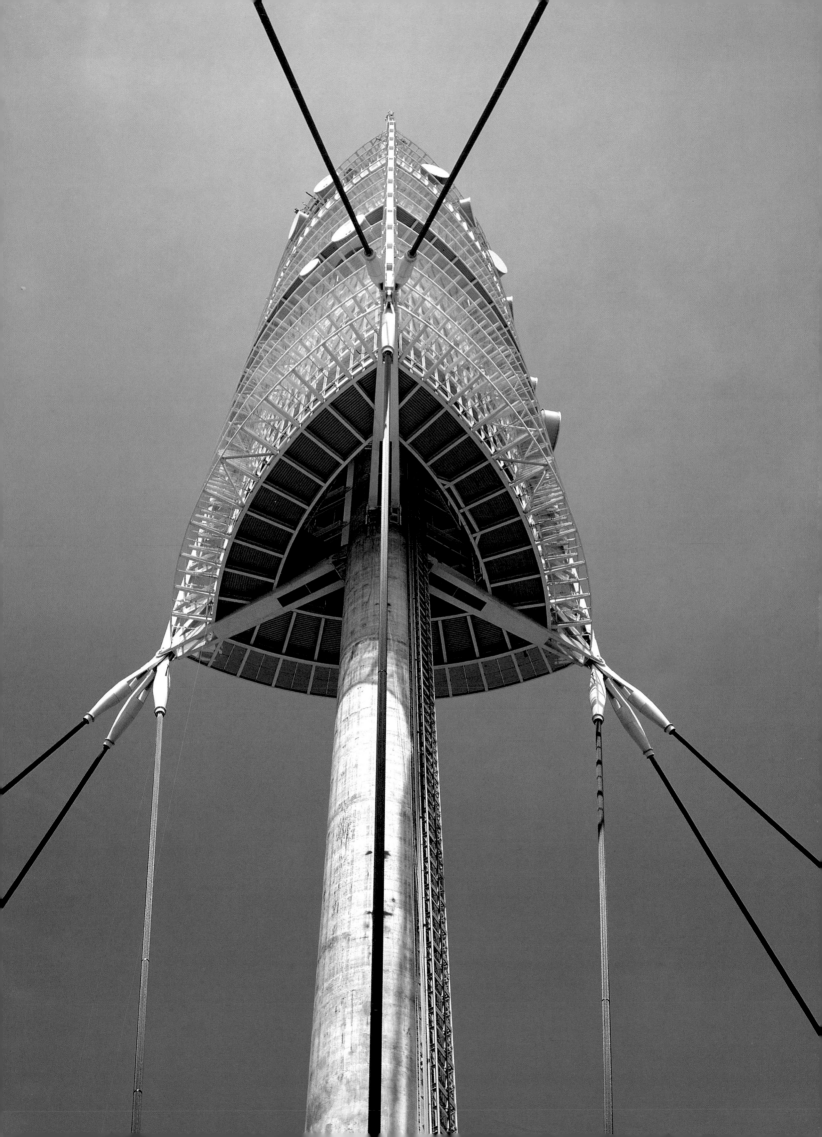

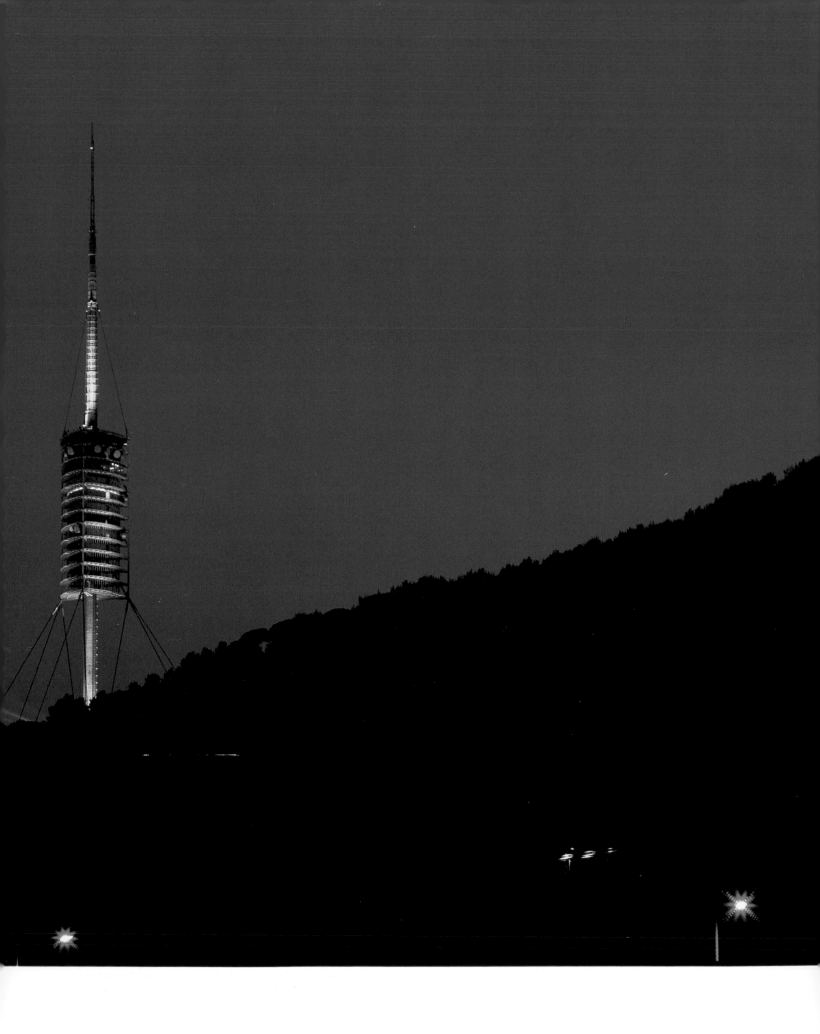

Although the tower stands symbolically above the city, its slim, elegant design allows it to be present without dominating either its immediate surroundings or Barcelona itself.

Der symbolisch hoch über Barcelona thronende Mast erscheint aufgrund seines schlanken, eleganten Designs präsent, ohne seine unmittelbare Umgebung oder die Stadt selbst zu dominieren.

Bien que, de manière symbolique, la tour se dresse au-dessus de la ville, elle s'impose par ses lignes élégantes et élancées sans écraser l'environnement immédiat ni la ville de Barcelone.

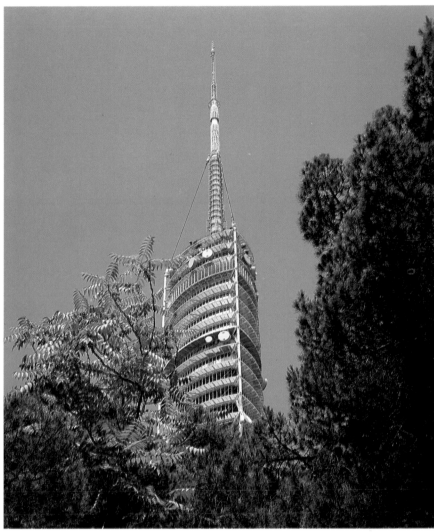

more conventional design for a tower of this height would have required a main shaft more than six times broader (25 meters in diameter). This solution was also sensitive to the site, which was a protected woodland. It was in May 1988 that he won the competition for a "monumental technological element" which was part of the city's renovation for the 1992 Summer Olympic Games.

signalen möglich wird.« Daneben legt Foster Wert auf die Feststellung, daß ein konventioneller Entwurf eines Turmes von dieser Größe einen sechsmal breiteren Säulenschaft mit einem Durchmesser von 25 m erfordert hätte – so daß das Baugelände, ein geschütztes Waldgebiet, erheblich stärker belastet worden wäre. Mit diesem Konzept hatte der britische Architekt im Mai 1988 die Ausschreibung für ein »monumentales technologisches Element« gewonnen, die zu den Sanierungsplänen der Stadt für die Olympischen Sommerspiele 1992 gehörte.

cune restriction». Foster est également fier du fait que, pour une tour de cette hauteur, un projet plus conventionnel aurait nécessité une hampe principale au moins six fois plus large (25 m de diamètre). Cette solution tient également compte du site au sein d'une forêt protégée. C'est en mai 1988 que Foster a remporté ce concours pour un «élément technologique monumental» qui a fait partie de la rénovation de la ville en vue des Jeux Olympiques d'été 1992.

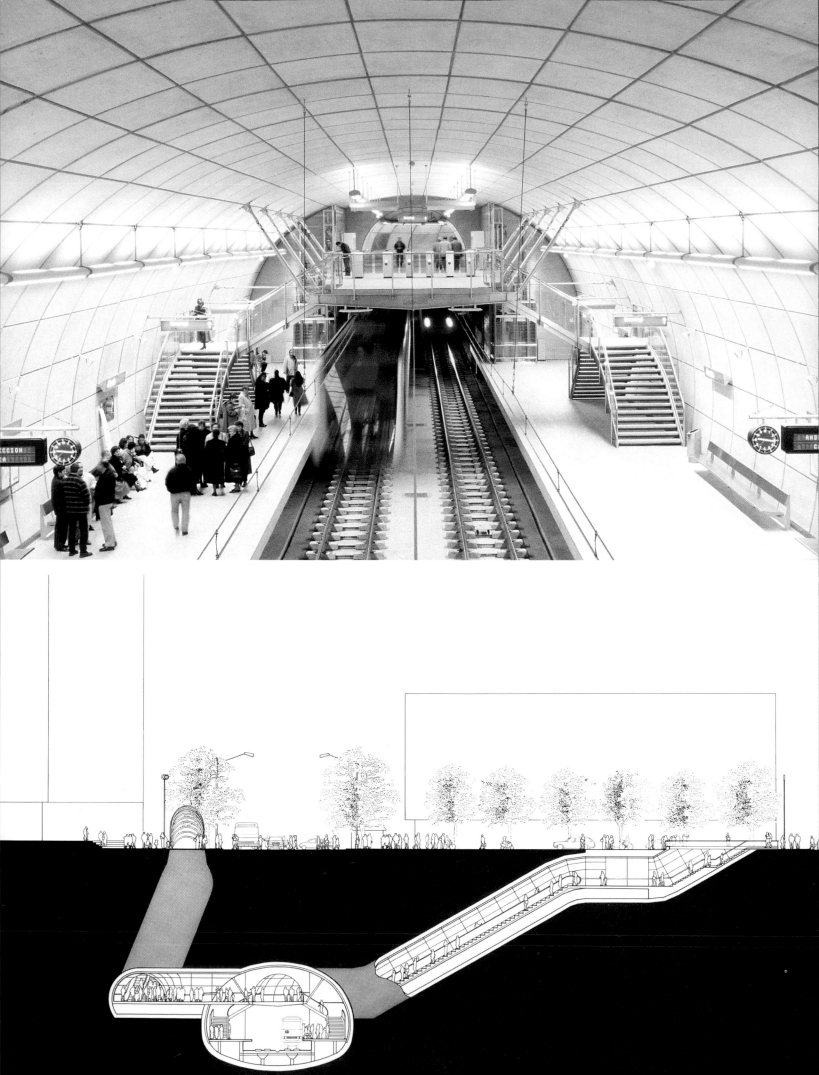

Metro Bilbao

Bilbao, Spain, 1990–95

Norman Foster's metro system is one of a number of projects that mark the 700th anniversary of Bilbao in the year 2000. The others include the Guggenheim Museum by Frank O. Gehry and a footbridge by Santiago Calatrava. The first phase of eight stations will eventually expand to twenty-nine, of which fourteen are underground, with a length of 60 kilometers. As in many other projects, Foster has emphasized accessibility and maintenance-free components. The above ground stations are simple curved glass enclosures, while the underground stations, measuring about 13,500 square meters are compared by the architect to "caverns." The integration of architecture and engineering is important in giving identity and legibility to the system, which serves the one million inhabitants of metropolitan Bilbao, connecting the industrial area, city center and coastal villages.

In Erwartung der Jubiläumsfeierlichkeiten zum 700-jährigen Bestehen der Stadt im Jahr 2000 beauftragte Bilbao eine Reihe international renommierter Architekten mit verschiedenen Projekten, darunter Frank O. Gehry mit dem Guggenheim Bilbao Museum, Santiago Calatrava mit einer Fußgängerbrücke und Norman Foster mit dem ersten Bauabschnitt (acht Stationen) der städtischen U-Bahn. Nach Fertigstellung soll Bilbaos U-Bahnsystem 29 Stationen – davon 14 unterirdische – auf einer Streckenlänge von 60 km umfassen. Foster legte besonderen Wert auf leichte Zugänglichkeit sowie wartungsfreie Bauelemente. Bei den oberirdischen Stationen handelt es sich um einfache gerundete Glasbauten, während Foster die unterirdischen Stationen von etwa 13 500 m² Gesamtfläche mit »Höhlen« vergleicht. Die gelungene Verbindung von Architektur und Ingenieurtechnik schafft einen hohen Wiedererkennungswert für ein U-Bahn-System, das das Industriegebiet mit dem Stadtzentrum und den Siedlungen an der Küste verbindet und so ein wichtiges Transportmittel der Millionenstadt Bilbao darstellt.

Pour préparer son 700ᵉ anniversaire en l'an 2000, Bilbao a fait appel à un certain nombre d'architectes mondialement reconnus, dont Frank O. Gehry pour le musée Guggenheim de Bilbao, une passerelle signée Santiago Calatrava, et la première phase du métro urbain, confiée à Norman Foster et qui comprend huit stations. Ultérieurement, le réseau comptera au total 29 stations dont 14 souterraines, et aura 60 km de voies. Comme dans beaucoup d'autres projets, Foster a mis l'accent sur l'accessibilité et la légèreté, grâce à des composants ne nécessitant pas d'entretien. Les stations en surface sont de simples enceintes en verre incurvé, tandis que les stations souterraines, d'une superficie d'environ 13 500 m², sont comparées – par l'architecte – à des «cavernes». L'intégration de l'architecture avec l'ingénierie donne au réseau cohérence et lisibilité: le métro dessert le million d'habitants de la région de Bilbao, et relie la zone industrielle, le centre-ville et les villages côtiers.

Page 100: A cross section through a typical cavern station (bottom) with an escalator visible to the right. This drawing emphasizes the discreet nature of the above ground presence of the station. Above, a station interior.
Page 101: The "Fosterito" station exit at night.

Seite 100: Unten ein Querschnitt durch eine typische »Höhlen«-Station; rechts erkennt man eine Rolltreppe. Die Zeichnung unterstreicht die unaufdringliche Präsenz der oberirdischen Stationen. Oben, Blick in eine Station.
Seite 101: Ausgang der »Fosterito«-Station bei Nacht.

Page 100: Coupe d'une station souterraine typique (en bas) avec les escaliers mécaniques à droite. Le croquis fait ressortir la discrétion de la station en surface. En haut, l'intérieur d'une station.
Page 101: La sortie de la station «Fosterito», la nuit.

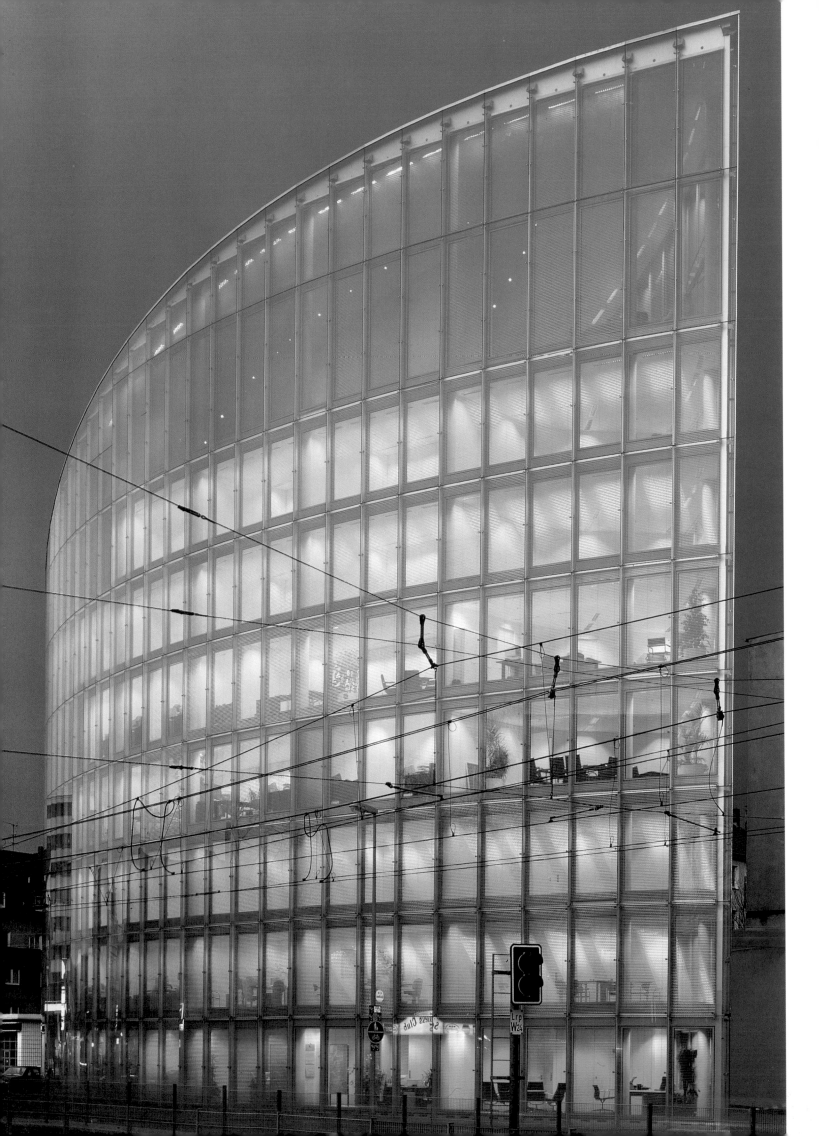

Micro-Electronic Park
Duisburg, Germany, 1990–1996

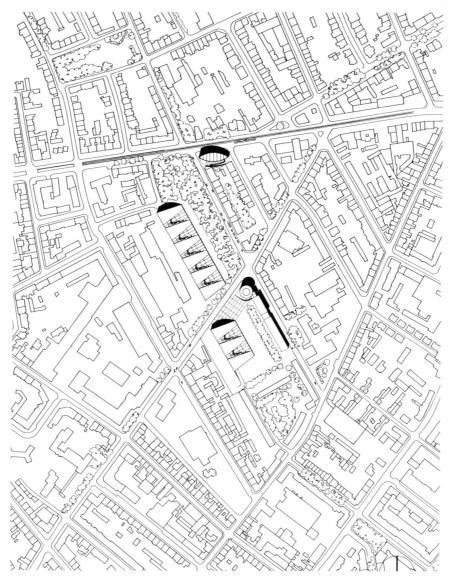

With the decline of the traditional steel industry, Duisburg was left with blighted areas and social problems such as high unemployment. Foster, working with the city and development agencies, has helped in the endeavor to bring in new, environmentally friendly industries such as microelectronics. He has built the Business Promotion Center (1990–93), a 4,000 square meter, £5 million, highly energy-efficient seven-story structure "air-conditioned with a 'source flow' fresh air supply" and the Telematic Center (1990–93), a 3,500 square meter, £4,5 million building "dedicated to cellular offices for small and medium sized new companies;" and the

Seit dem Niedergang der traditionellen Stahlindustrie hat die Stadt Duisburg mit sozialen Problemen wie der hohen Arbeitslosigkeit und mit ehemaligen Industrieflächen zu kämpfen. Aus diesem Grund unterstützten Foster Associates in Zusammenarbeit mit verschiedenen Bauunternehmen die Stadt in ihrem Bemühen um die Ansiedlung neuer, umweltverträglicher Industrien, z.B. aus dem Bereich der Mikroelektronik. Foster baute das Haus der Wirtschaftsförderung (1990–93) – eine 4 000 m² große, 13 Millionen DM teure, siebengeschossige Anlage, »vollklimatisiert durch eine Quelluftanlage« sowie das Telematik-Forum (1990–93, auf 3 500 m², Baukosten 12 Millionen DM) mit

À la suite du déclin de l'industrie sidérurgique, il ne reste à Duisburg que des zones sinistrées et des problèmes sociaux comme le chômage. Travaillant en collaboration avec la ville et les agences de développement, Foster s'efforce d'y faire venir de nouvelles industries, plus respectueuses de l'environnement, telle que la microélectronique. Là, il a construit le Centre de développement commercial (1990–93), une structure de 4 000 m², revenant à cinq millions de livres, sur sept étages avec «une climatisation provenant d'une circulation d'air frais spécialement étudiée». Le Centre Télématique (1990–93), bâtiment couvrant 3 500m², au prix de 4,5 millions de livres est

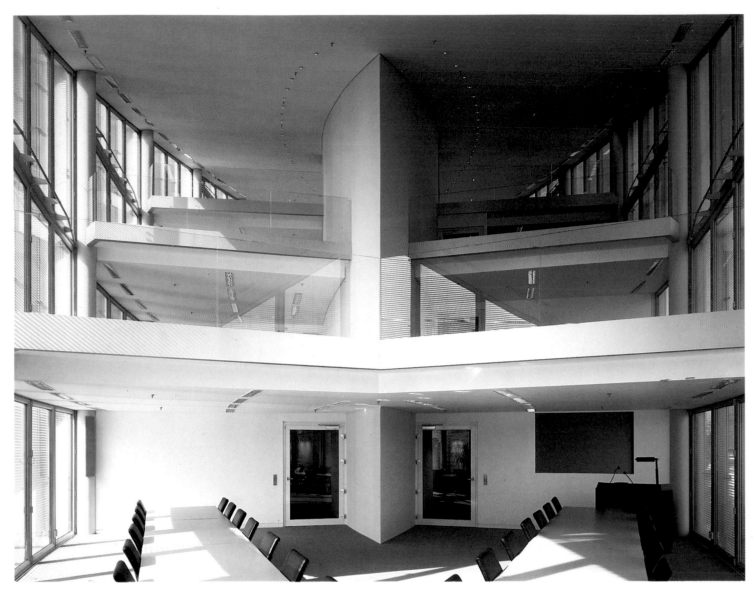

Page 104: *An interior view of the Business Promotion Center.*
Page 105: *The Telematic Center at night, and below, an interior view.*

Seite 104: *Eine Innenaufnahme des Hauses der Wirtschafts-förderung.*
Seite 105: *Das Telematik-Forum bei Nacht (oben) und eine Innenansicht (unten).*

Page 104: *Vue intérieure du Centre de développement commercial.*
Page 105: *Le Centre télématique, la nuit (en haut) et vu de l'intérieur (en bas).*

Micro-Electronic Center (1995–96), a laboratory and office building of 15,000 square meters. All of the projects pursue ecological concerns. For example, the Business Promotion Center generates its own electricity and converts the waste heat from the process into free cooling for the offices.

»Bürozellen für kleine und mittlere Betriebe« und das Mikroelektronik-Zentrum (1995–96), ein Labor- und Bürogebäude von 15 000 m². Alle drei Projekte wurden besonders umweltbewußt konzipiert: So ist beispielsweise das Haus der Wirtschaftsförderung in der Lage, seinen eigenen Strom zu erzeugen – wobei die bei diesem Prozeß anfallende überschüssige Wärme für die Klimatisierung der Büroräume umgewandelt wird.

«destiné à des bureaux cellulaires, pour de jeunes entreprises de petite et de moyenne dimensions». Enfin, le Centre de microélectronique (1995–96) est un immeuble de laboratoires et de bureaux. Tous les projets sont respectueux de l'environnement. Ainsi, le Centre de développement commercial génère sa propre électricité et convertit la chaleur non utilisée en un système de refroidissement pour les bureaux.

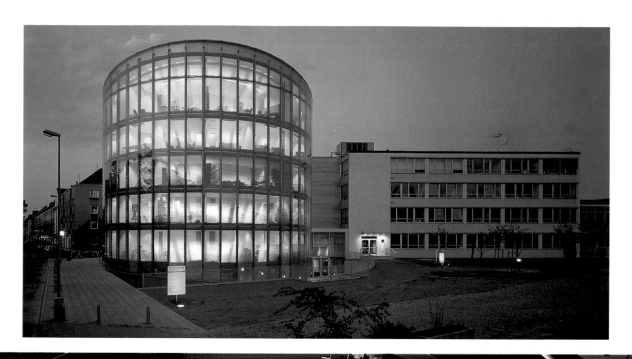

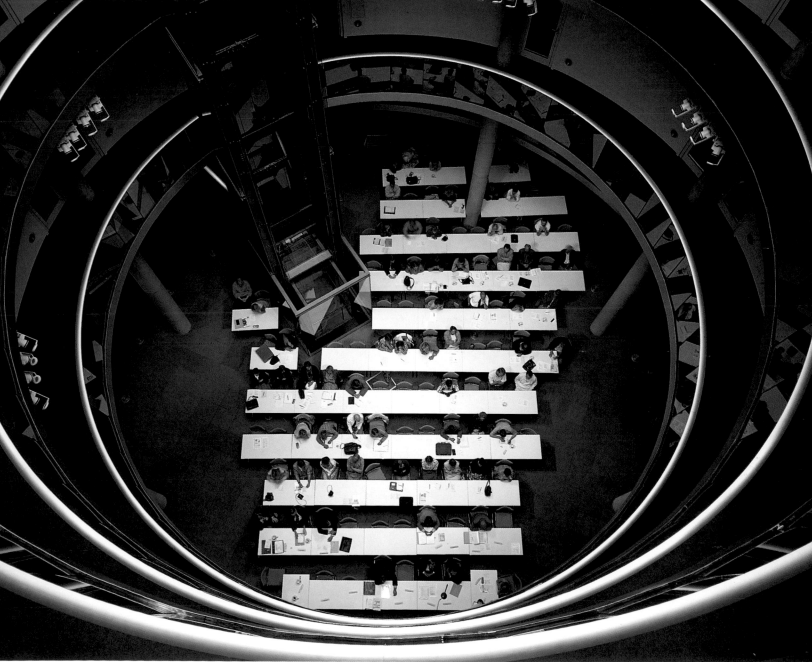

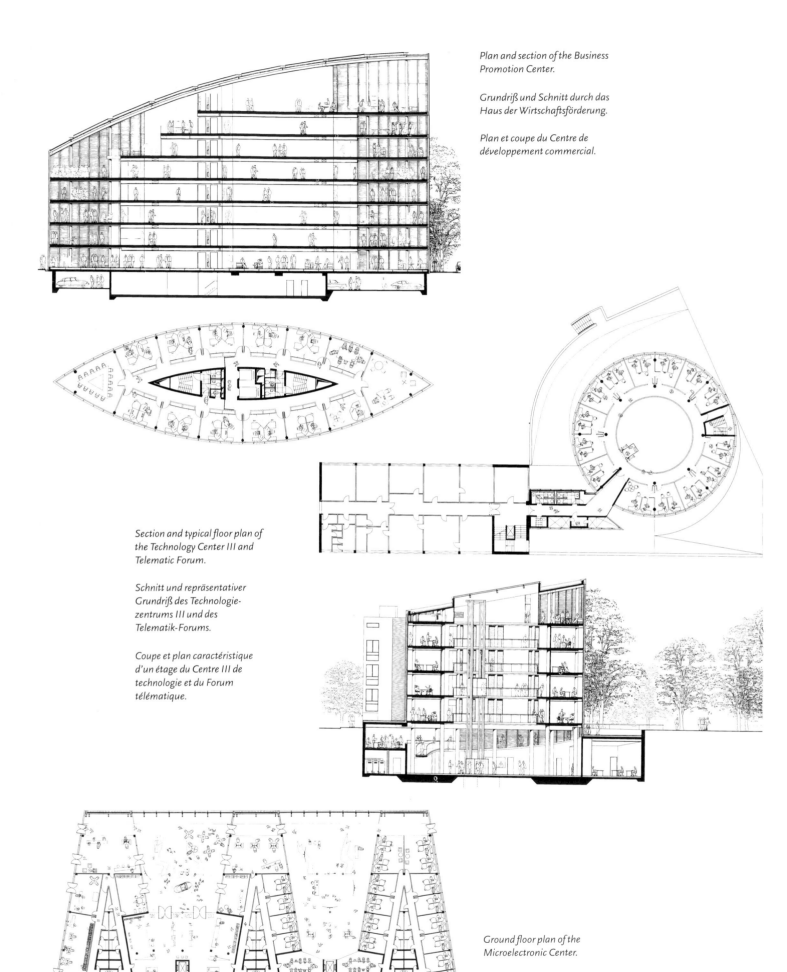

Plan and section of the Business Promotion Center.

Grundriß und Schnitt durch das Haus der Wirtschaftsförderung.

Plan et coupe du Centre de développement commercial.

Section and typical floor plan of the Technology Center III and Telematic Forum.

Schnitt und repräsentativer Grundriß des Technologie-zentrums III und des Telematik-Forums.

Coupe et plan caractéristique d'un étage du Centre III de technologie et du Forum télématique.

Ground floor plan of the Microelectronic Center.

Erdgeschoßgrundriß des Mikroelektronik-Zentrums.

Plan du rez-de-chaussée du Centre de microélectronique.

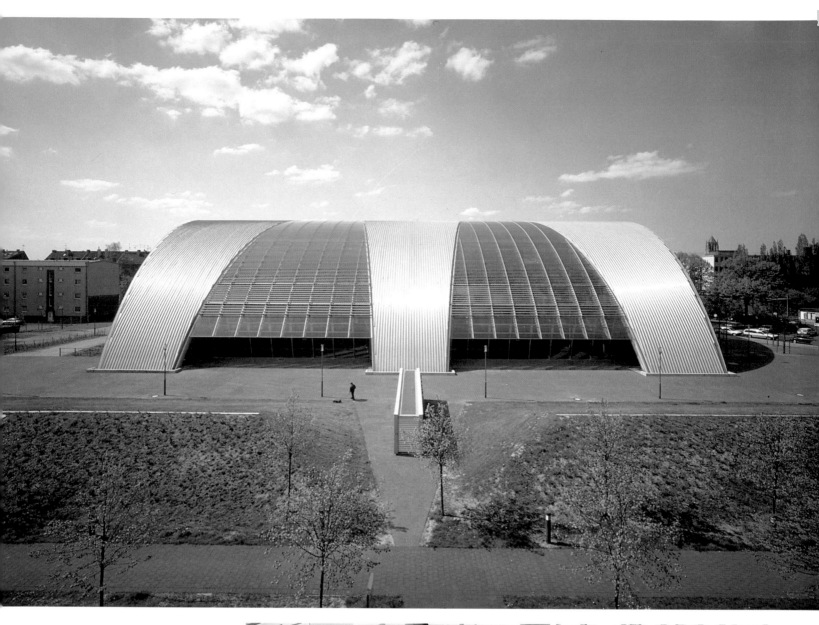

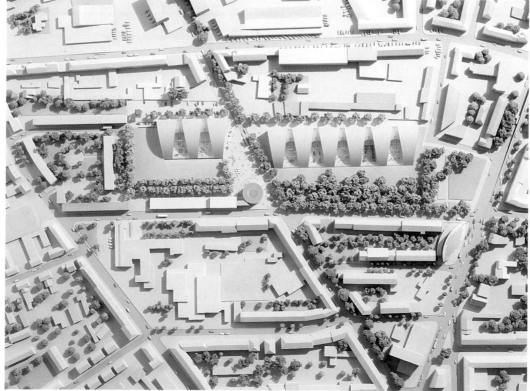

Above: The Microelectronic Center.
Right: In a bird's eye view, a model of the Micro-Electronic Park.

Oben: Das Mikroelektronik-Zentrum.
Rechts: Modell des Mikroelektronik-Parkes, aus der Vogelperspektive gesehen.

Ci-dessus: Centre de microélectronique.
À droite: Maquette du parc de microélectronique (vue cavalière).

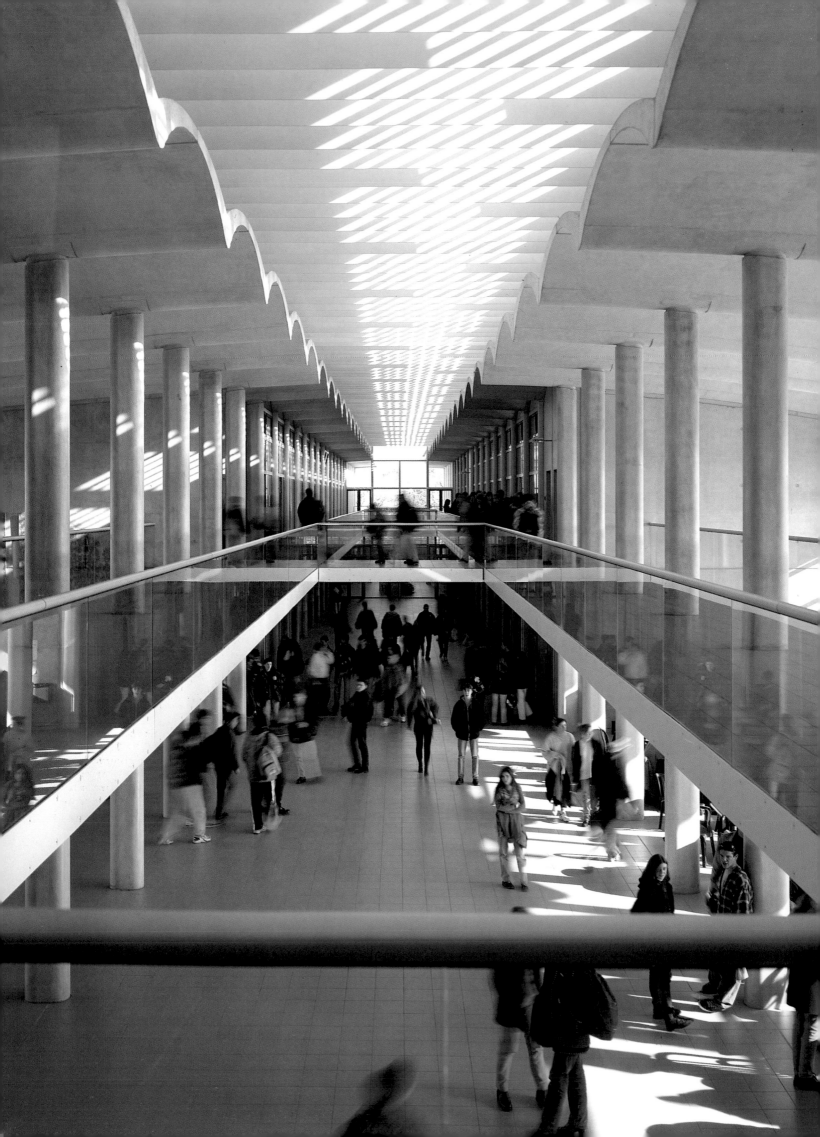

Lycée Albert Camus

Fréjus, France, 1992–1993

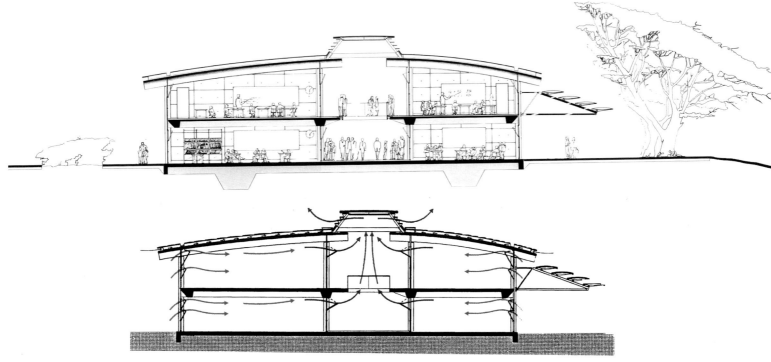

Standing on a hill looking out to sea, the Lycée Albert Camus accommodates 900 students. Foster emphasizes the use of a number of locally inspired devices in this building, such as the entrance space "like a Mediterranean village square," and a "double height cavity between the roof and concrete vaults (using) ventilation techniques of traditional Arab architecture." This "solar chimney" effect allows warm air to rise out of the building through operable louvers. One of the most visible elements of the 12,420 square meter school is the wide brise soleils on the southern side. These features of the design demonstrate the care taken in making use of natural cooling as opposed to the air conditioning. This Lycée was built for a budget of £2.8 million in one year, further proof of Foster's ability to deal effectively with tight schedules and budgets.

Das Lycée Albert Camus wurde für 900 Schüler gebaut und steht auf einem Hügel mit Blick auf das Meer. Foster hebt bei diesem Gebäude die Verwendung einiger lokal inspirierter Einfälle hervor, wie etwa im Falle des Eingangsbereichs, der »an einen mediterranen Dorfplatz erinnert« oder der »überhöhten Wölbung zwischen Dach und Betonschalung, die die Lüftungstechnik traditioneller arabischer Architektur nutzt«. Dieser »Sonnenkamin« ermöglicht den Abzug der warmen Luft durch steuerbare Lamellen. Eines der auffälligsten Kennzeichen der 12 420 m² großen Schule sind die breiten Sonnenschutzelemente auf der Südseite. Diese Besonderheiten des Entwurfs zeigen, wie hier mit sorgfältiger Planung natürliche Belüftungsmöglichkeiten ausgenutzt werden konnten, anstatt einfach auf eine herkömmliche Klimaanlage zurückzugreifen. Das Lycée wurde innerhalb eines Jahres mit einem Budget von 7 Millionen DM gebaut und ist ein weiterer Beweis für Fosters effektiven Umgang mit eng gesteckten Zeitplänen und schmalen Budgets.

Situé sur une colline orientée vers la mer, le lycée Albert Camus peut accueillir 900 élèves. Foster insiste sur l'emploi d'un certain nombre de dispositifs d'inspiration locale, comme le hall d'entrée «semblable à une place de village méditerranéen» et sur le vide aménagé entre le toit et les voûtes en béton, selon une technique d'aération inspirée de l'architecture arabe traditionnelle. Cet effet de «cheminée solaire» permet à l'air chaud de s'élever et de sortir du bâtiment entre des lames orientables. L'un des éléments les plus visibles de cette école d'une superficie de 12 420 m² est constitué par de larges brise-soleil, sur le côté sud. Ces particularités montrent bien le soin apporté à l'installation d'une climatisation naturelle qui évite le recours à l'air conditionné. Le lycée a été réalisé avec un budget de 2,8 millions de livres en une seule année, preuve supplémentaire de la capacité dont fait preuve Foster de respecter les délais et les budgets.

Page 108: *An interior view of the central "street."*
Page 109: *A section through classrooms, showing the overhanging sunscreen to the right. Below that, a diagram of the natural air flow generated through the structure.*

Seite 108: *Eine Innenansicht der zentralen »Straße«.*
Seite 109: *Ein Querschnitt durch die Klassenräume zeigt den auskragenden Sonnenschutz auf der rechten Seite , darunter ein Diagramm des natürlichen Luftstromes, der innerhalb des Gebäudes erzeugt wird.*

Page 108: *Vue de la «rue» centrale.*
Page 109: *Coupe des salles de classe montrant les brise-soleil en surplomb sur la droite. En dessous, diagramme de la circulation d'air naturel dans la structure.*

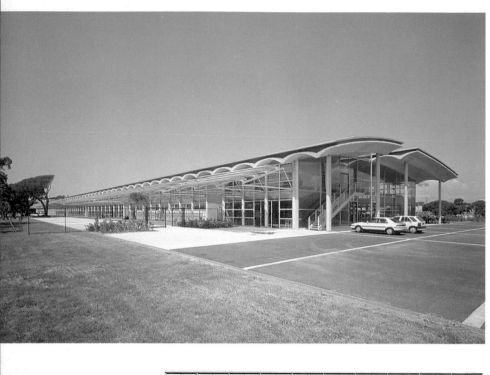

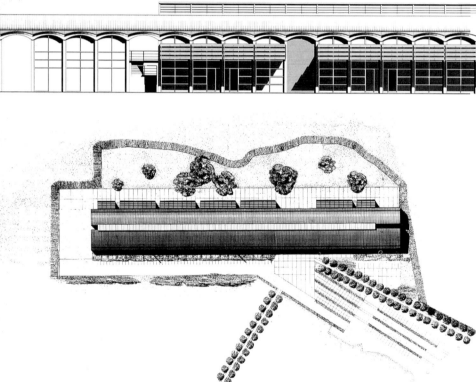

A site plan, elevation and exterior views of the Lycée Albert Camus. The design is intended to take advantage of breezes while shielding the interior from the intense sun.

Ein Lageplan, ein Querschnitt und Außenansichten des Lycée Albert Camus. Das Gebäude ist so konzipiert, daß es Luftströmungen nutzen und gleichzeitig das Innere vor intensiver Sonneneinstrahlung schützen kann.

Plan du site, élévation et vues du lycée Albert Camus. Le bâtiment est conçu de manière à profiter des brises et à protéger les espaces intérieurs de l'ardeur du soleil.

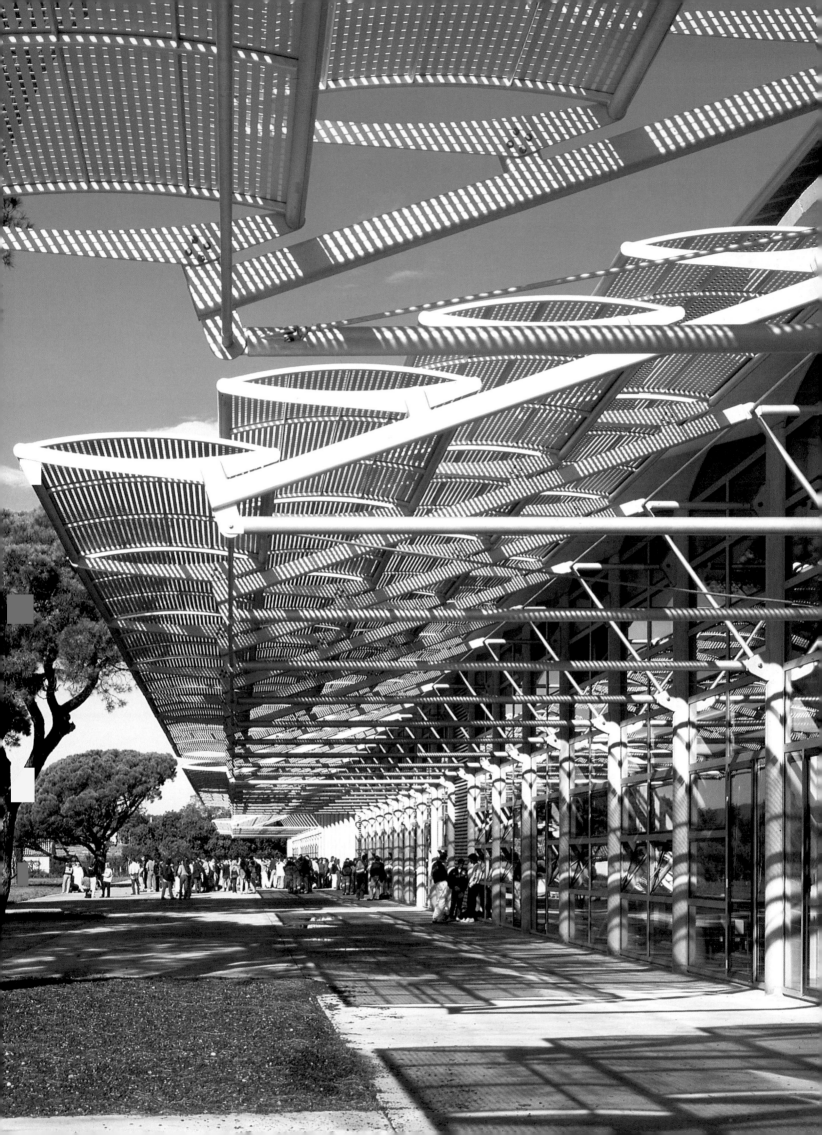

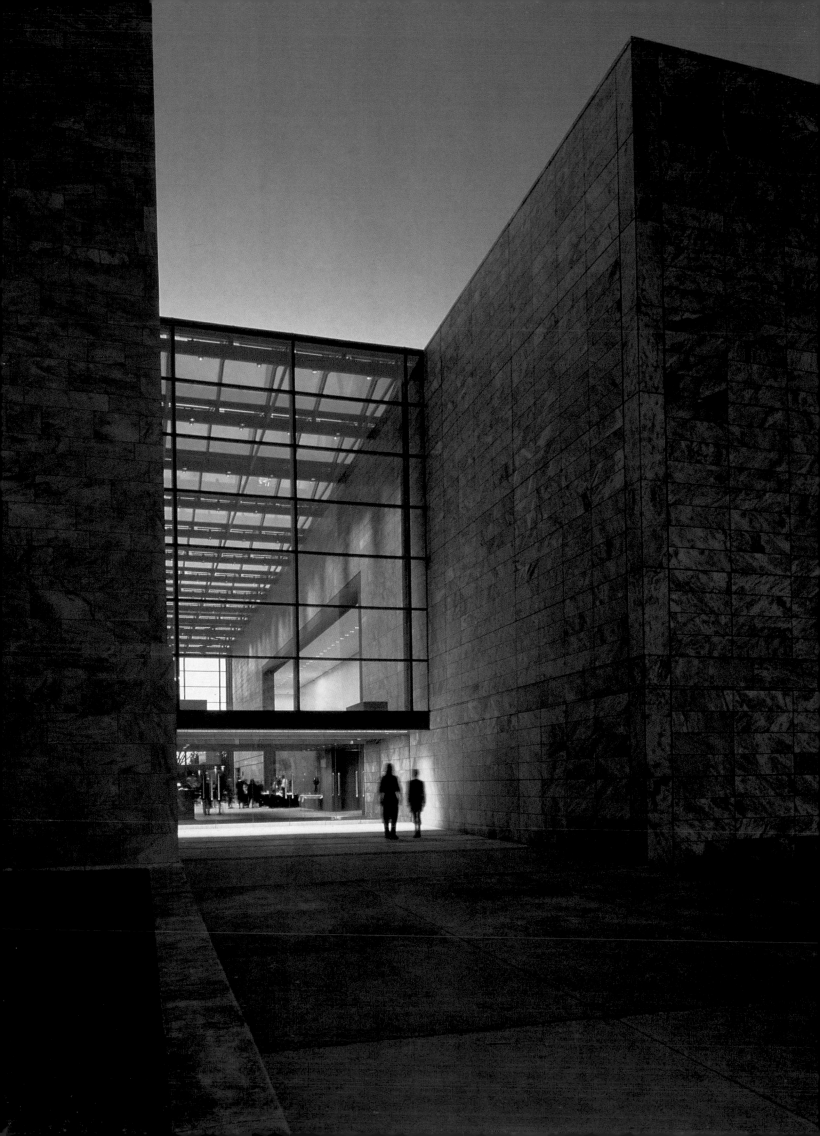

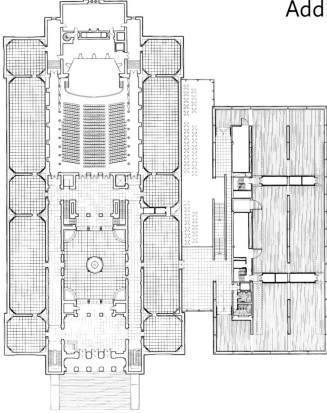

Addition to Joslyn Art Museum
Omaha, Nebraska, USA, 1993–1994

Norman Foster won this commission in an invited competition with James Freed, Antoine Predock, Christian de Portzamparc and Renzo Piano. He was called on to add 5,000 square meters of gallery and workshop space to the original 1931 Beaux Arts, Art Deco museum and concert hall structure. His site was a parking lot located directly to the north. Foster's solution is a rectangular block, clad in pink Etowah Fleuri marble like the 1931 building, and connected to it by a glazed passage. A high glass atrium mediates the relation of the old and the new, but the rather austere appearance of the whole, together with the marble cladding, set this building aside in the œuvre of Norman Foster, although it follows the same approach as his remodeling of the Royal Academy in London. It may be interesting to note that a maximum price of $140 per square foot (for a total of 58,000 square feet) was agreed to before construction began.

Bei einem Wettbewerb, zu dem Foster neben James Freed, Antoine Predock, Christian de Portzamparc und Renzo Piano eingeladen wurde, bekam Foster den Auftrag. Man forderte ihn auf, an den ursprünglichen, 1931 erbauten Komplex, bestehend aus einem Museum und einer Konzerthalle im Art déco Stil, weitere 5 000 m² Galerieflächen und Werkstätten anzufügen. Fosters Anbau besteht aus einem rechteckigen Block in Marmorverkleidung (wie das Originalgebäude), der mit dem ursprünglichen Bauwerk durch eine verglaste Passage verbunden ist. Ein hohes, gläsernes Atrium stellt einen Bezug zwischen Alt und Neu her. Aufgrund des eher strengen Erscheinungsbildes des Gesamtkomplexes und der Marmorverkleidung unterscheidet sich das Joslyn Art Museum von Fosters restlichen Bauten – obwohl es dem gleichen Konzept folgt wie Fosters Umgestaltung der Royal Academy in London. Interessanterweise wurde vor Baubeginn ein Maximalpreis von etwa 2 400 DM pro m² für eine Gesamtfläche von 5 390 m² genehmigt.

James Freed, Antoine Predock, Christian de Portzamparc, Renzo Piano et Norman Foster avaient été invités à présenter leurs idées pour l'extension du Joslyn Art Museum. C'est finalement le projet de Foster qui a été retenu. Le jury a, semble-t-il, été impressionné par le travail de l'architecte aux Sackler Galleries. Il s'agit d'ajouter une galerie de 5 000 m², ainsi que des ateliers, au musée et à la salle de concerts construits en 1931 dans le style Art déco. Pour site, il dispose d'un parking orienté directement au nord. Sa solution: un bloc rectangulaire, recouvert de marbre rose Etowah Fleuri, comme le bâtiment de 1931, et relié à celui-ci par un passage vitré. L'aspect plutôt austère de l'ensemble place ce bâtiment à part dans l'œuvre de Norman Foster. Il est intéressant de noter que l'architecte s'était engagé à ne pas dépasser le plafond de 140 dollars le pied carré.

Page 112: *A night view showing the glazed link between the old building and Foster's addition (on the right).*
Page 113: *A gallery-level plan with the addition to the right.*

Seite 112: *Eine Nachtaufnahme, die die verglaste Verbindung zwischen dem alten Gebäude und Fosters Anbau zeigt (rechts im Bild).*
Seite 113: *Der Erdgeschoß grundriß mit dem Anbau rechts.*

Page 112: *Vue nocturne montrant le passage vitré entre le vieux bâtiment et l'addition de Foster (sur la droite)*
Page 113: *Plan du niveau le plus bas, avec l'addition à droite.*

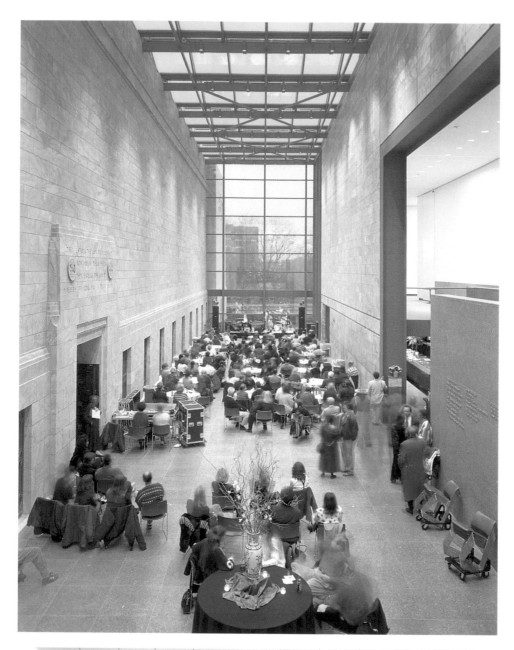

The interior of the link area (top), one of the new galleries (bottom), and above, a cross-section through the building's edge, showing how light is brought into the exhibition space.

Das Innere des Verbindungs-bereiches (oben), ein Blick in einen neuen Ausstellungsraum (unten) und ein Schnitt durch die Gebäudekante, der verdeutlicht, wie Licht in den Ausstellungsbereich geführt wird (oben rechts).

L'intérieur du passage (en haut), une des nouvelles galeries (en bas), et ci-dessus, coupe transversale du bord du bâtiment montrant comment la lumière se diffuse dans les salles d'exposition.

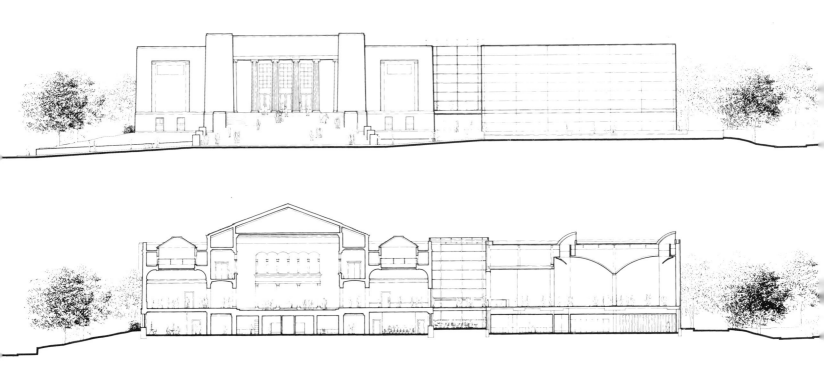

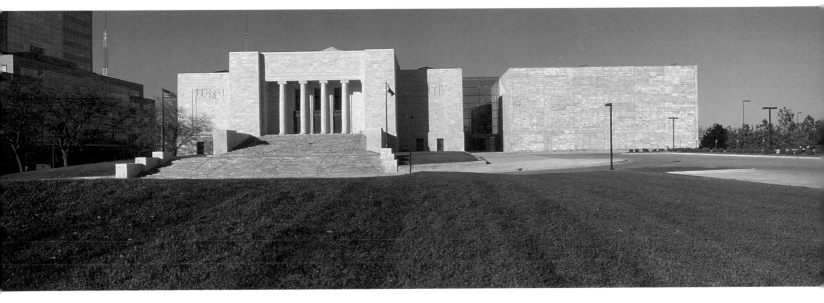

The East elevation and cross
section (top), an exterior view
of the entrance (center), and a
1994 Foster sketch of the same
facade (bottom).

*Aufriß und Schnitt des Ostteils
(oben). Außenansicht des
Eingangs (Mitte) und eine
Skizze der gleichen Fassade
aus dem Jahr 1994 (unten).*

*Élévation Est et coupe
transversale. Au-dessous, vue
extérieure de l'entrée et
croquis de la même façade
réalisé par Foster en 1994.*

Faculty of Law

University of Cambridge, Cambridge, Cambridgeshire, UK, 1993–1995

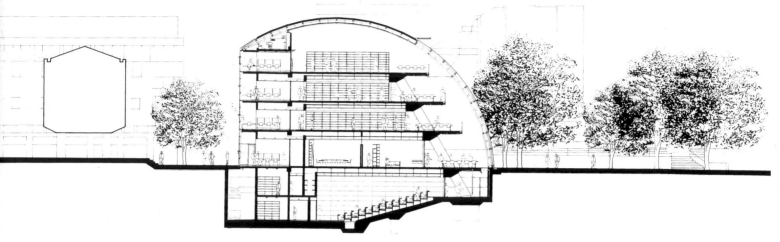

Page 116: *A cross-section.*
Page 117: *A view taken on the ground level inside the Faculty of Law.*

Seite 116: *Ein Querschnitt.*
Seite 117: *Das Erdgeschoß der Faculty of Law.*

Page: 116: *Coupe transversale.*
Page 117: *Vue du rez-de-chaussée à l'intérieur de la faculté de droit.*

Located on the Sidgwick Avenue Campus, directly next to James Stirling's 1967 History Faculty Library, Norman Foster's new Faculty of Law is a skillful blend of modern design and respect for an existing environment. Taking into account existing mature trees and carefully modifying the ground levels near the building to unify it more closely with its neighbors, Norman Foster has improved the immediate environment of the Law Faculty. Intended for a minimum life of fifty years, the building contains the Squire Law Library, five auditoria, seminar rooms and administrative offices. The outstanding feature of the 8,360 square meter building is its sweeping, curved glass facade, facing north away from Hugh Casson's Medieval Languages Faculty and Library. With the glass panels bonded onto subframes off the site, it was possible to create a particularly smooth skin. Attention has been taken making the building as energy efficient as possible, with only the underground lecture rooms being air conditioned. Careful calculations of sun angles and use of the concrete mass to cool the building result in a pleasant interior temperature, even during hot spells.

Fosters Faculty of Law befindet sich auf dem Sidgwick Avenue Campus in der Nähe von James Stirlings 1967 erbauter History Faculty Library und stellt eine geschickte Mischung aus modernem Design und Respekt vor der bestehenden Bebauung dar. Durch die Integration von Bäumen und die Anpassung der unterschiedlichen Bodenniveaus verband er sein Bauwerk enger mit den benachbarten Gebäuden und verbesserte sogar das Umfeld der juristischen Fakultät – die für eine Mindestlebensdauer von 50 Jahren geplant ist und die Squire Law Library, fünf Hörsäle, Seminarräume und Verwaltungsbüros umfaßt. Ein herausragendes Merkmal des 8 360 m² großen Gebäudes bildet die schwungvolle, gewölbte Glasfassade, die nach Norden und damit weg von Hugh Cassons Medieval Languages Faculty and Library weist. Durch die vorab erfolgte Montage der Glasscheiben auf Unterrahmen gelang Foster eine besonders glatte Fassade. Darüber hinaus legte er Wert auf eine energiesparende Bauweise, wobei nur die unterirdischen Hörsäle mit einer Klimaanlage ausgestattet werden mußten. Aufgrund genauer Berechnungen des Sonneneinstrahlungswinkels und der Baumasse zur Kühlung der Konstruktion herrscht selbst an heißen Tagen eine angenehme Innentemperatur.

Située sur le campus de Sidgwick Avenue, à côté de la bibliothèque de la faculté d'histoire construite par James Stirling en 1967, la faculté de droit signée Norman Foster fait preuve d'une conception moderne respectueuse de l'environnement. Prenant en compte la présence des arbres et modifiant le dénivelé du terrain autour du bâtiment pour l'unifier avec ses voisins, Norman Foster a amélioré l'aspect du lieu. Conçu pour une durée minimum de 50 ans, le bâtiment abrite la Squire Law Library, cinq auditoriums, des salles de séminaires et des bureaux administratifs. Avec ses 8 360 m², le bâtiment impressionne par la courbe majestueuse de sa façade en verre, face au nord, du côté opposé à la faculté et à la bibliothèque des langues médiévales, dues à Hugh Carson. Les panneaux en verre ont été scellés en usine dans des sous-châssis, ce qui a permis d'obtenir une surface particulièrement lisse. L'efficacité énergétique du bâtiment a été soigneusement projetée, et seules les salles de conférence du sous-sol recourent à l'air conditionné. La prise en compte des angles du soleil, ainsi que l'utilisation de la masse de béton pour refroidir le bâtiment, permettent de conserver des températures agréables, même durant les grosses chaleurs.

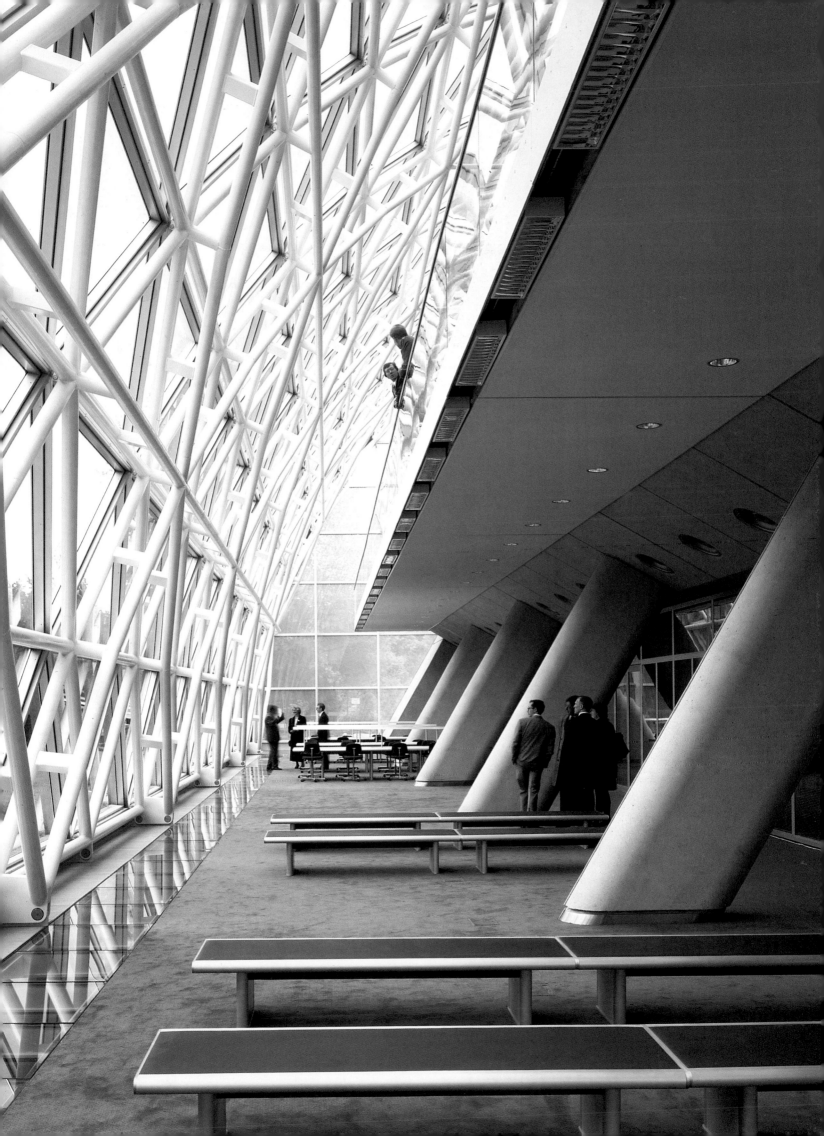

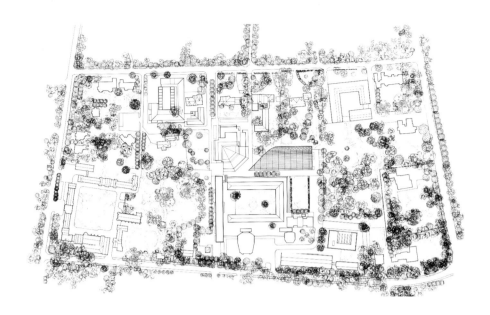

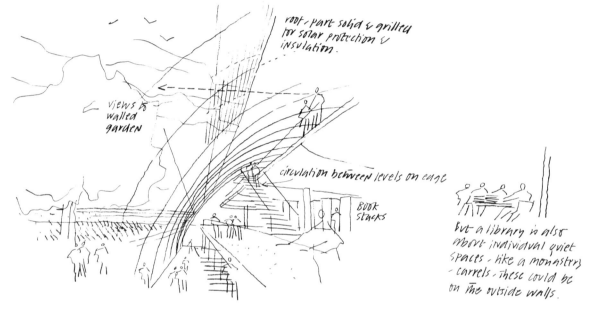

root - part solid & grilled for solar protection & insulation.

views to walled garden

circulation between levels on edge

BOOK stacks

But a library is also about individual quiet spaces - like a monastery - carrels. These could be on the outside walls.

The proposals are diagrammatic - a statement of intent - some flavours for _discussion_ & development.

4- NF - may 90 - co

Page 118: *The site plan, with Stirling's Library to the left of the new Faculty of Law (above). Norman Foster's sketches in 1990 showed the curved wall and a proposed Phase 2 building.*
Page 119: *A view of the sharp edge of the building, near the entrance (top). A ground-floor plan shows the curving glass facade facing north, and the revolving door at the entrance on the lower left.*

Seite 118: *Ein Lageplan mit Stirlings Bibliothek links neben der neuen Faculty of Law (oben). Norman Fosters Skizzen aus dem Jahr 1990 zeigen die geschwungene Wand und ein für einen zweiten Bauabschnitt geplantes Gebäude.*
Seite 119: *Ansicht der scharfen Gebäudekante in der Nähe des Eingangs (oben). Der Erdgeschoßrundriß zeigt die nach Norden ausgerichtete, gebogene Glasfassade und die Drehtür im Eingangsbereich unten links.*

Page 118: *Plan du site avec la bibliothèque de Stirling à gauche de la nouvelle faculté de droit (en haut). Des esquisses de Norman Foster datant de 1990 montrent le mur incurvé et le bâtiment proposé pour la Phase 2.*
Page 119: *Vue de l'angle aigu du bâtiment près de l'entrée (en haut). Plan du rez-de-chaussée montrant la façade en verre incurvé exposée au nord et la porte à tambour (en bas à gauche).*

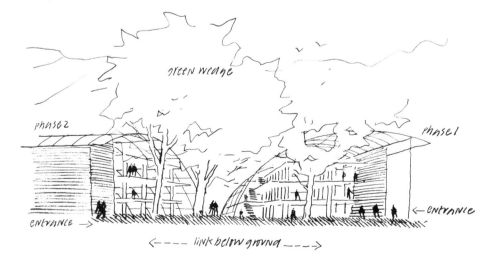

green wedge

phase 2

phase 1

entrance

entrance

link below ground

The existing trees are important - they inform massing & phasing - a foil to the transparency beyond

3 NF may 90 co

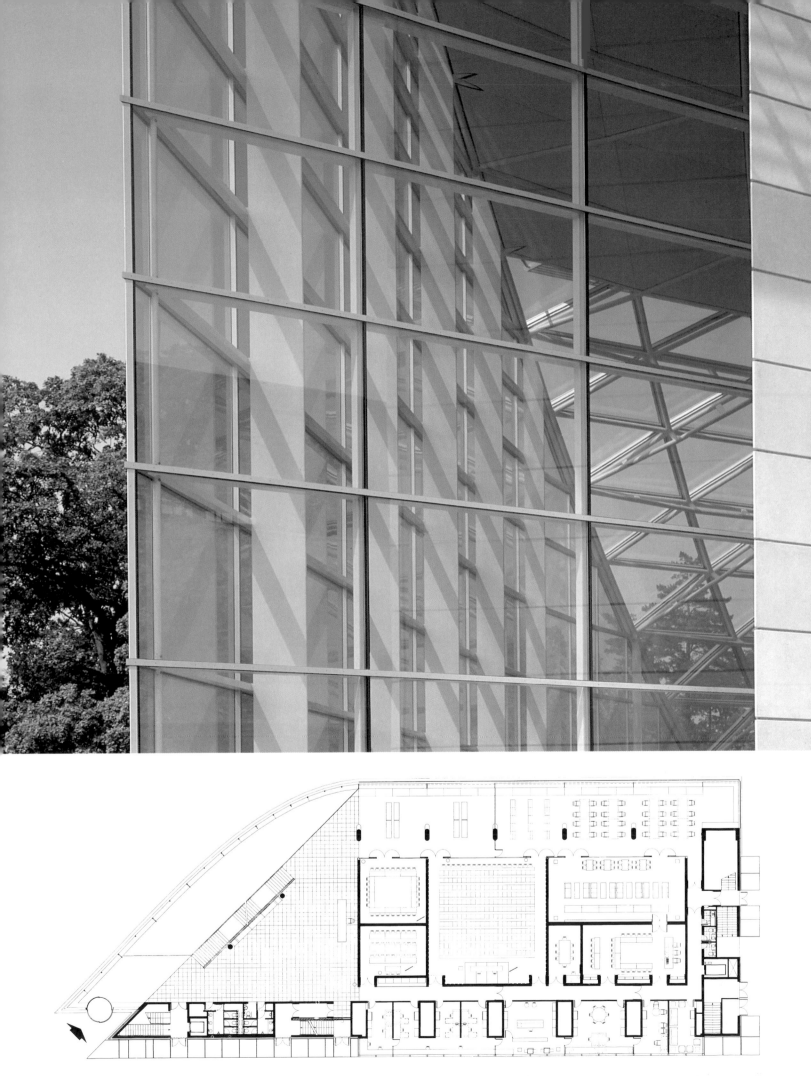

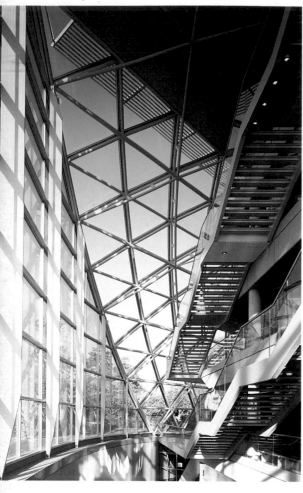

Interior and exterior night
views emphasize the great
transparency of the building and
its high vaulted internal space.

Innen- und Außenaufnahmen
bei Nacht heben die starke
Transparenz des Gebäudes
und den hohen gewölbten
Innenraum hervor.

Vues nocturnes de l'intérieur et
de l'extérieur accentuant la
grande transparence de la
construction et son espace
intérieur sous la haute voûte.

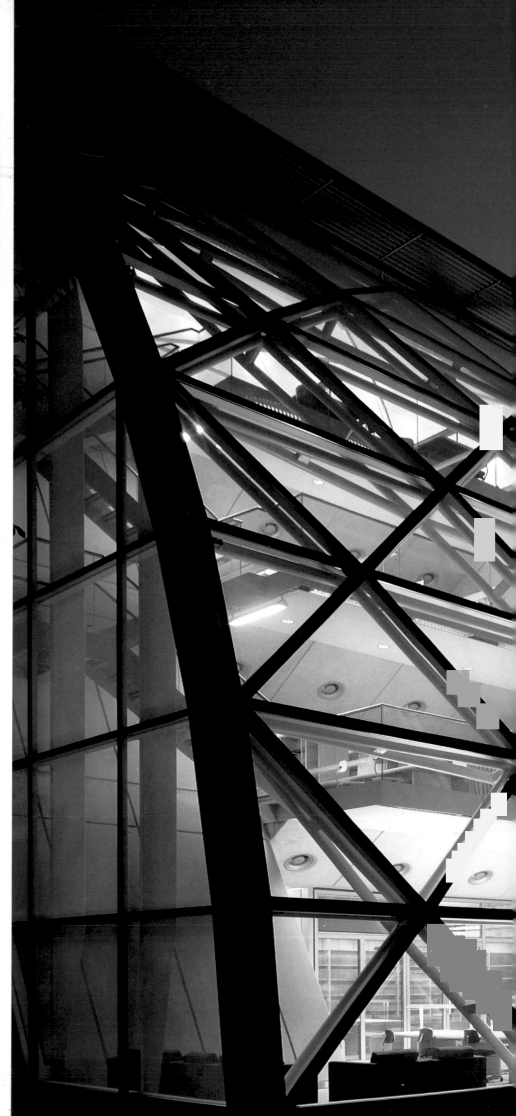

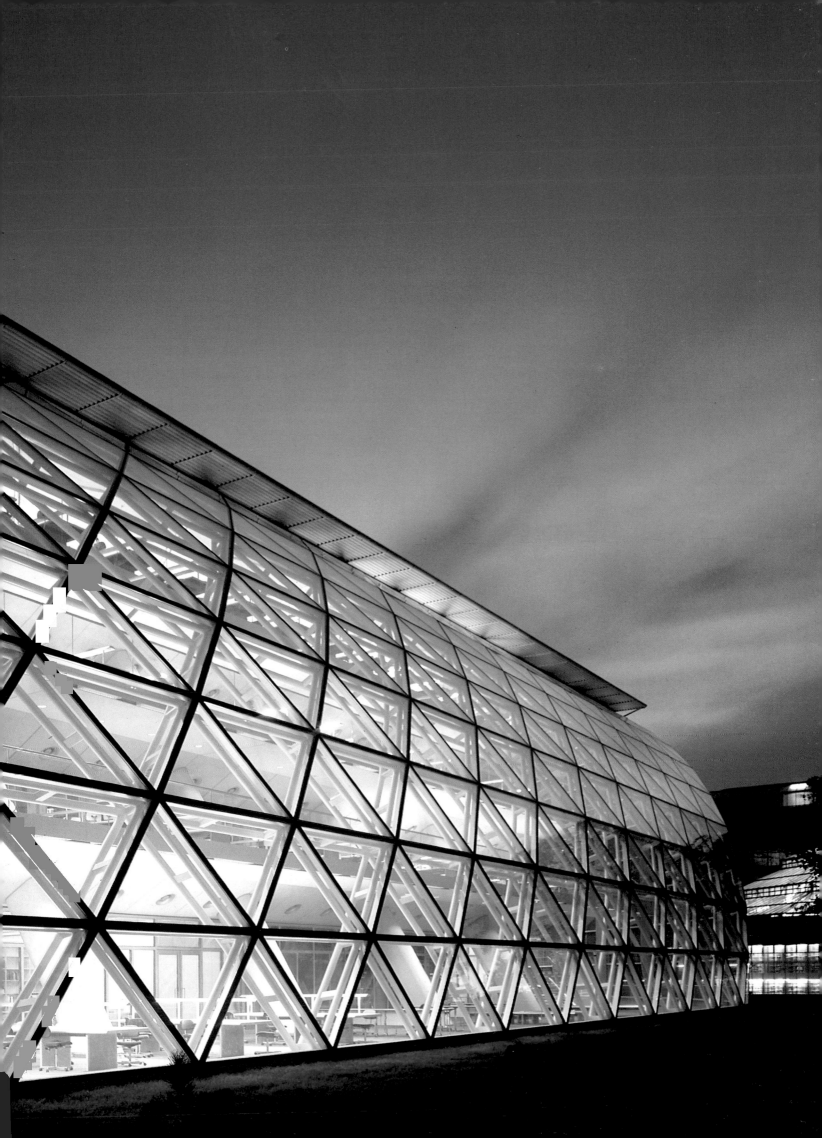

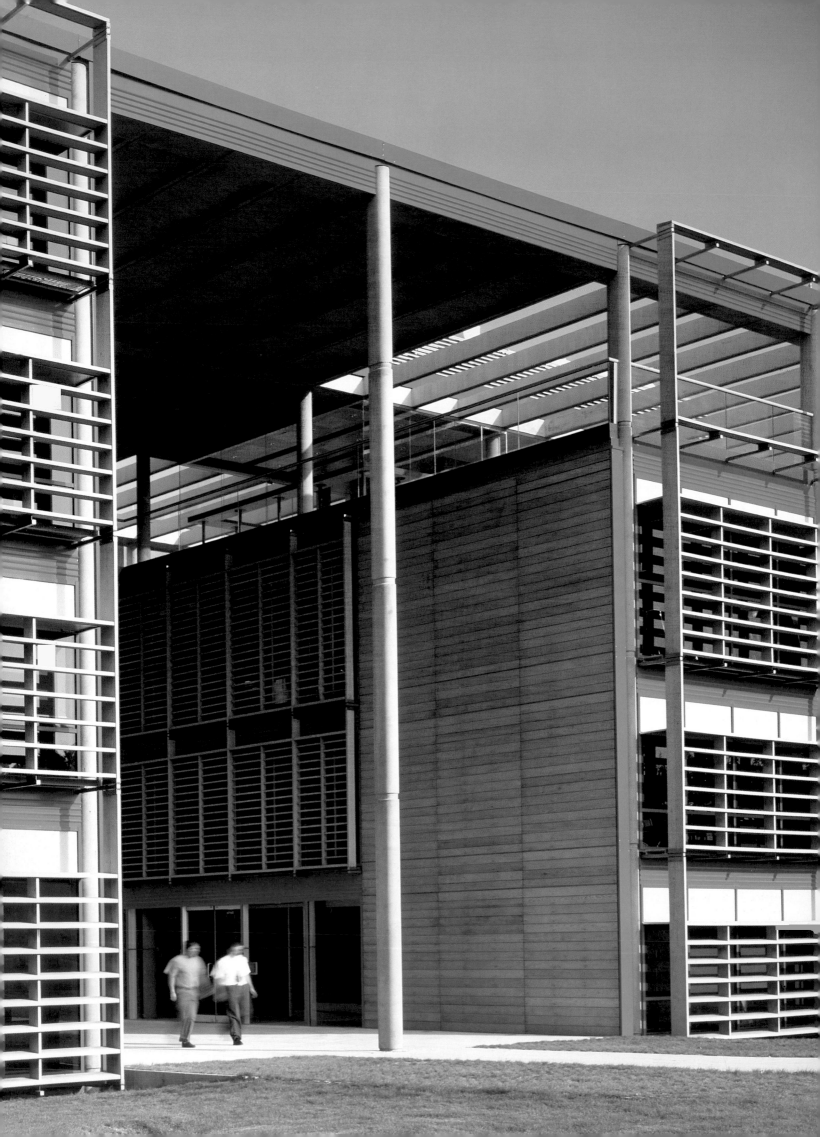

Bordeaux, France
1995–1996

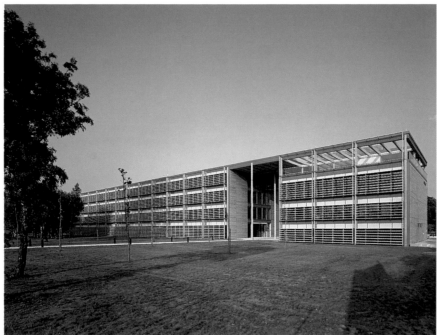

The EDF building measures 98 meters in length by 20 meters in width. Norman Foster has used a bright blue on the exterior of the building, visible behind the brise-soleil. A vivid yellow is used in the interior circulation zones. Right, the main staircase.

Das Gebäude der EDF ist 98 m lang und 20 m breit. Für das Äußere setzte Norman Foster ein leuchtendes Blau ein, das durch die Sonnenschutzelemente schimmert. Für die inneren Verkehrswege wurde ein lebendiges Gelb verwendet. Rechts die Haupttreppe.

L'immeuble EDF mesure 98 m de long sur 20 m de large. Pour l'extérieur, Norman Foster a utilisé un bleu vif, visible derrière les brise-soleil. Un jaune vif est utilisé pour les zones de circulation intérieure. À droite, le grand escalier.

This is a three-story, 7,230 square meter office building for 220 people. One outstanding feature of this structure is the highly efficient building envelope, designed by Foster to minimize heat gain and loss. As Sir Norman says, "Working closely with EDF we were able to demonstrate how electricity can be used efficiently in an energy-conscious building." Natural ventilation through windows on the east and west elevations, which open automatically at night in the summer to cool the concrete slabs. Bleached cedarwood louvers fitted on the elevations, an energy-efficient water-based heating and cooling system run by an electric heat pump, and "Norina" false flooring with 3,800 square meters of 2 millimeter diameter capillary pipes filled with 70,000 liters of water to constantly maintain the floor at an ambient temperature between 20 and 22 degrees celsius, are some of the energy-saving elements of the design. The EDF building also integrates strong colors into the design, both externally and internally.

Dieses dreigeschossige Gebäude mit einer Gesamtfläche von 7 230 m² ist für 220 Mitarbeiter ausgelegt. Ein herausragendes Kennzeichen der Konstruktion ist die hocheffiziente Fassadengestaltung, die Aufheizung und Wärmeverlust auf ein Minimum reduziert. Foster erklärt dazu: »In enger Zusammenarbeit mit der EDF ist es uns gelungen, zu zeigen, wie effizient Elektrizität in einem energiesparenden Gebäude eingesetzt werden kann.« Die ausgeklügelten Energiesparideen umfassen u.a. eine natürliche Lüftung durch Fenster an der Ost- und Westfassade (die sich im Sommer während der Nacht zur Kühlung der Sichtbetondecken automatisch öffnen), Außenjalousien aus gebleichtem Zedernholz, ein Warmwasserheizungs- und Kühlungssystem und einen 3 800 m² großen »Norina«-Blindboden mit 2 mm starken Rohrleitungen, in denen 70 000 Liter Wasser für eine konstante Boden- und Raumtemperatur von 20 bis 22°C sorgen. Das EDF Gebäude weist zudem starke Farben im Innen-und Außendesign auf.

Avec ses trois étages et ses 7 230 m², le bâtiment accueille 220 employés. Ses façades ont été conçues pour minimiser les gains et les pertes de chaleur. L'architecte explique: «Grâce à une collaboration étroite avec l'EDF, nous avons pu faire la démonstration que l'électricité peut être utilisée de manière efficace dans un bâtiment tenant compte du facteur énergétique.» L'aération se fait naturellement par des fenêtres situées côté est et côté ouest, et qui s'ouvrent automatiquement la nuit, en été, pour rafraîchir les dalles en béton. D'autres éléments ont été pensés pour économiser l'énergie: lames en cèdre blanc sur les façades, système de chauffage/climatisation par circulation d'eau alimenté par une pompe électrique, faux plafond de type «Norina» sous lequel courent 3 800 m² de tubes capillaires de 2 mm de diamètre, transportant 70 000 litres d'eau, qui maintiennent en permanence le sol à une température ambiante de 20 à 22 degrés. Ce bâtiment EDF montre aussi qu'à l'occasion, Norman Foster ne répugne pas aux couleurs vives.

Telecommunications Facility

Santiago de Compostela, Spain, 1994

As Norman Foster points out, the mayor of this famous pilgrimage city came to him because he had admired the Torre de Collserola in Barcelona, and hoped to have a similar telecommunications tower for Santiago. By analyzing the technical requirements of the site with his team, Foster was able to determine that a tall mast was unnecessary. In fact, he proposed a platform only 25 meters tall, which will double as a public viewing point, offering spectacular views over the old city opposite. The planned area of the structure is 4,100 square meters. Conscious that his innovative approach has often attracted imitators, Norman Foster explains that "each project is specific to its own site, and despite the success of Barcelona, we were able to pioneer a totally new form of communication structure. It is also important to remember that this is a pilgrimage city – and distant views of the church should ideally not be compromised by other structures on the skyline."
As in the Barcelona project, Foster is operating in this instance at the juncture of engineering and architecture.

Nach Aussage von Norman Foster hatte sich der Bürgermeister der berühmten Pilgerstadt an ihn gewandt, in der Hoffnung auf einen ähnlichen Sendemast wie den Torre de Collserola in Barcelona, den er sehr bewunderte. Nach Analyse der technischen Gegebenheiten vor Ort stellte Foster jedoch fest, daß ein hoher Mast unnötig sei. Statt dessen schlug er eine Plattform von nur 25 m Höhe für das 4 100 m² große Baugelände vor, die gleichzeitig eine spektakuläre Sicht auf die gegenüberliegende Stadt ermöglicht. Wohl wissend, daß sein innovativer Ansatz oft Nachahmer findet, erklärt Foster: »Jedes Projekt sollte speziell für sein Baugelände konzipiert werden, und trotz des Erfolgs in Barcelona ist es uns gelungen, in Santiago eine völlig neue Form der Telekommunikationseinrichtung zu schaffen. Darüber hinaus darf man nicht vergessen, daß es sich um eine Pilgerstadt handelt – und der Ausblick auf die Kathedrale nicht durch andere Gebäude der Stadtansicht verschandelt werden sollte.« Auch in diesem Fall ist Foster in einem Bereich tätig, der eine Schnittstelle zwischen Ingenieurbau und Architektur bildet.

Comme le souligne Norman Foster, le maire de cette célèbre ville de pèlerinage s'est adressé à lui après avoir admiré la Torre de Collserola à Barcelone. Il souhaitait une tour semblable pour Saint-Jacques. Après avoir analysé avec son équipe les nécessités techniques liées au site, Foster a jugé qu'un mât de cette hauteur était inutile, voire nuisible à l'environnement architectural. Il a donc proposé une plate-forme d'une hauteur limitée à 25 m, qui servirait également de point d'observation pour le public, avec une vue spectaculaire sur la vieille ville située en face. La superficie de cette structure est de 4 100 m². Conscient que son innovation a souvent séduit des imitateurs, Norman Foster explique que «chaque projet est spécifique à son propre site et, malgré le succès de Barcelone, nous avons pu faire œuvre de pionnier pour cette structure de communication d'une forme entièrement nouvelle. De plus, il est important de ne pas oublier qu'il s'agit là d'une ville de pèlerinage et qu'il ne fallait pas compromettre, par d'autres structures, la vue de la cathédrale, au loin». Comme pour le projet de Barcelone, Foster opère ici à la jonction de l'ingénierie et de l'architecture.

Page 124: A plan at the +5 meter level shows the outline of the platform against the background of the site.
Page 125: A model with extending antennae.

Seite 124: Ein Grundriß auf einer Schnitthöhe 5 m über Planum zeigt den Umriß der Plattform vor dem Hintergrund des Geländes.
Seite 125: Ein Modell mit der ausgefahrenen Antenne.

Page 124: Plan au niveau +5 m: il montre le contour de la plate-forme contre l'arrière-plan du site.
Page 125: Maquette avec l'antenne.

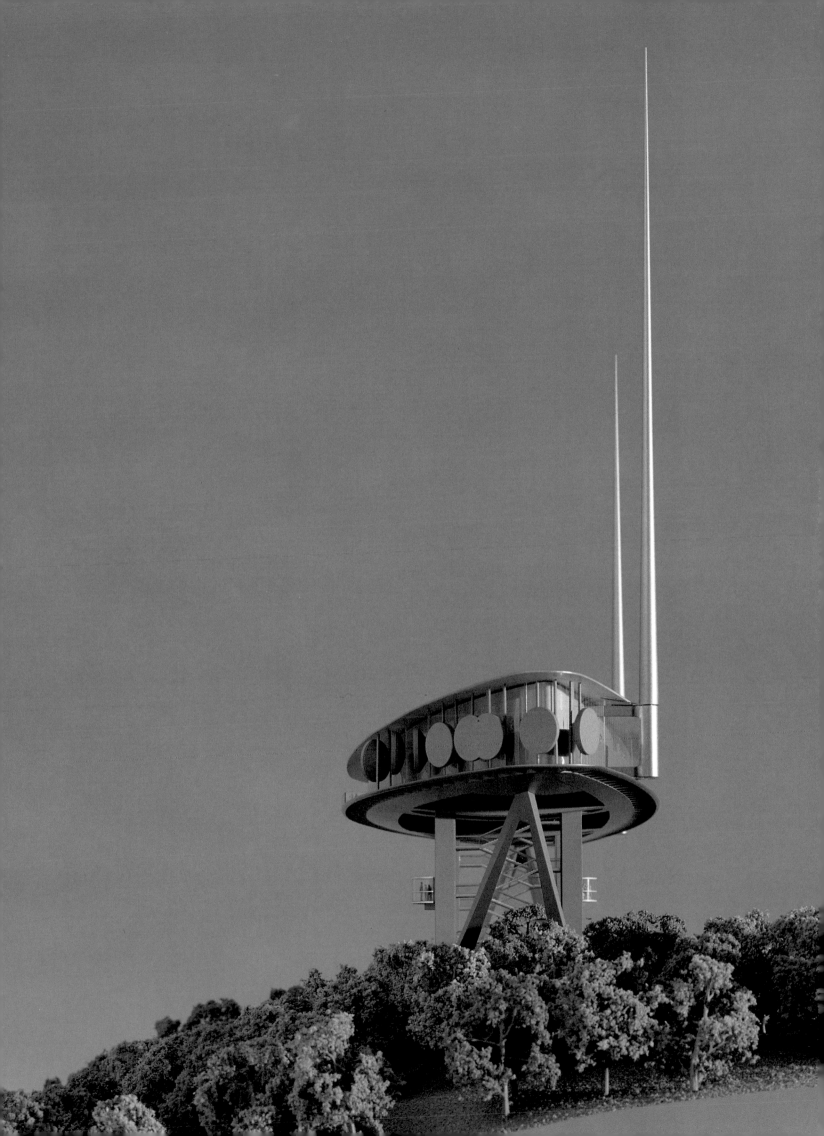

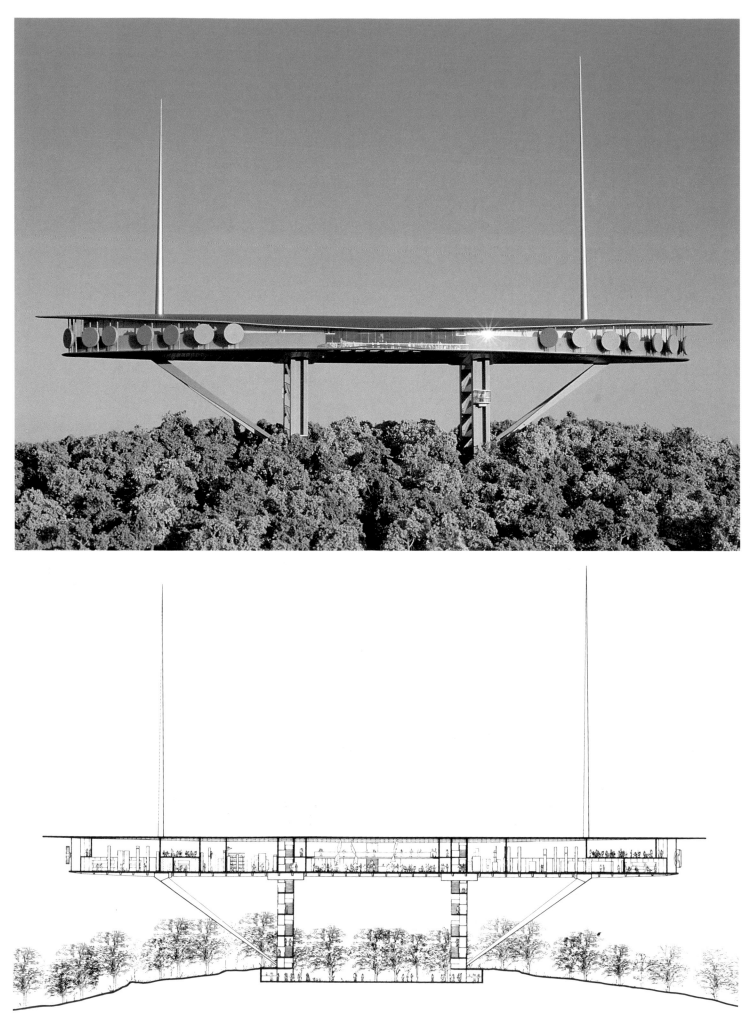

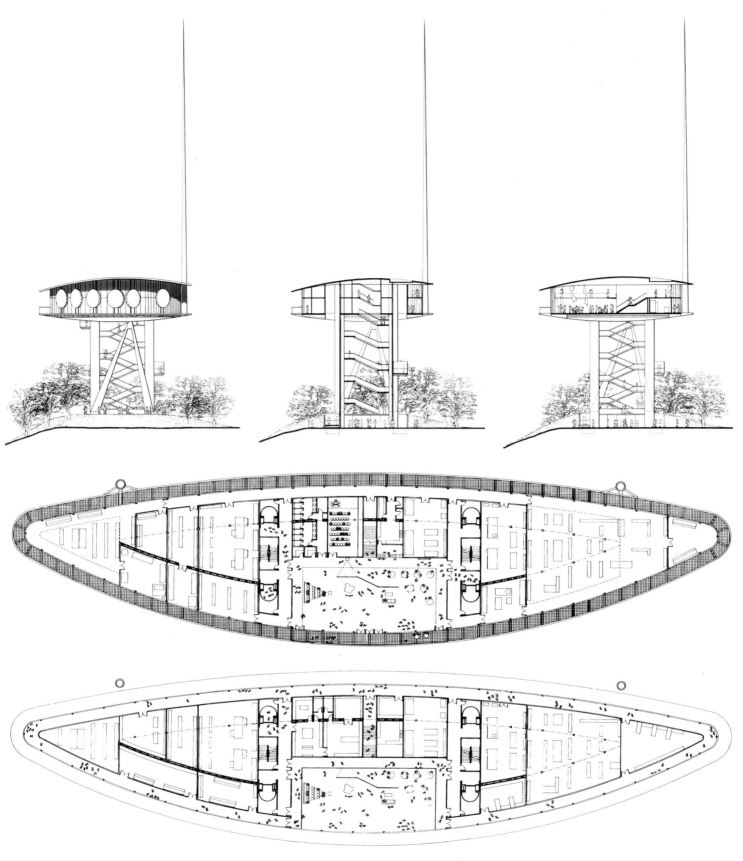

Page 126: A long section (bottom) and the corresponding model view.
Page 127: Cross-sections of the north elevation, and plans of the main and mezzanine levels.

Seite 126: Ein Längsschnitt (unten) und eine entsprechende Modellansicht.
Seite 127: Schnitte der Nordansicht und Grundrisse des Haupt- und Mezzanin-geschosses.

Page 126: Coupe longitudinale (en bas) et maquette correspondante.
Page 127: Coupes transversales de l'élévation nord et plans du rez-de-chaussée et de la mezzanine.

Commerzbank Headquarters

Frankfurt am Main, Germany, 1994–1997

The Commerzbank is one of Germany's "Big Three" private sector banks, with a staff of 30,000 people and 1,000 branches in Germany. These figures may explain why the bank is completing the tallest office building in Europe (298.74 meters with its aerial) for 2,400 staff. Norman Foster bills this as the "world's first ecological high rise tower – energy efficient and user friendly." Four-story gardens spiral around the gently curved triangular plan with its service cores placed in the corners, with a central atrium serving as a "natural ventilation chimney." In terms of energy efficiency and user comfort, the decision to allow windows of the tower, both inward and outward facing, to be opened in each office is certainly a good one. An automatic system closes the windows under extreme climatic conditions, just as it can open them to allow cooling at night. As is often the case in Foster's buildings, the offices are column-free. Another frequent feature of his designs, a careful attention to the immediate environment of the building, is respected here. Neighboring buildings have been restored, maintaining the height of the surrounding structures, and a winter garden with restaurants and exhibition space is open to the public.

Die Commerzbank ist eine der drei größten deutschen Privatbanken, mit 30 000 Mitarbeitern und 1 000 Filialen im Bundesgebiet. Die Bank ließ das höchste Bürogebäude Europas errichten (298,74 m Höhe mit der Antenne), das 2 400 Beschäftigten Platz bietet. Laut Foster handelt es sich um den »ersten ökologischen Büroturm der Welt – energiesparend und benutzerfreundlich«. Über vier Geschosse winden sich Gärten in dem sanft geschwungenen dreieckigen Grundriß, bei dem die Versorgungsleitungen in die Winkel verlegt sind und das zentrale Atrium als »natürlicher Lüftungsschacht« dient. Die Entscheidung, an den Innen- und Außenseiten des Turmes in jedem Büro Fenster anzubringen, die sich öffnen lassen, ist sowohl im Hinblick auf die Energieeinsparung als auch auf den Nutzerkomfort wohl überlegt. Ein automatisches Lüftungssystem schließt die Fenster bei extremen klimatischen Bedingungen bzw. öffnet sie zur Kühlung in der Nacht. Wie so häufig bei Fosters Gebäuden sind die Büros stützenfrei und die Umgebung des Gebäudes wurde in den Entwurf einbezogen: Angrenzende Bauten wurden restauriert und ein Wintergarten mit Restaurant und Ausstellungsflächen für den Publikumsverkehr geöffnet.

La Commerzbank est l'une des trois grandes banques allemandes du secteur privé. Elle emploie 30 000 personnes et compte un millier d'agences. Ces chiffres peuvent expliquer en partie pourquoi la banque a souhaité construire l'immeuble de bureaux le plus haut d'Europe (298,74 m avec son antenne) pour pouvoir accueillir 2 400 employés. Pour Norman Foster, il s'agit de «la première tour écologique, efficace sur le plan énergétique et agréable à vivre». Des jardins montent en spirale autour du plan de base triangulaire, légèrement courbé. Les espaces techniques sont logés dans les trois angles, et l'atrium central sert de «cheminée de ventilation naturelle». Qu'ils donnent sur l'extérieur ou sur l'atrium, tous les bureaux ont des fenêtres qui s'ouvrent - une bonne solution du point de vue énergétique et pour le confort du personnel. Un système automatique procède à la fermeture en cas de conditions climatiques extrêmes. De même il peut les ouvrir la nuit. Comme c'est souvent le cas dans les bâtiments de Foster, les bureaux n'ont pas de colonnes intérieures. Autre caractéristique fréquente, l'attention portée à l'environnement. Les bâtiments alentour ont été restaurés, et un jardin d'hiver, des restaurants et un espace d'exposition sont ouverts au public.

Page 128: A diagram showing the natural ventilation (left), and a typical, triangular floor plan (top).
Page 129: Photo of the building set in its urban context.

Seite 128: Ein Diagramm zeigt die natürliche Lüftung (links), oben ein typischer, dreieckiger Grundriß.
Seite 129: Das Gebäude prägt Frankfurts Stadtsilhouette.

Page 128: Diagramme montrant la ventilation naturelle (à gauche) ainsi qu'un plan au sol triangulaire typique (en haut).
Page 129: Photo du bâtiment dans son contexte urbain.

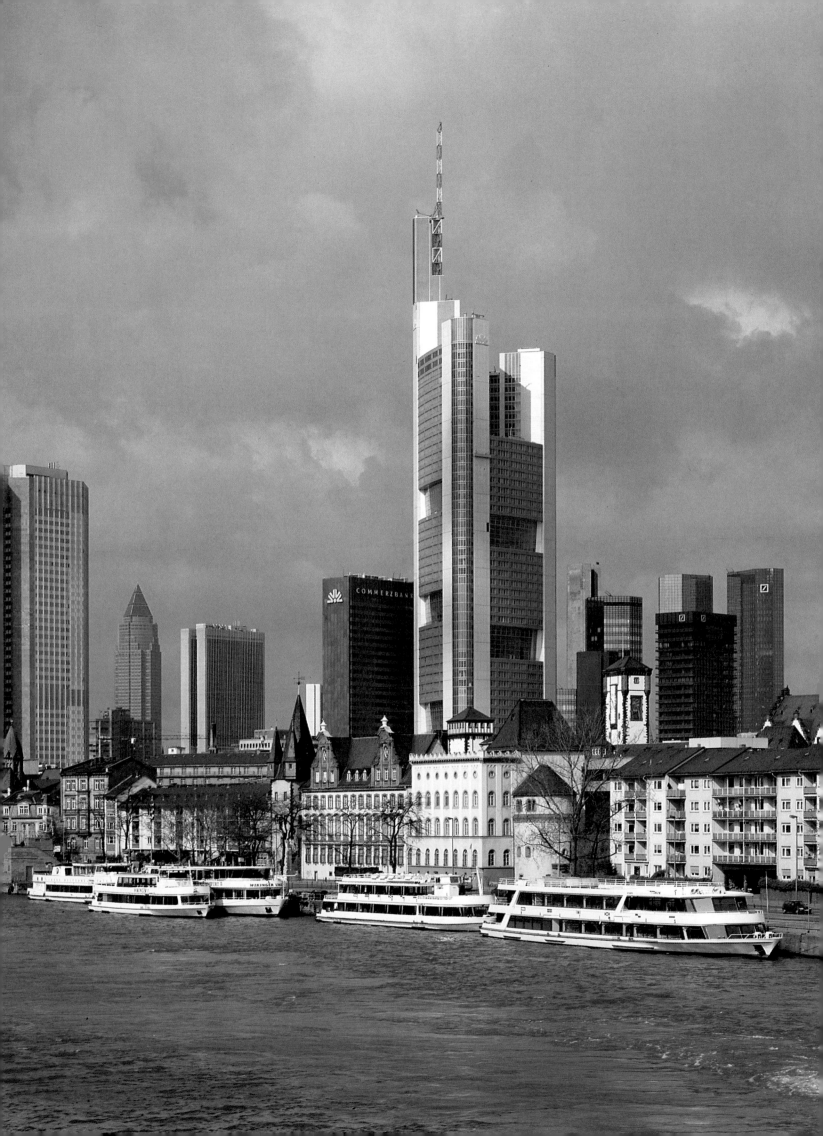

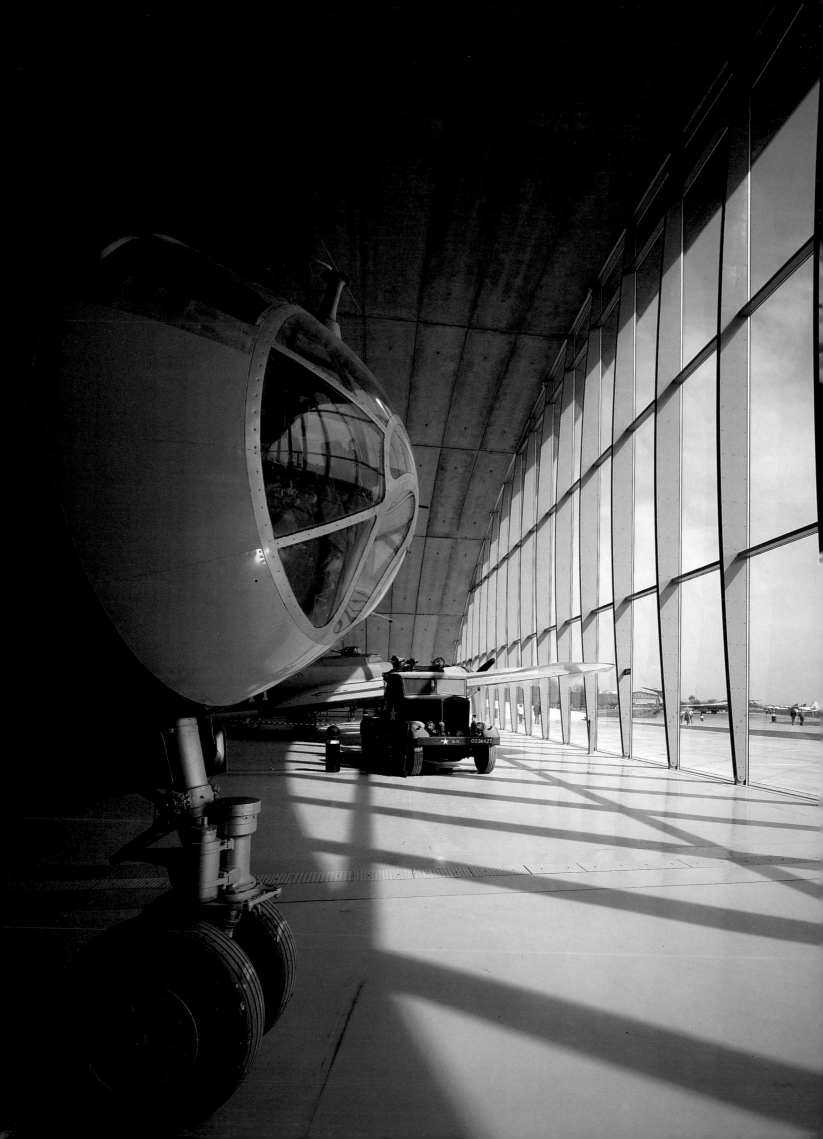

American Air Museum

*Duxford, Cambridgeshire,
UK, 1995–1997*

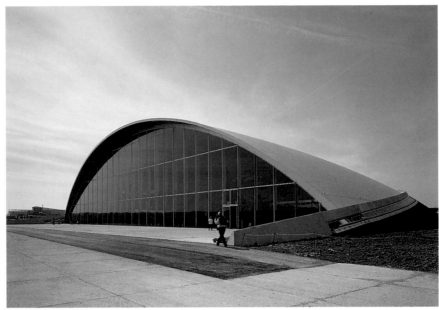

Located eight miles south of Cambridge, Duxford airfield has had a long association with American pilots. Some 200 of them were stationed there in 1918, and in 1943 it was used by the 78th Fighter Group. A collection of thirty-eight American planes, nineteen of which still fly, attracts 350,000 visitors a year. Some twenty of these warplanes will be exhibited in the new American Air Museum, which is a part of the Imperial War Museum. A complex curving roof over a glazed end elevation covers the aircraft, its size dictated by that of the B-52 nuclear bomber with its 16 meter high tail fin and 61 meter wing span. Built with the contributions of 50,000 individual subscribers in the United States, funds from the UK Lottery and other donations, the facility in Duxford offers further proof of Norman Foster's interest in aircraft. As he says, "Twenty years ago I learned to fly, and I have been fascinated ever since by flight. Like many schoolboys before, I was obsessed by the world of model aircraft, and it can be no accident that the machines which give me the most pleasure to fly are themselves like overgrown models."

Den Flugplatz von Duxford, acht Meilen südlich von Cambridge, verbindet eine lange Tradition mit amerikanischen Piloten. 1918 waren etwa 200 Piloten hier stationiert, und im Jahr 1943 diente er der 78th Fighter Group als Stützpunkt. Die 38 amerikanischen Flugzeuge, von denen 19 noch heute fliegen, ziehen pro Jahr 350 000 Besucher an. Etwa 20 dieser Kampfflugzeuge sollen im neuen American Air Museum, einem Teil des Imperial War Museum, ausgestellt werden, dessen »Grundriß an einen Flugzeugrumpf erinnert«. Die Größe der Anlage wurde von einem B 52-Bomber mit seinem 16 m hohen Leitwerk und seiner Spannweite von 61 m vorgegeben. Das Gebäude in Duxford, das u. a. mit Hilfe der Beiträge 50 000 einzelner Spender aus den USA gebaut wurde, beweist einmal mehr das Interesse Fosters an der Luftfahrt. »Ich lernte vor zwanzig Jahren fliegen und bin seitdem vom Fliegen fasziniert. Wie viele Schuljungen war auch ich besessen von der Welt der Modellflugzeuge, und es kann kein Zufall sein, daß die Maschinen, mit denen ich am liebsten fliege, ebenfalls an übergroße Modelle erinnern.«

Situé à 12 km au sud de Cambridge, le terrain d'aviation de Duxford a toujours été cher au cœur des pilotes américains. Environ 200 d'entre eux y étaient stationnés en 1918, tandis qu'en 1943, il a servi de base à la 78e escadrille. Une collection de 38 avions américains – dont 19 sont toujours en état de vol – attire chaque année quelque 350 000 visiteurs. Une vingtaine de ces avions de combat seront exposés dans le nouveau musée de l'air américain, qui fera partie de l'Imperial War Museum. Les avions sont exposés sous un grand toit incurvé. La façade avant est entièrement vitrée. La taille du bâtiment a été dictée par celle du B-52, cet énorme bombardier dont l'empennage atteint 16 m de hauteur et l'envergure 61 m. Construit grâce au financement de 50 000 souscripteurs américains, aux recettes du loto britannique et à diverses donations, le bâtiment de Duxford montre une fois encore l'intérêt de Norman Foster pour l'aviation. «Il y a 20 ans, j'ai appris à voler», raconte l'architecte. «Mais enfant, j'aimais déjà les modèles réduits ...»

Views showing the rounded shape of the structure with the enormous B-52 bomber as the most prominent display.

Die Ansichten zeigen die Bogenform der Konstruktion mit dem riesenhaften B 52-Bomber als bekanntestem Ausstellungsstück.

Vues montrant la forme arrondie de la structure avec l'énorme bombardier B-52 qui tient une place de choix dans l'exposition.

KCRC Kowloon Railway Station

Hong Kong, 1995–1997

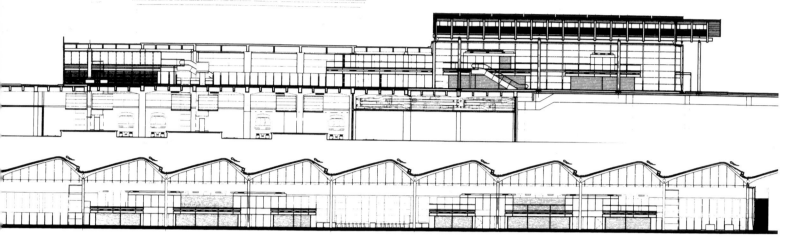

The original terminal for the Kowloon-Canton Railway Corporation was built in the mid 1970s, but as it handles as many as 80 million passengers a year, it was deemed necessary to expand the station and make its pedestrian traffic patterns clearer. By doubling the size of the building with a lightweight canopy erected to the east of the old station, and dividing operations into three distinct zones – international arrivals, international departures, and domestic traffic, – Norman Foster has made the terminal more efficient. Use of atriums brings natural light to the platforms below. Clarity of organization and movement are, as in so many Foster buildings, symbolized by the presence of natural light within. With an area of 45,000 square meters, the Kowloon Railway Station has sixty gates intended to handle 250 arriving trains and 250 departing, with a passenger flow of 160,000 persons per day.

Der ursprüngliche Terminal der Kowloon-Canton Railway Corporation wurde bereits Mitte der 70er Jahre erbaut. Aber aufgrund des hohen Passagieraufkommens von über 80 Millionen Fahrgästen im Jahr schien eine Vergrößerung des Bahnhofes unausweichlich, wobei gleichzeitig die Fußgängerführung klarer gestaltet werden sollte. Durch den Bau einer Überdachung in Leichtbauweise im Osten des Bahnhofes ließ sich die Größe des Gebäudes verdoppeln. Darüber hinaus wurde der Betrieb in drei getrennte Bereiche unterteilt – internationale Ankünfte, internationale Abfahrten und Nahverkehr –, wodurch Foster den Terminal effizienter gestaltete. Die unteren Bahnsteige erhalten durch ein Atrium natürliches Licht, das (wie bei vielen von Fosters Gebäuden) klare Organisationsstrukturen und Bewegungsabläufe symbolisiert. Auf einer Grundfläche von 45 000 m² verfügt die Kowloon Railway Station über 60 Bahnsteige, an denen 250 ankommende und 250 abfahrende Züge – mit einem Passagieraufkommen von 160 000 Personen pro Tag – abgefertigt werden sollen.

Le terminal d'origine de la Kowloon-Canton Railway Corporation (KCRC) a été construit au milieu des années 1970. Mais comme il reçoit 80 millions de voyageurs par an, il a fallu l'agrandir et en améliorer la circulation. En doublant la taille du bâtiment grâce à une voûte légère érigée à l'est de l'ancienne gare, et en divisant les opérations selon trois zones distinctes – les arrivées internationales, les départs internationaux et le trafic intérieur –, Norman Foster a rendu le terminal plus efficace. Les quais situés au niveau inférieur reçoivent la lumière du jour diffusée par les atriums. Ici, et comme dans de nombreux bâtiments signés Foster, la clarté des espaces et du plan de circulation est symbolisée par la présence de la lumière naturelle. Le terminal a une superficie de 45 000 m² et compte 60 portes d'embarquement pour répondre à l'arrivée ou au départ de 250 trains, pour un trafic de 160 000 voyageurs par jour.

Page 132: An East-west section and a section looking north toward the new pavilion.
Page 133: The public concourse, and a detail of the new glazed pavilion extension (top).

Seite 132: Ein Schnitt von Ost nach West und eine Ansicht nach Norden, in Richtung des neuen Pavillons.
Seite 133: Die Bahnhofshalle und eine Detailansicht (oben) der neuen Erweiterung des Glaspavillons.

Page 132: Coupe Est-Ouest et coupe vers le Nord en direction du nouveau pavillon.
Page 133: Le hall publique et détail de verre de la nouvelle extension du pavillon de verre (en haut).

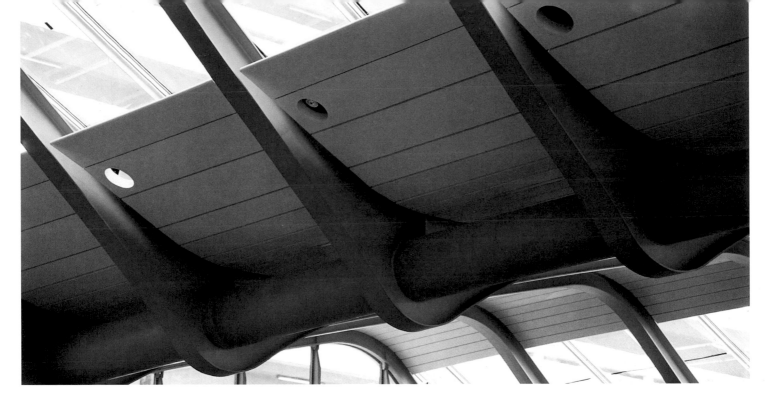

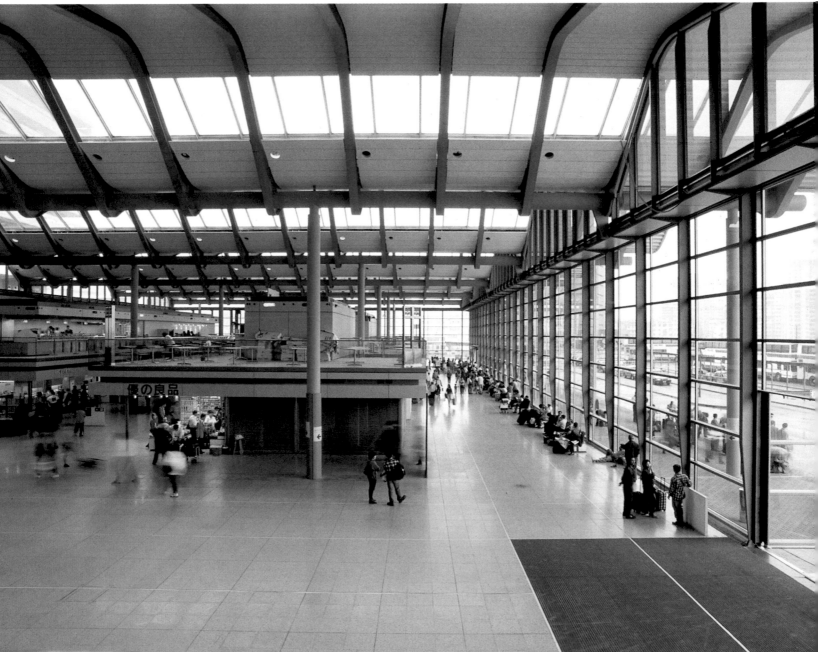

Airport at Chek Lap Kok

Hong Kong, 1995–1998

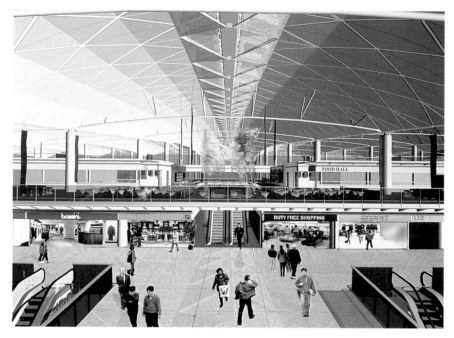

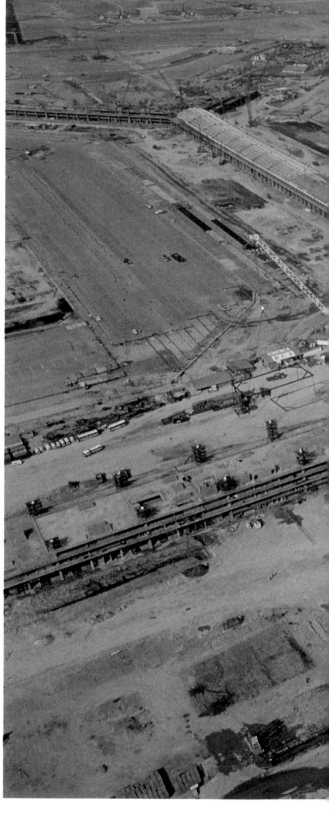

The largest construction project under way in the world is a veritable list of superlatives. Together with a new airport at Chek Lap Kok, Hong Kong is completing a series of nine other infrastructure projects, including the construction of the Tsing Ma Bridge, with the longest single span of any rail/road suspension link in the world. Norman Foster's involvement in this ambitious project includes not only the main terminal, being built on a mostly man-made island 6 kilometers long and 3.5 kilometers wide situated near Lantau Island, but also the HACTL Superterminal and Express Center, whose seven-story cargo-handling building measuring 260,000 square meters makes it the largest single cargo terminal in the world, and the Ground Transportation Center, concentrating train platforms and facilities and all landside transportation facilities. The terminal building itself will be 1.5 kilometers long, with continuous barrel vaults running from east to west, corresponding to the movement of passengers. With a gross floor area of no

Neben diesem neuen Flughafen in Chek Lap Kok stellt Hongkong neun weitere Infrastrukturprojekte fertig, zu denen auch die zukünftige Tsing Ma-Brücke gehört, die längste Einzelständer-Hängebrücke für Bahn- und Straßenverkehr der Welt. Fosters Beitrag zu diesem ambitionierten Projekt besteht nicht nur aus dem Hauptterminal des Flughafens, der auf einer größtenteils künstlich angelegten Insel von 6 km Länge und 3,5 km Breite nahe Lantau Island gebaut wird, sondern auch aus dem HACTL Superterminal and Express Center, dessen siebenstöckige Frachtgutabfertigungshalle mit einer Größe von 260 000 m² der größte Frachtgutterminal der Welt ist. Darüber hinaus zeichnet Foster auch für das Ground Transportation Center verantwortlich, das Bahnsteige und -anlagen sowie Einrichtungen für alle Transporte auf dem Landweg zusammenfaßt. Das Terminalgebäude des Flughafens wird auf einer Länge von 1,5 km – mit durchlaufenden Tonnengewölben von Ost nach West und einer Gesamtgrundfläche von 490 000 m² – 57 Flugsteige besitzen und

Le plus grand projet en construction dans le monde accumule les superlatifs. Parallèlement au nouvel aéroport, Hong Kong fait réaliser une série de neuf autres infrastructures, dont le pont route/rail Tsing Ma, le plus long de ce type dans le monde. La participation de Norman Foster à cet ambitieux projet ne concerne pas que le terminal central, construit sur Chek Lap Kok, île presque entièrement artificielle (6 km de long sur 3,5 km de large) proche de l'île de Lantau. On retrouve la signature de Foster sur le Superterminal HACTL et sur l'Express Center, dont le bâtiment est destiné au fret, avec ses 7 étages et ses 260 000 m², formant le plus grand terminal de fret au monde. Enfin Foster signe aussi le Centre de transports terrestres, qui regroupe les quais de chemin de fer, les aménagements et tous les transports routiers. Le terminal mesurera 1,5 km de long et portera une voûte continue, orientée d'est en ouest, selon le flux des passagers. Il aura une surperficie de 490 000 m² au moins, 57 portes d'embarquement, et aura une capacité de

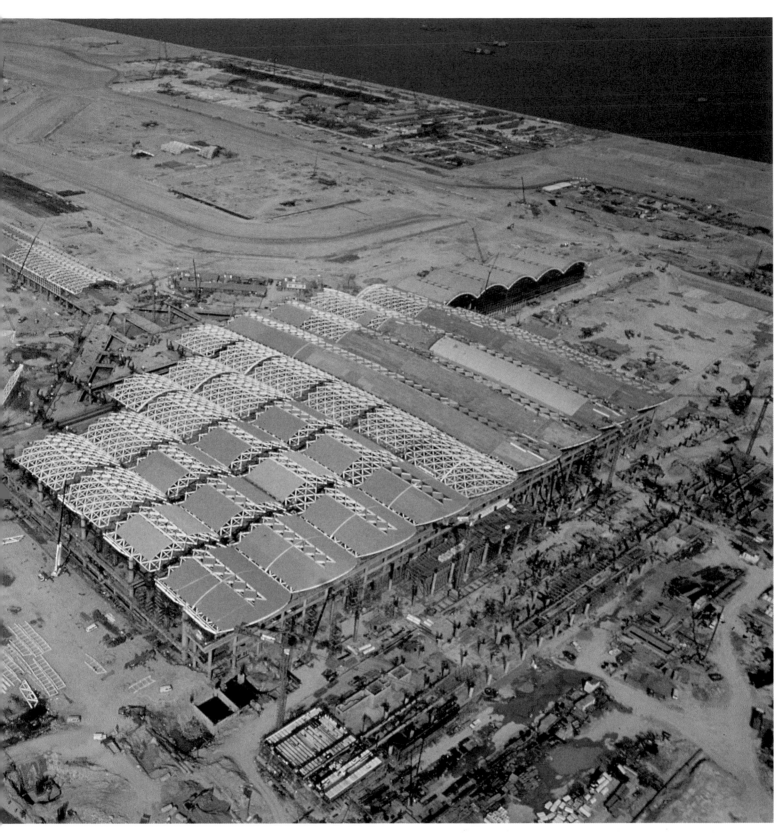

Page 134 top: A computer view of the interior.
Page 134–135: An aerial construction view taken at the end of 1996.
Page 135 bottom: An aerial view of the model.

Seite 134 oben: Eine vom Computer simulierte Innenansicht.
Seite 134–135: Eine Luftaufnahme während der Bauphase Ende 1996.
Seite 135 unten: Eine Luftaufnahme des Modells.

Page 134 en haut: Image de synthèse de l'intérieur.
Page 134–135: Vue aérienne prise au moment de la construction fin 1996.
Page 135 en bas: Vue aérienne de la maquette.

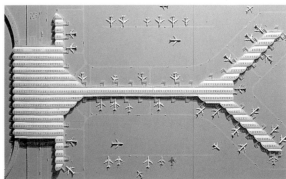

less than 490,000 square meters, this facility will have 57 gates and handle 37 million passengers a year at its opening, rising to a theoretical total of 80 million in 2040.

im Jahr seiner Eröffnung 37 Millionen Passagiere abfertigen können, deren Zahl bis zum Jahr 2040 auf theoretisch 80 Millionen ansteigen kann.

37 millions de passagers par an (80 millions sont prévus pour 2040).

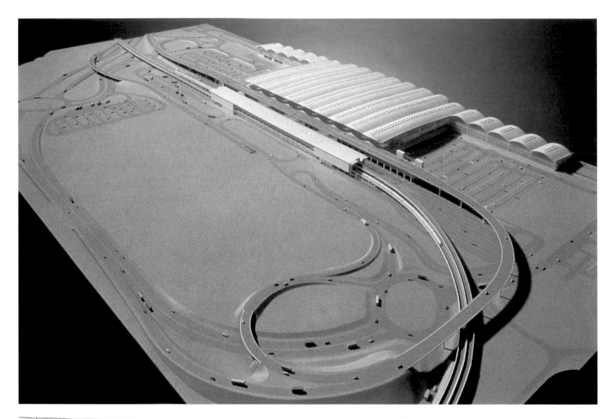

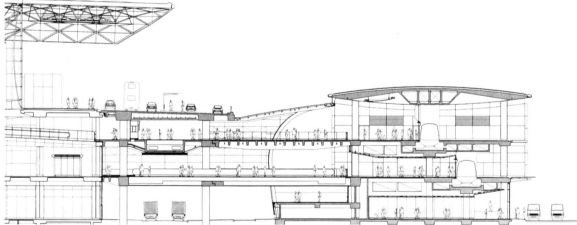

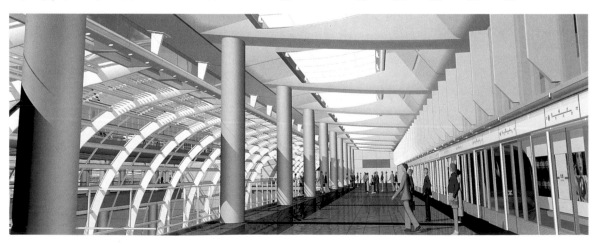

Page 136: The Transportation Center, seen in an aerial image of the model of the entire development (top). A cross section through the link bridge of the Transportation Center, and a computer interior perspective.
Page 137: A view of the model of the gate area, and below, a construction progress image taken in January 1997.

Seite 136: Modellaufnahme des Transportation Center aus der Vogelperspektive (oben); Querschnitt durch die Verbindungsbrücke des Transportation Center und eine computersimulierte Ansicht des Innenraums.
Seite 137: Die Modellaufnahme zeigt die Flugsteigzone, darunter eine Aufnahme während der Bauphase, Januar 1997.

Page 136: Maquette du projet montrant le Centre des transports terrestres (en haut), coupe transversale du pont de liaison et perspective de l'intérieur par image de synthèse.
Page 137: La zone d'embarquement telle qu'elle apparaîtra de l'extérieur une fois terminée. En bas, le chantier en janvier 1997.

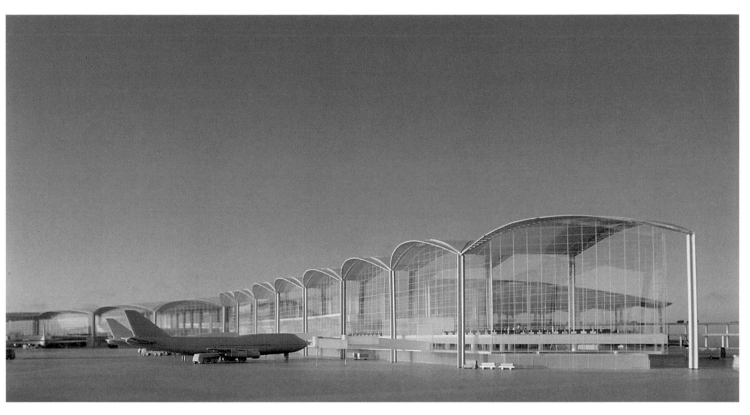

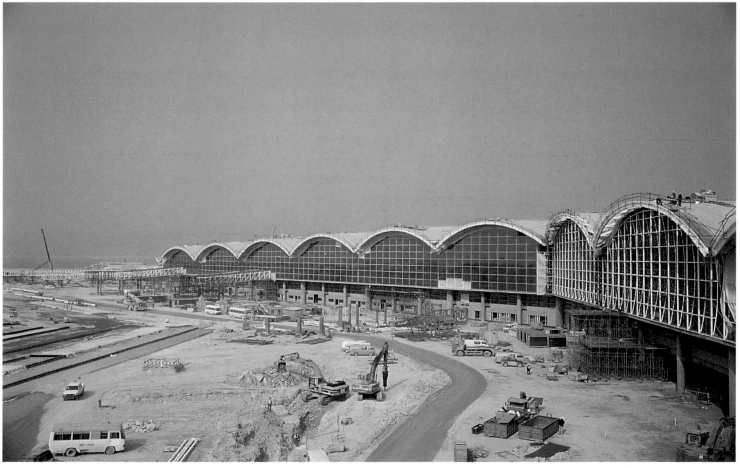

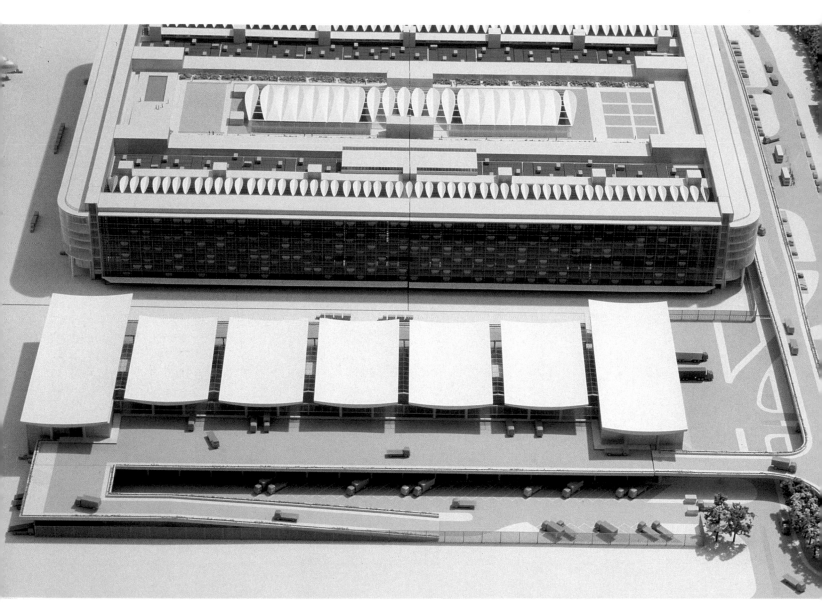

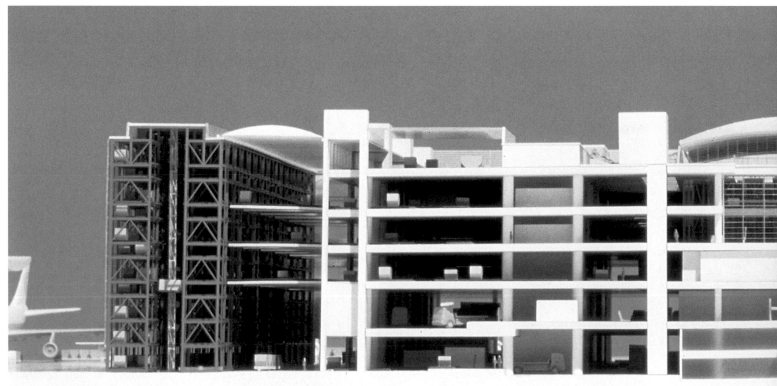

Page 138 top: An aerial model shot of the entire HACTL SuperTerminal 1 and Express Center complex.
Pages 138–139: A section of SuperTerminal 1.
Page 139 top: A model shot of the Express Center.

Seite 138 oben: Modellansicht des gesamten HACTL-Superterminal and Express Center aus der Vogelperspektive.
Seite 138–139: Querschnitt durch das Super Terminal 1.
Seite 139 oben: Modellaufnahme des Express Center.

Page 138 en haut: Vue de la maquette représentant l'ensemble du Super Terminal HACTL 1 et le complexe de l'Express Center.
Pages 138–139: Coupe du Super Terminal 1.
Page 139 en haut: La maquette de l'Express Center.

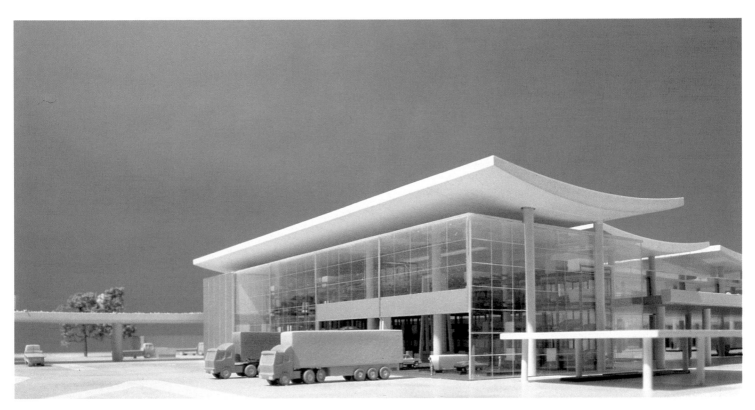

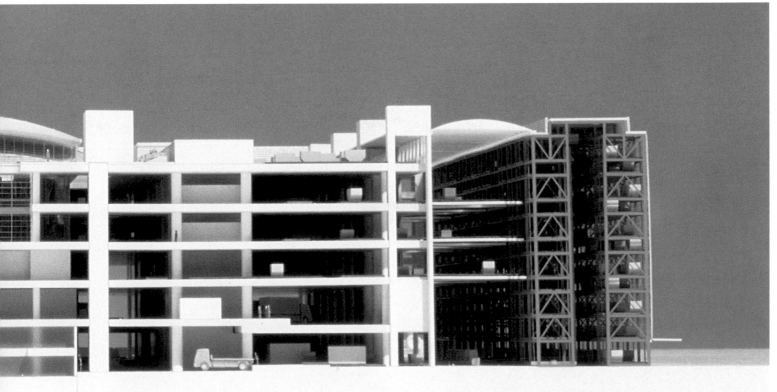

New German Parliament, Reichstag

Berlin, Germany, 1995–1999

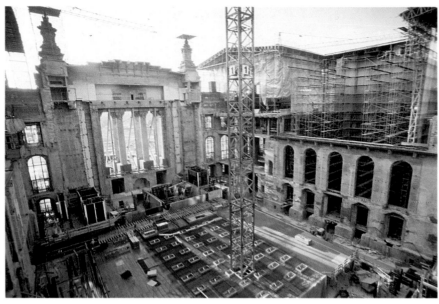

Page 140: *A construction progess image taken at the end of 1996.*
Page 141: *Foster's **initial scheme** called for a large canopy to cover the exisiting structure.*

Seite 140: *Eine Aufnahme während der Bauphase, Ende 1996.*
Seite 141: *Fosters **erster Entwurf** für den Reichstag sah einen großen Baldachin, der die bestehende Struktur überdachen sollte, vor.*

Page 140: *Le chantier, fin 1996.*
Page 141: *Le **projet initial** de Norman Foster pour le Reichstag qui prévoyait une grande couverture légère.*

One of Norman Foster's most prestigious commissions, the Reichstag project sets out to rebuild the famous assembly hall designed by Paul Wallot, built beginning in 1884. Ravaged first by fire and then by the War, the Reichstag lost its 76 meter high dome in 1954. After a first-phase entry where he proposed a 33,000 square meter canopy, Foster won the commission against Santiago Calatrava and the Dutch architect De Bruijn. Sir Norman prides himself in close personal involvement in his projects, and in this instance he is designing the eagle that will become the official symbol of the parliament. Traces of the building's history, such as shell marks, burnt wood and graffiti, will be conserved, so that the Reichstag will become a living museum. The Foster scheme also provides for the building to be energy self-sufficient using only renewable sources of energy. A co-generator burns rapeseed oil, and heat absorption machines convert waste heat into cooling. Unwanted heat in summer is thermally stored deep under ground for retrieval

Einer von Norman Fosters renommiertesten Aufträgen beschäftigt sich mit dem Wiederaufbau des berühmten, von Paul Wallot 1884 begonnenen Abgeordnetenhauses, dem Reichstag. Zuerst durch ein Feuer und dann durch den Krieg verwüstet, verlor der Reichstag 1954 seine 76 m hohe Kuppel. Nach einem ersten Entwurf, bei dem er einen 33 000 m² großen Baldachin vorschlug, gewann Foster den Auftrag gegen Santiago Calatrava und den niederländischen Architekten De Bruijn. Da sich Sir Norman Foster bei seinen Projekten seines großen persönlichen Engagements rühmt, wird er auch den Adler entwerfen, das offizielle Symbol des Bundestags. Eine Reihe von bauhistorischen Zeugnissen, wie Granatspuren, verbranntes Holz und Graffiti, sollen erhalten bleiben, so daß der Reichstag zu einem lebendigen Museum wird. Fosters Entwurf für das Gebäude sieht außerdem eine autarke Energieversorgung vor, die sich ausschließlich erneuerbarer Energiequellen bedient. Ein Hilfsgenerator verbrennt Rapsöl, wobei eine Wärmeabsorptionsanlage

L'une des commandes les plus prestigieuses de Norman Foster, le projet du Reichstag, consiste à reconstruire le célèbre Parlement dessiné par Paul Wallot, dont l'édification commença en 1884. Détruit par un incendie, puis par la guerre, le Reichstag a perdu son dôme de 76 m en 1954. Après une première sélection pour laquelle il propose une sorte de vélum de 33 000 m², Foster remporte le concours contre Santiago Calatrava et l'architecte hollandais De Bruijn. L'architecte se plaît à souligner son engagement personnel dans tous ses projets et, en particulier dans celui-ci, pour lequel il dessine l'aigle qui deviendra le symbole officiel du Parlement. Un certain nombre de vestiges historiques – traces d'obus, restes de bois calcinés, graffitis – seront conservés. Le Reichstag deviendra un musée vivant de l'histoire allemande. Le projet Foster prévoit aussi que le bâtiment sera autosuffisant sur le plan énergétique et n'utilisera que des sources d'énergie renouvelables. Un co-générateur brûle de l'huile de colza et un système d'absorption

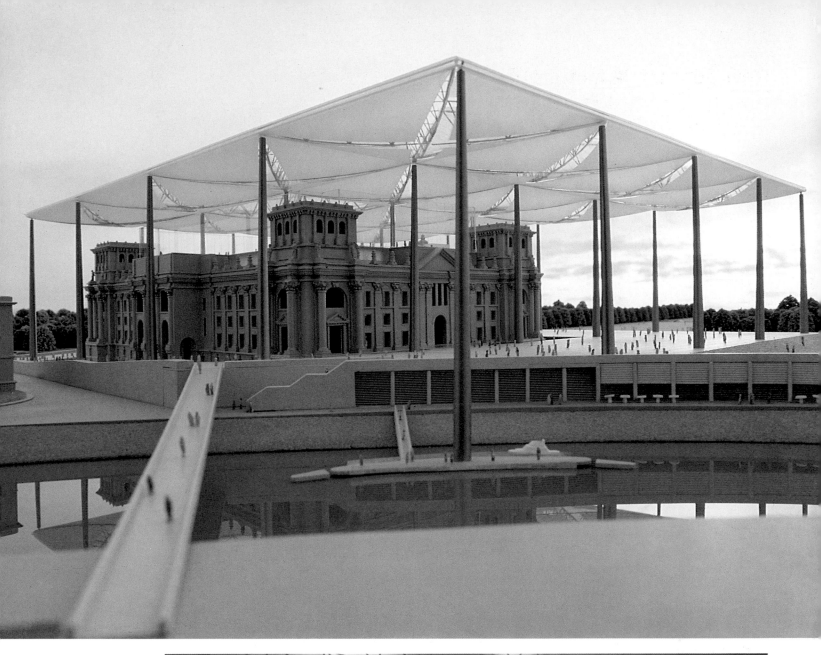

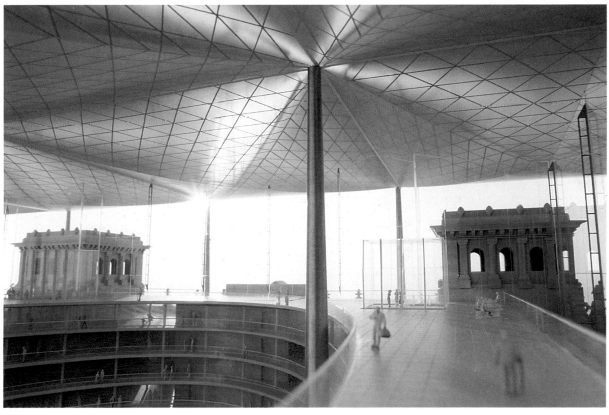

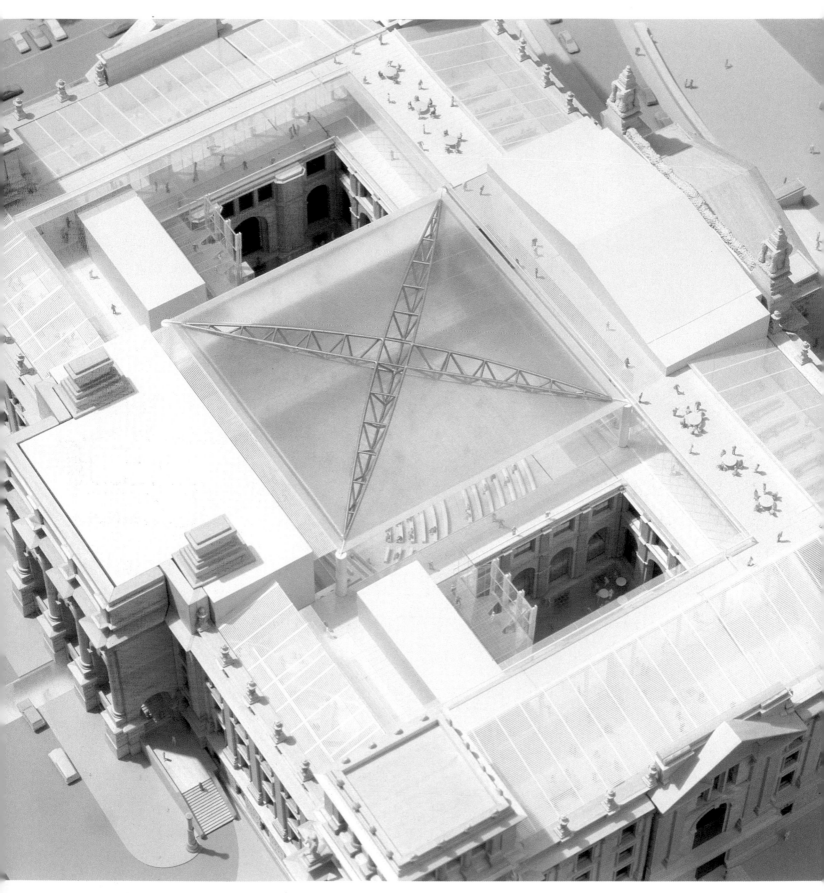

An **intermediate scheme** for
the Reichstag, which would have
limited overall height while
still bringing daylight into the
assembly area.
Page 143: A model, a north-
south section and an interior
perspective.

Ein **Zwischenentwurf** für den
Reichstag, der eine einheitliche
Gesamthöhe vorsieht und
dennoch Tageslicht in den
Plenarsaal führt.
Seite 143: Ein Modell, ein Nord-
Süd-Schnitt und eine Perspektiv-
zeichnung des Innenraums.

Projet intermédiaire pour le
Reichstag qui aurait réduit la
hauteur de l'ensemble, tout en
apportant la lumière du jour au
sein de la Chambre.
Page 143: Maquette, coupe nord-
sud et perspective intérieure.

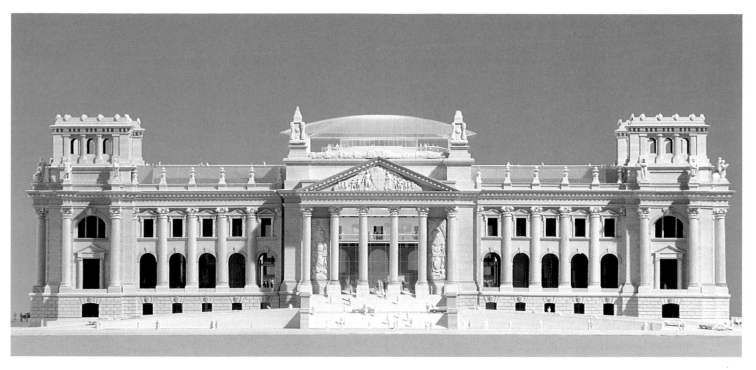

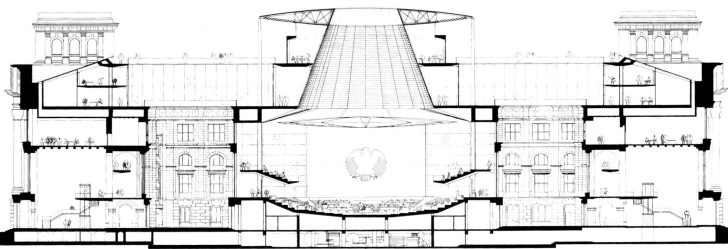

during winter. Natural ventilation is a priority, and the roof structure is an important part of the extract system. A revolving shield allows natural light to be channeled into the main chamber without solar gain. Spiral ramps connect an elevated public viewing platform to the main roof level.

entstehende Abwärme in Kühlung verwandelt. Die im Sommer entstehende überschüssige Hitzeeinstrahlung wird tief in den Erdboden geleitet und dient im Winter als zusätzliche Wärmequelle. Darüber hinaus wurde besonderer Wert auf eine natürliche Luftzirkulation gelegt, wobei die Dachkonstruktion im Be- und Entlüftungssystem eine zentrale Rolle spielt. Ein drehbares Sonnenschutzschild ermöglicht den Einfall natürlichen Lichtes in den Plenarsaal bei gleichzeitigem Schutz vor zu starker Sonneneinstrahlung, während spiralförmige Rampen eine erhöhte Besucherplattform mit der wichtigsten Dachebene verbinden.

convertit les excédents de chaleur en système de refroidissement. En été, les excédents de chaleur sont stockés en sous-sol, pour être utilisés durant l'hiver. Le dôme sert également à la ventilation naturelle des espaces. Un écran solaire orientable permet de diriger la lumière jusque dans la salle principale, sans gain solaire. Des rampes en spirale donnent accès au dernier niveau, celui du toit.

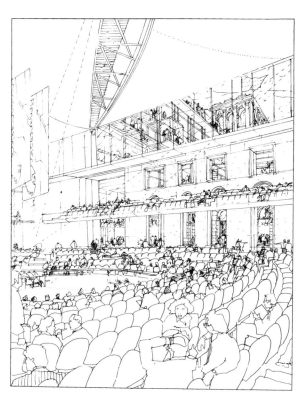

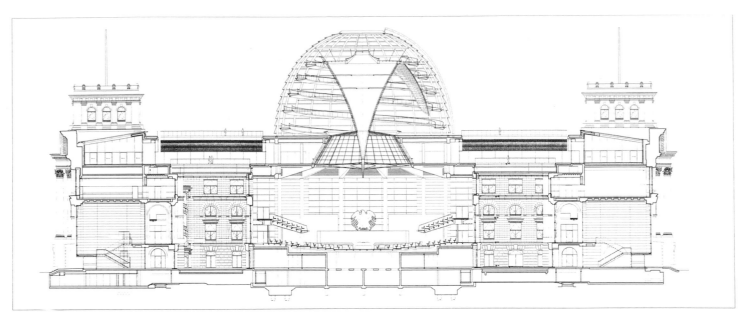

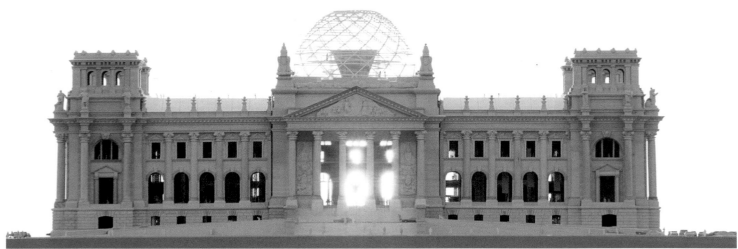

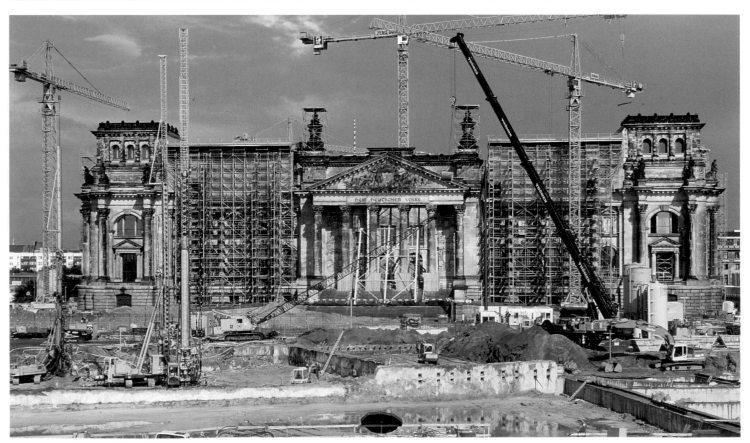

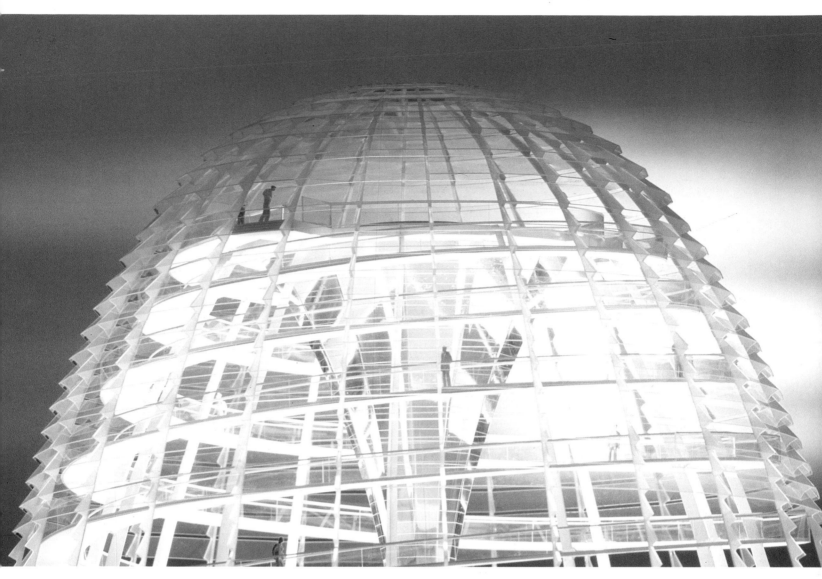

The **final scheme** for the Reichstag, which is being built.
Page 144: A cross-section of the building showing the parliamentary chambers, a model view, and a construction image taken late in 1996.
Page 145: A model demonstrating the transparency of the dome, and a sketch of the dome by Norman Foster.

Der **endgültige Entwurf** für den Reichstag.
Seite 144: Ein Schnitt durch das Gebäude, ein Modell und eine Aufnahme während der Bauphase, Ende 1996.
Seite 145: Ein Modell, das die Transparenz der Kuppel, die wirkungsvoll Licht in das Gebäudeinnere eindringen läßt, verdeutlicht und eine Skizze der Kuppel von Foster.

Projet final pour le Reichstag, en cours de réalisation.
Page 144: Coupe transversale montrant l'emplacement de l'hémicycle, maquette du projet et état d'avancement du chantier fin 1996.
Page 145: Maquette montrant la transparence du dôme et croquis de la coupole par Norman Foster.

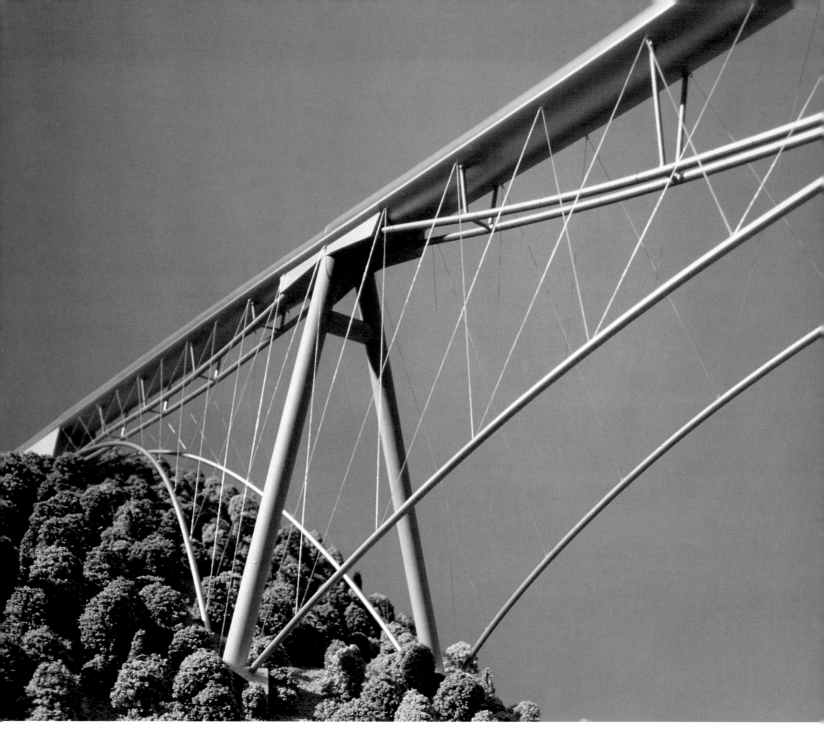

Millau Bridge

Millau, France, 1996

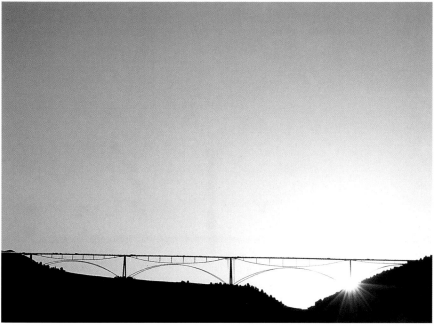

Teamed with the French engineers Sogelerg, EEG and SERF, Foster won a limited competition against French architects to build a 2.5 kilometer long viaduct on the A75 highway running between Clermont-Ferrand and Beziers, across the valley of the Tarn River. With columns varying in height between 75 and 235 meters, the viaduct is a multi-span cable-stayed design with sections each 350 meters in length. Intended to be completed in 2001, the viaduct is stated to cost 1.3 billion French francs, and has created a certain controversy because the design threatens in the mind of some to dwarf the features of the countryside. As in the case of his telecommunications facilities in Spain, Foster here undertakes a task often reserved to engineers, but as he says, "There are a whole series of visual options which permit you to achieve an optimal engineering solution, whether in a building, a bridge or an aircraft."

In Zusammenarbeit mit den französischen Ingenieur-büros Sogelerg, EEG und SERF setzte sich Foster in einem eingeladenen Wettbewerb gegen französische Architekten durch und erhielt den Auftrag zum Bau eines 2,5 km langen Viaduktes über das Tal des Flusses Tarn an der A57, die von Clermont-Ferrand nach Béziers führt. Bei diesem Viadukt handelt es sich um eine Mehrfeld-Schrägseil-konstruktion mit sieben Abschnitten von jeweils 350 m Länge und Pfeilern, deren Höhe zwischen 75 und 235 m variiert. Mit einer geplanten Fertigstellung im Jahr 2001 und angegebenen Baukosten von 1,3 Milliarden Franc löste das Bauwerk eine Kontroverse aus, da der Entwurf nach Meinung mancher Betrachter die Besonderheiten der Landschaft zu schmälern droht. Foster übernimmt hier eine Aufgabe, die oft in den Bereich der Ingenieure fällt, aber er erklärt dazu: »Es gibt eine ganze Reihe visueller Möglichkeiten, die eine optimale technische Lösung erlauben – ob es sich um ein Gebäude, eine Brücke oder ein Flugzeug handelt.«

En équipe avec les ingénieurs français de la Sogelerg, l'EEG et la SERF, Foster a remporté un concours restreint, face à des architectes français, pour construire un viaduc de 2,5 km de long sur l'autoroute A75, entre Clermont-Ferrand et Béziers, au-dessus de la vallée du Tarn. Avec des piliers dont la hauteur varie entre 75 et 235 m, le viaduc est une structure multi-haubanée, dont chaque section mesure 350 m de long. Devant être achevé pour l'an 2001, le viaduc devrait coûter 1,3 milliard de francs. De plus, il a suscité une controverse: certains craignent en effet qu'il n'écrase le paysage. Comme dans le cas des installations de télécommunications en Espagne, Foster s'attaque ici à un travail souvent réservé aux ingénieurs, mais, selon lui: «Il existe tout un ensemble d'options visuelles qui permettent d'aboutir à des solutions d'ingénierie optimale, que ce soit pour un bâtiment, un pont ou un avion.»

A sketch by Ken Shuttleworth and two model views show an early scheme for the Millau Viaduct, which was subsequently abandoned.

Eine Zeichnung von Ken Shuttleworth und zwei Modellansichten zeigen einen früheren Entwurf des Millau-Viadukts, der später verworfen wurde.

Esquisse de Ken Shuttleworth et deux vues de la maquette montrant un projet antérieur du viaduc de Millau qui devait être abandonné.

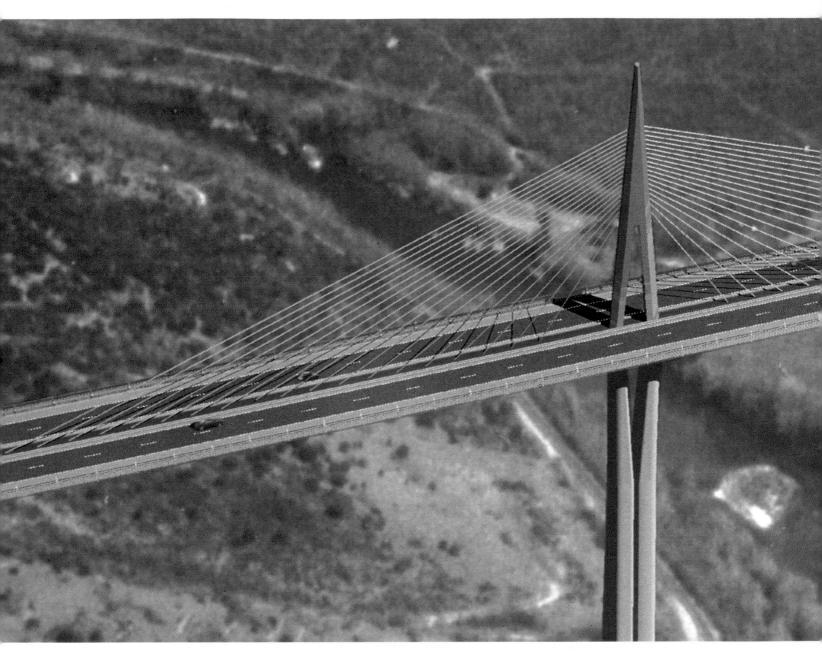

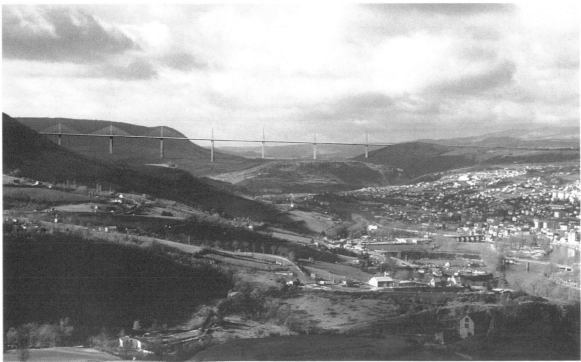

As requested by the French authorities, the competition-winning scheme spans the entire valley of the Tarn River with a total of seven pillars suspending sections of equal length.

Wie von der französischen Regierung gefordert, überspannt der preisgekrönte Entwurf das ganze Tal des Tarn durch acht gleich lange Abschnitte, die an sieben Pfeilern aufgehängt sind.

À la demande des autorités françaises, le projet gagnant franchit toute la vallée du Tarn avec, au total, sept piliers à intervalles égaux.

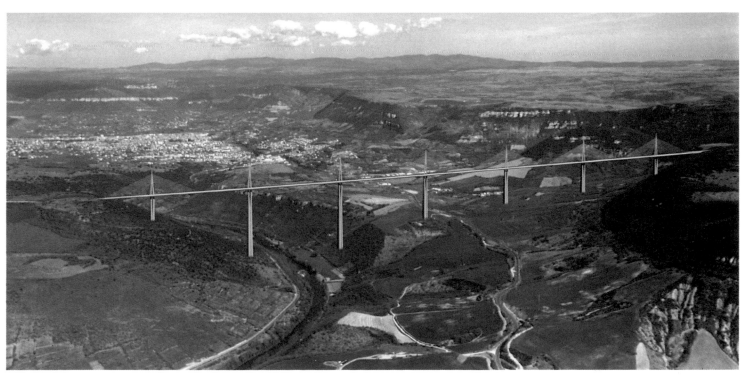

London Millennium Tower

London, UK, 1996

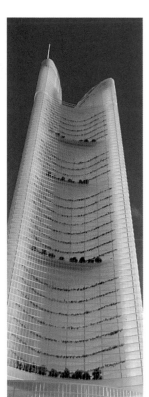

Another project that has elicited some controversy is Norman Foster's plan to build the tallest tower in Europe on the site of the Baltic Exchange, a structure in London's City damaged by an IRA bomb in 1992. The plan calls for a ninety-five-story office building to go up in the same quadrant as Lloyd's Headquarters, the Bank of England and Broadgate. Its height of 400 meters, or 435 meters to the top of the mast, would make it about 20 meters smaller than the tallest building in the world, currently the Petronas Twin Towers in Kuala Lumpur (Cesar Pelli). Along the lines of Foster's declared hope to build large mixed-use towers, from level seventy-three upwards there will be twelve stories of apartments in the north section, and seven in the south. Since the Baltic Exchange is a Grade II listed building the project requires the agreement of English Heritage, but it is one of the few sites in the City that is not inhibited by height-limiting factors such as the sight lines towards St Paul's Cathedral. A public viewing platform would be situated at precisely 1000 feet, symbolizing the Millennium for which the project is named.

Ein weiteres Projekt, das Kontroversen auslöste, ist Fosters Vorhaben, den höchsten Turm Europas auf dem Gelände der Baltic Exchange zu errichten – eines Gebäudes in der Londoner City, das 1992 durch einen Bombenanschlag der IRA beschädigt wurde. Foster sieht ein Bürogebäude mit 95 Geschossen im gleichen Viertel vor, in dem auch die Hauptverwaltung von Lloyd's, die Bank of England und Broadgate stehen. Mit einer Höhe von 400 m (bzw. 435 m bis zur Mastspitze) ist der Bau nur 20 m kleiner als das derzeit höchste Gebäude der Welt, die Petronas Twin Towers in Kuala Lumpur. Entsprechend Fosters Ziel, große Türme in Mischnutzung zu errichten, sollen ab der 73. Etage Wohngeschosse folgen. Da die Baltic Exchange auf der Liste der besonders erhaltenswerten Bauwerke steht, benötigt das Projekt die Zustimmung des English Heritage. Aber der Baugrund zählt zu den wenigen in der Stadt, für den keine besonderen Bauhöhenbestimmungen bestehen. In einer Höhe von 1000 Fuß soll eine Aussichtsplattform entstehen, die die Jahrtausendfeier symbolisiert, nach der das Projekt seinen Namen erhält.

Autre projet qui a suscité une certaine controverse: construire à Londres la tour la plus haute d'Europe, sur le site de la Baltic Exchange, endommagée par une bombe de l'IRA en 1992. Le plan prévoit une tour de bureaux de 95 étages, dans le même secteur que celles de la Lloyd's, la Banque d'Angleterre et Broadgate. Avec une hauteur de 400 m, soit 435 avec son mât, elle mesurerait environ 20 m de moins que le plus haut bâtiment du monde, à savoir les tours jumelles Petronas, à Kuala Lumpur (de Cesar Pelli). Foster, on le sait, rêve de construire des tours à vocation mixte. Ici il prévoit, à partir du 73e étage, douze étages d'appartements dans la section nord, et 7 au sud. Comme la Baltic Exchange est un Monument classé, le projet nécessite l'accord du gouvernement britannique. Cependant, il s'agit d'un des rares sites de la City qui ne soit pas soumis à des limites de hauteur, comme pour les bâtiments situés dans l'axe visuel de la cathédrale Saint-Paul. Une plateforme d'observation, destinée au public, serait située à 1000 pieds exactement, pour symboliser le Millénaire dont le bâtiment porte le nom.

Page 150: Intended to mix office, residential and commercial space, the London Millennium Tower would certainly mark the London skyline, but its curving top would somewhat soften its profile. A site plan shows the free form of the tower (top).
Page 151: A photomontage shows just how the volume of the building would fit into the City skyline.

Seite 150: Der als Kombination von Büro-, Wohn- und Geschäftsräumen konzipierte London Millennium Tower würde mit Sicherheit ein Wahrzeichen der Londoner Skyline darstellen, wobei seine gerundete Spitze die Konturen ein wenig mildert. Ein Lageplan zeigt die frei gestaltete Form des Turmes (oben).
Seite 151: Eine Fotomontage zeigt, wie das Gebäudevolumen sich in die Skyline der Stadt einfügen wird.

Page 150: Destinée à mêler bureaux, habitations et commerces, la London Millennium Tower marquerait certainement la ligne d'horizon de Londres. Toutefois, son sommet incurvé adoucirait quelque peu son profil. En haut, plan du site montrant la forme libre de la tour
Page 151: Photomontage montrant comment la tour s'inscrirait dans le paysage londonien.

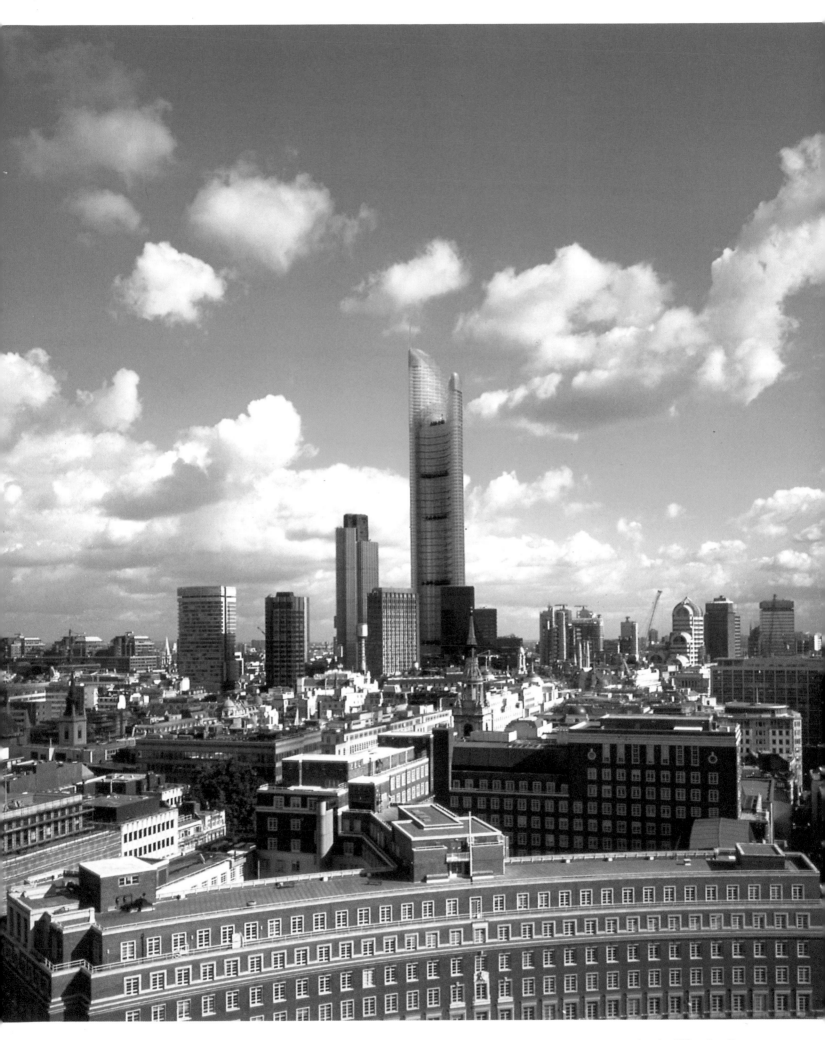

Daewoo Headquarters

Seoul, South Korea, 1997–2000

In a city not yet noted for architectural excellence, the Daewoo Headquarters would have a distinct, even unusual presence. Interior gardens and energy-efficient design mark this as a truly modern high rise.

In einer Stadt, die nicht unbedingt für ihre herausragende Architektur bekannt ist, wird das Gebäude der Daewoo-Hauptverwaltung eine charakteristische, sogar außergewöhnliche Stellung einnehmen. Die Innengärten und der energiesparende Entwurf machen es zu einem wirklich modernen Hochhaus.

Dans une ville guère remarquée jusqu'ici pour sa qualité architecturale, le siège social de Daewoo marquerait une présence inhabituelle. Des jardins intérieurs et une basse consommation en énergie font de cette tour un bâtiment très moderne.

Foster's Daewoo Headquarters tower stands out as a challenge not only to local ideas but also to the concept that Norman Foster's work has become too bland. It is a 172 meter structure including 95,000 square meters of office and laboratory space above ground, 10,000 square meters at the lower ground level, and 50,000 square meters of parking and technical areas below grade. With steel outrigger trusses providing stability, the steel and concrete structure features an unusual tapered design. Energy efficiency is the hallmark of the design, with a triple layered facade and adjustable shades and windows which can be opened to provide natural ventilation. Double-height garden levels correspond to the trusses and to the stopping points of elevators, where visitors transfer to internal escalators. Combining devices used in different forms in Hong Kong, Frankfurt or even in the earlier Willis Faber & Dumas building, the Daewoo Headquarters underlines the continuing evolution of Foster's designs within a framework of energy conservation, open legible spaces and technological innovation.

Fosters Turm für die Daewoo-Hauptverwaltung gilt nicht nur als eine Herausforderung an lokale Einflüsse, sondern auch als eine Kampfansage an die Auffassung, seine Arbeiten seien inzwischen zu angepaßt. Das Bauwerk von 172 m Höhe besitzt eine Fläche von 95 000 m² für Büro- und Laborräume, 10 000 m² im Souterrain sowie 50 000 m² für Parkplätze und technische Anlagen. Eine Stahl-Hängekonstruktion verleiht dem Stahlbetonbau Stabilität und ermöglicht seine ungewöhnliche, konisch zulaufende Form. Mit einer dreilagigen Fassade und regulierbaren Sonnenblenden vor den zu öffnenden Fenstern, die eine natürliche Lüftung gewährleisten, steht der Turm ganz im Zeichen energiesparender Maßnahmen. Durch die Kombination von Elementen, die bereits bei Projekten in Hongkong und Frankfurt oder sogar bei Willis Faber & Dumas Verwendung fanden, unterstreicht das Daewoo Haedquarters die Entwicklung von Fosters Entwürfen auf dem Gebiet der Energie-einsparung, der offenen Raumgestaltung und der innovativen Technologien.

Le siège social de Daewoo est un défi aux habitudes locales, mais aussi un démenti infligé à tous ceux qui trouvaient que le travail de Norman Foster était désormais trop conformiste. Il s'agit d'une structure de 172 m, comprenant 95 000 m² de bureaux et de laboratoires au-dessus du sol, 10 000 m² en rez-de-chaussée et 50 000 m² de parkings et d'espaces techniques en sous-sol. L'ossature saillante en acier donne un profil insolite à la structure en acier et béton. Parois extérieures à triple épaisseur, brise-soleil réglables et fenêtres ouvrables climatisent naturellement le bâtiment. Les jardins sur double hauteur sont au même niveau que les arrêts d'ascenseurs, là, où les visiteurs peuvent rejoindre les ascenseurs intérieurs. Combinant des dispositifs utilisés pour les bâtiments de Hong Kong, Francfort, voire même de Willis Faber & Dumas, on retrouve encore dans la tour Daewoo les préoccupations chères à Foster: conservation de l'énergie, lisibilité des volumes et innovation technologique.

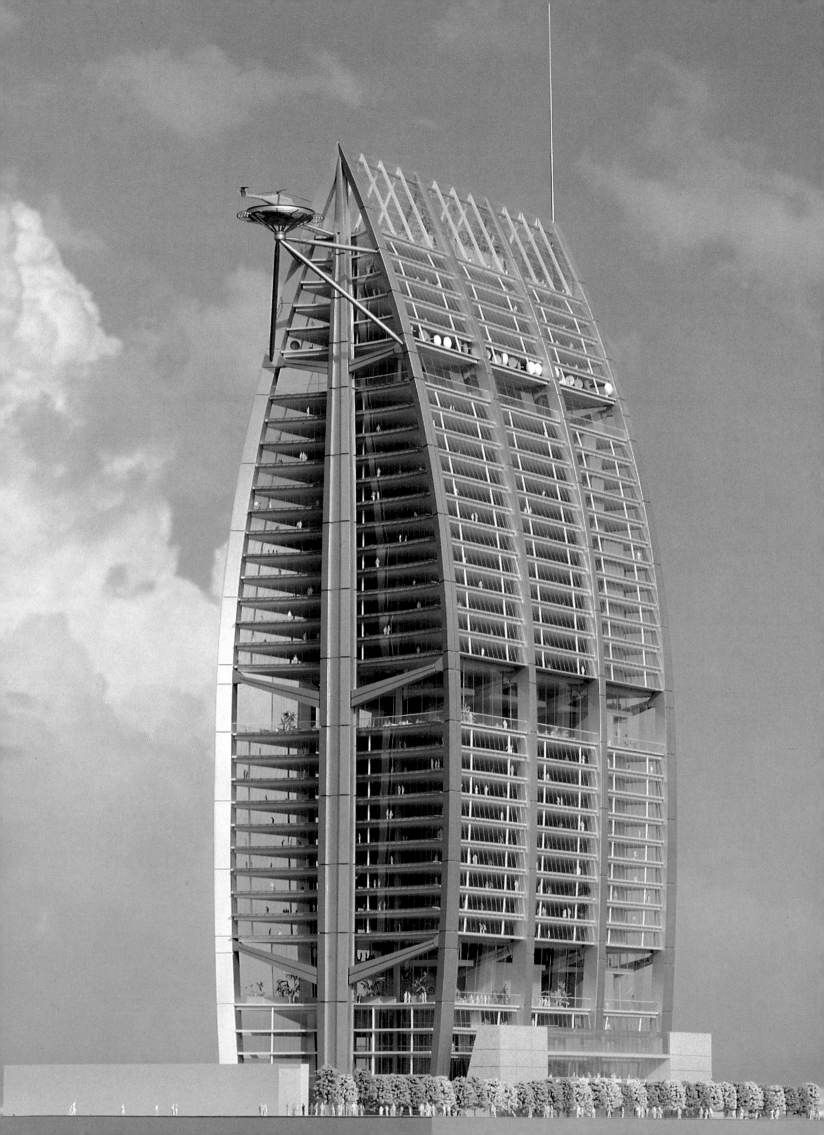

Level 1

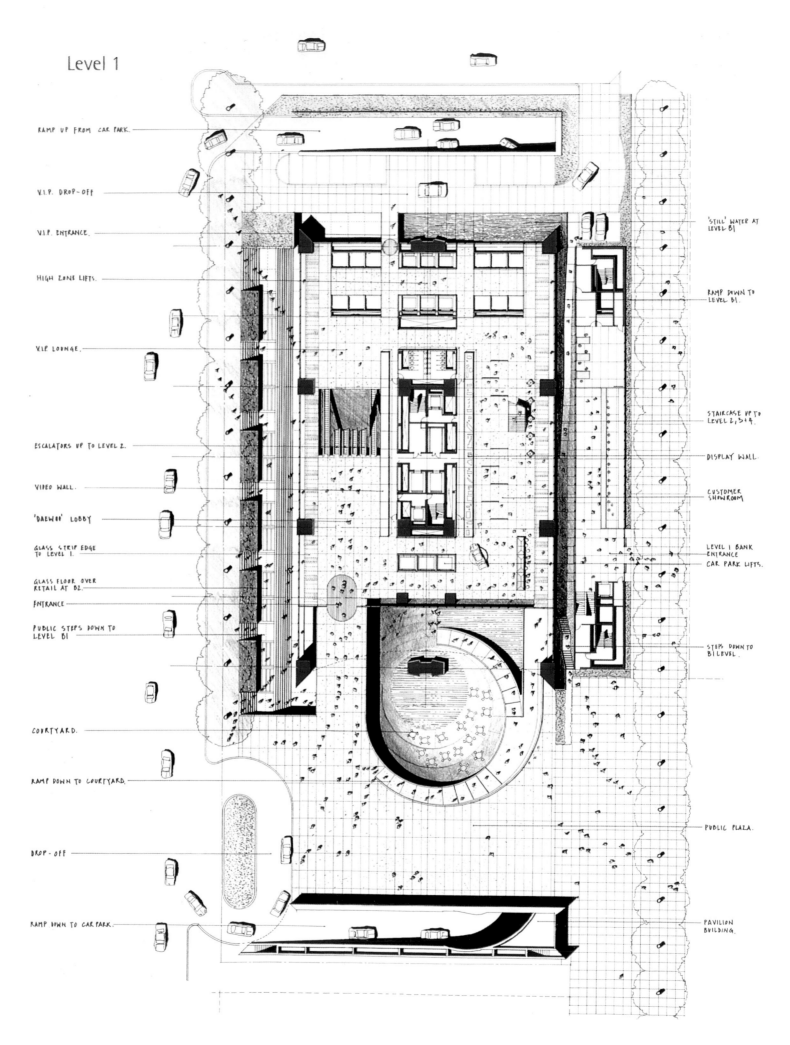

RAMP UP FROM CAR PARK.

V.I.P. DROP-OFF

V.I.P. ENTRANCE.

HIGH ZONE LIFTS.

V.I.P. LOUNGE.

ESCALATORS UP TO LEVEL 2.

VIDEO WALL.

'DAEWOO' LOBBY

GLASS STRIP EDGE TO LEVEL 1.

GLASS FLOOR OVER RETAIL AT B2.

ENTRANCE

PUBLIC STEPS DOWN TO LEVEL B1

COURTYARD.

RAMP DOWN TO COURTYARD.

DROP-OFF

RAMP DOWN TO CAR PARK.

'STILL' WATER AT LEVEL B1

RAMP DOWN TO LEVEL B1.

STAIRCASE UP TO LEVEL 2, 3 + 4.

DISPLAY WALL.

CUSTOMER SHOWROOM

LEVEL 1 BANK ENTRANCE CAR PARK LIFTS.

STEPS DOWN TO B1 LEVEL.

PUBLIC PLAZA.

PAVILION BUILDING.

Page 154: A plan of Level 1.
Page 155: A cross-section through the health club. Below, a long section .

Seite 154: Grundriß der ersten Etage.
Seite 155: Schnitt durch den Fitneßclub, darunter ein Längsschnitt.

Page 154: Plan du premier niveau.
Page 155: Coupe transversale du centre sportif. Ci-dessous, coupe longitudinale.

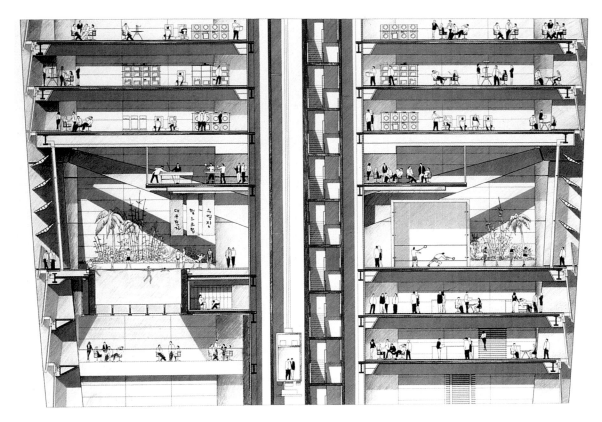

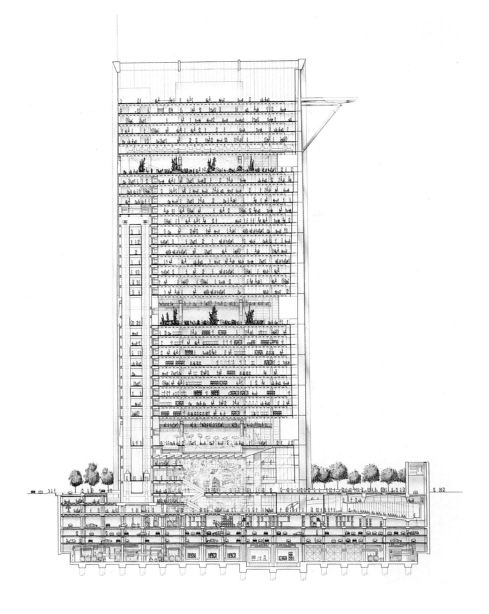

British Museum Redevelopment

London, UK, 1997–2000

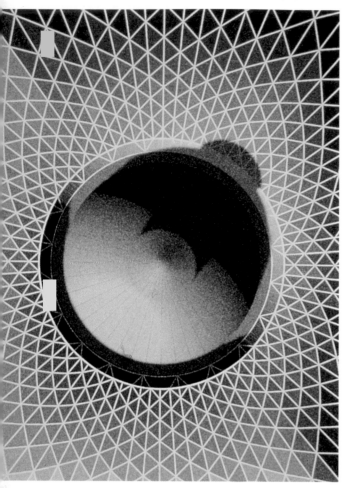

Page 156: *A computer view of the new roof over the central court.*
Page 157: *The British Museum as it was (bottom) and, in a computer perspective, as it will be with the courtyard covered (top).*

Seite 156: *Computersimulation des Daches über dem zentralen Innenhof*
Seite 157: *Das ursprüngliche British Museum (unten) und eine Computersimulation des zukünftigen Bauwerks mit dem überdachten Innenhof (oben).*

Page 156: *Image de synthèse du nouveau toit au-dessus de la cour centrale*
Page 157: *Le British Museum tel qu'il était (en bas). En haut, dans une perspective révélée par image de synthèse, tel qu'il sera avec la cour couverte.*

Established by an act of Parliament in 1753 to house the Cabinet of Curiosities of Sir Hans Sloane, the Cotton Collection and the Harleian Library, the British Museum opened to the public in 1759. The acquisition of the library of George III necessitated larger quarters, and the buildings designed by Sir Robert and Sydney Smirke were erected between the 1820s and the 1850s. The focus of this scheme was a central, public courtyard, which was soon to be lost by the erection of the famous Round Reading Room in that space in 1857. The long-awaited completion of the new British Library at St Pancras has permitted the Museum to launch a renovation program, for which Sir Norman Foster was chosen as architect in 1994. His plan creates a major new public space for London by opening up the Inner Courtyard and enclosing it with a new lightweight glazed roof. A double staircase around the reading room leads to the upper-level galleries. Below ground, new galleries for the Ethnography Collection are situated. Bookshops, a restaurant and a cafe on level 2 are included in the scheme, as well as a reorganization of the forecourt of the Museum, until now a parking area.

Im Jahre 1759 öffnete das British Museum seine Pforten, nachdem man es 1753 durch einen Parlamentsbeschluß ins Leben gerufen hatte, um Sir Hans Sloanes Cabinet of Curiosities, die Cotton Collection und die Harleian Library aufzunehmen. Durch den Ankauf der Bibliothek George III. wurde eine Erweiterung des Gebäudes erforderlich, dessen Bauarbeiten Sir Robert und Sydney Smirke zwischen 1823 und 1852 betreuten. Den Mittelpunkt bildete ein zentraler, öffentlicher Innenhof, der aber schon 1857 durch die Errichtung des berühmten runden Lesesaales (Round Reading Room) verlorenging. Die lang erwartete Fertigstellung der New British Library in St. Pancras erlaubte dem Museum ein Sanierungsprogramm, für das Foster 1994 als Architekt ausgewählt wurde. Er sieht einen neuen öffentlichen Platz vor, wozu der Innenhof geöffnet und mit einem Glasdach versehen werden soll. Eine zweiläufige Treppe um den Lesesaal führt zu den Galerien auf den oberen Etagen. Unter Planum befinden sich weitere Ausstellungsräume für die Ethnographische Sammlung. Buchläden, ein Restaurant und ein Café auf der zweiten Etage sowie die Neugestaltung des Museumsvorplatzes, bisher Parkplatz, runden das Bauvorhaben ab.

Fondé par le Parlement en 1753 afin d'accueillir le Cabinet des curiosités de Sir Hans Sloane, la collection Cotton et la Bibliothèque Harleian, le British Museum est ouvert au public en 1759. L'acquisition de la bibliothèque de Georges III nécessite davantage d'espaces, et les bâtiments dessinés par Sir Robert et Sydney Smirke sont érigés entre les années 1820 et 1850. L'axe du projet était alors une cour centrale ouverte au public qui allait bientôt disparaître avec la construction de la célèbre salle de lecture ronde en 1857. L'achèvement, longtemps attendu, de la nouvelle bibliothèque de St. Pancras (ce qui a permis à la British Library de déménager), a enfin laissé la voie libre au Musée afin de lancer un programme de rénovation, pour lequel Foster a été choisi en 1994. Son plan envisage de créer un nouveau grand lieu public pour Londres, en dégageant la cour intérieure et en la recouvrant d'une verrière légère. Autour de la salle de lecture, une double volée d'escaliers conduit aux galeries supérieures. En sous-sol de nouvelles galeries consacrées à la collection ethnographique ont été aménagées. Des librairies, un restaurant et un café sont prévus au deuxième niveau, ainsi que la réorganisation de l'esplanade du Museum, jusque-là occupée par un parking.

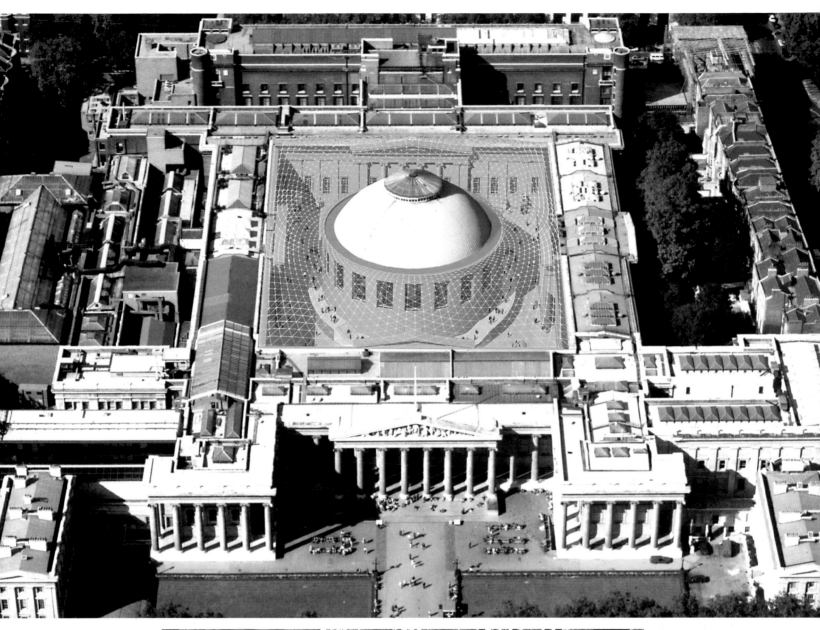

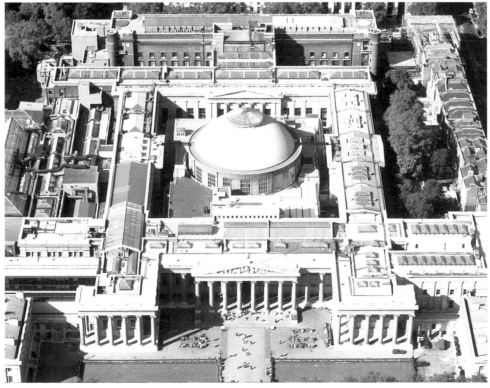

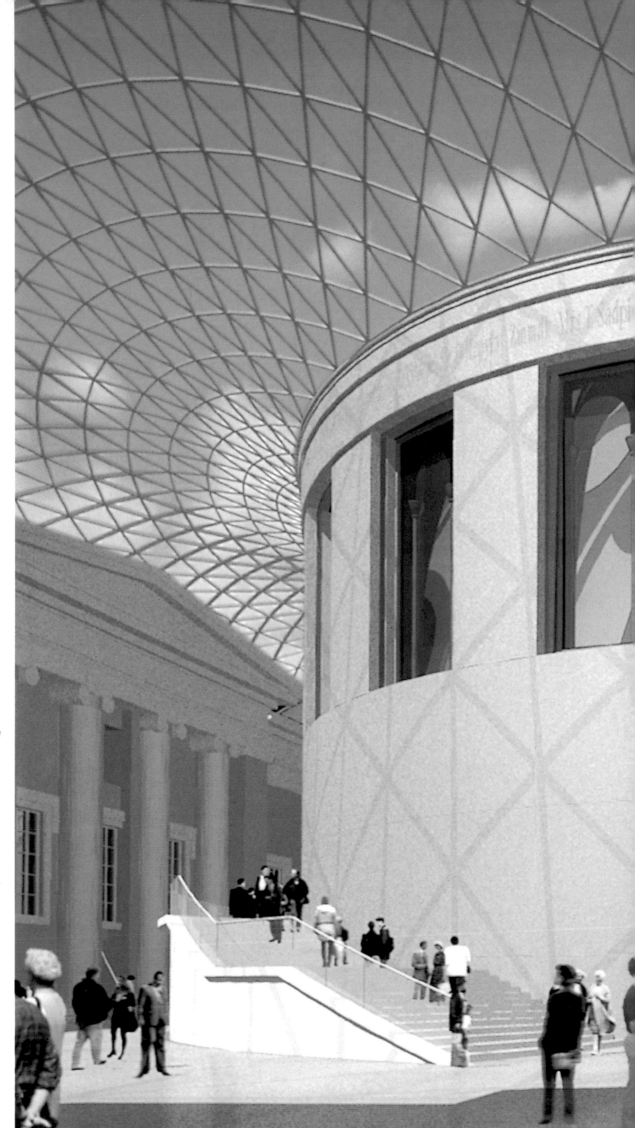

A perspective of the Great Court, which surrounds the famous Round Reading Room. Access to the entire museum will now be made possible through this area, formerly closed to the general public.

Perspektivansicht des Innenhofes, der den berühmten runden Lesesaal umgibt. Der Zugang zum gesamten Museum wird in Zukunft über diesen Bereich möglich sein, der früher für die Öffentlichkeit gesperrt war.

Perspective de la grande cour qui entoure la célèbre salle de lecture ronde. L'accès au musée tout entier se fera désormais par cet espace, autrefois fermé au public.

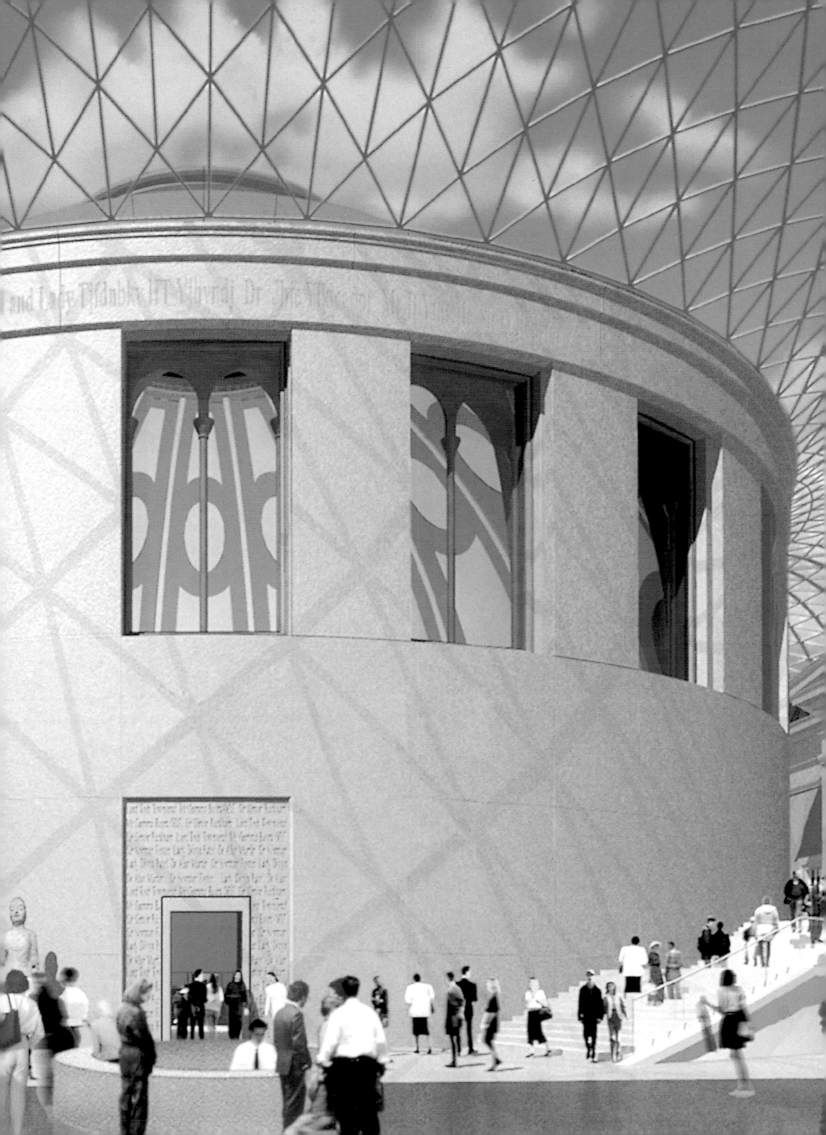

Buildings and projects
Bauten und Projekte
Projets et réalisations

From left to right | Von links nach rechts | De gauche à droite:
1968–69, Fred Olsen Limited Amenity Centre, Millwall, London, UK

1971, Foster Associates Studio, Fitzroy Street, London, UK

1978, Whitney Museum Development Project, New York, N. Y., USA

1982–83, Parts Distribution Centre for Renault UK Limited, Swindon, Wiltshire, UK

1982, Autonomous Dwelling (with R. Buckminster Fuller), USA

1964 *Cockpit,* Pill Creek, Cornwall, UK
Creek Vean House, Feock, Cornwall, UK (1964–66)
Skybreak House, Radlett, Hertfordshire, UK (1964–66)
Waterfront Housing, Pill Creek, Cornwall, UK
Mews Houses, Camden Town, London, UK
Forest Road Extension, East Horsley, Surrey, UK

1965 *Henrion Studio,* London, UK
Housing for Wates, Coulsdon, London, UK
Reliance Controls Limited, Swindon, Wiltshire, UK (1965–66)

1967 *Newport School Competition,* Newport, Wales, UK

1968 *Fred Olsen Limited Amenity Centre,* Millwall, London, UK (1968–69)

1969 *Masterplan for Fred Olsen Limited,* Millwall Docks, London, UK
Factory Systems Studies

1970 *Air-Supported Structure for Computer Technology Limited,* Hemel Hempstead, Hertfordshire, UK
IBM Pilot Head Office, Cosham, Hampshire, UK (1970–71)
Computer Technology Limited, Hemel Hempstead, Hertfordshire, UK (1970–71)

Fred Olsen Limited Passenger Terminal, Millwall, London, UK (1970–71)

1971 *Retail & Leisure Studies,* Liverpool, Exeter, UK; Badhoevedorp, The Netherlands
Climatroffice
Theatre for St Peter's College, Oxford, Oxfordshire, UK
Foster Associates Studio, London, UK
Special Care Unit, Hackney, London, UK (1971–73)

1972 *Modern Art Glass Limited,* Thamesmead, Kent, UK (1972–73)
Orange Hand Boys Wear Shops for Burton Group, UK (nationwide, 1972–73)

1973 *Willis Faber & Dumas Office,* Ipswich, Suffolk (1973–75, appointment 1970)
Aluminium Extrusion Plant for SAPA, Tibshelf, Derby, UK (1973–77, appointment 1972)
Headquarters for VW Audi NSU & Mercedes Benz, Milton Keynes, Buckinghamshire, UK (1973–74)
Low Rise Housing, Milton Keynes Development Corporation, Milton Keynes, Buckinghamshire, UK (1973–75)

1974 *Offices for Fred Olsen Limited,* Vestby, Norway

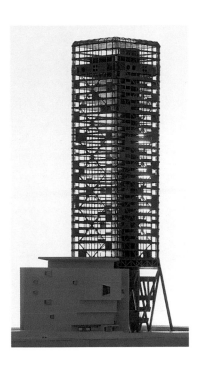

Travel Agency for Fred Olsen Limited,
London, UK
Country Club and Marina, Son, Norway
Palmerston Special School, Liverpool,
Merseyside, UK (1974–75)

1975 Fred Olsen Gate Redevelopment,
Oslo, Norway
Regional Planning Studies for Island of
Gomera, Canaries, Spain (1975–76)

1976 Sainsbury Centre for Visual Arts,
University of East Anglia, Norwich,
Norfolk, UK (1976–77, appointment
1974)
Masterplan for St Helier Harbour, Jersey,
Channel Islands, UK

1977 Transportation Interchange for LTE,
Hammersmith, London, UK
Technical Park for IBM, Greenford,
Middlesex, London, UK (1977–79,
appointment 1974)

1978 Whitney Museum Development Project,
New York, N.Y., USA
Open House Community Project,
Cwmbran, Wales, UK
Proposals for International Energy Expo,
Knoxville, USA
Foster Residence, Hampstead, London, UK
London Gliding Club, Dunstable
Downs, Bedfordshire, UK

1979 Shop for "Joseph", Knightsbridge,
London, UK
Granada Entertainment Centre, Milton
Keynes, Buckinghamshire, UK

1980 Students' Union Building, University
College, London, UK
Planning Studies for Statue Square,
Hong Kong

1981 Hongkong and Shanghai Banking
Corporation Headquarters, Hong Kong
(1981–86, competition 1979)
Competition for Billingsgate Fish Market,
London, UK
National Indoor Athletics Stadium,
Frankfurt am Main, Germany*
Internal Systems, Furniture for Foster
Associates
Foster Associates' Office, London, UK

1982 Parts Distribution Centre for Renault UK
Limited, Swindon, Wiltshire, UK
(1982–83, appointment 1980)
Competition for Headquarters of
Humana Inc., Louisville, Kentucky, USA
Autonomous Dwelling
(with R. Buckminster Fuller), USA
BBC Radio Headquarters, London, UK*

1984 IBM Head Office (refit), Cosham,
Hampshire, UK (1984–86)

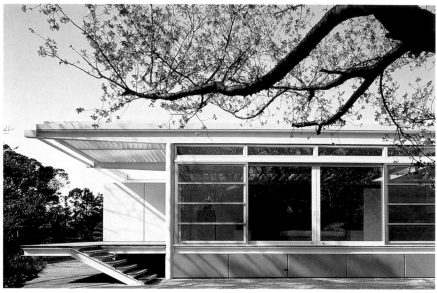

From left to right | Von links nach rechts | De gauche à droite:

1987, Competition for Paternoster Square Redevelopment, London, UK

1991–92, House in Japan

1988, Competition for Kansai Airport, Kansai, Japan

1989–91, Street Furniture for Decaux, Paris, France

1985 *New Offices for IBM*, Greenford, Middlesex, London, UK
Furniture System for Tecno, Milan, Italy (1985–87)

1986 *New York Marina*, New York, USA
Shop for Katharine Hamnett, London, UK
Headquarters for Televisa, Mexico City, Mexico
Salle de Spectacles, Nancy, France
Riverside Development, Apartments and Offices for Foster Associates, Riverside, London, UK (1986–90)

1987 *Carré d'Art*, Nîmes, France* (1987–93, appointment 1984)
Paternoster Square Redevelopment, London, UK
Bunka Radio Station, Yarai Cho, Tokyo, Japan
Shopping Centre for Savacentre, near Southampton, Hampshire, UK
Hotel for La Fondiaria, Florence, Italy
Turin Airport, Turin, Italy
Offices for Stanhope Securities, Uxbridge, Middlesex, London, UK (1987–89)
Riverside Housing and Light Industrial Complex, Hammersmith, London, UK
King's Cross Masterplan, London, UK*
Hotel and Club Knightsbridge, London, UK
London's Third Airport, Stansted, Essex, UK (1987–91, appointment 1981)

1988 *Holiday Inn*, The Hague, The Netherlands
Offices for Stanhope Securities, London, UK
Pont d'Austerlitz, Paris, France
Kansai Airport, Kansai, Japan
Contract Carpet and Tile Design for Vorwerk
City of London Heliport, London, UK
Sackler Galleries, Jerusalem, Israel
Shop for Esprit, London, UK
ITN Headquarters, London, UK (1988–90)

1989 *Century Tower*, Tokyo, Japan (1989–91, appointment 1987)
Crescent Wing, Sainsbury Centre for Visual Arts, University of East Anglia, Norwich, Norfolk, UK (1989–91, appointment 1988)
Sackler Galleries, Royal Academy of Arts, London, UK (1989–91, appointment 1985)
Office Building for Jacob's Island Co., Docklands, London, UK
Office Building DS2 at Canary Wharf, Docklands, London, UK*
Technology Centres, Edinburgh and Glasgow, Scotland, UK
British Rail Station, Stansted Airport, Stansted, Essex, UK (1989–91)
Competition for Terminal 5 Heathrow Airport, London, UK

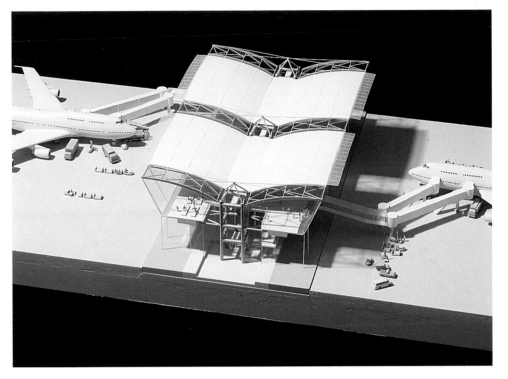

Street Furniture for Decaux, Paris,
France (1989–91)
Apartments and Offices, New York, USA
Office Building DS2 at Canary Wharf,
Docklands, London, UK*
Planning Studies for the City of
Cambridge, Cambridgeshire, UK*
New Library for Cranfield University,
Bedfordshire, UK (1989–92)
Offices for Stanhope Properties, Chiswick
Park Development, London, UK
Tokyo Millennium Tower, Tokyo, Japan
Passenger Concourse Building for British
Rail, King's Cross, London, UK

1990 Torre de Collserola (Telecommunications
Tower), Barcelona, Spain* (1990–92,
appointment 1988)
Metro Bilbao, Bilbao, Spain* (1990–95,
appointment 1988)
Micro-Electronic Park, Duisburg,
Germany (1990–96,
appointment 1988)
Trade Fair Center, Berlin, Germany
Congress Hall, San Sebastian, Spain
Hôtel du Département, Marseille, France
Refurbishment of Brittanic House, City of
London, UK
Office Building for Fonta, Toulouse,
France
Masterplan for Nîmes, Nîmes, France
Masterplan for Cannes, Cannes, France

Masterplan for Berlin, Berlin, Germany
House for M. Bousquet, Corsica, France
(1990–93)

1991 Viaduct for Rennes, Rennes, France*
Canary Wharf Station for the Jubilee Line
Underground Extension, London, UK*
(1991–98)
New Headquarters for Obunsha
Corporation, Yarai Cho, Tokyo, Japan
(1991–93)
New Headquarters for Agiplan,
Mülheim, Germany (1991–96)
New Headquarters and Retail Building
for Sanei Corporation, Makuhari, Japan
Office Building for Stanhope Properties
and County Natwest, London, UK
Institute of Criminology, University of
Cambridge, Cambridgeshire, UK
Napp Laboratories, Cambridge,
Cambridgeshire, UK
Gateway Office Building to Spitalfields
Redevelopment, London, UK
Paint Factory, Frankfurt Colloquium,
Frankfurt am Main, Germany
Masterplan for Duisburg Harbour,
Duisburg, Germany* (1991–99)
Masterplan for Greenwich, London, UK
Cladding System for Jansen Vegla Glass
(1991–92)
Private House, Japan (1991–92)

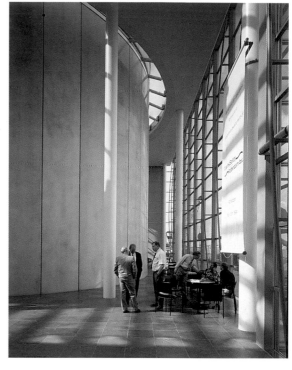

From left to right | Von links nach rechts | De gauche à droite:

1992–93, Motoryacht for Japanese client

1992, Musée de la Préhistoire, Quinson, Gorges du Verdon, France*

1992–93, Marine Simulator, Rotterdam, The Netherlands

1992, Yokohama Masterplan, Yokohama, Japan

1994–95, Forth Valley Community Care Village, Scotland, UK

1992 *Lycée Albert Camus*, Fréjus, France* (1992–93, appointment 1991)
Motoryacht for Japanese client (1992–93, appointment 1990)
Musée de la Préhistoire, Quinson, Gorges du Verdon, France*
Shops and Franchises for Cacharel, France
Clore Theatre, Imperial College, London, UK
Competition for World Trade Center, Berlin, Germany
Masterplan for Imperial College, London, UK
Masterplan for Rotterdam, Rotterdam, The Netherlands
Marine Simulator, Rotterdam, The Netherlands (1992–93)
Competition for Houston Museum of Fine Arts, Houston, USA
Masterplan for Lüdenscheid, Lüdenscheid, Germany
High Bay Warehouse, Lüdenscheid, Germany
House in Germany (1992–94)
School of Physiotherapy, Southampton, Hampshire, UK (1992–94)
Station Poterie, Rennes, France
Thames Valley Business Park, Reading, Berkshire, UK* (1992–96)
Competition for Spandau Bridge, Berlin, Germany
Refurbishment and Addition to the Hamlyn House, Chelsea, London, UK (1992–93)

Manchester Olympic Bid Masterplan, Manchester, UK
Competition for Business Park, Berlin, Germany*
Yokohama Masterplan, Yokohama, Japan
Tower Place Offices, City of London, UK
Headquarters, Factory and Warehouse for Tecno, Valencia, Spain
New York Police Academy, New York, USA
Solar Electric Vehicle, Kew, London, UK (1992–94)

1993 *Addition to Joslyn Art Museum*, Omaha, Nebraska, USA* (1993–94, appointment 1992)
Faculty of Law, University of Cambridge, Cambridgeshire, UK* (1993–95, appointment 1990)
New Headquarters for Crédit du Nord, Paris, France
Masterplanning Studies for Gare d'Austerlitz, Paris, France
Medieval Center for Chartres, Chartres, France
Urban Design at Porte Maillot, Paris, France
Exhibition Halls, Villepinte, Paris, France
Imperial War Museum, Hartlepool, Cleveland, UK*
Oresund Bridge, Copenhagen, Denmark
National Gallery of Scottish Art, Glasgow, Scotland, UK

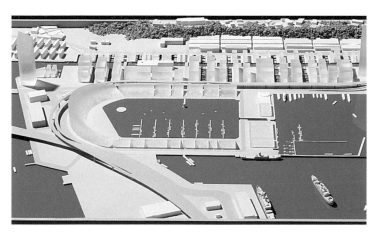
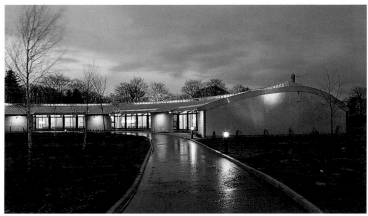

South Kensington Millennium Project
Albertopolis, London, UK*
Wind Turbine Energy Generator,
Germany
MTR Platform Edge Screens, Hong Kong
Street Lighting for Decaux
Headquarters for Timex, Connecticut,
USA
Tennis Centre, Manchester, UK
London School of Economics Library,
London, UK*
Competition for Hong Kong Convention
and Exhibition Centre, Hong Kong
Masterplan for Corfu, Corfu, Greece
Masterplan for Lisbon Expo 98, Lisbon,
Portugal*
Headquarters for ARAG 2000,
Düsseldorf, Germany
New Office and Railway Development,
Kuala Lumpur, Malaysia

1994 Forth Valley Community Care Village,
Scotland (1994–95, appointment 1993)
Commerzbank Headquarters, Frankfurt
am Main, Germany* (1994–97,
appointment 1991)
Design Center, Essen, Germany
(1994–97, appointment 1989)
Telecommunications Facility, Santiago
de Compostela, Spain
SeaLife Center, Blankenberge, Belgium
(1994–95)

SeaLife Centre, Birmingham,
West Midlands, UK (1994–96)
Al Faisaliah Complex, Riyadh,
Saudi Arabia*
Zhongshan Office Development,
Guangzhou, China*
Bangkok Airport, Bangkok, Thailand
Casino-Kursaal, Oostende, Belgium
Centre de la Memoire, Oradour-sur-
Glanes, France
Grand Stade, St Denis, Paris, France
New Offices at Holborn Circus, London, UK
Competition for Cardiff Bay Opera
House, Cardiff, Wales, UK
Visions for Europe, Düsseldorf,
Germany

1995 American Air Museum, Duxford,
Cambridgeshire, UK (1995–97,
appointment 1987)
EDF Regional Headquarters, Bordeaux,
France (1995–96, appointment 1992)
Congress Center, Valencia, Spain
(1995–98, appointment 1992)
KCRC Kowloon Railway Station, Hong
Kong (1995–97, appointment 1992)
Airport at Chek Lap Kok, Hong Kong
(1995–98, appointment 1992)
New German Parliament, Reichstag,
Berlin, Germany* (1995–99,
appointment 1992)
Offices for LIFFE, London, UK

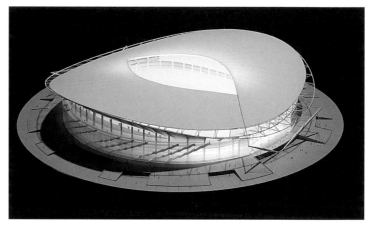

From left to right | Von links nach rechts | De gauche à droite:

1994, Al Faisaliah Complex, Riyadh, Saudi Arabia*

1994, Grand Stade, St-Denis, Paris, France

1994, Competition for Cardiff Bay Opera House, Cardiff, Wales, UK

1995–97, New Conference and Exhibition Facilities for SECC, Glasgow, Scotland, UK

Murr Tower, Beirut, Lebanon*
Jiu Shi Tower, Shanghai, China
Club House, Silverstone Race Track, Silverstone, Northamptonshire, UK
Criterion Place Development, Leeds, West Yorkshire, UK*
New Conference and Exhibition Facilities for SECC, Glasgow, Scotland, UK (1995–97)
Masterplan for Regensburg, Germany
Solar City Linz, Linz, Austria
Cladding System for Technal, France
Private House, Connecticut, USA
Bank Headquarters, Dubai, United Arab Emirates
National Botanic Gardens, Middleton, Wales, UK
Competition for IG Metall Headquarters, Frankfurt am Main, Germany
World Port Center, Rotterdam, The Netherlands
Swimming Pool and Fitness Centre, Stanmore, Middlesex, UK (1995–98)
Door Furniture for Fusital, Italy
Multimedia Center, Hamburg, Germany*
Office and Showroom for Samsung Motors, Korea*
Medical Research Laboratory, Stanford University, California, USA*
Robert Gordon University, Aberdeen, Scotland

London Underground Interchange, Greenwich, London, UK
Moorfields Offices, London, UK*
Baltic Exchange Office Development, London, UK*

1996 *Imperial College Basic Medical Sciences Building*, London, UK (1996–98, appointment 1994)
Stadium Design and Masterplan for Wembley Stadium, London, UK*
Millau Bridge, Millau, France
International Rail Terminal, St Pancras, London, UK
Offices for Slough Estates, Slough, Berkshire, UK (1996–97)
Offices for Slough Estates, Ascot, Berkshire, UK (1996–98)
London Millennium Tower, London, UK*
Oxford University Library, Oxfordshire, UK
Redevelopment of Treasury Offices, London, UK
Arsta Bridge, Stockholm, Sweden*
Offices for Citibank, Canary Wharf, London, UK
World Squares for All Masterplan for Central London, UK*
Control Tower Madrid Airport, Madrid, Spain*
Millennium Bridge, Thames pedestrian crossing, London, UK*

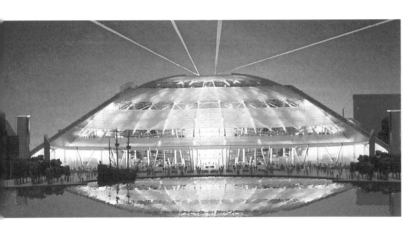

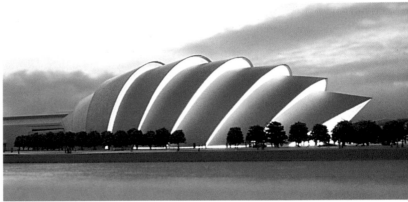

Gresham Street Offices,
City of London, UK*
Arts Centre, Oldham, Greater
Manchester, UK
Police Memorial, London, UK
Headquarters for Repsol, Bilbao, Spain
Wood Street Offices, City of London, UK

1997 *Daewoo Headquarters,* Seoul, South
Korea (1997–2000, appointment 1995)
British Museum Redevelopment,
London, UK* (1997–2000,
appointment 1994)
Department Store for Selfridges,
Glasgow, Scotland, UK
Reading Business Park for the Prudential,
Berkshire, UK
Feasibility Study for the Roundhouse,
Camden, London, UK
Housing Development for Rialto,
Wandsworth, London, UK
Moorhouse Offices, London, UK
Regional Music Centre, Gateshead,
Tyne and Wear, UK *
Headquarters for Decaux, Brentford,
London, UK
Bankers Trust Tower, Sydney, Australia
Feasibility Studies for Luton Airport,
Bedford, UK
Somapah Station, Singapore, Malaysia
Masterplan for Vienna, Austria

Office Building in Singapore for Parkview,
Singapore, Malaysia
Masterplan for Getafe, Getafe, Spain
Masterplan for Durban, Durban,
South Africa

* denotes winner of national or
international competition

Biography

SIR NORMAN FOSTER
Foster and Partners
Riverside Three
22 Hester Road
London SW11 4AN

Tel: + 44 171 738 0455
Fax: + 44 171 738 1107

1935–67

Norman Foster was born on June 1, 1935, into a family that, as he has said, did not consider going to a university or becoming an architect possible options. He worked briefly in the City Treasurer's office in Manchester Town Hall and completed two years of national service in the Royal Air Force, becoming a non-commissioned officer. It was only at the age of 21 that he began his architectural training, graduating from the University of Manchester School of Architecture and Department of Town and Country Planning in 1961. He obtained a Henry Fellowship to continue his studies at Yale University, in New Haven, Connecticut. It was there that he met another scholarship student, Richard Rogers. They worked together under Serge Chermayeff, and Foster obtained his Master's Degree in Architecture from Yale in 1963. One of the important influences at that time was Louis Kahn who was the architect of the Yale Art Gallery, which at the time of Fosters studies also housed the Yale School of Architecture. Foster married the architect Wendy Cheesman in 1964. They were both partners in the firm Team 4, created in 1963 in London with Richard Rogers and Georgie Wolton. One of their first significant projects was the *Creek Vean House* (Feock, Cornwall, 1964–66), built for Marcus and Irene Brumwell, who were the parents-in-law of Richard Rogers. The best-known project of Team 4 is undoubtedly their *Reliance Controls Limited factory* (Swindon, Wiltshire, 1965–66) which was completed just as the partnership broke up. This project received the 1967 *Financial Times* Industrial Architecture Award. It was also in 1967 that Norman and Wendy Foster established Foster Associates in London.

1968–79

Between 1968 and 1983, Foster worked on a number of projects with Buckminster Fuller, but one of his first important clients after the creation of Foster Associates was Fred Olsen Limited in Millwall. His *Fred Olsen Centre* (Millwall Docks, London, 1968–69) received a 1969 Architectural Design Project Award, and the *Financial Times* Industrial Architecture Award Commendation the following year. Other projects for Fred Olsen include a *Passenger Terminal* (Millwall, London, 1970–71), *offices* in Norway (Vestby, Norway, 1974), and the *Fred Olsen Gate Redevelopment* (Oslo, Norway, 1975). The year 1970 marked the beginning of construction of the *IBM Pilot Head Office* (Cosham, Hampshire, 1970–71), which set a standard in terms of providing permanent office facilities within the price and time constraints of temporary office units. Foster's second major achievement of this period was the *Willis Faber & Dumas Office*

(Ipswich, Suffolk, 1973–75), winner of a 1977 Royal Institute of British Architects Award, a prize which he was also to receive the following year, this time for the *Sainsbury Centre for Visual Arts* (University of East Anglia, Norwich, Norfolk, 1976–77). Very widely published, this project confirmed the architect's capacity to bring innovation in terms of both design and materials to a building type that seemed before his efforts to have been thoroughly investigated by other architects. This reputation undoubtedly played a role in 1979 in his obtaining the prestigious commission to build the new *Hongkong and Shanghai Banking Corporation Headquarters* (Hong Kong, 1981–86) which was to place him firmly in the international elite of contemporary architecture. Aside from the significant media attention generated by projects like that for the *Hong Kong tower*, it should be noted that the *IBM Pilot Head Office*, originally intended for short-term use, is still in service twenty-five years later, and that the *Willis Faber & Dumas Office* is a Grade One Listed Building, "the only modern building that has the same listing as a cathedral," as Foster says.

1980–88

One measure of the success of Foster is certainly the number of awards generated by his work, a fact that became clear in the early 1980s. In 1980 alone, he received the "Museum of the Year" Award, the Ambrose Congreve Award, the 6th International Prize for Architecture, Brussels – all of these for the *Sainsbury Centre for Visual Arts* in Norwich. In 1983 he was given by the Royal Institute of British Architects The Royal Gold Medal for Architecture. The 1980s also marked a transition of the office toward larger commissions, with the *Hongkong and Shanghai Bank*, completed in 1986, but also work on the *Third London Airport* (Stansted, Essex, completed in 1991), and the *King's Cross Masterplan*, (London, 1987). Foster also branched out into a broader range of international projects, ranging from the *Carré d'Art* (Nîmes, France, 1987–93), which he won in competition over a field of some of the world's best-known architects, to projects designed for Mexico (*Headquarters for Televisa*, Mexico City, Mexico, 1986) or Japan (*Century Tower*, Tokyo, Japan, 1989–91, design begun in 1987). Although some prestigious commissions such as the *BBC Radio Headquarters* (London, 1982) were never built, a surprisingly high number of the office's projects were in fact realized, a fact that again sets apart Foster's work as compared with that of many of his other well-known international colleagues.

1988–97

One change for Foster Associates which occurred in this period was their move to new purpose-built offices near Battersea Bridge (*Riverside Development*, London, 1986–90). Some 350 persons out of a total world-wide staff of 450 are located in these spacious quarters which look out onto the Thames. As has been the case in many Foster-designed buildings, the main work space is an open plan area, where even the large round table where the directors meet every Monday is set. Awards have been a constant of the office. In 1990 Foster received a Knighthood in the Queen's Birthday Honors. Since 1991 he has received the Mies van der Rohe Award for European Architecture, the Gold Medal of the French Academy of Architecture, the Arnold W. Brunner Memorial Prize of the American Academy and Institute of Arts and Letters in New York, the Officer of the Order of Arts and Letters from the French Ministry of Culture, and the Order of North Rhine-Westphalia. In 1994 he was given the American Institute of Architects Gold Medal for Architecture, another of the profession's most prestigious awards. Aside from the significant projects already outlined in this book, such as the *Telecommunications Tower* (Barcelona, Spain, 1990–92); the *Faculty of Law, University of Cambridge* (Cambridge, Cambridgeshire, 1993–95), the *Commerzbank Headquarters* (Frankfurt am Main, Germany, 1994–97); the enormous *Airport at Chek Lap Kok* (Hong Kong, 1995–98), the highly symbolic and visible *New German Parliament, Reichstag* (Berlin, Germany, 1995–99), or the recently announced *London Millennium Tower*, Sir Norman and his office have participated in a large number of competitions, such as that for the *Cardiff Bay Opera House* (Cardiff, South Glamorgan, Wales, 1994) or the *Grand Stade* (St Denis, Paris, France, 1994). A hallmark of their recent work has been great concern for environmental issues, as exemplified for example in the energy efficiency of such projects as the *Reichstag*, or the Bordeaux *EDF Headquarters* (Bordeaux, France, 1993–96).

Biographie

Sir Norman Foster
Foster and Partners
Riverside Three
22 Hester Road
London SW11 4AN

Tel: + 44 171 738 0455
Fax: + 44 171 738 1107

1935–67

Norman Foster wurde am 1. Juni 1935 in eine Familie hineingeboren, für die – wie er sagt – der Besuch einer Universität oder der Beruf des Architekten nicht in Frage kam. Er arbeitete kurze Zeit im Büro des Stadtkämmerers von Manchester und leistete zwei Jahre Wehrdienst bei der Royal Air Force ab, wo er es bis zum Offizier ohne Patent brachte. Erst im Alter von 21 Jahren begann er seine Ausbildung als Architekt und machte 1961 die Abschlußprüfung an der School of Architecture and Department of Town and Country Planning der Universität Manchester. Er erhielt ein Stipendium (Henry Fellowship), um sein Studium an der Yale University in New Haven, Connecticut fortsetzen zu können und begegnete dort einem anderen Stipendiaten, Richard Rogers. Sie studierten zusammen bei Serge Chermayeff, und 1963 erhielt Foster seinen Master's Degree in Architektur in Yale. Von maßgeblichem Einfluß zu dieser Zeit war Louis Kahn, Architekt der Yale Art Gallery, die zu Fosters Studienzeit ebenfalls in der Yale School of Architecture untergebracht war. 1964 heiratete Foster die Architektin Wendy Cheesman, seine Partnerin im Büro Team 4, das sie 1963 in London mit Richard Rogers und Georgie Wolton gegründet hatten. Eines ihrer ersten bedeutenden Projekte war das *Creek Vean House* (Feock, Cornwall, 1964–66) für die Schwiegereltern von Richard Rogers, Marcus und Irene Brumwell. Das bekannteste Projekt von Team 4 ist zweifellos ihre *Reliance Controls Limited Factory* (Swindon, Wiltshire, 1965–66), die gerade fertiggestellt wurde, als sich das Büro auflöste; der Entwurf erhielt 1967 den Industrial Architecture Award der »Financial Times«. Im selben Jahr gründeten Norman und Wendy Foster das Büro Foster Associates in London.

1968–79

Zwischen 1968 und 1983 arbeitete Foster bei einer Reihe von Projekten zusammen mit Buckminster Fuller, aber einer seiner wichtigsten Auftraggeber nach der Gründung von Foster Associates war die Fred Olsen Limited in Millwall. Sein *Fred Olsen Centre* (Millwall Docks, London, 1968–69) erhielt 1969 den Architectural Design Project Award und im darauffolgenden Jahr eine lobende Erwähnung beim Industrial Architecture Award der »Financial Times«. Zu den anderen Projekten für Olsen gehörten ein *Passagierterminal* (Millwall, London, 1970–71), *Büros in Norwegen* (Vestby, 1974) und das *Fred Olsen Gate Redevelopment* (Oslo, Norwegen, 1975). 1970 begann Foster mit dem Bau des *IBM Pilot Head Office* (Cosham, Hampshire, 1970–71), das neue Maßstäbe setzte, da hier zum ersten Mal ein permanentes Bürogebäude innerhalb der finanziellen und zeitlichen Beschränkungen provisorischer Büroeinheiten errichtet wurde. Fosters zweite große Leistung zu dieser Zeit waren das *Willis Faber & Dumas Office* (Ipswich, Suffolk, 1973–75), das 1977 den Preis des Royal Institute of British Architects (RIBA Award) gewann – einen Preis, den er im folgenden Jahr auch für sein *Sainsbury Centre for Visual Arts* (University of East Anglia, Norwich, Norfolk, 1976–77) erhielt. Dieses Projekt fand große Beachtung in den Medien und unterstrich die Fähigkeit des Architekten, sowohl im Design als auch bei der Materialwahl innovative Lösungen für einen Bautyp zu finden, mit dem sich vorher schon viele andere Architekten gründlich auseinandergesetzt hatten. Dieser Ruf war 1979 zweifellos einer der Gründe dafür, warum Foster den prestigeträchtigen Auftrag für das neue Hauptgebäude der *Hongkong and Shanghai Bank* (Hongkong, 1981–86) erhielt, das ihm einen festen Platz in der internationalen Architektenelite einbrachte. Aber ganz abgesehen von dem großen Medienecho, das Projekte wie dieser Turm in Hongkong hervorrufen, sollte darauf hingewiesen werden, daß das *IBM Pilot Head Office*, das eigentlich nur für eine kurzzeitige Nutzung gedacht war, auch nach 25 Jahren noch immer in Gebrauch ist, und daß das *Willis Faber & Dumas Office* als ein schützenswertes Gebäude eingestuft wurde – »das einzige moderne Bauwerk, das den gleichen Stellenwert wie eine Kathedrale besitzt«, wie Foster sagt.

1980–88

Ein Maßstab des Erfolges von Foster ist sicherlich die Anzahl von Preisen, die er für seine Arbeiten bekommt – eine Tatsache, die zu Beginn der 80er Jahre deutlich wurde. Allein 1980 erhielt er den »Museum of the Year« Award, den Ambrose Congreve Award und den 6th International Prize for Architecture in Brüssel – alle für sein *Sainsbury Centre for Visual Arts* in Norwich. 1983 erhielt er die Royal Gold Medal for Architecture vom Royal Institute of British Architects. In den 80er Jahren erhielt das Büro auch immer größere Aufträge, wie für die 1986 fertiggestellte *Hongkong and Shanghai Bank*, den Londoner *Third Airport* (Stansted, Essex, Fertigstellung 1991) oder den *Gesamtbebauungsplan für King's Cross* (London, 1987). Foster erweiterte seine Aufträge um eine breite Palette internationaler Projekte, die vom *Carré d'Art* (Nîmes, Frankreich, 1987–93) – er gewann den Auftrag in einem Wettbewerb mit den berühmtesten Architekten der Welt – bis zu Projekten reichen, die er in Mexiko (*Hauptverwaltung der Televisa*, Mexiko City, Mexiko, 1986) oder Japan (*Century Tower*, Tokio, Japan, 1989–91, Entwurfsphase ab 1987) konzipierte. Obwohl einige prestigeträchtige Aufträge wie die *BBC Radio Headquarters* (London, 1982) nie realisiert wurden, konnte sein Büro eine überraschend hohe Zahl von Projekten tatsächlich fertigstellen – eine Tatsache, in der sich Foster von vielen anderen international bekannten Kollegen unterscheidet.

1988–97

Eine große Veränderung für Foster Associates fand in dieser Periode mit dem Umzug in die eigens für die Firma konzipierten Büros an der Battersea Bridge statt (*Riverside Development*, 1986–90). Etwa 350 der weltweit 450 Mitarbeiter sind in diesen weitläufigen Räumlichkeiten mit Blick auf die Themse untergebracht. Wie in vielen von Foster entworfenen Gebäuden ist auch hier der Hauptarbeitsraum als Großraumbüro konzipiert; hier steht sogar der große runde Tisch, an dem sich jeden Montag die Direktoren treffen. Auszeichnungen sind eine konstante Größe für das Büro: 1990 erhielt Foster bei den Queen's Birthday Honors den Ritterschlag. Seit 1991 gewann er den Mies van der Rohe Award for European Architecture, die Médaille d'Or für Architektur der Académie française, den Arnold W. Brunner Memorial Prize der American Academy and Institute of Arts and Letters in New York, wurde Officier de l'Ordre des Arts et Lettres des französischen Kultusministeriums und erhielt den Orden des Landes Nordrhein-Westfalen. Im Jahre 1994 bekam er die Gold Medal for Architecture des American Institute of Architects, eine der renommiertesten Auszeichnungen seines Berufsstands. Neben der Arbeit an bedeutenden Projekten, die bereits in diesem Buch vorgestellt wurden, wie z.B. dem *Torre de Collserola* (Barcelona, Spanien, 1990–92), der *Faculty of Law der Universität Cambridge*, (Cambridge, Cambridgeshire, 1993–95), der *Commerzbank* (Frankfurt am Main, 1994–97), dem riesigen *Chek Lap Kok-Flughafen* (Hongkong, 1995–98), dem sehr symbolträchtigen und aufsehenerregenden neuen *Deutschen Bundestag im Reichstag* (Berlin, Deutschland, 1995–99) oder dem vor kurzem angekündigten *Millennium Tower* in London nahmen Sir Norman Foster und sein Büro an einer großen Zahl von Wettbewerben teil, wie dem für das *Cardiff Bay Opera House* (Cardiff, South Glamorgan, Wales, 1994) oder dem *Grand Stade* (St.Denis, Paris, Frankreich, 1994). Ein Merkmal der jüngsten Arbeiten von Foster ist das große Interesse an ökologischen Belangen, wie es z.B. in der Energieeffizienz solcher Projekte wie dem *Reichstag* oder der *Zentrale der EDF* in Bordeaux (Frankreich, 1993–96) deutlich wird.

Biographie

Sir Norman Foster
Foster and Partners
Riverside Three
22 Hester Road
London SW11 4AN

Tel: + 44 171 738 0455
Fax: + 44 171 738 1107

1935—67

Norman Foster naît le 1er juin 1935 dans une famille qui, comme il le dit, ne considère pas qu'aller à l'université ou devenir architecte sont des choix possibles. Il travaille brièvement au service des Finances de la ville de Manchester, puis fait deux ans de service militaire dans la Royal Air Force. C'est seulement à l'âge de 21 ans qu'il commence sa formation d'architecte et sort diplômé de l'université de Manchester, école d'architecture, d'urbanisme et de planification. En 1961, il obtient une bourse universitaire (Henry Fellowship) pour continuer ses études à l'université de Yale, New Haven, Connecticut. Là, il rencontre un autre étudiant boursier, Sir Richard Rogers. Ils travaillent ensemble sous la direction de Serge Chermayeff, et Foster obtient son doctorat en Architecture à Yale en 1963. Il est alors très influencé par Louis Kahn, qui a dessiné la Yale Art Gallery. Foster épouse l'architecte Wendy Cheesman en 1964. Ils s'associent et fondent la société Team 4 en 1963 à Londres en collaboration avec Sir Richard Rogers et Georgie Wolton. L'un de leurs premiers projets importants est la *Creek Vean House* (Feock, Cornouailles, 1964—66), construite pour Marcus et Irene Brumwell, les beaux-parents de Sir Richard Rogers. Le projet le plus connu de Team 4 est incontestablement l'*usine Reliance Controls Limited* (Swindon, Wiltshire, 1965—66) qui est achevée au moment même où cesse leur partenariat. Ce projet reçoit le Prix 1967 de l'Architecture Industrielle du «Financial Times». C'est aussi en 1967 que Norman et Wendy Foster créent Foster Associates à Londres.

1968—79

Entre 1968 et 1983, Foster travaille sur plusieurs projets en collaboration avec Buckminster Fuller. Toutefois, après la création de Foster Associates, l'un de ses plus importants clients est Fred Olsen Limited à Millwall. Pour son *Centre Fred Olsen* (Millwall Docks, Londres, 1968—69), Foster reçoit un Prix du Architectural Design Project, et l'année suivante, un accessit pour le Prix de l'Architecture Industrielle du «Financial Times». Parmi d'autres projets pour Fred Olsen, citons un *terminal pour passagers* (Millwall, Londres, 1970—71), des *bureaux* en Norvège (Vestby, Norvège, 1974) et l'*extension du Fred Olsen Gate* (Oslo, Norvège, 1975). 1970 marque le début de la construction du *siège social pilote d'IBM* (Cosham, Hampshire, 1970—71), qui va servir de norme dans la construction de bureaux permanents respectant des contraintes de prix et de temps qui étaient celles des bureaux temporaires. Dans cette même période, les *bureaux Willis Faber & Dumas* (Ipswich, Suffolk, 1973—75) reçoivent le prix 1977 de l'Institut Royal

des Architectes Britanniques (RIBA Award). L'année suivante, Foster reçoit à nouveau ce même prix, cette fois pour le *Centre Sainsbury pour les Arts Visuels* (université d'East Anglia, Norwich, Norfolk, 1976—77). Très largement commenté, ce projet confirme la capacité de l'architecte à pousser l'innovation à la fois dans la conception et dans les matériaux pour un type de construction qui, avant lui, semblait avoir été étudié en profondeur par d'autres architectes. Incontestablement, cette nouvelle réussite joue un rôle en 1979, quand il obtient la prestigieuse commande du nouveau *siège social de la Hongkong and Shanghai Banking Corporation* (Hong Kong, 1981—86). Cela le place définitivement dans l'élite internationale de l'architecture contemporaine. Le *IBM Pilot Head Office*, initialement prévu pour une utilisation temporaire, est toujours en service 25 ans plus tard, et les *bureaux Willis Faber & Dumas* (classé Monument historique) sont le «seul immeuble moderne à être classé comme une cathédrale», précise Foster.

1980—88

Une façon de mesurer le succès de Foster consiste certainement à compter le nombre de prix attribués à ses œuvres, évidence qui s'impose dès le début des années 1980. Rien qu'en 1980, il obtient le Prix du «Musée de l'Année», le Prix Ambrose Congreve, le 6e Prix International d'Architecture, Bruxelles – tous pour le *Centre Sainsbury pour les Arts Visuels*, à Norwich. En 1983, il reçoit la Médaille Royale d'Or pour l'Architecture de l'Institut Royal des Architectes Britanniques. Les années 1980 marquent aussi un passage de son agence vers des commandes plus importantes, avec, bien sûr, la *Banque de Hongkong et Shanghai*, terminée en 1986, mais aussi le *troisième aéroport londonien* (Stansted, Essex, terminé en 1991), ou encore le *plan directeur de King's Cross* (Londres, 1987). Foster étend aussi ses activités à un champ de projets internationaux qui vont du *Carré d'Art* (Nîmes, France, 1987—93), où il remporte le concours dans un peloton d'architectes célèbres, jusqu'à des projets conçus pour le Mexique (le *siège social de Televisa*, Mexico, 1986) ou le Japon (la *tour Century*, Tokyo, Japon, 1989—91, projet commencé en 1987). Si certaines commandes prestigieuses, comme le *siège social de la BBC Radio* (Londres, 1982) ne seront jamais construites, un nombre étonnamment élevé de projets sont en fait réalisés, ce qui met l'œuvre de Foster à part de celles de ses confrères étrangers.

1988—97

Alors, un changement survient chez Foster Associates: ils déménagent dans de nouveaux bureaux spéciale-

ment construits près de Battersea Bridge (*Extension de Riverside*, 1986—90). Environ 350 employés, sur les 450 personnes que la firme emploie dans le monde, s'installent dans ces locaux spacieux qui donnent sur la Tamise. Comme c'est déjà le cas pour de nombreux immeubles conçus par Foster, l'espace de travail principal est une aire ouverte où se trouve aussi la grande table ronde autour de laquelle, chaque lundi, se réunissent les directeurs. Les Prix sont une constante de cette agence. En 1990, Foster est anobli lors des Cérémonies de l'Anniversaire de la Reine. Depuis 1991, il a reçu: le Prix Mies van der Rohe de l'Architecture européenne, la Médaille d'Or pour l'Architecture de l'Académie française, le Prix commémoratif Arnold W. Brunner de l'Académie américaine et de l'Institut des Arts et Lettres de New York. Le ministre français de la Culture le fait Officier des Arts et des Lettres, et Foster est aussi décoré de l'Ordre de la Rhénanie-du-Nord-Westphalie. En 1994, il reçoit de l'Institut américain des Architectes la Médaille d'Or pour l'Architecture, l'un des prix les plus prestigieux de la profession. Parallèlement aux projets importants décrits dans ce livre, comme la *Tour de télécommunications* (Barcelone, Espagne, 1990—92), la *faculté de droit, université de Cambridge* (Cambridge, Cambridgeshire, 1993—95), le *siège social de la Commerzbank* (Francfort-sur-le-Main, Allemagne, 1994—97), le *gigantesque aéroport de Chep Lap Kok* (Hongkong, 1995—98), le nouveau Parlement allemand – éminemment symbolique et visible – le *Reichstag* (Berlin, Allemagne, 1995—99), ou encore, la *Millennium Tower* de Londres, récemment annoncée, Sir Norman Foster et son agence ont participé à un grand nombre de concours, comme ceux pour l'*Opéra de la Baie de Cardiff* (Cardiff, Pays de Galles, 1994) ou pour le *Grand Stade* (Saint-Denis, Paris, France, 1994). Depuis quelque temps, l'architecte s'intéresse encore plus à l'environnement, comme on peut le voir en particulier dans des projets tels que le *Reichstag*, ou que les *bureaux de l'EDF* à Bordeaux (France, 1993—96).

COLLABORATORS:

Otl Aicher	CAST SA	Fisher Marantz	Kaiser Bautechnik	Obayashi
Arup Acoustics	Cosentini	Renfro Stone	Lerch Bates Associates	Roger Preston and Partners
Ove Arup & Partners	Richard Davies	Gardiner and Theobald	Derek Lovejoy Partnership	Quickborner Team
BAA Consultancy	Davis Langdon and Everest	Gleeds	Rudi Meisel	Schumann Smith
Sandy Brown Associates	Desvigne and	Halcrow Fox & Associates	Dr Meyer	George Sexton Associates
Richard Buckminster Fuller	Dalnoky Paysagistes	Bill Hillier –	Mott MacDonald	Tim Smith Acoustics
Buro Happold	Jolyon Drury Consultancy	Space Syntax Group	NACO	Theatre Projects
Loren Butt	Anatole du Fresne	Anthony Hunt Associates Ltd	Northcroft Neighbour	Waterman Partnership
Cantor Seinuk	Claude and Danielle Engle	Jappsen & Stangier	and Nicolson	WET Design
				WI Partnership
				YRM Engineers Ltd

Bibliography
Bibliographie

Foster Associates
RIBA Publications 1978

Foster Associates: Six Architectural Projects 1975–1985
By Alastair Best
Sainsbury Centre for Visual Arts, Norwich 1985

Norman Foster: Une Volonté du fer
By François Chaslin, Armelle Lavalou and
Frédérique Hervet IFA (France)
Electa Moniteur 1986

Foster, Rogers, Stirling
By Deyan Sudjic
Thames and Hudson 1986

Norman Foster
By Chris Abel et al
A+U Monograph (Japan) 1987

Norman Foster
By Aldo Benedetti
Published by Nichola Zanichelli 1988
Published by Verlag für Architektur Artemis,
Zürich 1990
Published by Gustavo Gilli 1994

Norman Foster
Quaderns Monografia (Spain)
Editorial Gustavo Gilli 1988

*Hongkong Bank: The Building of Norman
Foster's Masterpiece*
By Stephanie Williams
Jonathan Cape 1989

*Norman Foster: Team Four and Foster
Associates Buildings and Projects 1964–1973*
Volume 1
Edited by Ian Lambot
Watermark Publications/Ernst & Sohn 1991

*Norman Foster: Foster Associates Buildings and
Projects 1971–1978* Volume 2
Edited by Ian Lambot
Watermark Publications/Ernst & Sohn 1989

*Norman Foster: Foster Associates Buildings and
Projects 1978–1985* Volume 3
Edited by Ian Lambot
Watermark Publications/Ernst & Sohn 1989

*Norman Foster: Foster Associates Buildings and
Projects 1982–1989* Volume 4
Edited by Ian Lambot
Watermark Publications/Birkhäuser 1996

Norman Foster
By Daniel Treiber
German version published by Birkhäuser 1991
French version published by Éric Hazan 1994
English version published by Spon 1995

Norman Foster Sketches
By Werner Blaser
Birkhäuser Verlag 1992

Norman Foster Sketch Book
By Werner Blaser
Birkhäuser Verlag 1993

Foster Associates Recent Works –
Architectural Monograph No 20
By Kenneth Powell
Academy Editions/St Martin's Press 1992

Norman Foster
A & V Monografias de Arquitectura y Vivienda 38
(1992) (Spanish)

Norman Foster and the Architecture of Flight
By Kenneth Powell
Blueprint Monograph 1992

Blueprint Extra 04 The Sackler Galleries
By Rowan Moore
Wordsearch, London 1992

*Willis, Faber & Dumas Building Foster
Associates*
By Gabriele Bramante
Phaidon Press, London 1993

Blueprint Extra 11 Carré d'Art Nîmes
By Kenneth Powell
Wordsearch, London 1994

*Norman Foster Arquitectura, urbanismo y medio
ambiente*
Fundacio San Benito de Alcantara, Spain 1994

Reichstag Berlin
Aedes Galerie, Berlin 1994

Deutsche Projekte
Sir Norman Foster and Partners
Architekturgalerie München 1995

The Architecture of Information
Venice Biennale 1996
By Michael Brawne
The British Council 1996

The Economy of Architecture
Proceedings of the Symposium in honour of
Sir Norman Foster doctor honoris causa at the
Eindhoven University of Technology 1996

*Foster and Partners Architects Designers
and Planners*
By Alastair Best et al.
Foster and Partners 1996

Credits

Fotonachweis

Crédits photographiques

l. = left | links | à gauche
r. = right | rechts | à droite
t. = top | oben | en haut
c. = centre | Mitte | centre
b. = bottom | unten | en bas

The publisher and author wish to thank Sir Norman Foster and Partners for kindly providing the pictorial material (photos, sketches and CAD drawings) for this publication, as well as to:

Airphotos international 134–135
Patrice Blot 81
Martin Charles 94 t.
Peter Cook/VIEW 67 l.
Hayes Davidson/Richard Davies 49
Richard Davies 18, 32, 35, 37, 38, 45, 72–74, 75 t., 76 t., 85–87, 90 t., 91, 100 t., 101, 135 b., 137 t., 138–139, 141–147, 150–153, 161 l., 161 r. 162 l., 163 l., 164 c., 166, 167, 169
Uwe Dettmar 42,129

John Donat 13
Patrick Drickey 112, 114, 115 c.
Richard Einzig/Arcaid 9, 10, 56, 60 t., 61 c.
Georg Fischer/Bilderberg 164 l.
Dennis Gilbert/VIEW 14, 21, 29, 31, 66 t., 67 c.r., 77–79, 92, 93 l., 102, 104, 105, 110–111, 117, 119 t., 164 r.
Alastair Hunter 161 c.
K. Ip 136 t.
Ben Johnson 22 t., 67 b.r., 99
Simon Jones/Illustration 158–159
Ken Kirkwood 58, 59, 60 b., 62 t., 64, 65, 76 b.
Ian Lambot 17, 68, 70, 71, 95
John Edward Linden 97, 120 l.
John Edward Linden/Arcaid 120–121

Rudi Meisel/VISUM 6, 54–55, 140, 171, 173
Tom Miller 125, 126 t, 165 l.
Mishima 162 r.
James H. Morris 50, 82 c.l., 82–83, 122, 123
NRSC Ltd. 157 t.
John Nye 136 b.
Paul Raftery 108, 110 t.
Bernard Saint-Genès 163 r.
Tim Soar 82 t.
Morley von Sternberg 165 r.
Tim Street-Porter 63 t., 160
Bobby Sum 133
X Basianas 98–99
Nigel Young 107 t., 130, 131